TEMPORARY
MONUMENTS

TEMPORARY MONUMENTS

Art, Land,
and America's
Racial Enterprise

**REBECCA
ZORACH**

The University of Chicago Press
Chicago and London

The University of Chicago Press, Chicago 60637
The University of Chicago Press, Ltd., London
© 2024 by The University of Chicago
Published 2024
Printed in the United States of America

33 32 31 30 29 28 27 26 25 24 1 2 3 4 5

ISBN-13: 978-0-226-82687-5 (cloth)
ISBN-13: 978-0-226-83101-5 (paper)
ISBN-13: 978-0-226-83100-8 (e-book)
DOI: https://doi.org/10.7208/chicago/9780226831008.001.0001

Publication is made possible in part by a gift from Elizabeth
Warnock to the Department of Art History at Northwestern
University.

Library of Congress Cataloging-in-Publication Data

Names: Zorach, Rebecca, 1969– author.
Title: Temporary monuments : art, land, and America's racial
 enterprise / Rebecca Zorach.
Description: Chicago : The University of Chicago, 2024. | Includes
 bibliographical references and index.
Identifiers: LCCN 2023031430 | ISBN 9780226826875 (cloth) |
 ISBN 9780226831015 (paperback) | ISBN 9780226831008 (ebook)
Subjects: LCSH: Art and society—United States. | Art and race. |
 Public art—United States—History. | Art—Political aspects—
 United States.
Classification: LCC N6505 .Z67 2024 | DDC 700.1/03—dc23/
 eng/20230801
LC record available at https://lccn.loc.gov/2023031430

♾ This paper meets the requirements of ANSI/NISO Z39.48-1992
(Permanence of Paper).

For Lauren Berlant

CONTENTS

Plates follow page 130.

Illustrations

PLATES

INTRODUCTION

Temporary Monuments

In 1967 Gwendolyn Brooks described a familiar kind of art that people see in public: "an astounding fountain, or a horse-and-rider."[1] Park features and ornaments, bronze or stone figures that honor historical people and events, such monuments have long dotted the public spaces of American cities and towns.[2] This book is not about *these* monuments, or not exactly. They are not its central subject matter. Their removal, their histories, debates about them, proposals for new ones—all these things will come into play. But I conceive "monuments" in a broader sense, as symbolic markings of space that gesture toward history, and in my title is an embedded irony: a temporary monument? Monuments are designed to endure. They are supposed to be forever. But they are not. They were put in place at a given time and responded to concerns of that time. They can be altered, given new meaning and new context, and they can be removed. My subject is the role art has had in constructing the public imagination, mythologies, ecologies, and symbolic spaces of "America"—the United States of America in particular—and how art and artists can intervene to change them.

So much has happened since I began the work that has resulted in *Temporary Monuments* that it is hard to know how to introduce my story. This book has taken shape during a time when it became clear that the 2016 presidential election represented not a fluke but a toehold for a mounting White supremacist and Fascist movement. It has taken shape in the midst of a pandemic that killed millions and was exploited to exacerbate divisions, a time in which the radical Right consolidated its hold on the Supreme Court and the deaths and trauma of mass shootings continued to mount, an existential time of climate crisis. At the same time, these years have also witnessed new and renewed movements for racial justice and climate justice, new calls for police and prison abolition,

and a reenergized labor movement—movements for survival in the face of an advancing machine of death.

Let me be clear: you cannot save yourself by becoming an ally of that machine. And in the thought that writing and artmaking might be a mode of resistance to it, I take encouragement from the call issued by Sylvia Wynter: "the buck stops with us."[3] "Us" can mean people of this moment, but for her it is specifically artists, writers, readers, academics. That is, not only do intellectuals have a role to play in the rewiring of the sense of the human and our place in planetary ecologies, but we must take up that challenge.

Some people, of course, already have. To rewind the tape just a little, we might think about an artistic intervention of a few years ago, one with real consequence. In an America once dubbed "postracial" (an ever more laughable notion), what does it take to muster enough public will to tear down a racist symbol? To Black South Carolinians, the Confederate Battle Flag at the South Carolina State Capitol was always an obscene symbol of slavery and of modern White supremacy. It became even more so in the wake of the murderous rampage of a White supremacist who, on June 17, 2015, gunned down worshippers at a Bible study at the Emanuel African Methodist Episcopal Church in Charleston, South Carolina, killing nine people and wounding another. Ten days later, the activist and artist Bree Newsome Bass had had enough of the flag that flew on the Capitol grounds, and she climbed to the top of the flagpole and pulled it down. She was arrested (the charges were later dropped), and authorities ran the flag back up the pole. A few weeks later, the state legislature voted to remove it permanently.[4]

Something similar seemed to happen, on a broader scale, in 2020. After the murder of George Floyd by police in Minneapolis (and Breonna Taylor in Louisville, and Ahmaud Arbery by White vigilantes in Brunswick, Georgia, and the list goes on), protests erupted all over the United States. Sometimes protests coalesced around demands to remove racist monuments—Confederate generals in the first instance but also Christopher Columbus, several US presidents, and other figures to whom the honor of a statue had been bestowed. As a twenty-first-century movement to remove them gained steam, artists took part in creative ways. When Newsome Bass removed the Confederate flag, scaling the flagpole guerrilla-style, her exploit was, as the artist Colette Gaiter argued in *Time* magazine, an act of socially engaged art.[5] At the Robert E. Lee statue in Richmond, Virginia, artists tagged the statue and its pedestal with graffiti and projected imagery onto it to create a colorful, multilayered palimpsest. Imagery included the faces of prominent political figures from African American history and recent events (Harriet Tubman, W. E. B. Du Bois, John Lewis, George Floyd himself), along with "BLM" and other slogans (fig. 0.1).[6] Like other artistic forms of protest, these actions insist that imagery, symbols, and monumental forms have the

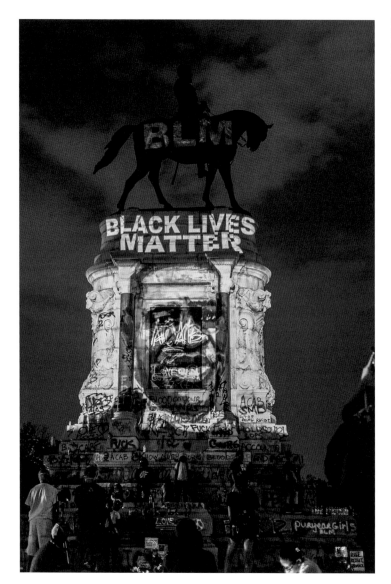

FIGURE 0.1
Image of George Floyd projected
onto the statue of Confederate
Gen. Robert E. Lee, Richmond,
Virginia. Projection by Dustin
Klein. Photo by Sandra Sellars.
Richmond Free Press, June
2020.

power to structure the experience of place. They seek to reclaim space for a just organization of society.

Not everyone, of course, agreed these symbols should go. In Chicago, when protesters, many of them Black, Brown, and Indigenous young people, rallied against the statue of Christopher Columbus in Grant Park—some attempting to topple it—an enormous police presence swarmed to meet them. Cops pepper sprayed the protesters, pulled them off bicycles, slammed them to the ground. An officer punched a young woman, Miracle Boyd, and knocked one of her teeth out. Events like these raise questions of their own: Is there more to this police

response than a simple defense of public order? What role do monuments play in creating that sense of order? Why do they provoke such heated attacks and such vigorous defenses? The protesters assert through words and deeds that these statues create and maintain conditions in which White supremacy flourishes, in which police violence goes unchecked. While different cities have had varying reckonings with these questions, protesters and police alike see these monuments as key to the symbolic order and to control over space. "Whose streets? Our streets."

A confrontation with the history of race in America has been long in the making, prepared and signaled in the work of numerous activists, scholars, and artists and writers in many media. One of the ways in which this reckoning has played itself out has been in the undoing of monumental statues that, for decades, staked out public space all over the United States. From the perspective of racial justice, what unites these monuments, whether they are dedicated to Christopher Columbus or George Washington or Robert E. Lee, is the violence these historical persons perpetrated on Black and Indigenous people. To monumentalize, from this perspective, perpetuates that violence, erases their crimes, and props up *Whiteness*—and male authority—in particular. To other observers, even some who think the men they depict are not actually admirable, these objects are worth saving simply because they are works of art—or because of the stories they tell about historical events, about artistic achievements, or even about the racism and patriarchy that produced them. How do we make sense of these differing positions?[7]

First, it's worth acknowledging that public monumental sculpture and its ubiquity in certain kinds of places contributes to our sense of what public space is. In many locations, statues help define civic space as such. They elevate it out of the realm of the ordinary spaces that afford us passage, that serve merely as convenient or inconvenient containers for our travel from home to work or leisure or shopping and back again. Monuments create an affirmative notion of public space that claims to have meaning and produce identity. And by design, monuments give the impression of having been here so long that it might as well be forever. Their presence suggests permanence, durable memory, continuity. Their traditional styles and materials—traditional for Europe and Euro-America, at any rate—seem to connect the United States to an even longer history, that of the statues of classical antiquity, Greece and Rome. Statues of rulers and heroes, gods and generals, they stand in a long and apparently seamless tradition.

This is an illusion, of course: each statue results from the concerns that drove its creation at a moment in time. Monuments to Confederate generals, in the main, emerged out of the politics of Southern White racial revanchism at very particular moments. They were, as M. M. Manring puts it, "a way of interpret-

ing the 'Old South' as a whole forming a public memory of a time, social order, and place."[8] To understand their effects, we have to contend with the histories of how these monuments were placed. According to a 2019 report by the Southern Poverty Law Center, "spikes" in the creation of monuments in the South, and the use of names, symbols, and iconography of the Confederacy, occurred in two distinct and historically significant moments: "The first began around 1900 as Southern states were enacting Jim Crow laws to disenfranchise African Americans and re-segregate society after several decades of integration that followed Reconstruction. It lasted well into the 1920s, a period that also saw a strong revival of the Ku Klux Klan. Many of these monuments were sponsored by the United Daughters of the Confederacy. The second period began in the mid-1950s and lasted until the late 1960s, the period encompassing the modern civil rights movement."[9] Within debates about their continued existence, some commentators—ostensibly sympathetic to the concerns of protesters—worry over the loss of "history" if statues are removed. But understanding how these campaigns of monument creation arose out of the politics of their moment, and how they served as a display of symbolic dominance, gives the lie to the notion that they neutrally represent history. The choice of particular statues does not merely allow for the telling of stories about history. They erase other histories that could have been represented, that might have told a different story. They say whose history matters; they communicate messages about who is held to belong in public space; and, when contested, they point us in the direction of which mythologies will be protected.

Moreover, even when the person honored by a given public statue does not give particular offense, the form itself is not neutral. Equestrian statues of generals, stiff and solemn men stuffed with their own importance, allegorical figures in antiquated garb—all these hark back to European types. This suggests not one but two forms of conquest. In Europe since antiquity, statues served as a form of virtual conquest, representing the power of gods and rulers whether in far-off places or at home. Their public placement puts them in the company of triumphal entries by which rulers represented conquest not only over lands they conquered militarily but even over their "own" cities.

One could argue that in the modern United States, we've neutralized this sense of conquest by devoting monumental statues to people we respect and admire who are not "conquerors" or rulers at all, and certainly not gods. And yet here precisely is where the second form of conquest comes in. The very fact that these are European forms should force some questions. Why and how did traditions of European art and architecture come to dominate the public visual culture of this land? To think about these questions we need to think beyond the idea of the monument. I will argue in the pages that follow that we need to think ourselves further back in history than the Confederate monument campaigns

to consider what the term "art" and its affiliate terms meant in conditions of early, slaveholding settler colonialism and how they have traveled through time to continue constructing how we imagine land, culture, community, and public space today.

Part of this imagination is how we understand our own identities. You may have already noticed that I've made a decision in this book to capitalize the word "White" when using it as a racial identity. As a White woman I do this not without some discomfort—the worry that the very use of the capital letter might appear to affiliate me with Far Right identitarian movements that also use a capital *W*. Yet I court this discomfort intentionally. As Eve Ewing argues, to leave only "white" as a lower-case term "runs the risk of reinforcing the dangerous myth that White people in America do not have a racial identity."[10] To capitalize the word, on the other hand, is to insist on marking an identity that typically goes unmarked, that often constitutes a norm from which others are held to deviate, that invisibly accrues benefits. It also reminds us that this identity, like others, is constructed and reinforced by many acts, large and small, and by institutions—including, and this is my argument throughout much of this book, the institutions of art and art history.

ART, NATURE, RACE, AND PLACE

The specific spaces that harbor these controversial statues can be ordinary streets and squares, in downtown areas or on the outskirts. Very often, such monuments are found in green spaces—liminal zones, parks and parkways that punctuate streets and represent "nature" in the city. The Columbus statue's empty pedestal now stands surrounded by greenery in a spot at the southern edge of Grant Park, on the path that leads directly to the Field Museum, Chicago's natural history museum.[11] The placement of monuments in parks reflects the garden design of early modern Europe, but its persistence wasn't a foregone conclusion. In a 2001 essay in the *New Yorker*, "Sowers and Reapers," Jamaica Kincaid describes the experience of participating in a panel discussion on gardens at the Charleston Garden Conservancy in South Carolina. Kincaid had prepared a different talk entirely. But after a previous speaker on her panel brought up a garden made by prisoners in the Holocaust, she was moved to talk about the statue of John Calhoun, defender of slavery and inventor of the rhetoric of states' rights, that she had noticed in the park across from the hotel where she was staying for the event. After the event, her host confronted her, demanding to know why she had "introduced race politics into the garden."

Why, Kincaid then reflects, "must people insist that the garden is a place of rest and repose, a place in which to distance yourself from the painful responsi-

bility that comes with being a human being?"[12] Rest and repose, of course, come more easily to those whose identities are fed and caressed—or *just not troubled*—by past decisions about who should be honored in such spaces. But gardens may be unquiet spaces for many who traverse them. These situations are not just incidental: when monuments make their home in green space, we can see in miniature the pairing of "art" and "nature," two terms whose oppositions, overlaps, and alliances constitute a key theme of cultural history. If statues represent power over the landscape, they tell us who holds that power.

When I said that parks represent nature in the city, I meant that they carry a symbolic allusion to nature. They are, of course, highly constructed and not "natural" at all. Take, for example, the land where Chicago's Columbus statue stood. Grant Park sits atop landfill that was created after Chicago's Great Fire of 1871 by offloading debris from the buildings destroyed by fire into Lake Michigan. In 1914 the Pokagon Band of Potawatomi filed suit in Federal District Court to seek the return of this territory, which was not formally ceded in the Potawatomi's 1833 treaty with the US government because it was not, at that time, land. The case eventually made its way to the Supreme Court, which ruled that the Potawatomi had "abandoned" the land. As the Settler Colonial City Project puts it, "In forcing the Supreme Court into an absurd argument—that nonexistent land could be abandoned—the Pokagon Potawatomi revealed the way in which United States law was structured by settler colonialism and the distance of both law and colonialism from an ethical relationship to land."[13] The statue of Columbus, erected in 1933, faced Columbus Drive, which runs on the north–south axis smack dab in the middle of the landfill area. In its overt artificiality—constructed territory—this example illustrates well the fact that green space is not natural. And not only is it not natural, but it also commonly reflects the politics of land use and land ownership—in this case, in especially pointed ways. It speaks to the role art has played in carving out spaces for something called "civilization" that presents itself as timeless in the garb of European artistic styles.

The dyad of art and nature, both a pairing and an opposition, derives from European ideas, and it found new manifestations in Europe's colonial projects. In the nineteenth-century US, artists and writers made claims for the special role of nature in the formation of the new nation through art, in what Angela Miller has called the "instrumentalization of nature as the raw material of American empire."[14] The painter Asher Durand's famous "Letters on Landscape Painting" twinned the artistic authority of nature as a teacher of artists with the "native" land of America—claiming Nativeness, that is, for the descendants of European settlers.[15] The pairing of art and nature served as a tool of the essentially colonial project of controlling land and access to it. To understand this argument requires taking seriously the idea that White supremacy, with its sturdy pillars in the form of settler colonialism and slavery, was a foundational structure of

US national identity: national identity as a racial enterprise. White supremacy in this sense is not a matter of white hoods and burning crosses; it is the business of racemaking central to the very constitution (and Constitution) of the United States. This implies certain ways of thinking about history: while a liberal school of thought that favors the expansion of civil rights and of equality of opportunity might imagine US history as a matter of progressive improvement upon flawed but promising foundations, another more radical position sees the very institutions charged with carrying this progress forward as thoroughly and irremediably imbued with the acts of dispossession and dehumanization that allowed them to come into being. When I mention institutions, I mean to allude to the museum and the university as much as the more obviously governmental institutions established by the United States Constitution. As long as "we the people" remain on *this* land, is it possible for this history to be transcended? At the very least, "we" have to grapple with it.

What would it look like for art to operate differently in public space? Alongside experiments in abstraction and performance in public art, and activist interventions to reclaim space, artists have expanded the possibilities for who can be commemorated in monuments or monument-like objects. In *The Lure of the Local*, Lucy Lippard gathers together a body of work by artists who took an interest, in the 1980s and 1990s, in "representing the historic in avant-garde forms," forging relationships between "past and present in place."[16] For example, Sheila Levrant de Bretteville's 1991 *Biddy Mason: Time and Place* in Los Angeles is a wall installation that uses both abstract and representational relief imagery to chronicle the life of a Black woman who was born in slavery and traveled to the West Coast, becoming a midwife and real estate entrepreneur. Judith Shea's 1994–95 *The Other Monument* took a different approach, responding to an existing equestrian monument at the edge of Central Park in Manhattan with a "shadow" wooden monument in a folk art style.[17]

Given how comprehensively monuments in traditional styles honoring White men dot the landscape, collective projects seem to have the best chance at making a difference. In the 1990s in New York, REPOhistory installed alternative monuments and historical markers that push back against the traditional monument narratives. Suzanne Lacy's installation *Full Circle*, part of the 1992–93 project Culture in Action in Chicago, dedicated rough-hewn boulders sourced from a woman-owned quarry to a multiracial group of one hundred Chicago women, present and historical.[18] The temporary intervention dotted downtown streets, making the point that Chicago has devoted only a tiny proportion its many monuments to women. More recently, groups like the New Orleans Committee to Erect Historical Markers on the Slave Trade; the Equal Justice Initiative in Montgomery, Alabama, and its National Memorial for Peace and Justice; and Ogimaa Mikana: Reclaiming/Renaming in Ontario, Canada, have begun similar

work.[19] The Philadelphia organization Monument Lab has sponsored conversations and commissioned public artworks that call traditional monuments into question while raising political questions about representation and justice.

Some works straightforwardly redress historical absences and myths; others seek to redefine what a monument is. Some monuments might be classed with the German public installations recognizing the Holocaust that the historian James E. Young has termed "counter-monuments," created by artists who reject traditional monuments that honor historical figures or claim to repair or redeem past wrongs. "Instead of searing memory into public consciousness," these artists and artworks suggest, "conventional memorials seal memory off from awareness altogether." The alternative is to create works "whose primary function . . . is to jar viewers from complacency and to challenge and denaturalize the viewers' assumptions."[20]

Artists' projects that we can call "critical monuments" have reckoned specifically with symbols of American history. A temporary outdoor installation, Abigail DeVille's *Light of Freedom* responded directly to the political events of 2020. It was inspired by photographs of the Statue of Liberty as it was displayed in pieces in the years before it was finally fully installed on Ellis Island in 1886. During this process, a disembodied hand holding a torch was put on view at the 1876 Centennial Exhibition in Philadelphia and then on a pedestal in Madison Square Park in New York; other old photos show the statue surrounded in scaffolding. In DeVille's statue the torch is filled with a rusted metal bell and the blue arms of mannequins and surrounded by a golden scaffold, suggesting the sense of freedom as something that is continually in progress and requires work to attain. Entering into pressing questions about monuments, whom they honor, and whom they welcome into public space, DeVille also imagined the statue as a monument to the lives of Angolan people who were brought to New York and enslaved by early Dutch settlers. Following its appearance in Madison Square Park, the statue moved to the National Mall, where it was installed in the outdoor sculpture garden of the Hirshhorn Museum.

Not all critical monuments exist in outdoor public spaces. Alan Michelson designed his 2018 *Hanödaga:yas (Town Destroyer)* (fig. 0.2) to stand in a museum space, but it directly addresses the relationship of monuments and historical landscapes. In the piece Michelson projects historical imagery—maps, documents, paintings, and prints—onto a replica of Jean-Antoine Houdon's portrait bust of George Washington. The work takes its title from the Haudenosaunee (Iroquois, or Six Nations Confederacy) name for Washington, Hanödaga:yas. The name translates as "town destroyer," a title he inherited from his great-grandfather, who murdered several chiefs during Bacon's Rebellion; Washington went on to earn the name himself through the brutal military campaign he waged against the Haudenosaunee during the Revolutionary War, in which his

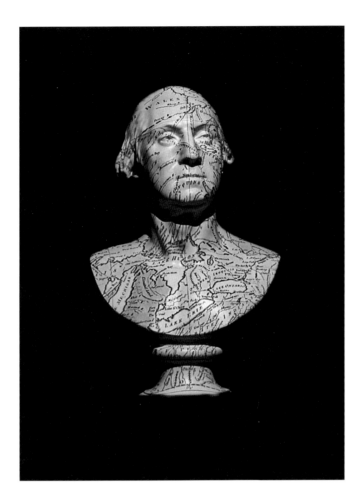

FIGURE 0.2
Alan Michelson, *Hanödaga:yas
(Town Destroyer)*, 2018.
HD video, bonded stone
Houdon replica bust, antique
surveyor's tripod, artificial
turf. 75 × 72 × 72 in. (190.5
× 182.9 × 182.9 cm). Sound:
members of Six Nations of the
Grand River Territory.

armies destroyed upward of forty villages and all their crops in the ground. The video projection is accompanied by an audio track consisting of the sound of a traditional Haudenosaunee water drum and rattle, followed by individual members of the Six Nations of the Grand River (Michelson is himself a Mohawk member) reciting each language's version of the name Hanödaga:yas. The bust sits atop an antique surveyor's tripod that rests on artificial turf, alluding to Washington's work as a land surveyor and speculator, through which he helped construct the legal groundwork for the westward expansion of European colonists' settlement and the seizure of Haudenosaunee homelands—acts also facilitated by the devastating military campaign.[21]

Alongside new artworks that critique past monuments and their traditions, removal and destruction also constitute a form of critique that we should take seriously. It is important to preserve knowledge of history, but specific artifacts in public places don't necessarily have a right to continue to exist there. Art his-

tory often holds to a precept that artworks must be understood within "their" historical context—a context to which they are thought firmly to belong.[22] This sometimes translates into a conservative position that enforces the preservation of monuments by minimizing the failings and misdeeds of historical figures. Standard historical and art historical methods demand that we not impose our prejudices on the past. Yet in this case—and perhaps others—it becomes especially important to understand the persistence of the past in the present. A decolonial position would push us to think forward and backward in history, refusing to use "context" to cordon off the past but rather to observe how the past continues to inflect the present.

I use the term "decolonial" advisedly. My thinking here has been shaped by the work of Eve Tuck and K. Wayne Yang, who argue in an influential scholarly article that decolonization "is not a metaphor."[23] While I am decidedly unsure that I can measure up to the demand of true decolonization, I have tried to reckon with the challenging positions of Tuck and Yang and with many other thinkers, particularly Black and Indigenous artists, writers, and scholars, who make claims on behalf of those historically dispossessed of land, freedom, and their own bodies.[24] For many of us, especially White people, especially those who love art, it can seem an impossible task to pitch in to dismantle the structures of oppression. And if we fear what we might be losing, what might be at risk? How will we see the canonical works of European and American art in light of their function within settler-colonial institutions and subjectivities? Would we leave institutions, histories, even the pleasures of art in tatters? Shall we do away with the very concept of art, to restate a question Carolyn Dean asks in "The Trouble with (the Term) Art"?[25] Should we radically change our institutions—museums, art schools and universities, the habits of art consumption?

I can't answer these questions honestly with a simple, "No, this doesn't mean that at all." Art—understood as European art or forms of art based in European traditions of painting, sculpture, and architecture—and its discourses have participated in the racially charged construction of territorial sovereignty in North America. But can contemporary artists and culture workers make theoretical interventions that can substantively address this history? We can imagine preserving joy in creation, in collaboration, in finding ways to express ideas, simple pleasure in working with the materials of art, the modes of thoughtful reflection that it prompts—and, in the context of these political claims particularly, the inventive forms of political contestation that artists can make. For those to whom these ideas are new, it might mean forming one's mouth around some words that feel strange and uncomfortable and wrapping one's mind around the corresponding concepts. For example, I do my best here to use language in a way that does not equate captive people whom others have enslaved with "slaves"— implying in Aristotle's terms that they are "slaves by nature"—and enslavers with

"masters" who might "give freedom," as if beneficently, to their captives. That this runs counter to some of the conventions of the English language demonstrates how deeply ingrained in the language the rationalization of slavery is.[26] We have to cast aside all assumptions and take seriously how Art with a capital *A* has served as White supremacy's tool. And finally, we must listen to voices and ways of thinking that have been cut out of national dialogues and barred from cultural institutions.

RACIAL ENTERPRISE, RACIAL ECOLOGIES

In this book I think specifically about how the entanglement of art with the idea of nature—as representation of it and foil for it—bear upon human and nonhuman ecologies in this particular colonial context. In her long essay, "Unsettling the Coloniality of Being/Power/Truth/Freedom," Sylvia Wynter addresses the idea of nature as a sphere separated from human beings and governed by its own laws. This understanding of nature came to stand in, in post-Reformation, colonial-era European thought, for the extrahuman authority constituted in the middle ages by God and God's laws.[27] Wynter argues that the idea of human beings as independent from a rule-bound entity called nature, and hence as privileged observers of it, was actually the tool of the divisions created by the colonial worldview, along with the formation of the natural sciences (encompassing the idea of politics itself as a science). In this view the European Renaissance constructed a notion of the human in such a way as to establish boundaries that define and exclude nonhuman nature and non-European humans, together. As part of this shift, the idea of natural laws imposed a divide between European "Man" and all other humans as the rationale for colonial exploitation and slavery that could no longer be justified through Christian ideology.

As the issue of climate change and others relating to environmental degradation have pressed on public consciousness more insistently, the art world has given renewed attention to artists whose work engages directly or indirectly with ecological issues.[28] Some art practices make direct interventions into nonhuman nature, while others attempt to change humans' consciousness around environmental issues, creating new ways of conceptualizing nonhuman nature. And to pick up on the line of thinking that Wynter proposes, the work often overlaps with the concerns of the environmental justice movement, which addresses environmental inequities between human social groups, particularly with respect to race and class-based injustices.

The discourse of ecology and environmentalism, we must bear in mind, is also deeply intertwined with American racial formation. The idea of "environment" has often manifested in particular ways with respect to urban and poor

Americans, to refer to social and not "natural" environments. This is the invidious question of "genetics" versus "environment" with respect to personality, behavior, and intelligence: invidious because the assumptions that animate even the "progressive" position in these debates are themselves generally racist. And already in the 1970s, scholars and activists whose point of departure was racial and social justice critiqued conservationist environmental discourses that emphasized leisure activities (say, clean water for swimming and boating) while purporting to be universal and "color-blind." Meanwhile, conservation discourse ignored problems of the toxicity of urban environments and even seemed to "regard the presence of Blacks as a kind of pollution," as the sociologist Nathan Hare put it. In his 1970 essay "Black Ecology," Hare wrote that "the ecological ordeal of the black race does not have to wait for a nuclear attack; present conditions are deadly enough."[29] He cogently addressed the ways in which prevailing ecological and environmental discourse failed to address the concerns of Black communities and urban environments. As ecological concerns come to the fore with the prospect of ecological disasters to come, as environmental hazards repeatedly map onto and intensify social inequality, activists continue to raise the question of the vulnerability of marginalized populations to toxic and damaged environments and catastrophic environmental change.

If the American landscape is fraught for descendants of enslaved African people, it is also fraught, in different ways, for Indigenous people and nations whose sovereignty is bound up in their historical relationships to the same land. American environmental ideology has tended to freeze Native people into roles of service, as primitive founts of wisdom—as in the famous "crying Indian" ad of the 1970s Keep America Beautiful campaign, which featured an Italian actor who made his career playing Native roles. The myth of the "ecological Indian" assumes that Indigenous people's relationship to the land will closely track with mainstream society's notion of "good" environmental ethics—which might, for example, emphasize wildlife protection over hunting despite the latter's cultural significance.[30] A life embedded in relations with nonhuman beings might look quite different from a modern conservation ethos. While sovereignty and environmental concerns can be deeply connected, in movements like the defense of Standing Rock and the #NoDAPL movement, non-Native allies often had to be reminded not to slip into giving priority to the ecological issues while glossing over Indigenous land rights and self-determination.

American environmental conservation ideology often would have it that "nature" must be maintained (in certain specific places) unspoiled by human touch—yet ever-present for the purpose of human leisure. But what happens when we take into account the violence associated with the "great outdoors," the violence required to make it (to clear the land of its Indigenous inhabitants) and the violence conducted there, the sense that the outdoors has also been charged

with fear and pain? In Tiana Clark's poem "The Ayes Have It," part of her collection *I Can't Talk about the Trees without the Blood*, she writes, "So when I think about a post-racial America, I don't— / because the trees in the South have strange fruit histories, / the roots are deep red, tangled and gnarled . . ."[31] How can we make sense of a "nature" harnessed to murder, trees that bear "strange fruit," as in the Billie Holiday song, whose roots are tangled in bloody histories?[32] In "What the Blood Does," Clark alludes to a lynching picture that "slips under a lake like silt"—the spacing lets us imagine the time it takes to disappear—and then she writes,

> I see trees, but they look like men, hanging.
> *I see men, but they look like trees, walking*
>
> (on fire)

Clark's poem suggests ambiguity between trees that look like "men, hanging" and men that look like "trees, walking"—a sympathy between human beings and the nonhuman world rather than an opposition.[33] The literary scholar Katherine Lynes has coined the term "reclamation ecopoetry" for poems that "[reassert] a relationship or connection between early African American poetic expressions of nature and human environmental concerns and those same expressions in contemporary poetry."[34] A prime example for Lynes is Paul Lawrence Dunbar's poem "The Haunted Oak," published in 1900. Dunbar animates an oak tree used for lynching, speaking in its voice of the damage it suffers in being pressed into participation in murder: "I feel the rope against my bark, / And the weight of him in my grain, / feel in the throe of his final woe / The touch of my own last pain." As Lynes points out, Dunbar's poem "calls into stark relief the difference between those humans and human groups who may more safely inhabit the natural spaces within the nation and those who may not."[35] Sometimes, perhaps, a tree is just a tree. But for many inhabitants of the Americas, the ancestral history of American violence tinges the livable and imaginable possibilities of outdoor spaces and "nature."

Visual artists, too, have made such divergent experiences of green spaces particularly concrete: for example, Brittney Leeanne Williams's *Leisure and the Unseen* series (plate 1) presents subtle, half-hidden imagery of lynching or murder looming at the margins of brightly colored scenes of White people's enjoyment of the outdoors. We know that White crowds of the early twentieth century treated lynchings as a form of entertainment and social event. This isn't exactly the case here. The White figures here simply remain cheerily oblivious to the evidence of violence as they eat and drink alfresco, insulated from the painting's own insights. Yet the echoes of "Strange Fruit" are palpable. "Pastoral

scene of the gallant south / The bulging eyes and the twisted mouth / Scent of magnolias, sweet and fresh / Then the sudden smell of burning flesh." In this series Williams explores the divide in how different viewers might see participation in the landscape, how knowledge and vision are infused by violent histories, and importantly how White supremacy operates through the maintenance of willful ignorance and not only through open wickedness. She enacts a kind of double vision, presenting a scene whose interpretation differs utterly based on the position with which one identifies within it.[36]

In the 1995 painting *Camp Fire Girls* (plate 2), Kerry James Marshall layers a depiction of childhood with traces of the violence that has defined the racial contours of who can and who can't occupy land as property in the United States. It was painted around the same time as his *Gardens* project, a series of paintings addressing the plethora of low-income housing projects called "gardens." His painting *Many Mansions*, for example, refers to Stateway Gardens, a high-rise housing project in Chicago. Marshall creates undecidable tensions between leisure and work, play and death, growing and vandalizing. The way paint is applied mimics elements of vernacular painting culture of the neighborhoods of Chicago: graffiti that's been painted over with brown stain-blocking paint, followed by more graffiti painted over it, and hand-painted, weathered block club signs. The series title reminds us, too, how these "garden" names have lived on with callous irony long past the demise of any utopian hopes associated with the original marketing of public housing.

In *Camp Fire Girls* we see at first glance what might otherwise be an iconic image of American childhood: kids camping out by a fire. The MCA Chicago's caption in Marshall's *Mastry* exhibition took this view, proposing a blandly encouraging interpretation: "The background statement 'Here I Am' brazenly asserts the girls' confidence in the life and times ahead. Set in a bucolic urban or suburban environment, pictured frequently in Marshall's work in the mid-1990s, this painting is an early example of the artist's interest in creating positive images of black everyday life."[37] To me, the girls look more apprehensive than confident as they direct their gaze toward the viewer. If we parse the details of the painting more closely, thinking about how antiblackness has shaped the landscape, things look very different. Although the title alludes to a specific organization, the Camp Fire Girls, any relationship to the organization is tenuous.[38] This image gestures toward the "great outdoors" in ways that differ sharply from what we might expect from a corresponding image of White girls. The girls are wrapped in stiff blankets. The tent is not a backpacker's tent but a miniature relief tent, a fact indicated both by its shape and by the red cross—international symbol of protection from attack on the battlefield—that emblazons the canvas just in front of it. Like the pale splotches and swirls that festoon the painting, the red cross splits the painted surface off from the depth of the depicted space.

The words "here I am" above, lettered at the top of the canvas, make me think of a comic song from my own childhood. It's Allan Sherman's "Hello Muddah, Hello Faddah": *Here I am* at Camp Granada." The song dates to 1963, and adopts the point of view of a child desperate to come home, who catalogs the rigors of summer camp life with humorous hyperbole. It could not apply to these girls' situation, or only with heavy irony—not a typical rhetorical stance in Marshall's work.[39] The banners that festoon the tree refer more ominously to the history of real estate profiteering in Black neighborhoods—something that has at times involved the deliberate setting of fires to "clear" lots for development. Perhaps the girls are camped out because they have lost their home to fire. Or to something else: appearing as ghostly objects made of thick lines of blue, furniture piles up on the ground around the girls, suggesting the results of eviction; indeed, the letters that spell out "here I am" look as if they have been overlaid on the taped-up pages of an eviction notice. Marshall recodes the "great outdoors" as a place of peril and estrangement, even as his figures reclaim the ability to live their lives.

HOLDING PLACE: CHAPTER SEQUENCE

What is the *place* of art in the land called America? The forces of Fascism do not hesitate to use art and architecture as vehicles for their message. On December 18, 2020, the lame-duck president Donald Trump signed Executive Order 13967, "Promoting Beautiful Federal Civic Architecture," a policy promoted by a little-known group called the National Civic Art Society. Alluding to the preferences of George Washington and Thomas Jefferson for classical architecture, it argued that "classical architecture . . . visually connect[s] our contemporary Republic with the antecedents of democracy in classical antiquity." The order mandated that "Federal public buildings should uplift and beautify public spaces, inspire the human spirit, ennoble the United States, and command respect from the general public" and described classical architecture as the "preferred architecture" for government buildings.[40] On the surface this salvo against modernist architecture could appear to be a simple matter of artistic tastes. But the history of ideological uses of classicism would suggest otherwise. This intervention also had political resonances with the imagery of the Far Right. Take for example the aesthetic preferred by the neo-Nazi organization Identity Evropa, a White supremacist group founded the same month, March 2016, that Trump clinched the 2016 Republican nomination. Identity Evropa explicitly renewed the connection between a classicizing aesthetic and Fascism with their campaign Project Siege. In this recruitment effort, Fascists plastered university neighborhoods with posters that used the heads of ancient, Renaissance, and

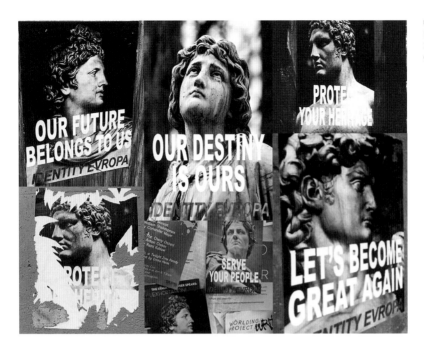

FIGURE 0.3
Digital collage of Identity
Evropa posters, 2022.
Courtesy of the author.

neoclassical sculptures to attempt to call Euro-Americans to a new racist awak-
ening (fig. 0.3). Identity Evropa's graphics use all capital letters and a V-shaped U,
"EVROPA," designed to look like Roman epigraphy—that is, words engraved in
stone on ancient buildings. The images include the Metropolitan Museum's
Roman imperial *Young Hercules*, the Vatican's second-century CE *Apollo Belvedere*,
Michelangelo's *David*, and Nicolas Coustou's late seventeenth-century *Julius
Caesar*, made for Louis XIV. A final example was a not terribly distinguished,
probably nineteenth-century, German cemetery angel from Saarlouis, a formerly
French-controlled part of what is now the Saarland in western Germany. Perhaps
the angel was included because of its location in territory that was contested
during World War II.[41] With these conscripted images, classicism lurched into
the American frame to (re)assert Whiteness, masculinity, power, tradition, and
prestige.[42]

 In the twentieth century, classicism—an artistic style associated with the
revival of classical antiquity—seemed flexible enough to suggest democracy,
revolt against tyranny, or, just as easily, Fascism, depending upon which ref-
erence points in antiquity you favored. Revivals of archaic or classical Greece,
the Roman republic, or the Roman empire can all signify differently. Similarly,
references to classical antiquity in contemporary culture can take many forms
and their meaning is often complex and ambiguous, as in the *Star Wars* fran-
chise with its "Republic," "Empire," and "Senate," or the *Percy Jackson* books with
their often troublesome Greek gods. In Bernardo Bertolucci's *The Conformist*, ele-

ments of Fascist classicism provide aesthetic pleasure even as they signal its intertwining with sexual repression and violence. Any number of examples can display the ideological flexibility in classicism's uses. For the partisans of civic classicism, on the other hand, it's a simple matter, a timeless aesthetic standard. In the view favored by Trump's executive order, classicism may present itself as an unbroken line. Yet a closer look often reveals a very specific local agenda at work with each reinvention.

In colonial and postcolonial contexts, the taste for antiquity also aggressively stated admiration for European models. This is clear in the case of the plaster casts brought from Europe to the Pennsylvania Academy of Fine Arts at the dawn of the early nineteenth century by Joseph Allen Smith, who will figure in my first chapter. With white marble statues—which early modern Europeans learned to love denuded of the vivid colors that Greeks and Romans gave them—classicism doubled down on *Whiteness*, presenting a fantasy of the color white and the racial formation "European."[43] It is tradition that rests on tradition, expressing pastness and privilege. And as Charmaine Nelson puts it, noting that "the practice of western art generally was colonial," the whiteness of marble "is not merely a case of the refusal of colour but the deliberate preference and validation of whiteness as the aesthetic choice which would result in a desired symbolic result, which had everything to do with contemporary racialized ideals of beauty and the body."[44]

It is with these ideas in mind that I pursue the project of this book: to consider how "art" has been produced as a category in the United States context, in opposition to a category of "nature" that is not natural at all—and not only not natural but deeply imbricated in American racial ideologies; to observe the legacies of this construction, in particular the way that art cooperates with Whiteness to occupy physical and imagined territory; and to learn from ways in which artists have intervened and are intervening in these legacies. It may seem I am taking on an excessively ambitious task. My project is indeed ambitious, but I don't imagine I am unique or alone; there are many precedents for it. I was not trained as an Americanist, a scholar of US art history—as I discuss in chapter 3, I had to go somewhere else to understand that I had to come back. My hope is that this experience enriches my perspective, but in addressing American art there are surely gaps in my education that reveal themselves in these pages. And in seeking to write in an accessible way, I've erred on the side of keeping scholarship I rely on in my notes, rather than in my text. But many touchstones and inspirations for the kind of work I hope to do here appear in those notes. In particular, books that have pushed me to think differently about the writing of art history include Nicolas Lampert's *People's Art History of the United States*, Lucy Lippard's *The Lure of the Local*, Lauret Savoy's *Trace*, and Rebecca Solnit's *Storming the Gates of Paradise*.[45]

Temporary Monuments operates through two distinct parts, with a consistent

set of concerns interwoven through its chapters. I follow a loose chronology, from the earliest to the most recent, but this chronology is willfully unstable: emphasizing place, real and symbolic, I allow time to come in and out of focus, weaving the contemporary together with the past. I alluded earlier to the fact that art history tends to confine objects to "their" particular historical context. This can stand as an important critique of the ways artworks—and monuments, to be more precise—present a visual rhetoric of timelessness. As I suggested at the outset, my title is an oxymoron: monuments claim permanence. In moving back and forth between past and present, or past and deeper past, I look not for unbroken histories but for unexpected echoes and resonances. And within historically specific moments I want to be alert to conflicts and tensions, to understand that resistance has a history and that nothing is inevitable. Multiple pasts may inhabit the present, and the present may inform the past. I allow juxtapositions to emerge here that are aesthetic and impressionistic, connections that travel through the color red or abstraction or seemingly improbable Asian geographies to make a point about the long history of globalism. Some key corporate actors—Standard Oil, General Dynamics—make repeated appearances. They serve as a synecdoche for ways in which fossil fuel exploitation and the military industrial complex intertwine with political, environmental, and cultural conditions on both a local and an international level.

Many of the artworks I will address in this book fall into the category of public art or installation art; some are time-based media, film or video; some are drawings or paintings. Where outdoor installations are concerned, they can be classed in a genealogy that includes murals and monuments and commissioned public projects in which artists have intervened in public spaces and neighborhoods at the behest of nonprofit organizations or government bodies (such as states or municipalities or the federal General Services Administration), or on their own initiative.[46] I emphasize their engagement with environmental issues in the broadest sense—the social as well as the "natural" environment—because land and land use are central to the subject matter in each case. They contest who possesses control over space, the "right to the city,"[47] even as they draw critical attention to major political issues including police violence, the economic distress of Black neighborhoods, environmental toxins, the prison industrial complex, and the violence current international borders and state formations do to Indigenous sovereignty.

Following this introduction, in the first three chapters, I look at how art has been constituted historically in the United States and how it informs understandings of land and the symbolic senses of "place." My first chapter, "Museum: 'Abundantly Illuminated,'" addresses the founding moment of the American museum, around the time of US independence from Great Britain, as the museum and its "civilizing mission" served as an explicit assertion of

(White) control over territory and dispossessed and subordinated bodies in the nascent republic. I begin with Charles Willson Peale's Philadelphia Museum, which originated in the years immediately following the establishment of the US Constitution, and played a key role in an ideological struggle over access to imagined racial integrity for White settlers. I then turn to the founding of the Philadelphia Academy of Fine Art, in which Peale also participated. I follow this with a discussion of other collecting projects in the early republic that established divisions between art and nature and made determinations that only the artifacts of European and Euro-American makers would belong to the category "art." The Pennsylvania Academy of Fine Arts possessed a collection of plaster casts of classical statuary—purchased with a fortune derived from slavery—whose arrival in Philadelphia established legal policy on the public functions of art. In the course of this chapter, I also give some attention to the modes of display and practices of entertainment to which Peale and his contemporaries had to resort because their institutions were precisely not supported by public funds. Municipal, state, and federal governments were reluctant to support museums financially; the kinship of early museums with the circus is neatly indicated by the fact that after the failure of Peale's Philadelphia Museum, many of the items in the collection came into the hands of the sensationalist impresario P. T. Barnum.

When the various spaces and beings designated by "nature" have not yet been tamed and domesticated by their surveying and incorporation into a museum, they might instead be referred to as *wild*. In chapter 2, "The Wild: Freedom, Slavery, and Desire," I turn to the idea of the "wild" as a spatial designation in the American landscape, an affective or emotional register, and a characterization that produces and polices difference. Particularly in the context of settler colonialism in North America, the idea of the wild is romanticized, represented as idle space—land not put to instrumental ends—to be tamed by agriculture, and feared as danger, just as some bodies are positioned on the "wild" or "savage" side of a divide between wildness and civilization. Tracking the idea of the wild brings me to nineteenth-century transcendentalist writings (Henry David Thoreau's essay "Walking"), twentieth-century painting (Barnett Newman's *The Wild*), and twenty-first-century hip-hop (two very different music videos created for the hip-hop track "No Church in the Wild"). These cultural objects resonate with one another in surprising ways. They also, obliquely, bring into play the subject of public sculpture, as well as race, gender, and nonhuman nature, into play. Temporally, the chapter revolves around the key date of 1862—the date of publication of Thoreau's essay and the date of Abraham Lincoln's Homestead Act—and its reverberations in its one-hundredth anniversary in 1962.

My third chapter, "Islands: Looking for Indian Things," addresses Whiteness, American art, and relations to land, from the personal perspective of my own

family history, in particular my connection to the American modernist artists William and Marguerite Zorach, my great-grandparents on my father's father's side. William Zorach was the creator of numerous works of public sculpture in an idiom that draws on European traditions. I acknowledge, here, the uncomfortable rhyme between Confederate statues (and others that celebrate obvious racists) and outdoor sculpture that stakes a claim to land on behalf of its European idiom, considering, as well, the continuum between them. I think about the way in which Whiteness is written into the landscape of the area of Maine where William and Marguerite lived and worked, and where I also grew up and developed my own set of interests in art, society, and politics. How did this racialized landscape and family legacy contribute to the fact that as a teen and young adult, my interests turned to medieval Europe? It might seem surprising to connect these things, given modernism's ostensible rejection of the sedimented history of European forms and models. Making sense of this is risky territory, and for some readers it may appear self-indulgent. My hope is that it makes some new connections, all the while illustrating possible ways of thinking about a scholar's situatedness with respect to their objects of study.

As I have claimed from the outset, this book is not an account of monuments per se. The "temporary monument" of its title is as much a claim about the American nation-state as any artwork or monumental object. Yet each of my chapters touches on public sculpture in some way. In the first half of this book, I write "around" traditional, monumental public sculpture. I make glancing, associative connections between these works and other art forms and histories, and I open up new questions about these public sculptural traditions by situating them in the context of politics and histories of land, race, art, and ecologies. In the second part of the book, I look at ways visual artists have intervened in these troubled histories. I consider a series of artworks and projects by artists, exploring how they have responded to, critiqued, and inserted themselves into questions of land, race, and history, how they force new understandings of history and new confrontations with the history of *art history*, the conventions and expectations of art in the US context, and how we might trace new historical narratives and political trajectories in and around them. In these chapters—4, 5, and 6—I have chosen to focus on a few specific contemporary artworks that can be categorized as public sculpture. Yet they do not claim monumentality for themselves. All these works all in some sense provisional. They may be monumental in scale, they "hold place," but they do not try to reshape it in a permanent way. They differ from reparative projects that go under the label "placemaking," a popular term for initiatives (often grant-funded) that manage and design public spaces to encourage participation and support community well-being. Often they involve creating or referring to local tradition and cultural identity.[48] City-sponsored placemaking projects include such initiatives as the High Line in New York City,

a green space created from a disused elevated rail line that embraces cultural programming and artist commissions; Oval+, a series of artistic summer "activations" of the Eakins Oval traffic circle in Philadelphia by Mural Arts Philadelphia and its partners; and the gathering places of the Burnham Wildlife Corridor in Chicago, a series of artist commissions by the Chicago Park District in a strip of reclaimed land between Jean Baptiste Point DuSable Drive (formerly Lake Shore Drive) and a rail corridor that the park district restored with native plants.[49]

"Placemaking" is a warm and affirming term.[50] But embedded in the word is the idea that place, once you make it, is made. I use the idea of place *holding* in this book to suggest a range of other meanings, some of them at odds with one another. Holding a place may be an occupation of space. It might be a resistant act, or might be violently colonial. Both are at stake here. But I am also thinking of the notion of holding space, imported into activism and pedagogy from therapeutic language, which asks groups and individuals (often but not only those with some form of privilege) to make room for others in collective discussion: allowing space to process trauma. The term may have originated in the psychologist D. W. Winnicott's account of the "holding space" or "holding environment" between parent and infant, or therapist and client. Winnicott avowedly stretched the notion of what "holding" could mean: he used it to indicate an environment of relative safety in which the one who is held can grow and, eventually, gain independence.[51] Holding space would therefore be a collective holding in the sense of embrace. But I am thinking not, or not only, of this metaphorical therapeutic space, but also of concrete places, and of the effort required at a grassroots level to occupy, to hang on, to maintain local control. Finally, place holding also suggests the notion of a placeholder, something that keeps space available, protects it, for an unknown future that hasn't arrived.

In my fourth chapter, "Garden: Violence and the Landscapes of Leisure," I begin with Theaster Gates's South Side Chicago installation of the gazebo from a park in Cleveland where twelve-year-old Tamir Rice was murdered by Cleveland police. I cannot, here, do anything like justice on behalf of Tamir, for whom the gazebo has become a memory object. What I try to do in the chapter is to trace a symbolic and historical context for the gazebo itself by examining the place of parks and gardens in American cultural history and racialized landscapes, in particular in the city of Cleveland, where the landscape—right down to its green spaces—was thoroughly shaped by a racist, corporatist agenda. To look at this landscape, at green spaces and garden structures, also takes me to modes of art historical pedagogy and histories of taste; to Atlantic histories of race, land, and leisure; and to the "eastern" exoticism implied by the term "gazebo" and its history.

The gazebo stands, now, at a site in Chicago. How does its displacement from its original site in Cleveland allow it to perform differently in its new space? As it

addresses the space in which it exists, the gazebo also gestures toward histories like Tamir's in Chicago, where police abuses and murder, including of young people, are all too common. One might argue that the gazebo's origin outside Chicago allows it to open a space for reflection without conveying the traumatic history in its full rawness and immediacy. The next chapter takes the example of a public art installation in Chicago that addresses the spatial histories and traumas of the place where it exists. We might, however, pose the question whether it does so in abstract or concrete ways—and whether and in what ways that matters. Chapter 5 is entitled "Home: Color, Abstraction, Estrangement, and the Grid," and as I have suggested, it shares some elements with chapter 4: both are spatial installations spearheaded by prominent Chicago artists that address questions of land use and structural racial violence. I focus in this chapter on Amanda Williams's *Color(ed) Theory* project, in which she painted abandoned houses in the Englewood neighborhood, making monochrome objects of them by deploying a color palette she developed of hues imbued with community meaning. This project engages inevitably with histories, both celebratory and critical, of abstraction in twentieth-century artmaking. I take up her project as a starting point to trace a history of the intertwining of abstraction, politics, housing, and the idea of home—with specific reference to the South Side of Chicago. I address in this chapter the entanglement of questions of abstraction in modern architecture and design with the idea of "home" and identity—from the arrangements of domestic space to the neighborhood scale.

Chapter 6, "Walls and Borders: Place Holding," begins with Cauleen Smith's critical trilogy of films that address the history and ideology of land art, considering how modes of artmaking that herald and travel alongside the environmental movement of the 1970s also operated according to settler-colonial logics. From these insights I move to a series of public artworks produced in recent years that move along surfaces of carceral boundaries and toxic landscapes to highlight their violence while intervening in the possibilities of the political imaginary. Resolutely antimonumental, they *hold* place and do not seek to *make* it.

A word on my own relationship to place is in order. Though I touch upon myriad places in this book, I return again and again to Chicago. Many of the artists I write about have a connection, past or present, to this place. William Cronon wrote in *Nature's Metropolis* that "no city played a more important role in shaping the landscape and economy of the midcontinent during the second half of the nineteenth century than Chicago."[52] Thomas Dyja calls the city "the nation's primary meeting place, market, workshop, and lab."[53] In the twentieth century it became a crucible of Black culture through music, commerce, art, journalism, and institution building. In this book, Chicago represents a place where some central conversations and interventions about central issues of environment, race, and public space have occurred on the part of the city's brilliant and

insightful artists. It is also the place where I write. And it is Zhegagoynak, settled by the Afro-Haitian trader Jean Baptiste Point DuSable, who by marrying the Potawatomi woman Kitihawa made himself kin of the Indigenous inhabitants of the place where the wild onions grow.

Place holding, as opposed to placemaking, allows for a provisional nature, operating with an orientation toward a future that hasn't yet arrived, and emphasizing the sense of ongoing effort—the work isn't done. In a conversation I had with Brittney Leeanne Williams about the work she was making in 2020, she reflected on how place is created by people and their memories. Equipped with this insight, she aimed to create paintings in which bodies, as she put it, "hold place" in a landscape (plate 3). In works like *Naomi and Ruth: Mitosis*, figures act as geological anchors of place, even as they play out family dramas through unexpected morphologies that are both playful and challenging, lush and abject. In a different way, the artworks I am calling temporary monuments hold place. They hold it by existing in space, but they may also hold within themselves a someplace—an imagined place—that can only be materialized in a not-yet-found, not-yet-invented moment of collectivity. It can be temporary, problematic, healing, perhaps future-oriented. But place holding isn't forever.

1
MUSEUM

"Abundantly Illuminated"

THE ENJOYMENT OF ART

Gallery 324 of the Minneapolis Institute of Arts is the last place you would expect a fight to break out. It's not a gallery at all, really, just one end of a long hallway that displays a few stately portraits and items usually referred to as decorative arts: small bronze statuettes, a Turkish box, Meissen porcelain bowls and teapots, a Sèvres bisque porcelain statue (fig. 1.1). This incongruous spot is where on Sunday, February 26, 2017, members of the Far Right group Alt Right MN tangled with members of the leftist IWW (the International Workers of the World, also known as Wobblies). Alt Right MN posted a narrative of the events, stating in their own defense: "We were there only to meet a few new faces and enjoy the Minneapolis Institute of Art's collection of traditional art."[1]

It's not clear who exactly the aggressors were in the conflict. What is clear is the definition of "traditional art" the racist group's members were "enjoying" when the fight erupted: European decorative arts of the seventeenth to nineteenth centuries. A *New York Times* article about the fracas described the space as "a gallery of 18th-century art with two English landscape paintings, French armchairs and a Sèvres porcelain sculpture."[2] Ironically, perhaps, the unnamed sculpture is an *Allegorical Figure of Peace*. The half-nude figure, fourteen inches of Sèvres bisque porcelain, cradles a dove. Her face is pliant, her skin milky, her eyes mournful—or just empty? If the nymphet mourns, who or what is she mourning? Made in France around 1780, the statuette perhaps reflects upon the Anglo-French war, the European counterpart of the American colonies' War of Independence. Or does she foresee the social unrest that would lead in a few years to revolution in France?

How in any case did objects like these come to be considered indispensable to

an American museum, part of the cultural baggage of the United States, placed and displayed in such a way that they can elicit the admiration of an ethnofascist militia group? In this chapter I turn to the beginnings of museums in the United States to consider how the project of importing European hierarchies of art and aesthetics to the newly constituted nation played out in the late eighteenth and early nineteenth century. In this period, European colonists, now citizens of the United States, consolidated the cultural presuppositions they had imported into North America as they built institutions that reflected them. In this context, the idea of art stood in a relationship of mastery over and imitation of nature, with all that it connoted—land as property (often emptied of its inhabitants), visible reality, the world of nonhuman species, the inner "natures" of human subjects, and, even more problematically, the hierarchies by which

Euro-Americans rationalized the violent subjection of some humans to others. Art, on the other hand, they considered the province of their European cultures, part of the toolkit of civilization which they believed they alone, messianically, brought to the wildness of the West.

In North America, these institutions of art and science established themselves in concert with the invention of Whiteness. Along with the modes of art-making they brought with them across the Atlantic, Europeans also brought, constructed, and imposed systems of value by which some arts were better than others. Although today we might think of the arts as a haven for progressive politics, in the nascent US political order of the nineteenth century, they served as often as not as a method of making invidious racial distinctions. The founding of art institutions, sometimes explicitly, sometimes implicitly, reinforced the equivalence of Whiteness, or Europeanness, with civilization.

We can see this ideology on display in the equestrian statue of Theodore Roosevelt, flanked by an Indigenous man and a Black man, both on foot, that had stood, since 1940, outside the American Museum of Natural History in New York. On June 22, 2021, after years of public debate, the New York City Public Design Commission took the final step when it voted to remove the statue. In elevating Roosevelt, placing the White man on horseback towering above the other two figures, the sculptor, James Earle Fraser, may have intended to emphasize Roosevelt's benevolence to "other races," but this intention in no way counteracts the message of literal White supremacy—domination of White people over everyone else—that the statue conveys.[3] Such a message, one could argue, is baked into the museum itself, and the way in which anthropological collections—including artworks—are typically inserted into museums of natural history while the artifacts produced by Europeans and Euro-Americans are housed in art museums.

The American Museum of Natural History, which opened in 1871, was preceded by one year in its founding by the Metropolitan Museum of Art. Their twinned beginnings underline this divide. Historians often associate this moment with the origins of museums in the United States, placing them in a genealogy that begins with the great European public museums of the nineteenth century, whose signal event is the Louvre's opening as a public museum following the French Revolution. In this sequential ordering of history, American institutions, building on European precedents, begin to appear in the later nineteenth century, with "universal survey museums," like the Metropolitan Museum of Art. Scholarship on the history and theory of museums typically tracks their development in Europe up through the mid-nineteenth century before starting to consider American museums modeled on the European type.[4] But in the early United States and the colonies that preceded it, there were multiple museums, or museum-like institutions. We skip over these earliest US

museums because they may seem to reflect the structure of Baroque collectors' cabinets more than that of the nineteenth-century public museum as classically understood, or because they did not survive.[5] And yet, as we will see, an international court case in 1813 in which an early US museum was a plaintiff defined these institutions quite clearly as repositories for the public interest. It was a notion of the public that developed in tandem with settler colonialism in North America. And if we explore the earliest museums founded in the thirteen colonies or the early republic, we also find that their distinctive qualities and histories have everything to do with the institution of slavery. They served up a view of Europeanness as model for the new republic and they did so using tools of racial domination and resources that arose from it. Public space, public land, public museums—these categories are difficult to disentangle from the racial politics of territory in a settler state.

The land of the Americas appeared to Europeans as the very embodiment of nature. In this view, it spatialized the temporal fantasy of the Golden Age, becoming a primordial site of reproduction of life and abundance. Its wildness was a rich resource, for economies and thought, but one that also harbored uncertainty and danger. As Eve Tuck and K. Wayne Yang put it in their powerful essay "Decolonization Is Not a Metaphor," the settler "sees himself as holding dominion over the earth and its flora and fauna, as the anthropocentric normal, and as more developed, more human, more deserving than other groups or species. The settler is making a new 'home' and that home is rooted in a homesteading worldview where the wild land and wild people were made for his benefit." In the North American context, settler colonialism also results in a triad of settler, native, and slave, because the exploitation of the land requires excess labor. The settler position, according to Tuck and Yang, is "naturalized" in the process.[6] A starting point for this book is the recognition that to produce a world of European and European-affiliated art in the Americas was to help make that naturalization possible.

And, indeed, the story of the emergence of early art institutions in the thirteen colonies and early republic shows that art in its institutional forms in the United States cannot be understood separately from the construction of racial hierarchy. Take, for example, the fact that the earliest art museums in the United States have deep ties to slavery—they were founded by slaveholders and the children of slaveholders with funds extracted from those evil enterprises. It is unsurprising to find that the very first museum in the thirteen colonies, the Charleston Museum in South Carolina, founded by the Charleston Library Society, was housed at the time of its founding in the warehouse of an enslaver and human trafficker, Gabriel Manigault.[7] But the connection to slavery holds true even for those early museums that were founded in northern states, in Pennsylvania, for example, and in Connecticut. At the time of the adoption of

the US Constitution, slavery was scheduled for dismantling in the North. But we sometimes conveniently forget that it took an excruciatingly long time for many northern Whites finally to accept this change in their own daily lives. And in their livelihoods, which often continued to depend upon Southern slavery, there may have been no change at all.

THE WORLD IN MINIATURE

In these early years, two primary museum types developed: one to house art, the other to house nature. There were many hybrid enterprises, but in general, the divide reflects the developing institutionalization of the conceptual opposition between nature and art. The institutions founded for the new republic also rested upon White supremacist logics and on resources deeply entwined with dispossession and displacement of African and Indigenous people. We can see this in the two different institutional projects of the painter, naturalist, and entrepreneurial museum founder Charles Willson Peale, which both instantiate and blur the divide between art and nature. The Pennsylvania Academy of Fine Arts is billed as the "first school and museum of fine arts" in the United States. In 1805, Peale joined together with the sculptor William Rush and a group of other stakeholders to found it. Peale was a well-known figure in the intellectual and artistic life of the early republic, and this was not his first museum. In 1786 he had announced a "Repository for Natural Curiosities" in Philadelphia. Later it became known as the Philadelphia Museum or Peale's Museum. When the Academy was founded, plaster casts of European antiquities that had previously been housed at the Museum were transferred there, underlining the fact that these replicas of European objects were held to adhere to the category "art" while other artifacts still counted as "nature."

At the outset, Peale's Museum often blurred the boundaries between the two categories. In a view of the museum that appears as the backdrop of Peale's very large 1822 self-portrait (plate 4), it can be difficult to distinguish between living and taxidermied specimens, or between those specimens and the human portraits that surmount them. Peale presents himself with a painter's palette, constituting one set of technologies of display; another appears to his right, where the body of a turkey has been slung over a set of taxidermy tools. Behind them, a lady visitor raises both hands in astonishment as she encounters Peale's famous mastodon skeleton, on which I will have more to say shortly. Within the Museum, Peale included a gallery of his own portraits of Revolutionary heroes, wonders of natural history, paleontological specimens, a menagerie of living animals, and various gimmicks and "curious and ingenious productions of the mechanic art."[8]

In 1790 he composed an open letter "To the Citizens of the United States of America" seeking contributions to his collection, which was to include "all *animated* Nature," "a greater variety of beasts, birds, fishes, insects, reptiles, vegetables, minerals, shells, fossils, medals, old coins, and of utensils, cloathing, arms, dyes and colours, or materials for colouring or for physic, from amongst the Indian, African, or other savage people; and all particulars, although but in model or delineation, promising to be useful in advancing knowledge and the arts; in a word, all that is likely to be beneficial, curious or entertaining to the citizens of the new world."[9] To the more generic collection of items familiar from European cabinets of curiosities, Peale added items connected to the practices and cultural products of what he calls "savage" people, Indian (presumably Native American) and African. Thomas Jefferson, as president of the United States, consigned to the museum a number of animal specimens and Native American artifacts that had been sent to him by the Lewis and Clark expedition (1803–6). These included pipes from the Iowa, Sioux, Ho-Chunk (Winnebago), and Meskwaki (Fox) nations.[10] (There was also an Oneida pipe: an Oneida man had visited the museum and presented the pipe himself.[11]) There was a Sioux garment, "a complete dress of the Soux Indian, chiefly composed of crow skins, singularly ornamented, one of the leggings belonging to this is ornamented with stripes, indicating the number of scalps taken by the wearer."[12] This may be the Sioux legging, accession number 99-12-10/53056, still held by the Peabody museum at Harvard. Other garments included a hat from the Clatsop Tribe (a small Pacific Northwest tribe); leggings from the Palouse (Palus) Tribe of the Sahaptin nation; Sioux and Apsáalooke (Crow) buffalo mantles.[13] There were tobacco pouches, arrows, moccasins, and ceramics.

There was a precedent for this kind of collection in Philadelphia. Peale's opening followed closely the death in 1784 of a Swiss artist, antiquarian, and naturalist, Pierre Eugène du Simitière, who had founded a museum in Philadelphia just two years earlier. Du Simitière's collection had included a large quantity of "Antiquities of the Indians of the West Indies and North American Indians," which he described as "stone hatchets, pestles, tomahaws, hammers, arrow heads and points of darts, cups, bowls of pipes, idols figures cut on clam shells and many other things found in the old burying places, for which there is no name."[14] While his historical and cultural interest in these objects was undoubtedly sincere, the ironically named du Simitière (originally du Cimetière, "of the graveyard") seems to have had little remorse about the act of robbing graves.

In his letters, lectures, articles, and public announcements, Peale presented his Museum as an institution for the scientific study of nature that would serve a major nation-building function. He hoped and worked in vain throughout his life to obtain federal public financing for his museum. While the state of Pennsylvania did agree to house the collection, it did not pay its expenses, and

so Peale was constantly in search of ways to bring paying visitors in to allow him to support his ever-growing family, all of whom, boys and girls, were given names of famous European artists. The imperative to attract visitors prompted an emphasis on entertainment along with instruction, and the institution thus acquired something of the character of an amusement hall. While the decorum of his 1822 self-portrait masks the more freewheeling aspects of the Museum's attractions, the act of lifting a curtain gives a sense of his character as a showman. In its rhyme with the institution's stationery (fig. 1.2), it is as if he is positioning himself as both nature itself and the unveiler of its mysteries.[15]

To create his visual attractions, Peale made ample use of technologies proper to the visual arts. The artifice involved in creating a representation of nature was considerable and the lines between natural and artistic display were fine ones. One famous trompe l'oeil painting tricked visitors into thinking they were looking into a stairwell (fig. 1.3), with Titian Ramsay Peale peeking out through the doorframe and Raphaelle Peale climbing the stairs, palette in hand.[16] Specimen taxidermy also required artistic skills, and Peale also devoted his and his family's artistic talents to creating wax figures of racial "types," including replicas of

FIGURE 1.2
Peale Museum solicitation letter, with engraving titled *Nature* by James Akin (ca. 1801), 1815. American Philosophical Society, Peale–Sellers Family Collection.

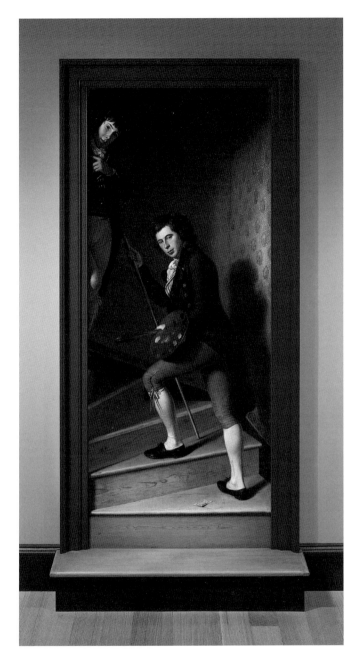

FIGURE 1.3

Charles Willson Peale,
*Staircase Group (Portrait
of Raphaelle Peale and
Titian Ramsay Peale I)*,
1795. Oil on canvas, 89½ in.
× 39⅜ in. (227.3 × 100 cm).
Philadelphia Museum of
Art, The George W. Elkins
Collection, 1945, E1945-1-1.

people belonging to several different Native American nations. The attractions of
Peale's Museum included a show of "moving pictures," transparencies that were
moved across a stage by stagehands as an audience looked on, a forerunner of
the panoramas of later decades. The displays were "abundantly illuminated," as
he described it in advertisements, with kerosene lamplight until ten o'clock at

night.[17] (He experimented with gas lighting, but the smell was too noxious.) The emphasis on illumination was alluring in a practical way, but we might also catch a whiff of the idea of Enlightenment, the illumination afforded by knowledge, also certainly at stake in this context. (The scientists of the Enlightenment themselves were not always averse to the entertainment value of experimental tricks and visual games.[18]) The variegated nature of the collections and presentations might be aptly expressed in the fact that after Peale's death, the museum collection would be purchased by the famed circus entrepreneur P. T. Barnum and his associate Moses Kimball. Most of these items, housed in Barnum's Museum in New York City, were lost in an 1865 fire. In a real sense it was the destruction by fire of Barnum's museum that cleared the way for the founding of the more "properly" scientific American Museum of Natural History six years later.

One of the more profound attractions—one we have already seen peeking out from behind the curtain of Peale's self-portrait—was the reconstructed skeleton of the "American incognitum," a mastodon (sometimes referred to as a mammoth) that Peale excavated in 1801. Back in the early eighteenth century, a huge tooth unearthed in Claverack, New York, had given the Puritan intellectual and witch-hunter Cotton Mather confirmation of Biblical accounts of giants.[19] Later in the century, responding to reports from Indigenous people who had found these bones for generations, European settlers unearthed bones in the Ohio River Valley as well as in the Hudson Valley. In 1799 an enormous thighbone was found on a farm in Newburgh, New York, a discovery that roused Peale's attention. Further excavation produced two nearly complete skeletons. The family's artistic skills helped supply the missing parts with speculative replicas of papier-mâché and wood, and mounted the skeleton—Peale called it an "antique wonder of North America"—in the Museum.[20]

These bones played a powerful ideological role in the formation of the new republic. The mastodon served to counter the arguments made by the French naturalist Georges-Louis Leclerc, Comte de Buffon, that American animal life was inferior to that of the Old World. Thomas Jefferson was particularly interested in mammoth bones for this reason as well; in commissioning the famous Lewis and Clark expedition in 1804, he specifically sought animal specimens, asking Meriwether Lewis in a letter to keep an eye out for "the animals of the country generally, and expecially those not known in the United States" and "the remains and accounts of any which may be deemed rare or extinct."[21] Peale's son Rembrandt, who took one of the skeletons to display in London, reconstructed the mastodon with its tusks facing down, rather than up like an elephant's (fig. 1.4). His assumption that the *incognitum* was a gigantic carnivore tracked with the institution's inflationary nationalistic desires. In making choices about what to highlight in his self-portrait, the elder Peale presented the mastodon's jawbone in the foreground, along with the turkey, palette, and taxidermy tools:

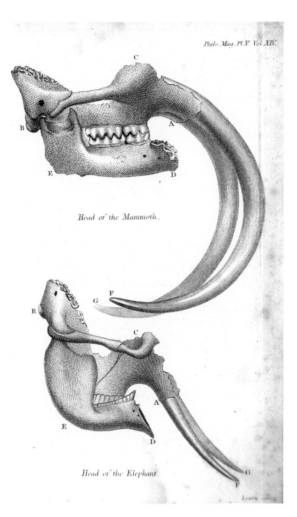

Philo. Mag. Pl. V. Vol. XIV.

Head of the Mammoth.

Head of the Elephant.

FIGURE 1.4
Rembrandt Peale's
original reconstruction
of the position of
mastodon tusks, from
the *Philosophical
Magazine*, series 1,
volume 14, 1802.

the massive teeth were thought to support the view of the extinct beast as a carnivore. The nation-building character of this positioning rhymes with the bald eagle specimen and the portrait of George Washington in the upper left corner of the self-portrait.

Why did the *incognitum*, as a matter of natural historical debate, play such a significant aspirational role for the new nation? To marvel at the scale of the mammoth was to emphasize the prospect of international importance for the new nation and to gesture toward the vastness of its potential territory, understood through the lens of settler manifest destiny. Just on these grounds it already carries within it the racial ideology that erased Indigenous presence, literally and figuratively, assigning the land to White settlers while drawing on Indigenous knowledge. Notably, Rembrandt Peale dismissed that knowledge in writing about the mastodon: "No calculation can be made of the length of time

necessary to have formed these morasses, although we are certain that, as in fifty years past scarcely any change appears, it must have been proportionally slower in the commencement; and a period has elapsed in which all accounts of this animal have dwindled into oblivion, unless a confused Indian tradition about the great Buffalo be supposed connected with it."[22]

But we must also consider the turn the mastodon's size enabled settler thinking about race to take. In this period, debates pitted earlier climatic theories of racial difference against newer essentialist and hereditary ones, locating race as a natural feature of the body rather than—as it was held to be earlier—an effect of the environment. A tacit or not-so-tacit element of the claim is that, if there were giant animals in the Americas, that *also* meant that human beings who emigrated from Europe to the Americas would not be subject to the purportedly degenerative effects of American climate. Racial difference, this view holds, is inherent. Europeans may not be European anymore when they become Americans—but what they retain, what they bring with them as they move around, and indeed what is being invented in this moment, is their Whiteness, a Whiteness they have *by nature*. In her book *Transporting Visions*, Jennifer Roberts demonstrates clearly how the visual culture of the young nation was built on the transportability of images, a quality that can be read deeply in the images themselves.[23] But it was *also* based on the presumed portability of Whiteness itself.

The fact that this debate was understood to apply to humans is evident from a letter from a French government official who visited the Museum and, upon his return to France, wrote to Peale in praise of his mastodon display. The mastodon skeleton is evidence, he argues, of the powerful generative forces of the Americas. Far from producing "bastardized and stunted" animals (as Buffon and others argued), these natural generative forces have instead produced heroic beings of massive heights. The tusks, he writes, "are proportionally greater, and their double curvature traced by the hands of a more Sublime geometry, than the simply curved tusks of the Elephant." And lest we think the respect due American fauna is restricted to nonhuman animals, he insists on the human aspect of the argument: "Should the harmonious Buffon, the systematic De Pauw, all the exaggerators of these famous men arrive to tell us that America is the miscarriage of the terrestrial Globe, and that men there are overgrown children and for the most part imbecilic, we can respond as follows: Read Franklin, converse with Peale, and see in the Museum the American heroes and savants whose faithful portraits Peale's brush has transmitted to us."[24]

This was not just any French government official, but Philippe Rose Roume de Saint-Laurent, former commissioner of Saint Domingue, the French colony that preceded the nation of Haiti on the island of Hispaniola. He visited Peale's Museum on his way back to France after having been expelled by Toussaint Louverture's revolutionary government, which formed following the successful

revolt carried out by enslaved African people and free mixed-race people on the island. Roume, to be clear, was not a proponent of slavery. But he was thoroughly mixed up in it, as a colonial administrator, and his presence in Philadelphia, his visit to Peale's Museum, his letter in praise of the White men of the New World, his refutation of the view that the New World climate exercises degenerative effects on them—all this is inextricable from the historical trajectory of slavery in the Americas.

In fact, slavery runs like a red thread through the story of Peale and his museum enterprises, though it is often occluded in the way this story is told. As with many colonial Americans, North and South, the practice ran deep in the Peale family history. Charles Willson Peale's father's salary as schoolmaster was paid through taxation of the slave trade.[25] Peale himself, for many years, held captives in his own household. We know these African people only through names given to them by their captors: Scarborough, Lucy, their son Moses, and other children whose names were not recorded. There is speculation that a client paid for a portrait by transferring the family to Peale.[26] In another instance Peale casually discussed accepting an enslaved person as payment for services with a plan to sell him for cash.[27] The idea that he obtained enslaved people through the art of portraiture is a troublingly suggestive one. What is clear is that as colonial Whites were using art to *self-fashion*—to construct their identities through Europhile portraiture, an act whose importance Roume emphasized in his letter—they were simultaneously doing their best to dismantle the identities (genders, families, languages, social connectedness) of the people they enslaved.[28]

In the literature on Peale it has even been said that he "hated" slavery, but there is little or no evidence that he put any such dislike of the institution into personal practice.[29] As a member of the Pennsylvania General Assembly, he did vote in 1780 for the Gradual Abolition Act, which provided for the phased emancipation of African captives in the state. Perhaps he voted for it out of true conviction that he subsequently, for some reason, had difficulty implementing, or perhaps his vote reflected a politician's sensitivity to appearances. What is certain is that he did not immediately hasten to relinquish his hold on the captive people laboring in his own household. For six years after this date, he held Scarborough and Lucy in captivity, finally acknowledging their freedom in 1786. But he retained their son Moses Williams until 1802, when Williams was in his late twenties.[30]

There has been much confusion about how the law applied to Moses. Since he was born before 1780, his status was the same as that of his parents. Peale was certainly not obligated to keep him enslaved, as some scholars have implied, any more than he was obligated to acknowledge Moses's freedom. For twenty-two years after voting to end slavery in the state, he kept Moses Williams in captivity. And Williams's labor for Peale was extensive. It included taxidermy and helping to mount the mammoth skeleton. He was assigned and came to specialize in the

task of cutting silhouette portraits in the museum using the apparatus known as the "physiognotrace," which created scaled portraits by physically tracing the contours of subjects' heads (figs. 1.5 and 1.6).[31] Peale also had him dress as a Native American horseman to ride throughout the city announcing the display of the mammoth, alluding—much as a watercolor by Rembrandt Peale (fig. 1.7) does—to the Indigenous knowledge of the bones and stories of their origins that settlers drew upon in unearthing the large mammals.[32]

In addition to the labor and skills of enslaved persons, particularly Moses Williams's, that supported Peale's museum enterprise, we also have to consider what forms of wealth made possible the amassing of collections. For a few years at the Museum—before the Academy was available as a separate institution—the mastodon skeleton shared a room with a collection of plaster casts of antique statuary brought from Europe by the South Carolinian Joseph Allen Smith.[33] A book illustration from decades later (fig. 1.8) gives something of a sense of this, as the skeleton appears with two nudes, one reclining and the other running, both of which are emphatically white in color; one might imagine they are plaster statues still represented as they had been in the years before they moved.

This separate room had its own entrance fee of fifty cents. The purpose for charging an extra fee opens the question of a certain confusion of motives: it allowed for the possibility that ladies' delicate eyes would not be offended by the sculptures' nudity unless they specifically chose to see them; it also *attracted* viewers to them with the promise of the mastodon.[34] While the casts were labeled as belonging to Joseph Allen Smith's private collection, some of the visiting ladies apparently graffitied the plaster statues—or anyway, so a British visitor speculated on viewing the handwriting on them.[35] The move to the Academy established category divisions—art versus nature—even if it did not entirely put an end to the inappropriate responses.[36] The statues had a way of gesturing toward nature in spite of themselves.

Smith, the donor of the casts, was an early American traveler in the European "grand tour" (fig. 1.9). And it should not be a surprise to learn that the funds that enabled him to travel to Europe and acquire these collections only existed because of slavery. Smith's father Benjamin, who served as speaker of South Carolina's Royal Assembly from 1755 to 1763, was no simple plantation owner but a major slave trader in Charleston. His firm Smith, Brewton, and Smith did a substantial business in African captives for decades in the mid-eighteenth century.[37] Benjamin's second wife Mary, mother of Joseph, was the daughter of Joseph Wragg, one of the largest slave traders in the British colonies. One might consider the purchase of artworks with blood money and subsequent donation to a high-minded civic institution to be a form of "artwashing," such as we see now among corporations—an attempt at cleaning up the family image. And yet in their context one can see that the ideologies at work are simply consistent with one another.

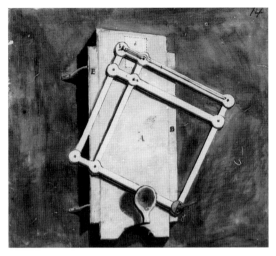

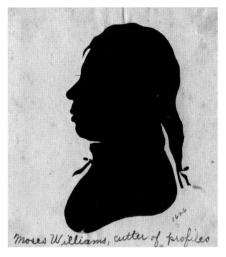

FIGURE 1.5
Charles Wilson Peale, Explanation of John Isaac Hawkins's physiognotrace invention, 1803. Watercolor on paper, 8 × 10 in. (20.3 × 25.4 cm). Enclosure in Charles Wilson Peale to Thomas Jefferson, January 28, 1803, Thomas Jefferson Papers, Series 1: General Correspondence. 1651–1827, Library of Congress, Washington, DC.

FIGURE 1.6
Moses Williams (presumed), *Moses Williams, Cutter of Profiles*, ca. 1803. Physiognotrace portrait, 3½ × 3¼ in. (9 × 8 cm). Image courtesy of the Library Company of Philadelphia.

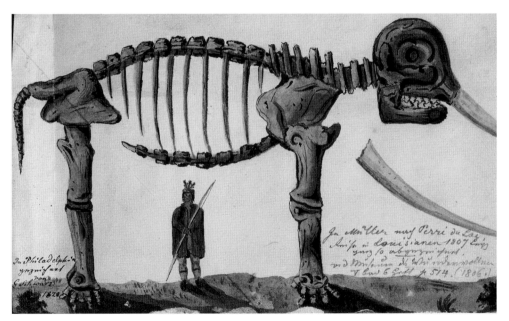

FIGURE 1.7
Rembrandt Peale (presumed), handpainted illustration from copy of his *An Historical Disquisition on the Mammoth*, 1803, showing an Indigenous person standing underneath the mastodon. *An Historical Disquisition on the Mammoth, or, Great American Incognitum an Extinct, Immense, Carnivorous Animal, Whose Fossil Remains Have Been Found in North America*, frontispiece. Rembrandt Peale, 1803. Printed for E. Lawrence by ca. Mercier, London. HSP in LCP [LCP Aa.803 L 71], Collection of the Historical Society of Pennsylvania.

fought like a trooper. She was called Major Molly ever after.

CHAP. XXIX.

STATE OF PENNSYLVANIA.

1. This is a large, wealthy and flourishing State. Our travels through it will afford us much gratification. We must examine Philadelphia in the first place. In my opinion, it is the handsomest city in the United States. The streets are all straight, and cross each other in a regular manner.

2. We shall find many interesting objects in the city. The Bank of the United States is built of white marble, and is one of the most beautiful edifices in the world. The Arcade is a very curious building, in which there are a great many shops. In the upper part of this building is Peale's Museum.

3. This is a most interesting collection. There are hundreds of stuffed birds and animals, which look as if they were really alive. There are grisly bears, and deer, and elks, and prodigious great serpents, and birds with beautiful feathers, and cranes, with legs as long as a man; and there are bugs and butterflies, and Indian tomahawks, and a multitude of other things.

Questions on the Map.—Boundaries? Describe the Delaware, Susquehanna, Schuylkill, Juniata, Lehigh, Ohio, Alleghany. What ranges of mountains in Pennsylvania? Through what counties do they run? Describe Delaware Bay. How many counties in Pennsylvania? Which lie west of the Alleghanies? Which East? Capital? In what county is Harrisburg? In what county is Philadelphia? *Ans.* In the county of Philadelphia. Describe the following towns: Lancaster, Harrisburg, Pittsburg, Chester, Wilkesbarre, Huntingdon, Bedford, Carlisle, York, Easton. Population of Pennsylvania? Extent? Greatest length of Pennsylvania? Greatest width? Average length? Average width?

4. But the most wonderful of all is the skeleton of the Mastodon, or Mammoth. These bones were found in the State of New York; the animal to which they belonged must have been as large as a small house. No animals of this kind now live in America, or anywhere else. But long before the white people came to this country, it is certain that they roamed through the forests of America. Some of them must have been at least four times as large as the largest elephant.

Skeleton of the Mastodon at Philadelphia.

5. After leaving the museum, we should go and see the Fairmount waterworks, about two or three miles out of town. These are situated on the Schuylkill river. There are here several large wheels, which are so contrived as to force the water from the river up into a reservoir on the top of a high hill. From thence the water flows to the city, and supplies the whole town. This is a most useful invention, and one that may well excite our admiration.

6. We must now leave Philadelphia,

1. What of Pennsylvania? Philadelphia? 2. Bank of the United States? Arcade? 3. Peale's Museum? What is to be seen there? 4. What of the Mastodon? Describe the picture. 5. Fairmount water-works? What is the use of

As it turns out, the story of Smith's acquisitions and donations to the Academy had far-reaching consequences for questions of international cultural property. While traveling in Italy in the 1790s, he first assembled a collection of European art objects that he planned to send back to the United States. Napoleon's forces waylaid part of the shipment; in 1800 Smith was finally able to send home an initial selection that included the plaster casts.[38] In 1807, having returned from Europe, and pleased by the progress of the Academy, Smith decided to give to the new institution an additional consignment of Italian paintings and engravings—including works by such artists as Guido Reni, Salvator Rosa, and Bartolommeo Schedoni. Five years later, following various delays, the shipment was loaded on an American ship, the *Marquis de Somerueles*, that set sail from the Italian port of Civitavecchia for Salem, Massachusetts. The War of 1812 was on the verge of being declared.[39]

And so it was that the *Marquis* had the misfortune of being captured en route

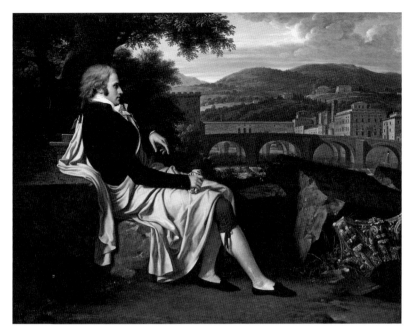

FIGURE 1.9
François-Xavier Fabre, *Joseph Allen Smith Contemplating Florence across the Arno*, 1797. Oil on canvas, 27$^{15}/_{16}$ in. × 35$^5/_8$ in. (70.9 × 90.5 cm). Gift of the Friends of the Fitzwilliam Museum. © Fitzwilliam Museum, Cambridge / Art Resource, NY.

by the British Royal Navy and taken to Halifax, Nova Scotia. Normally, warring parties considered captured cargo the prize of the captain, to be kept, sold, or otherwise distributed at his pleasure. But in this case the Pennsylvania Academy of Fine Arts sought the return of the artworks in the British court in Halifax, and the court returned a judgment in the institution's favor, establishing a key principle in the international law of cultural property: the idea that art possesses importance for something known as the "public interest." The judge in the case, Sir Alexander Croke, alluded to an important letter by Antoine-Chrysostome Quatremère de Quincy in which the French writer denounced the looting of objects of Italian cultural heritage by Napoleon's armies. Croke opined that the arts and sciences "are admitted amongst all civilized nations, as forming an exception to the severe rights of warfare, and as entitled to favour and protection. They are considered not as the peculium of this or of that nation, but as the property of mankind at large, and as belonging to the common interests of the whole species."[40] The decision thus demarcates what counts as a civilized nation; in the specific case at hand, the judge wrote, "the time may shortly come when in an advanced state of the arts, to which this very institution, which is now before the court as a petitioner, may contribute its share, new [Benjamin] *Wests* may arise to revive the school of Rafaelle in the wilds of *America* . . ." The moral improvement wrought by art might also, Croke suggested, prevent the new country from taking up arms against Great Britain again in future conflicts. Unstated but also clear is the implication that the American territory is otherwise void of culture.

The implications of this judgment continue even now to make themselves felt. The court decision constituted art objects as a special form of property that belongs to all—at least all "civilized" peoples. They thus fall outside the normal laws of property, specifically outside the rules of war for captured booty. What the judgment does not do, however, is establish where the best location is for artworks to be housed. Quatremère de Quincy had argued that by staying in situ—that is, in Italy—Italian artworks best maintain their existence as part of the collective patrimony of all Europe. It is helpful to see the Somerueles judgment in this light, because it rests on a somewhat different argument: not that the works should remain in situ but that they should go *wherever they best serve the public interest*. This position could as easily rationalize looting as condemn it: the sense that the works belong where they can do the most moral good is readily molded by ideology. The portability of the object, its dislocation from a particular site wherein its importance lies, rhymes, too, with the transportability of Whiteness. And if we think about the transatlantic shipping of art objects to the New World in light of the source of Smith's fortune, we might note that human beings held in slavery were also barbarically constituted as a "special" form of property in their being defined legally as property at all. The transportability of racial identity, of cultural objects, and of knowledge also implied the ability to dislocate objects and cultures and dispossess *people* while claiming to advance knowledge, civilization, and science.

NATURE'S MEN

While the Pennsylvania Academy of Fine Arts continues on to this day, Peale's Philadelphia Museum came to an end by 1849. The natural history collections were sold to P. T. Barnum and Moses Kimball. Peale had died in 1827. The Museum had expanded its collections continuously, even opening branches in New York and Baltimore (run by Peale's sons Rembrandt and Rubens), but it never received a major government subsidy other than the space it occupied in the Pennsylvania State House. Peale and his family struggled to operate the museum on admissions and subscriptions alone. Its legacy extended far beyond its existence as an institution in Philadelphia, however. The Lewis and Clark expedition to the West did not find any mastodon bones, but it did supply many Native American artifacts to Peale's Museum. And it was viewing some of these objects at Peale's Museum that inspired one young White painter, George Catlin, to travel west to visit Indian tribes and document them, painting portraits of individuals and depicting key events (plate 5).

Catlin can be considered one of the first salvage ethnographers: believing that the Indians were dying out, an ideological assumption that allowed even

well-meaning Whites to rationalize the violence of Indian "removal," he sought to document their appearance, culture, and customs as best he could. In the 1830s, he conceived for himself the grandiosely benevolent plan to revivify Native Americans (regardless of the fact that many were still living) such that "phoenix-like, they may rise from the 'stain on a painter's palette,' and live again upon canvass, and stand forth for centuries yet to come, the living monuments of a noble race."[41]

Catlin wrote at length about his exploits in his *Letters and Notes on the Manners, Customs, and Condition of the North American Indians*, which he published in 1841 in New York and London. In recounting his westward travels he delights in describing the natural wonders—"Nature's beautiful works"—of the North American landscape, like rock formations and rivers.[42] In order to "relish the works of Nature," Catlin writes, he sought out the "extreme wilderness of Nature's original work."[43] In Catlin's telling, nature acts as an artist, with features and visual effects that suggest paintings, sculpture, and architecture. He sees

> strange and picturesque appearances . . . produced by the rains and frosts, which are continually changing the dimensions, and varying the thousand shapes of these denuded hills, by washing down their sides and carrying them into the river. Amongst these groups may be seen tens and hundreds of thousands of different forms and figures, of the sublime and the picturesque; in many places for miles together, as the boat glides along, there is one continued appearance, before and behind us, of some ancient and boundless city in ruins—ramparts, terraces, domes, towers, citadels and castles may be seen,—cupolas, and magnificent porticoes, and here and there a solitary column and crumbling pedestal, and even spires of clay which stand alone—and glistening in distance, as the sun's rays are refracted back by the thousand crystals of gypsum which are imbedded in the clay of which they are formed.[44]

The word "ruin" recurs repeatedly: the architectural production of nature is not just a city but a ruined city, lending a character of past glory to this newfound American landscape. On the one hand, the idea of the ruin patterns itself on the well-known ruins of Rome and its empire; on the other, this sense of pastness associated with nature harmonizes with Catlin's ideas about Indigenous people and their dwindling cultures and populations.

For he associates Indigenous people with nature too, as works of nature: "It has ever been the predominant passion of my soul to seek Nature's wildest haunts, and give my hand to Nature's men."[45] He admires, in his primitivist way, the Indians' "state of nature": the Indians in the Upper Missouri "are all entirely in a state of primitive rudeness and wildness, and consequently are picturesque and handsome, almost beyond description."[46] Their "wildness" confers pictur-

esqueness on them, implying they are literally made to be pictured. The defi-nition of wildness that he uses diverges from that of Indians as "savage" in the sense of ferocious or cruel, but it is no less primitivist for it: it denies them access to life in the present time.[47] As Matthew N. Johnston has pointed out, Catlin also associates Native people with art objects—classical sculpture in particular—whose timeless monumentality chimes with his sense that they have neither past nor future.[48] Catlin writes, "I have for a long time been of opinion, that the wilderness of our country afforded models equal to those from which the Gre-cian sculptors transferred to the marble such inimitable grace and beauty."[49] They offer an equivalent, thus, of the plaster casts Smith transported to Phil-adelphia from Europe. Those statues are of course nude, and reveal nature in a way that the clothed body—that is the body clothed in European garb, which he equates with "civilization"—does not. In his terms, "Black and blue cloth and civilization are destined, not only to veil, but to obliterate the grace and beauty of Nature. Man, in the simplicity and loftiness of his nature, unrestrained and unfettered by the disguises of art, is surely the most beautiful model for the painter,—and the country from which he hails is unquestionably the best study or school of the arts in the world."[50]

Equally striking is the insistence that Indigenous people do not produce art or history. While nature can be both artist and architect, Catlin finds it impos-sible to see his Native subjects as capable of making their own art or commu-nicating their own history—this might imply there is no need for his salvage project! "And the history and customs of such a people, presented by pictorial illustrations, are themes worthy [of] the life-time of one man, and nothing short of the loss of my life, shall prevent me from visiting their country, and of becom-ing their historian."[51] Appointing himself "their historian," he desires to devote his life "to the production of a literal and graphic delineation of the living man-ners, customs, and character of an interesting race of people, who are rapidly passing away from the face of the earth" and "who have no historians or biogra-phers of their own to pourtray with fidelity their native looks and history." He sees his mission as that of "snatching from a hasty oblivion what could be saved for the benefit of posterity, and perpetuating it, as a fair and just monument, to the memory of a truly lofty and noble race."[52]

Catlin finds it possible to make this claim—that Indigenous people have no historians or biographers—even as he describes artistic productions that clearly record history and biography. The inside of a chief's robe is "beautifully garnished with porcupine quills"; the history of battles he has engaged in are "very ingeniously, though rudely, pourtrayed in pictorial representations."[53] An Ojibwe chief wears a buckskin shirt on which were "beautifully embroidered and painted in curious hieroglyphics, the history of his battles and charts of his life."[54] He views Mandan bedcurtains that are "exceedingly beautiful, being

cut tastefully into fringe, and handsomely ornamented with porcupine's quills and picture writings or hieroglyphics."[55] Mandan men wear robes "curiously ornamented with pictured representations of the creditable events and battles of their lives."[56] He sees Crow lodges that artists "paint and ornament them in such a variety of ways, as renders them exceedingly picturesque and agreeable to the eye."[57] While he asserts that Indians think of *his* art of painting as a form of medicine, a "strange and unaccountable thing to them," this is not very credible, given the quantity of Indian artistic production he describes on the exact same page, tents and robes and medicine bags that are "ornamented and preserved in a thousand different ways, as suits the taste . . . of the person who constructs them."[58] Surrounded by beautiful artifacts, many of them directly encoding specific historical events, he cannot see them as history *or* as art.

In 1838, following the creation of his set of portraits, Catlin took them on tour to the East Coast and then on to Europe, displaying them salon-style, cheek by jowl and stacked to the ceiling, and conducting lectures on the cultural observations he had been able to glean. In 1839 he took this "Indian Gallery," a mobile ethnographic museum, to Europe, presenting it in London, Paris, and Brussels. These "moving" images, and Catlin's conviction that they animated a dead past, also drew upon the showmanship in Peale's enterprise. But Catlin drew a line between art and performance: notably, he reacted with horror when another entrepreneur brought actual Indians to perform their Indianness in London. One might wonder what he was more concerned about: was it the indignity done to the Indigenous people themselves? Was it aesthetic incongruity he felt in their presence in London? Or was it fear that they might "look back," that they might well—justifiably—judge his actions in appropriating images of Native people for his own purposes? Catlin froze Indigenous people into a past he saw as slipping away, making their actual loss—past, present, and future—palatable by redressing it with symbolic substitutes. He makes them appear *movable*, literally moving their images (their "living monuments"), further separating them, conceptually, from any particular location they might call home and from communities or nations that could make territorial claims.

THE WHITE MEN WOULD EAT THEM

During the same decade in which Catlin was traveling with his "Indian Gallery," another new art institution emerged in the United States, the Wadsworth Atheneum in Hartford, Connecticut. The Atheneum, founded in 1844 by Daniel Wadsworth, stakes a claim to being the oldest continuously operating public art museum in the United States. Like the Pennsylvania Academy of Fine Art, it owes its existence, in part, to the slave trade. Much of the money for the

Wadsworth's founding, and a substantial proportion of its first artworks, not to mention its name, came from Daniel Wadsworth, who inherited his wealth from his father Jeremiah, a well-known resident of Hartford. The elder Wadsworth got his start working for his uncle Matthew Talcott as a mariner plying the West Indies trade, supplying sugar plantations with livestock; later, as commissary of George Washington's Revolutionary troops, he entered into a partnership to purchase a South Carolina slave plantation. And in 1790, the first US Census counted enslaved people in his household, at a time when the vast majority of White households in Hartford County held none at all.

In considering historical figures who benefited from slavery, a question sometimes arises, akin to the broader issue of working within "historical context": shouldn't we judge people by the standards of their own time? The fact that most White households did not hold African people in captivity might have been only a matter of lack of opportunity. But when a French chronicler, François-Jean de Chastellux, reported that Jeremiah had been involved in trade to Guinea as well as the West Indies, he hastened to correct the account: he had never sailed to Guinea.[59] It was obvious what that would have meant. Another French chronicler, Brissot, corrected the purported error, stating that Wadsworth had denied it and had always hated slavery.[60] Perhaps he hated it—but then, just like Peale, he practiced what he hated in his own household.

And the "West Indies trade" itself in this period was unthinkable without slavery. The Caribbean plantations the elder Wadsworth supplied, which in turn produced sugar and molasses for the thirteen colonies, were based on brutal enslavement. Almost all of the enslaved people in Connecticut at the time of the Revolution had been brought from the islands.[61] And even if Connecticut was a free state, it was still imbricated in these relationships many decades later. The major insurance company Aetna, based in Hartford, provided life insurance on enslaved people in Southern states, with their captors as beneficiaries, into the 1850s. It was a Hartford court that, in 1839, heard initial arguments in the case of the Amistad, the rebellion by African captives brought to Cuba by a ship sailing under the Spanish flag. It is worth dwelling on this case both to give some context for the issue of slavery in this period of Hartford's history and to make space for the voice of a historical African man who was kidnapped into the slave trade. In the case, the Mende man Sengbe Pieh (often known as Joseph Cinque) stated in his deposition to the court that

> he was born at Mani, a town in Jopoa in the Mendi country in Africa, and
> that his king Mahe Katumbo resided at Kwommendi, capital of Jopoa in said
> Mendi country; that he was sold by Birmaja son of Shaka, king of Gendumah
> in the Fai country to a Spaniard about 6 moons ago, that he was brought from
> Lomboka in a vessel with two masts, that he was landed at a village one day

from Havanna, where he was kept 5 days, then taken to another village nearer
to Havanna where he was kept 5 days more, that he was taken there by night
on foot through Havanna to the vessel which brought him from Havanna, that
he was driven by force and put on board said vessel; that they sailed the next
morning, that by night his hands were confined by irons, that a board said
vessel he had not half enough to eat or drink only two potatoes and one plan-
tain twice a day and half a tea cup of water morning and evening, that he was
beaten on the head by the cook in presence of Pipi, who claims to be his owner,
and Montez and that he was told one morning after breakfast that the white
man would eat them when they landed.[62]

In Hartford, the US circuit court judge ruled partially in favor of the defendants
but deferred to federal courts on the question of Spanish claims to what they
asserted was their property; eventually the case made its way to the US Supreme
Court and the defendants were officially exonerated on grounds of the harsh-
ness of their treatment, and thirty-five of them survived to return home.

Today, the Amistad Center, founded in 1987 and housed at the Atheneum,
commemorates the rebellion and its relationship to Hartford, as well as docu-
menting and presenting a broad spectrum of African American art and history.

Along with portraits of eminent White individuals—also well represented in
the Pennsylvania Academy of Fine Arts' collections—many of the artworks that
formed the original core of the Atheneum's collection were landscape paintings
of the Hudson River School. As I draw this chapter on the museum to a close,
I want to consider how the emphasis on landscape, and therefore on particular
modes of representing and seeing land, bind the museum tightly into the occu-
pation of American territory. These enormous vistas demonstrate the sublime
power of nature, dividing nature from culture and presenting it as "unspoiled,"
cleansed of human entanglements. Human figures who do appear are tiny in
comparison with wild nature, and most are White. This is the wild emptied of
its inhabitants. In depicting wild expanses of nature with no humans, they sym-
bolically erase Native people, and invite the White viewer's entry. Their spaces
do not represent a "tame" landscape—far from it. But as painted vistas they are
approachable, a wild nature framed.[63] W. J. T. Mitchell wrote in 1994 that land-
scape is "integrally connected with imperialism," and this argument can be
extended to encompass settler colonialism and the practices of enslavement that
it instituted (as well as American imperialism and neoimperialism).[64]

The foundational artworks of the early American museum painted Native
Americans out of the picture, at just the moment when Catlin was taking their
pictures with him to tour Europe as his "Indian Gallery." Where Indigenous
people appear, they are portrayed as villainous or moribund, subject to the "nat-
ural" racial succession by which Whites take over their land and even their iden-

tities, as Tuck and Yang have pointed out.[65] For example, in 1850 the institution purchased the bluntly ideological *Murder of Jane McCrea*; painted in 1804 by John Vanderlyn, it is a depiction of two British-allied Huron soldiers murdering a White woman settler during the Revolutionary War. For a scene in which landscape is a primary focus, we can turn to Thomas Cole's 1827 painting *Scene from "The Last of the Mohicans"* (fig. 1.10), which has been further labeled "Cora at the Feet of Tamenund." This painting belonged to Daniel Wadsworth, Cole's key patron, and although it was not part of his original bequest to the Atheneum, it eventually entered the collection in 1868. At first glance it is wholly a landscape, a mountainous view in which fading autumn light tips patches of trees that have not yet reached the full brilliance of their fall color. But the sunlight pulls our attention to a rock ledge, in front of a craggy, temple-like and almost monstrous rock formation. (On another jutting ledge in the foreground, Cole inscribes his own signature, as if carved in the actual rock.) On this spotlit stage, a dramatic scene unfolds.

Cole created this painting shortly after the 1826 publication of James Fenimore Cooper's bestselling novel. He chose a moment of high dramatic tension. On the large, rounded ledge, hundreds of Lenape (Delaware) Indians have gathered for the judgment the ancient sage Tamenund will deliver on the fate of a group of travelers captured by Magua, chief of the rival Huron tribe. The travelers include the two daughters, Alice and Cora, of the British Lieutenant Colonel George Munro; Magua is pursuing the two women out of his desire for vengeance against their father's mistreatment of him. Along with Alice and Cora are their escorts, charged with their safe passage through the wilderness: Duncan Heyward, a British officer; Nathaniel Bumppo, the story's protagonist, a frontiersman close to the Mohican tribe; and Uncas, the last "pure-blooded" Mohican. Notably, Cora and Alice are half sisters with different mothers: Alice's is unambiguously White, but Cora's was a West Indian Creole woman and "descended, remotely, from that unfortunate class who are so basely enslaved to administer to the wants of a luxurious people."[66]

In this dramatic landscape, as the virtuous Cora throws herself on the mercy of the elder, Tamenund makes his decision: he declines to turn over most of the prisoners to Magua. But his decision about Cora's fate is different. With the assent of Uncas, who appears to bow to an understanding of Indian custom—Magua had previously captured her with the intent to make her serve him as his wife, so she "belongs" to him—Tamenund assigns Cora to Magua. It is a pivotal moment in the story. The decision unleashes a final battle in which Uncas, Cora, and Magua are all killed on another mountain peak which this one might seem to foreshadow.

Against the vast mountainous landscape of the painting, the figures are tiny.

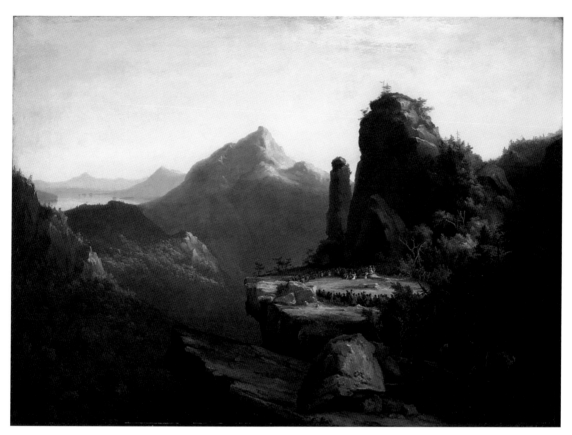

FIGURE 1.10
Thomas Cole, *Scene from "The Last of the Mohicans," Cora Kneeling at the Feet of Tamenund*, 1827. Oil on canvas, 25³/₈ × 35 ¹/₁₆ in. (64.5 × 89.1 cm). Wadsworth Atheneum Museum of Art, Hartford, CT. Bequest of Alfred Smith, 1868.3. Photography credit: Allen Phillips/Wadsworth Atheneum.

The image of vast landscape, otherwise empty of human presence, implicates "nature" itself in the narrative's denouement, in the story of gendered submission and in the story of racial succession. In the end, Whiteness prevails not once but twice. The blond sister Alice survives while the not-quite-White-enough Cora, with her "dark, glossy tresses," perishes. Cora associates her own racial misfortune with that of the Native Americans and offers herself up as sacrifice on behalf of her "good" and "precious" White half sister. "Like thee and thine, venerable chief," Cora says, "the curse of my ancestors has fallen heavily on their child." And as Tuck and Yang note in their analysis of the novel's fantasy of the "adoption" of Whites into Native identity, Bumppo symbolically takes Uncas's place as the "last" Mohican.[67] As pictures substitute for persons in Catlin's project, so too do Whites substitute for Native people in the spaces marked out by the Atheneum.

HEAP OF CURIOSITIES

After the demise of Peale's Museum, when a considerable portion of its collections were sold to P. T. Barnum and Moses Kimball, the two partners split them between their New York and Boston museums. Thus it was that when fire destroyed Barnum's New York museum in 1865, the Native artifacts and other collections held by Kimball in Boston were preserved—and thus, that some objects from Peale's original collection found their way to Harvard's Peabody Museum after Kimball's death. But the demise of Barnum's enterprise in New York meant a clean slate in that city; it was as if the hucksterish associations had to be cleared away first. The passing of the Barnum Museum opened the possibility of a new museum that could serve as a tool to educate middle-class people, one that would not just be a sensationalistic hodgepodge to gawk at. An article in the *Nation* in 1865 made this view very clear: "Without scientific arrangement, without a catalogue, without attendants, without even labels, in very many instances, the heterogeneous heap of 'curiosities,' valuable and worthless well mixed together, could not attract our students very often to detain them long."[68] The article proposed a new, scientifically ordered museum for enlightenment and public good. In this moment of Reconstruction, the Metropolitan Museum emerged in 1870, and the American Museum of Natural History in 1871. More than a link in a chain that follows from the European public museums, these museums responded directly to the history of museums that culminated in Barnum's institution. They put firmly into place the division between art and nature that Peale had not quite been able to maintain, and they kept non-Europeans on the side of nature. It was not until 1969 that the Met would incorporate what they at the time called "primitive" art into the museum, by building a new wing to house a large collection donated by Nelson A. Rockefeller, grandson of the Standard Oil magnate John D. Rockefeller.

The visual arts, or "fine arts" as now understood in North America, established themselves, like so many other institutions, as an organ of White supremacy. It is of course no surprise that Europeans would have brought artworks, objects—designed, crafted, ornamented, and pictorial objects—with them when they came to the Americas. They likewise encountered Indigenous people in the Americas who were adept at making designed, crafted, ornamented, and pictorial objects of their own. But in imposing systems of value, they argued that some arts, in fact, were art, and others something else entirely. As Simon Gikandi has argued, by the eighteenth century, Europeans and White Americans had set about constructing a system of aesthetics that enforced racial hierarchies, such that "even the hint that blacks [and I would add, Indigenous people in the Americas] could be active agents in the production of art . . . rile[d] the enlightened men of taste."[69]

Many and varied stories can be told about the "museum" as a space and institution. What interests me here is the history of how White Americans, in the early decades of the United States, began building institutions and notions of "high art" and "fine arts" that traveled alongside, indeed *supported* a colonial endeavor that relied on violence, enslavement, and genocide.[70] I do not wish to vilify the study or appreciation of European art, or the art forms that grew up in the US in dialogue with European traditions. But if, in the course of appreciating such forms, we gloss over the history of how these works became part of an accepted canon here, why—when threatened—they inspire such passionate defenses, we participate in the project they began rather than dismantling it. To equate Whiteness with art, culture, civilization, history, had terrifying consequences for Native people in the Americas and for African people brought to the Americas to serve as captive labor under conditions of torture. And as much as this critique has been repeated, the conversations it inspires have not reached a full reckoning that would alter how we teach and present histories of human creative activity.

2
THE WILD

Freedom, Slavery, and Desire

BRIGHTER AND MORE COSTLY COLORS

"It has ever been the predominant passion of my soul to seek Nature's wildest haunts, and give my hand to Nature's men," George Catlin wrote.[1] Like many of his contemporaries, Catlin associated art, history, and culture with European modes of creation that present themselves as the very antithesis of the wilds of the American landscape. Even aside from the fact that he failed to understand the art, history, and culture of Indigenous tribes, the opposition is already unstable in the metaphors to which he resorts to describe his "objects." Native people for Catlin are "nature's undisguised models" in their "beauty and wildness." Young Indian men represent a past historical time, as "knights of the forest."[2] If the wilds are themselves works of art, their privileged spectators and interpreters are White settlers.

For Henry David Thoreau, as for Catlin, the vivid beauties of nature's artistic production in the New World make the "old world" pale in comparison. Paraphrasing Sir Francis Head, Thoreau wrote that "in both the northern and southern hemispheres of the New World, Nature has not only outlined her works on a larger scale, but has painted the whole picture with brighter and more costly colors than she used in delineating and in beautifying the Old World . . . The heavens of America appear infinitely higher, the sky is bluer, the air is fresher, the cold is intenser, the thunder is louder, the lightning is vivider, the wind is stronger, the rain is heavier . . ."[3] This perspective continues the line of thinking in Peale's fascination with the mastodon, taking part in the rejoinder by White Americans to European claims about the insalubrious effects of the American climate.

This sense of brilliant vigor was inseparable from colonists' notion of the

wildness of the landscape, a quality that defined North American territory for them, making it both available and exciting in a dangerous way. Associating land and its inhabitants, the "wild" is also the "savage," a slur Europeans habitually lobbed at Indigenous people of the Americas, Africa, and Oceania. European uses of this concept were not unremittingly negative; they often contained a sprinkling of admiration. But even Europeans who admired Native people almost always believed their civilization rendered them superior, uniquely endowing them with a vantage point from which they could—as both Catlin and Thoreau did—critique the notion of civilization itself.

"Wild," in this chapter, serves as a counterpoint to the "museum" of the previous one, which took on museums as institutions, but also the broader construction of an idea of civilization based in Whiteness. And although the wild connects to real and symbolic spaces of American territory, it is also more than just the name for a type of place. What purchase indeed might wildness have in the twenty-first century, when it has become difficult to observe any actual "wild nature"—if there ever was such a thing? And yet the later life of the phantasms of the wild can be seen in many places. A key example for me is the 2011 hip-hop track "No Church in the Wild," the last track of Jay-Z and Kanye West's album *Watch the Throne*. Its lyrics recount the internal narrative of a self-described "thug" protagonist whose "wild" is constituted by lawlessness and appetites for sex and violence that play out across a contemporary urban American landscape. In this, the artists capture something that might be described as a quintessentially American antihero narrative. It is a flexible one. In Baz Luhrmann's 2013 film adaptation of *The Great Gatsby*, the song provides the sound of the decadent, voracious Roaring Twenties in New York, the backdrop against which Jay Gatsby's story unfolds. The two music videos the song inspired also construct alternative settings and narratives—past and present, American and global.

"No Church in the Wild" emerged out of a multifaceted collaboration: it includes vocals by Frank Ocean and The-Dream and beats by 88-Keys, along with numerous sampled tracks—altogether, there are ten writing credits. The authorized video for "No Church," directed by the French filmmaker Romain Gavras, melds the classicism present in the lyrics with a different setting and a different kind of violence.[4] Shots of classicizing public sculpture punctuate a visual storyline of urban political upheaval that plays out over a European cityscape and connects only loosely to the narrative of the song. An unauthorized video, much less widely seen, offers its own richly provocative imagery. Made by a group of filmmakers called High5Collective, based at the time in Los Angeles, it, too, refrains from simply illustrating the lyrics. Rather, it constructs a new visual narrative that is firmly set in an American historical context. Conjuring painful histories with a twist, it hints at how race, gender, and violence interlock with one another in the United States.

In this chapter I trace the sense of the wild through an unexpected dialogue that emerges from a series of objects that span 150 years of cultural production. I begin with Thoreau's formative conceptualization of the wild in his essay "Walking," given as a speech in 1851 and published in 1862. Next, I turn to "No Church in the Wild," and the two videos I introduced above. Along the way, Barnett Newman's mid-twentieth-century modernist painting "The Wild"—and the artist's ambiguous modernist primitivism and gender ideology—play a supporting role. Ultimately, the song and videos are at the heart of this chapter: together they clarify what remains at stake in the idea of the wild, its interlacing of external and internal senses of "wildness," its conjoining of race, gender, and sexuality. I take them as a profound and powerfully ambiguous reflection on one of the distinctive elements of American mythmaking: the idea of the wild, of wildness and wilderness.

To be sure, this wild is not the "great outdoors" of natural wilderness, although it has a certain naturalizing force: the wild as appetitive being is what humans are *in the wild*, in their natural state (or "state of nature"). The wild is the counterpoint to the "civilized," of course—in opposition to it and yet perpetually and robustly tapped by it as a resource.[5] In its overlapping connotations, the "wild" spreads out expansively: natural, untamed, not domesticated; joyously raucous; ungoverned or ungovernable, disobedient; and, at times, vicious and cruel. In the American context, it is also repeatedly and explicitly gendered as a masculine preserve. As territory for men—often but not only White men—it is nonetheless haunted by the gender division that subordinates women while making control over their sexuality central to the reproduction of race, culture, and power.

WILDERNESS THEOLOGY AND MEDIEVAL ADVENTURE

Perhaps the best-known American paean to the wild appears in the writings of Thoreau, naturalist, essayist, and poet who, in his famous book *Walden*, recounted his experiences living for two years in a cabin near Walden Pond in Concord, Massachusetts. Walden Pond was not exactly wilderness: it's only two miles from the center of town, an easy walk or ride even in those days. But Thoreau's idea of the wild stretched out far beyond Walden Pond and delved deep inside himself. In his essay "Walking," first given as a speech at the Concord Lyceum in 1851 and then published in the *Atlantic Monthly* soon after his death in 1862, he ponders the idea of the wild as reflected in nineteenth-century North American landscapes.[6] Thoreau begins by suggesting that human beings in general—or perhaps he really means men—should position themselves on the side of nature: "I wish to speak a word for Nature, for absolute freedom and wild-

ness, as contrasted with a freedom and culture merely civil,—to regard man as an inhabitant, or a part and parcel of Nature, rather than a member of society. I wish to make an extreme statement, if so I may make an emphatic one, for there are enough champions of civilization: the minister and the school-committee, and every one of you will take care of that."[7] Classing organized religion and education together with civilization, Thoreau finds value instead in a wild where, as in the song, there is *no church*.

Thoreau's notion of the "wild," both internal and external, reflects a Romantic-era fascination with wild nature: "Life consists with wildness. The most alive is the wildest. Not yet subdued to man, its presence refreshes him."[8] He builds on earlier ideas of the state of nature that philosophers like Locke and Rousseau associated with the Americas. Conversely, these ideas entail anxieties about Western civilization and its fate: the sense that without wildness to nourish it, civilization is destined to reach a dead end. With only itself to feed on, what is civilized quickly becomes stale. Thoreau uses vivid botanical language, describing rotting plant matter, muck, and swampy ground that produce soil out of which new poets and philosophers can grow. Modern habitations lacking this material basis suffer from a weakened, blighted culture, what the German philosopher Friedrich Nietzsche would, a bit later in the century, refer to as Alexandrianism.[9] "The civilized nations—Greece, Rome, England," Thoreau writes, "have been sustained by the primitive forests which anciently rotted where they stand. They survive as long as the soil is not exhausted. Alas for human culture! Little is to be expected of a nation, when the vegetable mould is exhausted, and it is compelled to make manure of the bones of its fathers. There the poet sustains himself merely by his own superfluous fat, and the philosopher comes down on his marrow-bones."[10] Thoreau intimates here that America must forge its own culture rather than relying on a dull repetition of European traditions.

While he excludes organized religion from his ideal of the wild, he makes ample room for spiritual yearning. He begins his essay by imagining an etymology for the word "saunter," referring to an aimless wandering, not a goal-directed mode of locomotion: one "saunters" out without a specific plan for return. He claims first that the word comes from "Saint-Terre," referring to the Holy Land, and therefore, to medieval Christians who collected donations fraudulently by claiming to be going on pilgrimage (or, perhaps, Crusade). He acknowledges an alternative etymology, that of "*sans terre*," or "landless"—people who wander because they have no place of their own—but rejects it, offering up a sanctification of the American wilderness. "They who never go to the Holy Land in their walks, as they pretend, are indeed mere idlers and vagabonds; but they who do go there are saunterers in the good sense, such as I mean."[11] The sanctified land in this case is, simply, the wild. Thoreau pursues this idea throughout the essay, where it underpins his pervasive medievalism. Imagining "a new, or rather an

old, order"—a knightly order, or something out of a fairy tale—Thoreau envisions "not Equestrians or Chevaliers, not Ritters or riders, but Walkers, a still more ancient and honorable class, I trust."[12] To be a walker in the true sense, he proposes, comes by grace of God.[13] "It is true," he writes, "we are but faint-hearted crusaders, even the walkers, nowadays, who undertake no persevering, never-ending enterprises. Our expeditions are but tours, and come round again at evening to the old hearth-side from which we set out. Half the walk is but retracing our steps. We should go forth on the shortest walk, per-chance, in the spirit of undying adventure, never to return,—prepared to send back our embalmed hearts only as relics to our desolate kingdoms."[14]

Thoreau was a champion of abolition who went to jail to resist paying taxes to support slavery and imperialist wars, but his cultural frame of reference is— as we might expect—resolutely European. He reflects explicitly on Whiteness in discussing what it means for a White man to be tanned by exposure to the sun. Alluding to comparisons of White and non-White bodies, drawn from Darwin and an anonymous African man, and implicitly countering any deprecation of tan skin based in White class snobbery, he asserts, "A tanned skin is something more than respectable, and perhaps olive is a fitter color than white for a man,—a denizen of the woods."[15] Here he hints at a rhyme between men and trees, tanned skin and bark, which he pursues a few pages later. "To preserve wild animals," he writes, "implies generally the creation of a forest for them to dwell in or resort to. So it is with man. A hundred years ago they sold bark in our streets peeled from our own woods. In the very aspect of those primitive and rugged trees, there was, methinks, a tanning principle which hardened and consolidated the fibres of men's thoughts. Ah! Already I shudder for these comparatively degenerate days of my native village, when you cannot collect a load of bark of good thickness,— and we no longer produce tar and turpentine."[16]

Like the wood used in the pencils that Thoreau's family made, bark and tar and turpentine were all products of trees. Turpentine was used as a solvent (for example, for housepaint); tar was chiefly used to seal the hulls of boats for shipping. Shipbuilding indeed took huge quantities of timber, and was the most significant driver of deforestation in New England in the nineteenth century, much more directly than the establishment of towns and cities—the encroaching "civilization" that Thoreau ambivalently laments—though of course commerce in these population centers also depended on the trade pursued by ships. Bark was used for tonics, as Thoreau notes, but in greater quantities to produce tannins for treating—tanning—leather, which helps to explain the "tanning principle" he mentions amid his thoughts on bark. His suggestion is that trees not only provide tannin for leather with their bark, but their appearance—"the very aspect of those primitive and rugged trees"—had the effect of "hardening" the "fibres of men's thoughts."

If this seems like highly gendered language, it is, I would contend, no accident. Thoreau's wild necessitates a White male subject—indeed, a White man of a certain class, for whom outdoor physical labor is not a given—to reap its benefits. The walker who saunters can only be male. Wondering how women, confined to the home, can "stand" to be inside all the time, Thoreau speculates (absurdly) that, in fact, they do not *stand*: they actually sleep their days away! And although in his general outlook the wild is superior to the houses and buildings of towns and cities, at the same time, paradoxically, Thoreau finds architecture beautiful in its role of protecting White womanhood. This despite his acknowledgment of the role of the house as not only guardian but also tool of confinement: "Then it is that I appreciate the beauty and glory of architecture, which itself never turns in, but forever stands out and erect, protecting the slumberers."[17]

If the houses in which he imagines White women sleeping as they preserve Whiteness are anything like the houses Thoreau himself inhabited in Concord, Massachusetts, they were houses adorned in the Greek Revival style. This is true of the farmhouse where he was born, as well as the house he bought in 1850 in Concord, which has a particularly pronounced classical portico (fig. 2.1). If Thoreau's medievalism represents epic adventure, the classical might represent the constraints of civilization. For men to stay indoors may produce "softness and smoothness, not to say thinness of skin"; in the case of the ostensibly slumbering women, not it also produces (a fantasy of) Whiteness: "mere sentimentality that

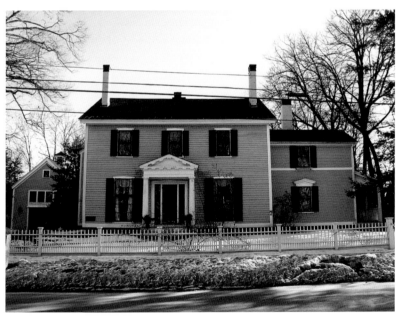

FIGURE 2.1
Thoreau–Alcott House, photograph by John Phelan, licensed under CC BY 3.0.

lies abed and thinks itself white."[18] Whether this means *imagines that it is white* or actually *makes itself white* by thinking, the turn of phrase reveals Whiteness as constructed. White women implicitly produce Whiteness as fantasy. It is a fantasy, of course, with real consequences. Historically, it is women who were charged with the literal (and linear, lineal) reproduction of Whiteness, which accounts for the political imperative to regulate their sexuality. Even as Thoreau suggests the phantasmatic nature of Whiteness, he still accepts it as the starting point for his own thinking—and, indeed, his own walking.

VISIONS OF THE WEST

Thoreau's notion of the wild did not derive exclusively from his experiences in the woods. Modern, urban experiences of cultural production also shaped Thoreau's views. In the midst of his essay, he mentions he had recently viewed two moving panoramas, one depicting the banks of the Rhine River and the other those of the Mississippi. These were probably a panorama of the Rhine created by Benjamin Champney and one of the Mississippi by Samuel Stockwell, both presented in Boston.[19] These panoramas, a favored public visual performance medium of the mid-nineteenth century, were typically extremely long paintings (one was advertised as three miles long) that were displayed to audiences as a sequence of images by moving them along on rollers.[20] It might be argued that rivers were the perfect subject for this kind of panorama, because they provided a series of scenes of nature and culture whose succession can be explained by geography. Describing the Rhine panorama, he writes,

> It was like a dream of the Middle Age. I floated down its historic stream in something more than imagination, under bridges built by the Romans, and repaired by later heroes, past cities and castles whose very names were music to my ears, and each of which was the subject of a legend. There were Ehrenbreitstein and Rolandseck and Coblentz, which I knew only in history. They were ruins that interested me chiefly. There seemed to come up from its waters and its vine-clad hills and valleys a hushed music as of Crusaders departing for the Holy Land. I floated along under the spell of enchantment, as if I had been transported to an heroic age, and breathed an atmosphere of chivalry.

While the vision of the Rhine is a "dream" (note that he enlists the idea of the Holy Land again), that of the Mississippi is "to-day": "As I worked my way up the river in the light of to-day, and saw the steamboats wooding up, counted the rising cities, gazed on the fresh ruins of Nauvoo, beheld the Indians moving west across the stream . . . I saw that this was a Rhine stream of a different kind; that

the foundations of castles were yet to be laid, and the famous bridges were yet to be thrown over the river; and I felt that *this was the heroic age itself* . . ."[21]

The parallel of the Rhine and the Mississippi suggests to Thoreau a notion of modern medieval heroics. It comes to justify something that might seem incongruous in our standard understanding of Thoreau as a retiring pacifist: an expansionist orientation toward the western frontier. This was not entirely inconsistent with his abolitionism, since one response to the threat of slavery's expansion into the West—a specter raised by the Missouri Compromise of 1820—was to expand westward by establishing more free states in the western "unorganized territories." Returning to Thoreau's imagined etymology of "saunter," we are reminded that the holy mandate of westward expansion to the new *Saint-Terre* is only accomplished by dispossessing Indigenous peoples of their land, rendering them *sans terre*. And what indeed were the medieval crusades but a holy mandate of violent dispossession?

What might Thoreau have actually seen in those panoramas? Numerous panoramas of the Mississippi were displayed in Boston in the 1840s and 1850s, showcasing natural wonders, settlements past and present, ships and their cargo, battles and rebellions, plantations and other disaster scenes.[22] Ruins appearing in these panoramas included an abandoned settlement of the Mandan tribe (recall the Mandans were among Catlin's subjects), as well as the ruins of Nauvoo, which had been a Mormon settlement. Though Thoreau's description wraps the mighty river in misty legend, the makers of the panoramas also traded on their ability to convey up-to-the-minute current events. Benjamin Champney's panorama of the Rhine—almost certainly the one Thoreau saw—interspersed scenery with tableaux representing events of the French revolution of 1848.[23] Samuel B. Stockwell's panorama of the Mississippi, displayed in Boston on dates that correspond to Thoreau's timeline, crowded the southern portions of his panorama into one scene, which meant that he gave comparatively less attention to plantations that depended on the forced labor of enslaved African people. But Stockwell did include a vignette of the burning of the steamer *Clarksville*, an event in which most of the crew who lost their lives were Black, and all the passengers who died were the African captives of White passengers—all of whom survived.[24] He also included what one observer described as a "great number of Indian villages and encampments, with their 'lodges,' wigwams, &c, and groups of Indians in full costume, dancing, playing ball, fishing, and equipped for battle."[25]

At least one other panorama, John Banvard's, devoted more space and even a celebratory presentation to Southern plantations. Thoreau could have seen it in Boston as early as 1846, and an official description was published in 1848. The published description lauds the beauty of slave plantations beginning in Memphis as the panorama moves southward: "Here the voyager will begin to

see fine cotton plantations, with the slaves working in the cotton fields. He will see the beautiful mansions of the planters, rows of 'negro quarters'; and lofty cypress trees, the pride of the Southern forests."[26] Between Baton Rouge and New Orleans, similarly, the description refers to "extensive sugar fields, noble mansions, beautiful gardens, large sugar houses, groups of negro quarters, lofty churches, splendid villas, presenting, in all, one of the finest views of country to be met with in the United States."[27] Along the way, the violence of slavery is indicated by the vignette of an island where three captives were burned alive as punishment for killing their captors.[28] The narrative arc of Banvard's panorama created by movement from north to south implies a kind of crescendo of movement from wild to civilized, where civilized meant the slavery-based economic system of the South and the grand neoclassical architecture supported by it.

Thoreau may not have seen Banvard's panorama, and if he had, he might have been repelled by it. But even without the celebration of slavery, the presentation of scenes of the West that encouraged easterners and city dwellers to think of the western wild as their domain encoded a deep strain of racial violence. The year 1862, the same year the essay appeared in the *Atlantic Monthly*, was also the year Abraham Lincoln signed the Homestead Act, which opened up western land to largely White homesteaders who would commit to working the land and "improving" it for five years to qualify for ownership. The Homestead Act created new tensions and further displaced Native people, many of whom had already been driven along the Trail of Tears from their homes in eastern states.

Although Thoreau strongly emphasizes the notion of a walk with no set goal, a presumed directionality surfaces again and again in his text: the wild is found in the West. He attributes it to a "prevailing tendency" among his countrymen: "Let me live where I will, on this side is the city, on that the wilderness, and ever I am leaving the city more and more, and withdrawing into the wilderness. I should not lay so much stress on this fact, if I did not believe that some thing like this is the prevailing tendency of my countrymen. I must walk toward Oregon, and not toward Europe. And that way the nation is moving, and I may say that mankind progress from east to west."[29] Thoreau's broad understanding of wilderness as a natural resource to feed an aging and purportedly effete civilization explicitly associates "the wild" with the West. Implicitly, he conceived "Europe" itself as the product of an ancient westward movement of culture and the United States as a more recent one: within the continent, then, westward motion was preordained.

In 1962 Eliot Porter used a quote from this essay for the title of his influential book of color nature photography, *In Wildness is the Preservation of the World*. In combination with Porter's glorious photographs, it is a stirring phrase. But in context what precedes it is an undisguised equation of the cardinal direc-

tion "West" with the wild, which casts a somewhat disturbing light on the brief excerpt:

> The West of which I speak is but another name for the Wild; and what I have been preparing to say is, that in Wildness is the preservation of the World. Every tree sends its fibres forth in search of the Wild. The cities import it at any price. Men plough and sail for it. From the forest and wilderness come the tonics and barks which brace mankind. Our ancestors were savages. The story of Romulus and Remus being suckled by a wolf is not a meaningless fable. The founders of every State which has risen to eminence have drawn their nourishment and vigor from a similar wild source. It was because the children of the Empire were not suckled by the wolf that they were conquered and displaced by the children of the Northern forests who were.[30]

Thoreau seeks an identification with "the savage"—"we have a wild savage in us,"[31] he writes elsewhere—yet appears to accept the displacement of Indigenous people as part and parcel of the movement of White men westward. He writes, "we go eastward to realize history and study the works of art and literature, retracing the steps of the race; we go westward as into the future, with a spirit of enterprise and adventure."[32] This applies to White settlers dwelling in the eastern United States who move westward, taking part in the broader movement of Europeans. And Thoreau quotes approvingly a bald statement of the ideology of manifest destiny made by the geographer Arnold Henry Guyot: "As the plant is made for the animal, as the vegetable world is made for the animal world, America is made for the man of the Old World."[33]

Thoreau identifies wildness with western expansion and justifies the latter as a matter of necessity to the continued production of a culture of greatness— one that is decisively White and male. It is not so surprising, of course, that he would imagine the White man as privileged spectator of the West's natural bounties. And my interest here is not in dismantling Thoreau's contradictions as an individual. As Andrew Menard has argued, his view of the West is not equivalent in any simple way with manifest destiny; the whole notion of "sauntering," of aimless walking, is inconsistent with a direct drive to conquer.[34] Still, it is useful to consider some of the ideological knots into which his quasi theology of the wild (Lydia Willsky-Ciollo calls it his "practical theology of wildness"[35]), and his gospel of living in the moment, gets itself tied. Though elsewhere he gave considerable attention to contemporary politics, in this essay he seems to turn away from the troubling political implications of his own musings, and disregards the contemporary issues represented in the very panoramas that excite his imagination. His thinking is so infused with historical references that it is then startling

that as his essay nears its end, he turns to a declaration of a new "gospel," a new "testament," that of living only in the moment:

> Above all, we cannot afford not to live in the present. He is blessed over all mortals who loses no moment of the passing life in remembering the past. Unless our philosophy hears the cock crow in every barn-yard within our horizon, it is belated. That sound commonly reminds us that we are growing rusty and antique in our employments and habits of thought. His philosophy comes down to a more recent time than ours. There is something suggested by it that is a newer testament,—the gospel according to this moment. He has not fallen astern; he has got up early, and kept up early, and to be where he is to be in season, in the foremost rank of time. It is an expression of the health and soundness of Nature, a brag for all the world, healthiness as of a spring burst forth, a new fountain of the Muses, to celebrate this last instant of time. Where he lives no fugitive slave laws are passed. Who has not betrayed his master many times since last he heard that note?[36]

It's possible to skate across the surface of this passage and appreciate its poetic embellishments without being too concerned about its ambiguities, but let's keep after them for a while, like a dog gnawing at a bone. At times, in this passage, it is not clear who is being discussed—man, or rooster. With the pronouns "His" and "He," beginning with the sentence "His philosophy . . ." but even more with "He has not fallen . . . ," we might presume Thoreau refers to the same man who is, earlier in the passage, "blessed over all other mortals." And yet it would be equally logical, for a time, to think that it is the cock who crows—"he has got up early, and kept up early . . ." One could even imagine that, in the context of a reflection on the wild, the rooster is the one in possession of philosophy, of which the man is only the student: "It is an expression of the health and soundness of Nature, a brag for all the world . . ."

Yet if we have begun to think along these lines, we are forced to revise our interpretation on reaching the sentence about fugitive slave laws. For surely, in literal terms these laws are passed not only in the South but everywhere in the United States that land has been settled for European-style agriculture, and thus everywhere, or almost everywhere, that cocks crow. The final line of the paragraph—"Who has not betrayed his master many times since last he heard that note?" follows poetically—yet there are multiple frictions here. The modal White man of Thoreau's text does not have a "master" in the same sense as an enslaved person, so it's unclear who this metaphorical master is. However, given that it seems to have been a long time since he heard the note—the cock's crow, the song of the moment—it appears that the master he has betrayed is his true wild self, the one who would urge him to live for the moment. No "fugitive slave

laws" (a bad metaphor; we know in actual practice Thoreau deplored them) will bring him back to himself. In his view civilization imposes itself, internalizes itself—via "our employments and habits of thought"—to urge flight from man's true master. From whom, in this convoluted complex of metaphors, he should not actually flee.

THE CLASSICAL AND THE WILD

Does the "wild" that surfaces in "No Church" have anything to do with Thoreau? The song and the imagery associated with it certainly elaborate on questions that also inform "Walking." Still, it would be hard to establish any direct connection. Jay-Z had multiple dialogues with Cornel West that could, for all I know, have involved some discussion of Thoreau; but my interest in juxtaposing these works does not depend on ascertaining whether the track and videos were created with any knowledge of the essay.[37] It is striking nonetheless to notice how many common threads stand out in the fabric of their significance; together they traffic in the idea of the wild as a central site of American mythmaking.

The authorized video for "No Church in the Wild," directed by Romain Gavras, appeared on May 29, 2012, and (at this writing) has more than 108 million views on YouTube. It presents a setting and players that differ sharply from the narrative the song itself constructs. The setting is a European city, and the multiracial, male cast has no single clear protagonist, downplaying the culturally specific protagonist identities mobilized by the song. On the other hand, it adds additional texture to the idea of the urban "wild," representing violence and chaos as part of a vision of collective political uprising rather than the personal story and philosophical reflections of the song's individual voice. Within this visual landscape, Gavras's fragmented shots of classicizing sculpture serve as punctuation and commentary—often ambiguously portentous—of scenes of urban insurrection in which a multiracial band of renegades fight in the street with heavily armed police (fig. 2.2). It is of its moment: the tumultuous political events of 2011–12 include the Arab Spring, a series of uprisings in the Arab world; Occupy Wall Street and its echoes throughout the US and the globe; and riots in Greece that followed financial collapse and the European Union's imposition of austerity measures. The resonances with these experiences in Gavras's video are clear.

In it, the battle is relentless. Young men, loosely organized and armed with Molotov cocktails, confront a mounted police force. The contemporary reference to urban uprising seems clear, but the video doesn't maneuver its viewers into immediate sympathy with either side. For the most part, the camera observes its subjects from some distance, a medium to medium-long shot; and Gavras

FIGURE 2.2
Romain Gavras, dir., *No Church in the Wild*,
music video, 2012, general melee, still.

calibrates his actors' emotional range to retain some ambiguity. He does give more attention to the subjective experience of the protesters: they react with joy to successfully lobbed projectiles; they show fear when threatened. The police, for their part, remain impassive, robotic, their faces shielded. Their galloping attacks from horseback are vicious. We can see that this is an unequal battle, and yet the protesters' unrestrained jubilation at their successes might give a viewer pause. Our sense of their politics—left or right?—remains uncertain. The attention the camera pays to the protesters' faces certainly does not make for full identification with their point of view. The consequences of their actions are chaotic and devastating. At the end of the video, a police officer attempting to drag a protester down from atop a statue falls to what we can only assume is his death; a man runs through the streets on fire; and a live elephant raises itself onto its hind legs in slow motion—an uncontrollable yet vulnerable, perhaps self-destructive force unleashed, with what consequences we never fully grasp.

Though the action was shot in Prague, as we can divine from the signage on storefronts, the brief shots of marble statuary that accompany the keening treble and infectious guitar riff are of classicizing nineteenth-century public sculptures located in Paris: the exterior of the Arc de Triomphe—the monumental arch commissioned by Napoleon in 1806—and several freestanding statues in the Tuileries Garden. At moments in the sequence of events we see brief insert shots of the white bodies of Charles François Leboeuf's *Alexander Fighting* (1836), Laurent Honoré Marqueste's *Nessus and Deianira* (1892), and Henri Vidal's *Cain* (1896). To a French audience, the statues would be highly recognizable—they are,

indeed, of substantial public significance. The Arc de Triomphe groups represent French national triumph, with imagery tied to the French Revolution and symbolic representations of peace. The Tuileries Garden is a site of great national symbolism: a royal garden attached to a royal palace, taken over in the 1789 revolution to become a national palace of culture and public gardens. But these same sculptures read as generically "classical" to almost anyone else.

Are we to take these classical references as expressions of the authority being wielded, the social order being maintained by the police?[38] Or should we take them as affective signs, glosses that help us make sense of what the camera's distant view of the conflict won't show? Contrasting with the long shots of the action, the tight, close-up framing of the inserts of public sculpture renders the statues more violent, emotional, and grotesque than the way they appear from the perspective of an ordinary passerby in the public space of Paris. The camera excerpts and intensifies the statues: we see, close in, the centaur's fingers pressing into Deianira's flesh (fig. 2.3). Theseus looks more arbitrarily savage. Cain's anguish crystallizes in the close-up of his hand clutching at his face (fig. 2.4).

Classicism presents itself as a bulwark of "civilization"—but it is an anxious bulwark, trying to look and act serene against an imagined savagery. And where is that savagery found? What if the call, as they say, is coming from inside the house? What if the violence is part and parcel of the classical itself—the colonial violence that so often adopts the classical as an aspirational aesthetic vocabulary? The "wild" might be seen as classicism's opposite. Yet these things are intertwined: the wild incessantly conjures classicism, and conversely, it often seems that classicism harbors its own wildness—even brutality—within itself.

If we did not delve more deeply into the song's lyrics, we might assume the (European) filmmaker, setting his imagery in urban turmoil in a European setting, has made an incongruous choice in using classical statuary, slanting his vision toward his own familiar context. And certainly, the video does not illustrate the song. But it draws on themes present in it, without directly representing the loosely evoked "thug" narrative of sex, drugs, and violence. The song's lyrics are, in fact, peppered with philosophical ideas, evoking Greek philosophy and Greek and Roman architecture.[39]

The song's hook, hauntingly intoned by Frank Ocean (and later repeated two more times), sets up a hierarchy of increasing power, from the fragile individual to the gods—implicitly gods of classical antiquity. The first lines of the track, which must, I think, have inspired the focus of the Gavras video, allude to a mob:

> Human beings in a mob
> What's a mob to a king?
> What's a king to a god?

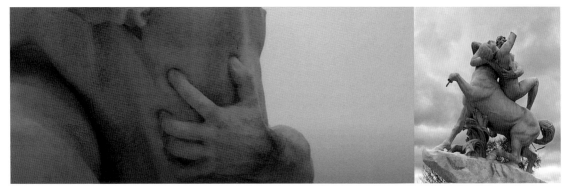

FIGURE 2.3
Left: Romain Gavras, dir., *No Church in the Wild* music video, 2012. Shot
of *Le Centaure Nessus enlevant Déjanire*, Jardin des Tuileries, sculpture by
Laurent Marqueste, 1892, still. Right: photograph by Natalia Wang.

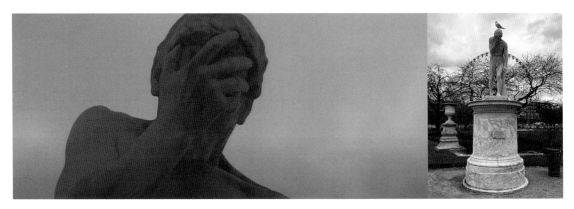

FIGURE 2.4
Left: Romain Gavras, dir., *No Church in the Wild* music video, 2012.
Shot of *Cain*, Jardin des Tuileries, sculpture by Henri Vidal, 1896, still.
Right: photograph by Natalia Wang.

Each term is in a relation of subordination, or power differential, to the next.
The mob is greater than the human being; the king more powerful than the mob;
the god more powerful than a king. But then Ocean flips this hierarchy on its head:

> What's a god to a non-believer
> Who don't believe in anything?
> We make it out alive
> All right all right
> No church in the wild

On the one hand, a nonbeliever may make himself godlike by simply disregard-
ing the power of the gods; on the other, all life is reduced to mere survival.

One of the more obvious classical references in the song appears in the first verse, in which, over a relentless beat, Jay-Z hammers together allusions to classical architecture (mausoleum, Coliseum) with American mythmaking:

> Tears on the mausoleum floor
> Blood stains the Coliseum doors
> Lies on the lips of the priest
> Thanksgiving disguised as a feast.[40]

Since "priest" could be ancient or modern, "lies on the lips of the priest" (delivered as two rolling l's followed by two spitting p's) does something in this verse like what classicism does, more generally. It stitches together the distant past of "mausoleum" and "Coliseum" with the more local, recent, and specific "feast" of Thanksgiving, eliding the memory of conquest, slavery, subordination, massacre. While the nineteenth-century French monuments might be taken to represent accomplishments of civilization, to couple the violence of their imagery with the words of the song implies they in fact represent brutality.

Jay-Z then introduces a "thug" narrator, "hidin' from police," who seems to have been wounded and is wondering "if a thug's prayers reach"—is there a church in this (urban) wild? The question of who has access to divine aid prompts another question:

> Is Pious pious 'cause God loves pious?
> Socrates asks "whose bias do y'all seek?"[41]

These lines (as comments on Rap Genius, Genius.com, were the first to point out) seem to refer to Plato's dialogue *Euthyphro*, in which Socrates reflects on whether the gods love what is pious because it is pious or whether it is only considered pious because it's what the gods love.[42] Socrates inquires into the nature of piety: that is, in this context, not religiosity but *good behavior that is pleasing to the gods and to humankind*. He decenters the authority of the gods, talking about how they, too, hate and love arbitrarily, and describing how they disagree among themselves—such that the very same actions can be both loved and hated by them. One of the first lessons of ancient Greek literature, indeed, is that the gods are arbitrary and callous in their application of their power. The question is this: Is there an abstract moral code that applies regardless of the gods' particular taste, and to which the gods are bound? Or is it simply that the gods arbitrarily decide what is considered "pious," and human beings are left to observe this form of piety or face the consequences?

It's in this situation of indecision (or undecidability) that the rest of the song plays out. While there may be gods, they are not offering salvation or eternal life.

The trappings of religion present in the song—and there are many—allude to the idea of "church," but the *Euthyphro* dialogue suggests that what's really at stake is a question about whether there are abstract ethical norms that can be said to apply regardless of relationships of power.[43] The suspicion that these norms—"church"—are simply absent is part of what sketches the portrait of a "wild," what we might also call a "state of nature," in which violence and desire are checked only by power, not by right.

While the music and the videos return us to the moment of Occupy Wall Street and other uprisings that seemed to herald new openings for political change, to write now about this album raises the question of how to situate the role of Kanye West, now known as Ye, who has become infamous for spouting antisemitism, fraternizing with White nationalists, and even endorsing genocide. It is hard to square Ye's current hard Right public persona with lines like "lies on the lips of the priest / Thanksgiving disguised as a feast"—and, indeed, with the judgment levied on the foundations of piety itself. These words are in Jay-Z's verses, not Kanye's. While we cannot equate the song with Ye's own point of view, its nihilism—the idea that a man might make himself a god by rejecting all human or divine authority over him—is consonant with his later behavior. The behavior plays out along well-worn grooves in American ideologies that have always encoded White supremacy in the ways I have been exploring, but which have reemerged with new force in recent years. And I could say that Ye didn't absorb the lessons of the critique contained in his own words—but the critique itself seems designed from the start to allow for ambiguity, to be taken in more than one way.

1862 TURNED UPSIDE DOWN

For a number of months fans believed that "the" video for "No Church in the Wild" was the one released in early September of 2011, less than a month after the release of the album and shortly before Occupy Wall Street began.[44] Created by High5Collective, an independent, multiracial group of videomakers who were in art school at the time, the unauthorized video was the one that Everett Brown, a student in a class I taught to high school students at Harlan Community Academy High School in 2011, suggested I look at as I searched for material for class discussion. Having found it a challenge to teach the standard boring syllabus of canonical art history to teens, I asked my students for help: could they bring in examples of music videos that were visually interesting or especially meaningful to them, where the images added something significant to the experience of the song? Everett's suggestion was, at the time, the only video anyone had seen for the song, and it set us off on an exploration of Plato, literary language, visual

analysis, and racial politics. By the fall of 2012, when the official video had been released, my new group of students had all seen the Gavras one. I had to call Everett back in to the classroom one day to vouch for my claim that there had ever even been another video.[45]

The European setting of the Romain Gavras video can seem a bit incongruous, given how resolutely American are the scenes suggested by the lyrics. The setting of the unauthorized video diverges from the lyrics in a different way: it unfolds in the American South in 1862—or rather, in a role-reversed fantasy of that place and time.[46] High5Collective explicitly makes race in the United States their subject. In the video, the opening title sets the historical stage with a literally upside-down date, 1862: think of the dramatic overturning of hierarchy that appears in the song's hook. Jordan Riggs, who conceived and directed the video, told me he wanted to "imagine a world where the tables had turned" and wondered "if the oppressor saw themselves as the oppressed, would it change their outlook on the present situation and their hand in it."[47] An American flag appears as part of a sequence of portentous images in the first seconds. Later it appears progressively more tattered as it is devoured by flames, echoed in the blazing torches in the scenes of pursuit that punctuate the narrative. Though it represents a fantasy of the past, the visual story also clearly orients itself toward concerns of the present. And it disorders time in more than one way: the precise chronological sequence of the story told in the video is difficult to determine with exactitude, because of the number of flash-backs and flash-forwards. Early on in the High5 video we see a close-up of the brooding protagonist illuminated by flames, a tear—or a scar?—visible on his face; we cut back to him again following a flashback in which he's whipping his victim. A woman, her bowed face veiled by her bonnet, stands witness as men whip their captive by daylight. After this—or before?—in a pursuit through dark woods, men with dogs and torches set upon the runaway slave, whose back is covered with the healed scars of previous lashings. There's no question, therefore, that the man pursued is a slave. For a brief moment, this human prey finds sanctuary in a church. First the dogs enter, then the men, who drag their victim, his body bloodied, from under a pew; we see them upside down, from his perspective (fig. 2.5). Later another shot inside the church, as the pursuers are leaving, appears upside down, for no apparent narrative reason (since their victim has already been dragged out), but a symbolic one: it notably overturns the cross that hangs on the wall. The chief pursuer joylessly whips the captive, then knocks a block from beneath his feet to hang him. The dog looks on.

If the storyline allows for some ambiguity, what's unequivocal is the inversion of the racial power relationships between enslaver and enslaved. The enslavers are Black, pursuing a victim to the death, and that victim is White. Reversing the races of villain and victim, does this piece present a fantasy of retribution?

FIGURE 2.5
High5Collective (Jordan Riggs, dir.), *No Church in the Wild* music video, 2011.
View of church interior, still.

That possibility is certainly present, but I do not think it is the main point. I think the High5Collective version asks questions more than it implies revenge. It might be possible to say that it asks Black viewers to reflect on what they would do in an analogous position of power. But most directly, it asks a question of White viewers: how does it *feel* when the positions are reversed? Do you identify more directly with the slave being pursued, dragged out of the church where he has sought sanctuary, then whipped and hanged? The overturning of Black and White positions suggests that without ideology sustaining racial hierarchy, without social conventions to which individuals are attached, that hierarchy can be arbitrarily flipped based on who happens to hold power. If even the space of the church is not respected, indeed, no rules apply: no church in the wild.

It is striking that both videos stage an encounter between a man and a dog at exactly the same moment in the song; it seems as if Gavras was, perhaps, making a nod to this moment in the High5 video. Just before the bridge we hear a sampled James Brown wail, vibrating: "weeeleee." In Gavras's version, at 2:36, a German shepherd snaps its jaws in the air, and a downed Black combatant wearing a kaffiyeh looks up at the dog (fig. 2.6). His eyes tick up a bit higher to the dog's human master. At this moment, the guitar riff has quieted to a heartbeat for The-Dream's piercing Auto-tuned falsetto: "your love . . . is my scripture." The video cuts dramatically to a shot of a marble winged Victory hovering atop François Rude's *Departure of the Volunteers of 1792* on the Arc de Triomphe, a

group colloquially known as La Marseillaise, the name of the French national anthem (fig. 2.7).

In the High5 version, at the same moment in the song, the escaped captive is being pursued by a dog. We've already seen the dog released by its master. We know—or we should—how bloodhounds were used in the antebellum South, the long history of dogs being unleashed on peaceful Civil Rights protesters.[48] As the beat builds again toward the end of the bridge, it synchronizes with the trotting dog's footsteps. As The-Dream sings "let me in to your encryption," human and dog come to a stop, confronting one another. The man freezes in fear. They look at each other. Dog looks; man looks back (fig. 2.8). The next verse is beginning. (With Kanye's line "Coke on her black skin made a stripe like a zebra"—followed later by "a girl in all leopard"—he associates women in particular with animality.) Dog turns and walks away. In that moment, the sense of subjectivity, of interior life, travels back and forth between them; the dog turns away, and the dog will make a decision; what will the dog decide? A quick sequence of shots reminds us of the daylight whipping and the woman in the bonnet. The sequence in the church follows: the White man hides and is dragged out, in a fragmented series of shots that are out of temporal sequence; in one of them, we see the space of the church, and the crucifix, emphatically upside down, just like the date, just like the overturning at the beginning of the song. At the end, words dissolve into

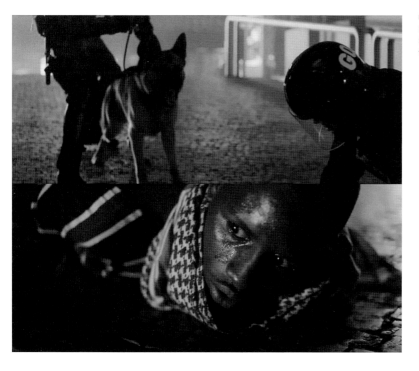

FIGURE 2.6
Romain Gavras, dir., *No Church in the Wild* music video, 2012. Facing the dog, still.

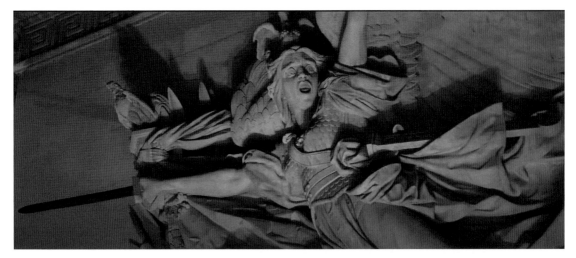

Romain Gavras, dir., *No Church in the Wild* music video, 2012. Shot of
La Marseillaise (The Departure of the Volunteers of 1792), sculptural group
by François Rude on the Arc de Triomphe,1833–36, still.

shrieks, growls, gurgles, and echoes, and an oddly jocular tune starts up: interlude music that appears several times on the album, sampled from "Tristessa"
by the Italian jazz-rock band Orchestra Njervudarov. The dog placidly watches
the man hanging.

We can guess that, following that momentary encounter, the dog returned
to its master to indicate what it had found. But with the fractured temporality
of the video we never actually learn whether this encounter is decisive in determining the man's fate, because there is simply no way to know when in the
sequence of events it falls. I venture that the ambiguity opened in this version
offers a possibility of sympathy between man and animal. As the song suggests
that desire might form the basis of a "new religion," perhaps, in the video, the
dog is a figure of animal appetite that could potentially serve as a point of commonality among living beings.

In her book *Afro-Dog: Blackness and the Animal Question*, Bénédicte Boisseron
addresses multiple relations between Blackness and the figure of the dog—an
inappropriate analogy by animal rights activists ("animals are the new slaves"),
a dehumanizing slur that associates Black people with animality, and the history of the "master's dog" as violent threat, obviously at stake in these moments.
But she also proposes the notion of "commensalism" to describe another form
of relationship between human and dog. "Commensalism," she explains, "does
not require a return for a given since it invites participants to share a table (*cum/*
with, *mensa*/table) independently of whether a participant has something to
bring to the table or not."[49] Enslaved people also had dogs as companions, and

FIGURE 2.8
High5Collective
(Jordan Riggs, dir.),
*No Church in the
Wild* music video,
2011. Facing the dog,
still.

enslavers resented their ability to help captive people hunt for food—as in the case of Thomas Jefferson and George Washington, who both ordered their captives' dogs slaughtered to protect their sheep and hogs.[50] In the High5Collective version of the scene, we do not know what passes between man and dog. The moment remains open to the viewer's interpretation. For his part, Gavras eliminates the possibility of sympathy: the dog for him is not a potential costruggler

but clearly the instrument of another's violent will. The camera cuts away from the confrontation while it is still in course, in order to gloss it with the statue, in essence manipulating the viewer's understanding of the events. Sickly pink light from below renders the white marble Victory horrible, expressing the violence inherent in sustaining the European hierarchy of values, in "civilization" attempting to impose order, the poorly controlled wildness within the classical itself.

THE PANORAMA TURNED SIDEWAYS

The sense of possibility in the exchange of glances between human and animal is complicated by a similar exchange at the heart of the video: one between the central female figure and the viewer, or the presumed viewer. Rhyming with Thoreau, "No Church in the Wild" proposes a "new religion": "I live by you, desire . . . Your love is my scripture." As with Thoreau, it is something that "the pastor don't preach . . . a teacher can't teach." The Black woman's place in the narrative of High5Collective's video is revelatory, even as the ironic imagery adds texture to just how fragile the song's "new religion" of free love is. "We formed a new religion / No sins as long as there's permission / And deception is the only felony / so never fuck nobody without telling me." In the video, this moment is the one in which we see the woman's eyes (fig. 2.9). Submissive and downcast, demurely dressed in the scenes of punishment, she glances up and then, pained, looks away again at "deception is the only felony." The video cuts to an extreme close-up of her face, in a different, intimate setting, as her eyes take three beats to open—blinking open just slightly, parting further, then finally opening fully and seeming to acknowledge the camera—and then glance off again.

FIGURE 2.9
High5Collective (Jordan Riggs, dir.), *No Church in the Wild*, music video. 2011. Woman's eyes, still.

These glances, this exchange of looks, between this barely present woman and whoever the viewer may be, is the video's only such moment of direct address to the viewer, but it might serve as a counterpoint to the exchange of looks between dog and slave. That one, with its question—*are you going to kill me?*—resonates with this one in its intimacy and danger. Regardless of your position in the matrix of race and gender, you as viewer may be drawn into this interchange, and hence into the plot. Who will be betrayed?

If Thoreau's wild cannot help but confuse the expansionist drive westward to extend settler land occupation with the need for cultural fodder—the raw stuff to nourish civilization—"No Church" reveals the wild as the brutality lurking within civilization itself. An awareness of this violence advanced by those who purport to be civilized threads its way, too—however imperfectly—through twentieth-century culture. I turn now to how Euro-American artists in the twentieth century struggled with anxieties about modernity, technology, and civilization. When they faced the question of how to go on in the wake of the horror of World War II and the Holocaust, abstract painting could have seemed a balm.[51] But what was the wild, in relation to abstraction? Here, too, we will find, if we look closely, that questions of wildness, and what it takes to give order to it, turn around race and gender.

The abstract expressionists were frequently characterized as wild, particularly Jackson Pollock, with his physical, gestural drip paintings. The fauves of the very early twentieth century had also been "wild"—wild animals, to be precise. In contrast to the freedom of these strokes and drips, the painting Barnett Newman titled *The Wild*, a stripe (or "zip") of red, eight feet tall and only one and one-half inches wide, looks formally quite constrained (plate 6).[52] Its freedom might, however, be understood in the dramatic break it makes with the expectations of the medium of painting, the liberation of a single stroke from the need to take part in a standard canvas at all. Newman gave it its title in 1962, twelve years after painting it. It was a significant date, the centenary of Thoreau's death. Although we do not know if Newman read "Walking" before painting *The Wild*, or before giving it its title, or at all, he surely knew some of Thoreau's works. In the essay "*The Wild* and Company," Yve-Alain Bois suggests that the painter might have been thinking of the Concord philosopher's idea of the wild when he gave it this title: a two-volume reprint of Thoreau's diaries was published that year, and Newman owned it.[53] The members of Students for a Democratic Society, writing their Port Huron statement in that same year, drew on Thoreau's vision of civil disobedience. It was also the year that Eliot Porter helped raise environmental awareness with his *In Wildness is the Preservation of the World*. As we have seen, the title was a quote from Thoreau's "Walking"; the book constituted an extended dialogue between Porter's photographs and quotations from Thoreau, critiques aimed at the ills of modernity.[54] It seems plausible, then, that when Newman

retitled the painting, he was thinking of Thoreau. What does the painter bring to the notion of the wild?

Newman was a central figure in American painting from the 1950s onward, affiliated with the abstract expressionists and, within that group, with color field painters like Robert Motherwell, Mark Rothko, and Clyfford Still. Newman's work in the 1940s and '50s was also informed by his interest in art of the ancient Americas and Northwest Coast Indigenous artists, whose work he studied at the American Museum of Natural History (AMNH).[55] In 1944, collaborating with Betty Parsons—a gallerist working at what was at the time the Wakefield Gallery—he curated an exhibition, *Pre-Columbian Stone Sculpture*, based on loans from the museum's collection of objects from Mexico and Central America. In his curatorial statement, he disavows the derogatory connotations of the label "primitive" (while continuing to use the word). Praising the "sense of dignity" and "high purpose" of these works, he argues that they "[make] clearer to us why our modern sculptors were compelled to discard the mock heroic, the voluptuous, the superficial realism that inhibited the medium for so many European centuries."[56] A proposal to the AMNH to put on an exhibition of modern art that would have revealed the affinities Newman intuited did not bear fruit. But Newman and Parsons again worked with the museum in 1946, for the exhibition with which Parsons opened a new gallery, under her own name. This show was called *Northwest Coast Indian Painting*, but considerable anxiety attended its status as a "painting" exhibition. Having curated a sculpture exhibition, Newman wished to have one that focused on painting, but the collections available to him were a source of frustration. In a letter, Newman complained to the head of the anthropology department, Harry Shapiro, that the AMNH had not approved the loan of one of its two precious painted house fronts, rendering the exhibition material "fragmentary." He wrote,

> I am sending you a proof copy of the catalogue foreword so that you will see how important a good showing of pure painting is to the point we are making in the hope that you will reconsider your refusal to lend us one of the wall paintings. The material we now have will, I am afraid, by its mixed nature in the sense that the painting is applied to garments, blankets, etc. confuse the public's reaction towards this work since there is a lack of understanding toward the integration that existed between art and articles of use among primitive peoples.[57]

Newman clearly thought that painted functional objects diluted his argument; to make the connection to Euro-American abstract painting, he required "pure painting," as he put it. In the end he also included sculpture but made a point of stating in the brochure that "the sculpture in this exhibition has been included

to show the influence exerted on this art form by the concepts evolved within the painting tradition," giving clear primacy to painting. Only a relatively small number of the objects in the checklist are actually painted at all, and it would indeed be hard to imagine that the show's audience would see them as primarily examples of painting. They include masks, boxes, drumheads, a suit of leather armor, and the house front the museum finally agreed to lend. Others were blankets, displaying woven designs or, in one case, "hide ornamented with puffin bills and deer hoofs."[58] The brochure's cover image is actually a woven blanket whose extensive fringes had been carefully cropped away in the photograph so as to present the appearance of a painted shaped canvas.[59]

The following year at the Betty Parsons Gallery, Newman curated an exhibition entitled *The Ideographic Picture*, of modernist art this time, but once again nourished by his study of Northwest Coast art. In a brief essay for the exhibition announcement, he constructed parallels between the ideas he saw in Indigenous art and those present in abstract expressionism, the "modern counterpart of the primitive art impulse."[60] He wrote of "the Kwakiutl [Kwakwaka'wakw] artist" that "to him a shape was a living thing, a vehicle for an abstract thought-complex, a carrier of the awesome feelings he felt before the terror of the unknowable."[61] Shape was "real" rather than "a formal 'abstraction' of a visual fact, with its overtone of an already-known nature." This is to say that abstract art, in this view, should not be understood as a subtractive process based on already experienced reality or "nature." The titles of many of the works in the show allude to mysticism—fury, sacrifice, alchemy, and Ad Reinhardt's "Dark Symbol" and "Cosmic Sign." These ideas of the awesome, the terrible, and the unknowable—projected onto Indigenous makers—hint at something like wildness itself.

Perhaps the emphasis on verticality that drives the zip paintings in general and *The Wild* in particular derived from Kwakwaka'wakw carved cedar poles ("totem poles") that Newman had seen at the AMNH. At the 1950 exhibition at the Betty Parsons Gallery at which he first showed *The Wild*, Newman described the painting as "full of restrained passion."[62] The zip, passionate yet restrained, constructs a "wild" that can only be understood as internal, a matter of subjective feeling. The stripe of raw red color that constitutes it might allude to wildness, might open onto an oceanic feeling—what a psychoanalyst would explain as presemiotic affect or id. The painting displayed opposite it at Betty Parsons was *Vir Heroicus Sublimis*, a vast painting, nearly eight feet tall by eighteen feet wide, its expanse broken up by vertical zips that structure it like a huge triptych— a Renaissance altarpiece (plate 7). The shape of *The Wild* might suggest a crack to peer through between the slats in a fence: the gallery wall as the fence of civilization. But its shape is a little too orderly to be a crack or a break or even a gesture. It is sometimes seen as a liberated zip, freed from the canvas—yet it is *still* on canvas. The architecture that sustains it also constrains it. It requires

tall gallery walls to be displayed and hardware to fix it there. It is meaningless, indeed, without a wall.

As with many of Newman's titles, *Vir Heroicus Sublimis* gives off a kind of ambivalent classicism: its Latin can be translated in different ways, but I would suggest "the heroic man is sublime," transcendent—a statement about the heroic masculinity of abstraction itself. *Vir* means man in Latin, and it is specifically man as virile, not man as human in a more universal sense, which would be *Homo*. Newman's investment in patriarchy did not go unnoticed by his contemporaries.[63] Around the same time, he gave the title *Eve* to a rectangular canvas of uninterrupted red (except for a thin brown stripe at the rightmost edge), and *Adam* to an earthy brown painting with vertical stripes of red (two sturdy ones, and a thin, wispy one). The morphological gendering of *The Wild* is ambiguous, perhaps intentionally so. Is it a tall, solid, standing object, or a slit to be parted, entered, peered through, breaking down any clarity of vision into something primal?

Whether it is inherent in the works themselves or not, the way they were repeatedly photographed—by different photographers—insistently stages a gender divide, almost as if the very function of the paintings is to produce a grid of gender. Again and again, photographers placed a White man and a White woman in front of them with the painting's vertical strip splitting them by gender, like Adam and Eve on either side of the Tree of Knowledge in a German Renaissance engraving (fig. 2.10).

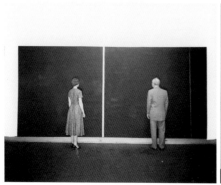 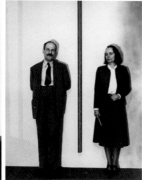 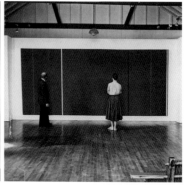

FIGURE 2.10
Peter A. Juley & Son, Barnett Newman and unidentified woman standing in front of *Cathedra* in his Front Street studio, New York, 1958. © Peter A. Juley & Son Collection, Smithsonian American Art Museum and The Barnett Newman Foundation; Hans Namuth, *Untitled* (Barnett Newman and Betty Parsons with *The Wild*), 1951. © 1991 Hans Namuth Estate, Courtesy Center for Creative Photography, University of Arizona, and the Barnett Newman Foundation; Matthias Tarnay, Viewers in front of *Vir Heroicus Sublimis* at Bennington College, Vermont, 1958. Barnett Newman Foundation Photo Archive. Artwork © 2023 The Barnett Newman Foundation / Artists Rights Society (ARS), New York.

Newman's account of Kwakwaka'wakw artists, too, creates invidious gender divides. The Kwakwaka'wakw painter dealing in profound realities "left . . . the pleasant play of non-objective pattern" (what Newman elsewhere calls the "meaningless materialism of design") to "the women basket weavers."[64] Newman thus aligns the superficial understanding of abstraction as mere decorative pattern squarely with the feminine, insisting on reserving access to the "real" to heroic masculine subjects. In this, he reiterates statements from the *Northwest Coast* brochure:

> It is our hope that these great works of art, whether on house walls, ceremonial shaman frocks and aprons, or as ceremonial blankets, will be enjoyed for their own sake, but it is not inappropriate to emphasize that it would be a mistake to consider these paintings as mere decorative devices; that they constitute a kind of heightened design. Design was a separate function carried on by the women and took the form of geometric, non-objective pattern.[65]

By contrast to this feminine function, "these paintings," Newman writes, constructing a distinction between the objects produced by "the women" and those produced by men, "are ritualistic." He goes on: "They are an expression of the mythological beliefs of these peoples and take place on ceremonial objects only because these peoples did not practice a formal art of easel painting on canvas."[66] The repetition and emphasis on this point seem strained, anxious. If the grid of gender difference is so clearly defined, would not such strict alignments risk compromising the depth of feeling in the wild, quieting its mystical fury, making desire and difference very orderly indeed?

THE WOMAN AND THE ANIMAL

Disentangled from the requirement of reproducing Whiteness, what remains of gender, sexuality, civilization, religion? The objects I've discussed in this chapter—the song and its videos, "Walking," and *The Wild*—deal with, traffic in, and in some cases critique the idea of the wild as a central site of American mythmaking, a place where the violence of civilization belies the purported protection afforded to (White) womanhood within it. It is striking that the only signs of female gender in Gavras's video are statues tinged with monstrosity— they fall victim to a hybrid animal-human creature (Deianira) or themselves appear monstrous (the figure of Victory, lit from below). The Minotaur that battles Theseus, subject of another statue seen briefly, is also a hybrid—itself gendered masculine but the monstrous offspring of a human woman and a bull. It is a world without women, except for these representational limit cases. In

contrast to the Gavras video, the High5Collective one foregrounds gender as pivotal to the maintenance of racial hierarchy, even if that hierarchy plays out primarily as a relationship between men. It is easy for it to do this, because the conventional narrative of sexual betrayal is so ingrained: the mere presence of the (submissive) female figure at the scene of punishment makes the nature of the enslaved White man's crime crystal clear—a sexual crime, adultery.

As theorists from Sojourner Truth to Hortense Spillers, Sylvia Wynter, and Saidiya Hartman have shown, racial categories are gendered categories. Gender is at stake in the production and reproduction of race, as sexual reproduction secures its "natural" status. As we saw with Charles Willson Peale's fascination with the mastodon and its implications for the new nation, settler colonialism stabilized race as a heritable quality, and thus one that makes use of gender difference as its very foundation. Earlier theories by which phenotypic difference was the product of differing climates did not withstand the evidence of colonial generations—bolstered, as we have seen, by claims about gigantic creatures that might still be alive in the beckoning West. Hereditary race conferred a particular role on White womanhood in securing racial integrity, or as White supremacist ideology would have it, racial purity.

In her 2020 book *Becoming Human: Matter and Meaning in an Antiblack World*, Zakkiyah Iman Jackson argues for an attentiveness to Black people's "conceptions of being that defy the disparagement of the nonhuman and the 'animal.'"[67] Central to her argument is the idea that "black female flesh persistently functions as the limit case of 'the human' and is its matrix-figure."[68] Taking this position as a starting point, it is possible to see the figure of the Black woman—despite or perhaps because of her merely peripheral presence in the visual storyline—as a fulcrum for what remains unsettling about the High5Collective video. Although the races of the two men are reversed, the core truth of sexual crimes enacted by White men on Black women adds dimension to the simple reversal in the video's imagined story. Though the White male character reads as "slave" here, a role reversal, his punishment appears to be for an act that actually preserves the racial and gender positions (though not the power dynamic) of the most routine sexual crimes of American slavery. As Hortense Spillers has pointed out, the rape of Black women by White men is fundamental to the economics of enslavement in America and the invention of hereditary slavery: "*partus sequitur ventrem*: the condition of the slave mother is [quoting William Goodell's *Slave Code*] 'forever entailed on all her remotest posterity.'"[69]

The words "no church in the wild" form, in a sense, an oxymoron, as "church" and "wild" are defined as one another's outside. "Church" in the title serves as a metaphor for the (putatively) beneficial and constraining effects of religion as civilized morality itself. Wild is whatever that isn't. (Extending this usage, perhaps in an echo of the song title, a weekly open-mic hip-hop event in Chicago

active from 2016 to 2018 styled itself "Church on the 9," with "The 9" referring to 79th Street, a frequent location of street wars. In this case church meant the regularity and collectivity invested in a space for political, cultural, and personal expression. It was a joyous event.)

The title doesn't just pose an obvious antinomy; the real force of the phrase (in which "there is" has to be understood) is to consider *what wild this is* that has no church. It tells us, in fact, that *we are in the wild*. Taken together, the videos bring out the violence that was always at the heart of "civilization" as constructed in the Europhilic colonial setting, which is laid bare in continuing appeals to classical tradition coupled with the brutal exercise of dominance by the strong over the weak. Let us say that the purported foundation of order—European civilizational "superiority"—is revealed to serve and to have always served as an efficient means of authorizing untrammeled violence. And if that wasn't always all there was to it, if its part in violence should be cleansed from it, then what is actually left?

3
ISLANDS

Looking for Indian Things

NOTHING THERE

The summer before I began studying medieval art history at the University of Chicago, a German history student asked me what it could even mean to study the "Middle Ages" in the United States. We were sharing a meal in a hostel on the Ile Saint Louis, in Paris. More specifically, she asked, "How can you study the Middle Ages in America? There was nothing there." Her question betrayed nationalist assumptions about why one does history—that of course you would study your *own* country's history—and a strange notion of "nothing." For there were of course Indigenous people and Indigenous culture in the land that would be renamed America during the time that corresponded to the Middle Ages in Europe. For a long time, I recalled this exchange as a sign of *her* narrow perspective (and, indeed, racism). It didn't occur to me to wonder why it seemed so self-evident to me that I should study the European Middle Ages. Why did it not occur to me that it might be an anomaly? Why should Europe be taken for granted—how does a person who grows up in the United States come to be a European medievalist? How was it that the very notion of culture at all, in the Americas, came to be equated to Europe?

There are some reasons that seem personal: the fairy tales and fantasy novels I read as a child, the stories my mother brought home from her classes on medieval literature and art history, tales of distant kings and queens, how Beowulf fought the monster and its mother, how Jan van Eyck painted himself into his jewellike panels, how unnamed Byzantine artists pieced glorious images together from small stones. Sometime around the time I started graduate school, planning on a PhD in medieval art history, my mom told me she had wanted to do that too. She wanted to do many things, but this is the one I remember best.

Once in my graduate student years I was lucky enough to be at dinner with a visiting speaker and some professors, and talk turned to how we became art historians. One colleague declared that everyone he knew who had become an art historian had been trained through some unusual practice of visual discernment as a child. I didn't mention that we had art all over our house because we had artists in the family. My great-grandparents were semifamous modern artists, but that was something I never wanted to be the first person in a conversation to bring up. The story I told that night was about how when I was a child in Maine, we had a family tradition of going to a rocky area near an island beach and "looking for Indian things." We didn't say "arrowheads" because we had learned that the points we found were not affixed to arrows, but used on spears. Others were scrapers, or axes. The Abenaki name for the island is "Erascohegan": "good spearfishing." This is the way I remember training my eyes: to notice the characteristic edges and faces of stones worked in particular ways, to distinguish them from other stones. I was told by my parents that, if anyone asked what I was doing, I should just say I was looking for pretty stones. There was no shortage of pretty stones and no shortage of people on the beach who just looked for them. But we looked for Indian things.

In the years that corresponded to the European Middle Ages, Kennebec River people came every summer to the coast of Maine to harvest the fish that were abundant in those days. They chipped and polished stones into beautiful and functional shapes to fish with. There could have been enough fish for everyone. But the English who eventually came there wanted something more than fish; they wanted to own the land itself. English people started trying to set up shop in the region in 1607, when a group attempted to found a colony, the "Popham Colony," in what is now Phippsburg, next to the city of Bath. The colony famously failed. It shut down in 1608; the survivors went back to England. But others kept coming.

One who came was John Parker, who in 1649 made out a "contract" with the Kennebec chief Mowhatawormit for the island of Erascohegan. Mowhatawormit got a hogshead of rum and some pumpkins; John Parker got the island. In the contract, the chief is called Robert Wood. Perhaps it was because of actions Mowhatawormit undertook after he grasped what the English people believed had occurred in that transaction that his name changed a second time. The name Robert Wood, given to him by the colonists, mutated into "Robin Hood." For nearly eighty years thereafter, English settlements in the vicinity were raided and burned on a regular basis. The documents in the official archives don't record what the English did to the Indians. *There was nothing there*. The principle of "domicilium vacuum," a Latin phrase that meant "vacant habitation," said that the colonists could take, and take.

In 1741, a few years after the last devastating raid, the English claimed a sym-

bolic victory by changing the name of Erascohegan. They called it "Georgetown," for a distant king. Even in 1790, when Benjamin Riggs built his Georgian-Federal style house (Georgian, for that king, and Federal, for the new government that replaced him), a house with thin walls and many windows was a conscious claim about the new security colonists felt they possessed. It had only been a few decades since colonists had succeeded in implanting themselves permanently, and Riggs's first house there was a thick-walled log cabin. The 1790 house is now the oldest house standing on the island. Riggs gave his name to the village on the island, Riggsville, where he set up his shipping business and opened a general store.

In 1790 the first US Census lists 96,540 residents of Maine, of whom 538 were "other free persons." This designation referred to free African Americans; Indians were not counted. In the same year the Pennsylvania Abolition Society petitioned the new United States Congress to end slavery everywhere in the new country. Congress declined to do that, but it did extend its powers over the buying and selling of Indian land, drawing up and passing the "Nonintercourse Act," which would make the transfer of land from Indian tribes to the State of Massachusetts (to which Maine then belonged) unconstitutional. Around this time in Portland, Maine, the new United Statesians renamed their "Queen Street": it came to be known, instead, as "Congress Street." Georgetown, named for a distant king, kept its name. Other islands—like two small islands off nearby Arrowsic, for example—received names that dehumanized Black people. Those names were made illegal in 1977 thanks to a bill sponsored by Maine's first Black state representative, Gerald E. Talbot. But even in 2020, a few of them were still found listed in the registry of Maine islands.

Names don't tell every story. Near where the Popham Colony could not take hold, a few miles from where I grew up, is another small island. This one is known as Malaga: "cedar" in Abenaki. In the late nineteenth century, the island was home to a small group of mixed-race residents. "Other free persons." Free—so they thought. In the early twentieth century, the United States of America was in the throes of eugenicism and Jim Crow. In 1912, at the height of the wave of Confederate statue installation that swept the South, the State of Maine labeled the Malagans "degenerate" and "feeble-minded." The state kidnapped some and placed them in institutions; it evicted and scattered the others. It replayed what federal and state governments had been doing to Native Americans for decades.

A few years later, the village of Riggsville, on Georgetown Island, was renamed the more mellifluous "Robinhood," perhaps with the thought of enticing tourists.[1] The settlers gave it back to the Indian chief, not really to him, but to the name he had been given by the English. In 1923, eleven years after Malaga Island was cleared and seven years after the Indian chief's made-up name gave the place a faint air of medieval England, my great-grandparents bought the

Federal style James Riggs house, now known as the Riggs-Zorach House. I grew up visiting this house, curling up with books in its odd corners and alcoves, soaking up its musty smells and treasures. In the winter, Marguerite and William Zorach were cosmopolitan residents of the West Village in Manhattan. "I went to the Museum of Natural History," William wrote, "and studied the carvings of the Eskimos, the Aztecs, and the Mayans."[2] In the summer they went back to the land. They lived without telephones or electricity, kept a garden, picked berries, made art.

They had met as art students in Paris, learning how to paint like wild animals. In Paris, the century was new, and gender didn't seem so much like a constraint on a woman artist. Once they had children, things changed. Marguerite, so it turned out, required an art form that was compatible with babies and toddlers. William, so it turned out, didn't. So Marguerite embroidered tapestries. William worked outside or in his studio, with mallets and chisels. He chipped and polished stones into beautiful shapes.

In New York in the winter, in Stieglitz's gallery, or the Museum of Natural History, they looked at African art. You can see it especially if you put William's representations of children, like *Figure of a Child* (fig. 3.1) and *First Steps* (fig. 3.2) next to late nineteenth-century African sculptures—by Fang and Lagoons (Côte d'Ivoire) artists—that were photographed by Charles Sheeler, who also photographed Zorach's work.[3] Consciously or unconsciously, when he borrowed ideas from African objects, he associated them with childhood.

His adult figures are more classical, and so are his family groups, like *Pioneer Family* (fig. 3.3), a design originally created in 1935 for Texas Woman's University (formerly Texas State College for Women) as part of a competition honoring the "Pioneer Woman." 1936 was the centennial year of Texan independence from Mexico, and the competition sought to honor nineteenth-century pioneer women. In 1935, recall, battles between settlers and Native forces were as recent as the era of the 1960s today, and it's thus hard to think of the competition as anything but an expression of White settler triumphalism. Even more striking is that Zorach chose to represent an entire family and not a woman. The father and older son stand above the mother, who nurses, and reads to, a young child. The group is patriarchal. The Pioneer Woman is protected by her men, but she has the role of holding "civilization" in her hand.

Although William's design was selected by a jury, the figures' nudity displeased local artists and members of the public. He revised the group to add clothes, but the damage was done. Leo Friedlander got the commission. The verbal attacks on Zorach's figures crudely racialized them. Perhaps his Jewish background opened the door to the racial rhetoric, which sounds more anti-Black than anti-Semitic: "The newspapers said," wrote my great-grandfather, "that if a Texas pioneer had gone around in such a state of nudity he would have been

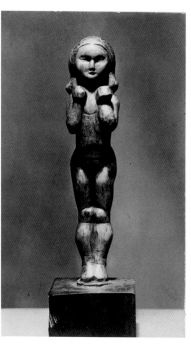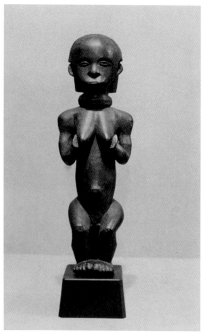

FIGURE 3.1

Left: Charles Sheeler, *Figure of a Child by William Zorach*, ca. 1925. Toned gelatin silver print, Smithsonian American Art Museum, Transfer from the Office of Museum Resources, Smithsonian American Art Museum, 1985.21.1. Right: Fang artist (Ntumu group, Equatorial Guinea or Gabon), figure from a reliquary ensemble, nineteenth or early twentieth century. Wood. Photograph in Charles Sheeler, plate 2 of *African Negro Sculpture*, ca. 1919. Gelatin silver print, 9³/₈ × 5³/₄ in. (23.8 × 14.6 cm). Smithsonian American Art Museum, Gift of Dahlov Ipcar and Tessim Zorach.

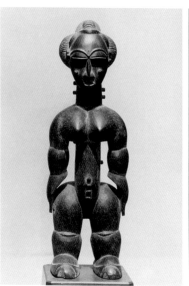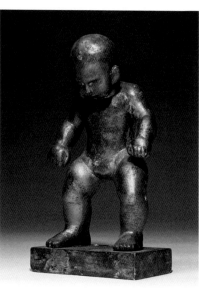

FIGURE 3.2

Left: *Master of the Rounded Volumes* (Kyaman or Akye), female figure (Nkpasopi). Côte d'Ivoire, Lagoons region, late nineteenth or early twentieth century. Wood and thread. Object in the collection of the Barnes Foundation. Photograph by Charles Sheeler, plate 6 of *African Negro Sculpture*, ca. 1919. Gelatin silver print, 9¹/₈ × 6³/₈ in. (23.2 × 16.1 cm). Smithsonian American Art Museum, Gift of Dahlov Ipcar and Tessim Zorach. Right, William Zorach, *Walking Baby* (also known as *First Steps*), 1918. Cast and patinated plaster. Smithsonian American Art Museum, Gift of Tessim Zorach and Dahlov Ipcar, 1968.154.117.

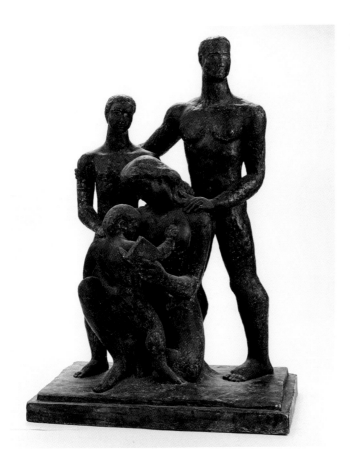

FIGURE 3.3
William Zorach, *Pioneer Family* (model for), 1927. Plaster, 23½ × 16¼ × 10¾ in. (59.7 × 41.2 × 27.3 cm). Smithsonian American Art Museum, Gift of Tessim Zorach and Dahlov Ipcar.

strung to the nearest tree." He added that "Gutzon Borglum was down there at the time and I was told that he said my figures looked like a bunch of apes."⁴ (Gutzon Borglum was the KKK-sympathizing sculptor who produced the Confederate monument at Stone Mountain and the presidential faces on Mount Rushmore.)

This wasn't the first time a Zorach sculpture had been controversial for its nudity. The Riggs-Zorach house has a vista opening onto Robinhood Cove, and for almost my entire life, as far back as I can remember, my great-grandfather's bronze, *Spirit of the Dance* (fig. 3.4) rested on a plinth on a rock ledge in front of the house. *Spirit of the Dance* is both modern and classical. It is graceful and rhythmic but solid. The first version of the statue was cast from aluminum, an eminently modern material, for Radio City Music Hall in Rockefeller Center. Its nudity was modern too. Originally unveiled in 1932, it caused a minor scandal. It may have pleased the Rockefeller family, but it upset S. L. "Roxy" Rothafels, who ran the venue. "Antiquities" could be nude, "primitives" could be nude, but this statue was neither antique nor primitive enough. Complaints poured in.

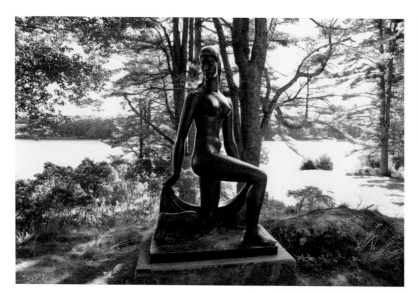

"One man wrote," said William, "that he couldn't stand the idea of some young squirt standing in front of that naked statue with his daughter and ruining her morals—one thing could lead to another until it was too late."[5] The power of idols. The statue was removed. A plaster model went on tour to general acclaim. Eventually, quietly, the aluminum statue returned.

In 1959 the Bath Garden Club commissioned a similar sculpture, the *Spirit of the Sea*, as a fountain for City Park, also known as Library Park, in the middle of this small shipbuilding city. The red scare almost prevented my great-grandfather from accepting the commission; he was accused of being a Communist. According to family lore, the head of Bath Iron Works, the major local shipyard, personally opposed the commission on political grounds. William wrote a letter to the local paper in which he disavowed communism and, indeed, politics altogether: "In fact I am not and have never been politically minded. I am art minded; art is my life."[6] This line, "art is my life," became the title of his autobiography. For all the times I've read his book, it only struck me recently that a claim about art as an island, free from politics, was the source of its title.

Perhaps it was reasonable for an executive at Bath Iron Works to feel the company had a stake in the selection of an artist to represent the spirit of the sea—a statue that would commemorate the local taste for sailing and shipbuilding. The first English ship built in the Americas was constructed a few miles away at the Popham Colony. The company was the region's major employer. Bath Iron Works built the US Navy's first steel ships, and today it continues to build battleships, frigates, cruisers, and destroyers for the navy. The shipyard's signature orange-and-white crane was installed in 1973 and at that time, it was the largest crane in

the western hemisphere. When I was a child, visiting the house in Georgetown, the crane signaled the beginning of our trek across the big bridge, the first of several bridges that took us to Georgetown: across the Kennebec River to Wool-wich, across the passage between the Kennebec and Sasanoa Rivers to Arrowsic, across the Back River to Georgetown. You look for the Smokey Bear, with its fire danger sign, and the rock reliably painted to look like a turtle. Then you turn left.

Bath Iron Works (BIW, as it is usually known) was founded by Thomas Hyde in 1884. Thomas Hyde had fought in the Civil War—on the Union side of course. When I made the decision to attend graduate school at the University of Chicago I did not realize that this Bath landmark had been founded by a member of the very first class of graduates of the University of Chicago. Technically—so the story goes—it was not the same university. Hyde graduated in 1861 from a university now known as the "Old University of Chicago." This meant that before the outbreak of the Civil War Hyde chose to attend a university founded, in 1856, on property given by Stephen Douglas, the senator from Illinois who argued against the abolition of slavery in the famous Lincoln-Douglas debates. The problem isn't just Douglas's expressed political positions. Douglas used his in-laws' cotton plantations as collateral to purchase the land he gave to the university. It was blood money, and his own management of the plantations was notably brutal.

When the university ran into financial troubles in the 1880s, its trustees for-mally renamed it the Old University of Chicago as a legal fiction to avoid creditors and clear the way for a "new" institution to be financed by John D. Rockefeller.[7] But the connections between the two institutions are manifold. Historians who researched Douglas's relationship to the university drew on the research of the erstwhile dean of the university's undergraduate college, the historian John Boyer. They described "continuities between the two campuses" that "can be found almost everywhere among its trustees, faculty members, student alumni, donor networks, intellectual culture, institutional memory, distinctive architec-ture, library books, and, of course, the University of Chicago's name itself."[8] And the relationship between the new university and the alumni of the old manifests itself concretely in the case of Thomas W. Hyde. In 1892—after the dissolution of the "old" university and the founding of the new—Hyde was listed as the very first graduate of "The University of Chicago." T. W. Goodspeed, secretary of the new university, wrote: "To the Alumni of the University of Chicago: It is made my duty, as it is also a pleasure, to communicate to you the following action of the Board of Trustees of the new University, which was taken on the 2nd of February, 1891. 'Res[olved], That in view of the relation of the New University of Chicago to the institution that formerly bore that name, we hereby confirm and re-enact the degrees of B.A. and B.S. conferred by the former University of Chicago, and we invite the graduates to consider themselves Alumni of this University, and

to co-operate with us in building it into greatness.'"[9] The neogothic architectural style used in the Bronzeville campus of the first university was reiterated in the new university in Hyde Park, with its famous medieval gargoyles on Cobb Gate. The fiction of separateness was cemented even as the continuity was assured.

THE FALL OF IDOLS

When idols fall in Michael Camille's *The Gothic Idol*—the rich and incisive book that was my dazzling first introduction to medieval art history—it is a sign of Christian triumph. Idolaters are "the other," often a dehumanized other, in these images: they are Jews and Muslims and pagans; later, in the colonial period, the "idol worshippers" would be Africans and Asians and Native Americans. Medieval images of idolaters mark otherness with the idea of the worship of statues; they need a crutch, so the thinking goes, because they cannot understand an invisible God. In 2017, violent and proud White supremacists marched in Charlottesville, Virginia, to protest the removal of a statue of the Confederate general Robert E. Lee. Some of them chanted "Blood and Soil" and "Deus vult" and some worshipped Odin and some bore emblems they imagined were medieval. As the events of Charlottesville and their aftermath unfolded, I was in Maine at the house my great-grandparents bought in 1923, thinking about statues coming down.

I began this book with reflections on the placement, preservation, and removal of statues in public places. When historical figures are presented in public, they never serve as a neutral recounting of history; they are being declared significant. Such choices organize public space, public memory, and public emotion. Much like discussions of what history can be taught in schools, they reflect and create expectations about community consensus. To maintain Confederate statues in public spaces is to send a message to the descendants of those who were enslaved that their towns, cities, and states remember fondly a time when they were still enslaved, remember proudly those who fought to preserve that state of affairs, remember heroics on the battlefield in the service of a glorious "lost cause." These monuments say this: if you are African American, this public space is not for you. It says: this place celebrates horrible crimes against your ancestors. It cheers your continued subjugation. The out-and-out, unabashed racists are clear about why they want these monuments preserved. But losing history is easy; we let history drift away all the time. It's the investments of the present that people, and I mean White people—and that includes liberals—are scared to lose: demons of the present and not (only) the past. When such statues are removed, history is not being lost. What's being lost (for Whites) is an imaginary consensus *around* history. What's being lost is the feeling of easy

ownership of the public sphere, the sense that you can debate this question or not within yourself, but regardless, you can go on undisturbed in the confidence that whatever you decide, or whatever it means to you, *is what it means*.

For those who observe them from afar, the fate of Confederate statues may seem straightforward, even if Southern cities and towns do not experience it this way. But what should we do with statues of men who have been foundational to national myths in an even deeper sense—Christopher Columbus, George Washington? Although the language of public monuments may seek to establish a sense of timeless truths, there is nothing necessary or obvious about the idea of commemorating particular historical individuals in public places with statues that represent them. In Europe, where this visual tradition originated, public monuments created visible reminders of who held power—kings, emperors, God and saints—and demanded public respect. Public monuments often served as a sign of conquest, a way of displaying spoils of war or expressing imperial power, which often—in premodern eras, at least—came with the presumption of divinity. Looking back further, past the statues of conquering, divinized Roman emperors, we find outdoor statues dividing up territory, in the form of "herms," statues of divinities that doubled as boundary markers. In Christian Europe, religious images on street corners helped enact a kind of surveillance, as Christians were expected to physically perform acts of veneration as they passed by. People who didn't show proper respect could be charged with heresy. The fact that signs of conquest could be enacted over a ruler's "own" territory becomes clear in such phenomena as the "statue campaign" of the French King Louis XIV in the 1680s, in which equestrian statues of the king—for many subjects a distant and resented ruler—were placed in twenty city squares all over the national territory.[10] And people also tore down many of *those* historic statues as part of social upheavals fueled by new demands for justice and civil rights.

Controversies over public art are not always as dramatic, but they often serve as proxies for conversations about civic identity and belonging. They reflect presumptions—consensus, real or imagined—about how public space should be organized, how it represents "the public," and who should have access to it. These debates are necessary. The specific statues are not. We should be talking about the things Columbus and Washington and other founding figures did, how they enslaved and brutalized people, facts for which there is ample historical evidence. Where the statues are concerned, we need to have a vigorous debate in which preservation is not the default outcome. The very assumptions on which the artistic and political conventions of civic monuments are based should, in fact, be called into question.

In speeches in 2020, on July 3 at Tȟuŋkášila Šákpe, Six Grandfathers—the mountain in the Black Hills now known as Mount Rushmore—and July 4 at the White House, Donald Trump performed a passionate defense of public

monuments. Trump reserved for bronze and marble and granite the energy he was unable to muster for saving human lives in the COVID-19 pandemic. Not only did he ratchet up jail time for people who damage monuments, but he also signed an executive order establishing a "National Garden of American Heroes"—to all appearances a direct descendant of Mussolini's Fascist Foro Italico, complete with classical aesthetic precepts (no modernism, no abstraction). But the choice of site is revelatory. I noted earlier that Gutzon Borglum, the sculptor of the faces, was an enthusiastic supporter of the KKK; in close collaboration with the Klan, he produced the sculptures of Confederate generals on Stone Mountain in Georgia. It doesn't require a minute historical examination of the deeds of the four men depicted on Mount Rushmore to see the crux: this monument enshrines the US government's theft, by explicit breach of treaty, of the Black Hills, which are sacred to the Lakota Sioux.

My great-grandfather had made the aluminum cast of *Spirit of the Dance* for next to nothing because of the potential for exposure; he had a bronze cast made of the same statue to try to recoup some expenses. When he did not succeed in selling it, he had it moved to the house in Robinhood. Eventually, the aluminum one made its way back to the theater after all. As a child in Maine I climbed all over the six-foot bronze statue. Down by the water there was also an Indigenous shell heap dating to precolonial times. I didn't know about that then. I didn't think about how *this* statue might look from a certain angle, down by the shore, like a marking out of Europhilic territory, a kind of unconscious racial triumphalism, not of a historical individual, but of an artistic style. In 2017, my family sold the statue to the Portland Museum of Art—right off Congress Street, the one that used to be Queen Street. I trust more people will get to enjoy it, though perhaps not climb on it, unless surreptitiously. When I visit the house in Maine now, another empty plinth greets me, out in front of the house.

When I stayed at the house as a child, I slept in a room next to the attic. One whole wall was a bookshelf, and there were little cast iron doorstops, ancient guns, remarkable shells, handmade wooden toys. Nearby hang two small silhouette portraits backed with newspaper from early nineteenth-century Philadelphia (fig. 3.5). (Did Moses Williams make them?) In Robinhood I drew pictures of princesses and read Robertson Davies books, crumbling nineteenth-century books about seafaring adventures, Greek and Norse and Egyptian mythologies, *Black Heroes of the American Revolution*, Robert Louis Stevenson's *Black Arrow*, Charles Addams's *Dear Dead Days: A Family Album* (that one, full of weird and morbid ephemera, was hidden away in a closet downstairs where I snooped), and my grandmother's political economy textbook. That was her major at Radcliffe in the 1930s; my grandfather asked her out on a date after spotting her at a leftist political meeting. She asked her roommate, Dora Heineman, what she should

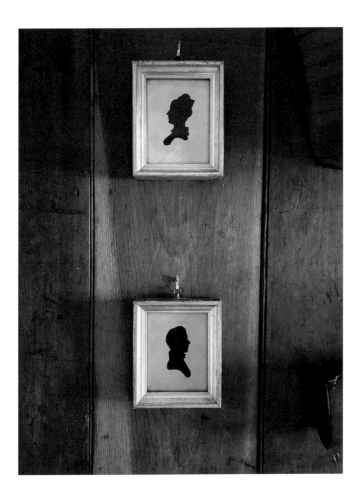

FIGURE 3.5
Two silhouette portraits.
Philadelphia, early
nineteenth century. Photo
by author, Zorach family
collection.

do if the conversation flagged. Dora told her to write a list of topics on which she could converse and put it in her purse and surreptitiously look at it if she needed to. (Dora, by the way, was an art historian, and went on to marry another art historian, Horst Janson, author of one of the best-known art history textbooks. Did she keep notes in her purse about what to talk to him about?) My grandmother never needed to look at her list.

When I was growing up, we didn't always have a lot of money, but we had a financial cushion if things were really dire. My great-grandparents had been poor artists living on the generosity of patrons like the Rockefellers, but even they had domestic help. One such helper was William Holly, an African American man who had the same first name as my great-grandfather. During the war, so the story goes, they felt it was too much of a luxury to "keep a servant," and they let him go. He went to work as a Pullman porter, he had a weak heart, and he died. When my grandmother told me this unbearable story her voice got

gravelly. After my grandfather Tessim died, I saw his passport and realized his actual legal name was William too, and I thought about these three Williams. Tessim was called Tessim, not William, because as a baby he was "infin*itesimal*."

I learned something—a little—about how the help could be invisible when I worked as a waitress in my senior year of high school. I walked into my interview with a Radcliffe alumna and realized she was a regular at the restaurant where I worked. I had waited on her often. I didn't bring it up throughout the whole interview. She didn't notice. After I was accepted I saw her again at the restaurant and identified myself. She laughed. She said the admissions committee was very aware of my family. My heart sank.

In the big election year of 1980, one of the Democratic primary candidates was Ted Kennedy, and he came and spoke in my town and I shook his hand. Sometime that year I also heard the word "Chappaquiddick" (Wampanoag, tchepi-aquidenet, "place of separate island") for the first time. In school that year we did a group assignment to create our own political parties, and I had to answer a series of survey questions about my political beliefs in order to be placed in a group with like-minded students. I filled it out perched on my bed in Robinhood in front of those bookshelves. I had to answer a question about how I identified politically. There were five choices. I checked "radical." My mother said, "No, you're a liberal." In 1980, several tribes resident in the State of Maine won a major land rights claim. But Ronald Reagan won the presidency.

For much of the history of the slaveholding settler nation called the USA, "art" was a way of expressing affinity with Europe, expressing the superiority of Europe. The fields we study in art history derive from this history too. Europe, as many have noted, gets a history, where other parts of the world just have geography. I am embedded in this. The Zorachs' daughter, Dahlov Zorach Ipcar, my great-aunt, was a farmer and a painter, a novelist and a children's book author, and she dedicated the most medieval of her books to me: *Sir Addlepate and the Unicorn*, which was inspired by medieval bestiaries. It is a romance about a medieval knight charged with finding a unicorn for the princess he serves. He travels the world, finds a rhinoceros—a one-horned beast—and brings it home. Understanding that the princess expects the unicorn to conform to her idea of one, he keeps the rhino for himself. To the princess, instead, he delivers a pure white foal, explaining that he has been obliged to remove the unicorn's horn for her safety. It's a funny book, and profound, a thoughtful meditation on what it means to encounter alterity, and, not knowing what to make of it, slot it into familiar categories. But Dahlov was of her generation. There's a reason this particular book hasn't been reprinted in recent years, unlike many of her other beloved books: the imagery on the page that represents African people is based on racist stereotypes. It jumped out, jarringly, when I looked at the book again after decades. What else was embedded in my American fantasy of the Middle Ages?

In Maine in the 1970s, "back to the land" seemed like an unambiguously utopian and leftist or at least progressive movement. It was a movement in which young people created communes or homesteads, engaged with "nature," learned skills that modern mass production had obviated. (While my mother grew up on a farm, she never learned to spin wool until she bought two spinning wheels—a modern one and an antique—in the early 1970s.) It was a reaction against modern consumerism, and an effort at reversing a distinct demographic shift, the decline of small farms throughout the US. The young people going "back to the land" in the 1970s were participating in a return to country life that was billed as a "rural renaissance."

After living in cities for my entire adult life, I remain captivated by the idea of the country, but if I think in terms of social justice, the simple life doesn't seem so simple anymore. Almost all of the "back to the landers" who moved into rural areas in the 1970s were White. For some, who did it as part of a counterculture ethos, it felt like they were living according to their principles and modeling a life lived in harmony with the land. But it was also, in many cases, a quietist response to political crisis. They made an island for themselves, a retreat from what could have been the work of building a movement that was political as well as cultural. They also rested on generations of White forgetting about how the rural landscape had been shaped by colonialism and conquest. The back to the landers made a choice that, from a distance, looks not unlike the White flight of their parents' generation. Rather than move to the racially segregated suburbs, they moved to the racially segregated countryside. A quick glance at the history of "sundown towns" demonstrates that the countryside was, indeed, highly segregated. That they thereby avoided engaging with the racial politics of cities, that it was a matter of racial privilege to be accepted by rural White communities with only a little bit of hassle, were facts that were not at the forefront of their consciousness. A few new Black rural communities formed in the southern United States in this era: one was the Oyotunji African Village in South Carolina, and several operated under the flag of the Republic of New Afrika.[11] In Chicago, the Institute of Positive Education, an umbrella organization that runs Afrocentric schools that was closely associated with Third World Press, also managed a farm in Michigan with the goal of self-sufficiency. But the rural commune was primarily a White phenomenon. African Americans who were interested in communal living did not typically join rural communes initiated or dominated by White people.[12]

Even if "escaping" urban America was not always a conservative move, still, in many places in rural America, it was something only White people could do without fear of violence or harassment. For those who saw themselves as liberal, leftist even, did getting away from the "problems" of the city also mean escaping the dilemmas they faced in urban areas as White people? Did the European Middle

FIGURE 3.6
Empty plinth, former site of William Zorach, *Spirit of the Dance*,
Robinhood, Maine. Photo by author.

Ages do something like that for me, as a White child in America, one who couldn't quite shake the nation's mythmaking, but sensed something was awry? Were the Middle Ages a way of identifying with, not Whiteness, but White-ish-ness— before the concept of Whiteness had been invented to sit atop a violent racial hierarchy? Were there White people who weren't automatically oppressors simply by virtue of being White? Was my desire for this nothing more and nothing less than what Tuck and Yang call a "settler move to innocence"?

I'm sure it was something like this. But what I found when I got there was not what I went looking for. It was difference, a way of recognizing an alterity in Europe: what I loved about the medieval literature I studied in college was *how different it was*. Different, but the same: the first text I read in Old French was *Yvain*, the knight of the lion, in which enslaved textile workers complained about their lot. Different, but the same. When I shifted to Renaissance art from medieval it was a way of engaging politically with what seemed like an even more traditionalist wing of the field, with the core of art history's traditionalism, and reckoning with colonialism in a new way. But the chance to see alterity in Europe, to see something not so familiar after all, not something with which any of us (White or otherwise) should readily, seamlessly identify, remains. I left the Middle Ages, but stayed a medievalist.

In 2017, in an early draft of this text, I wrote "My father wants to put a gazebo up where the statue was. I think I would like to let it remain an empty plinth" (fig. 3.6). In 2020, in 2021, statues were coming down everywhere. Robert E. Lee in Richmond, Virginia. Edward Colston in Bristol. Columbus statues in Baltimore and Chicago. In 2020, we had a screened-in tent for eating on the lawn so that we could visit more safely during the early months of the COVID pandemic. The plinth stayed empty.

4
GARDEN

Violence and the
Landscapes of Leisure

THE GAZEBO IS NOT ART

As you approach the gazebo from a distance, you might not think anything of it. You certainly wouldn't immediately imagine that it is different from any other park shelter. It's only as you come closer that you might start to wonder about its purpose. It stands behind a tall fence. The landscaped space that surrounds it is tasteful and spare. The public can only enter the grounds when the nearby building is open, so most of the time, the gazebo does not shelter, unless it shelters symbolically. The building, with its facade of monumental fluted columns, is the Stony Island Arts Bank, the flagship location of the Rebuild Foundation, a nonprofit organization founded by the Chicago artist Theaster Gates. Formerly housing a community bank, the Stony Island Trust and Savings Bank, this classical temple architecture seems equally appropriate to a grand citadel of culture. In the green space outside, dubbed the Arts Bank Lawn, the displaced gazebo holds ambiguities. Unavailable for everyday use, protected more than a typical piece of public art, it is not quite an artwork, nor, anymore, an ordinary picnic shelter, but not exactly a monument either.[1]

Gates hosted the gazebo's solemn dedication on June 25, 2019, after three years in which its dismantled materials waited in a room at the Arts Bank.[2] It wasn't a foregone conclusion that it would be reconstructed at all. In its former incarnation in a park in Cleveland, this was the structure where, in 2014, a police officer gunned down Tamir Rice, a twelve-year-old child who had been playing under the shelter. A 911 caller reported a person with a gun that was "probably fake"— it was a replica airsoft gun—but this did not stop police officer Timothy Loehmann from fatally shooting Tamir seconds after arriving on the scene.[3]

For two years, the gazebo still stood in the park, and family, friends, and com-

munity members found space there to commemorate Tamir's life with candles, stuffed animals, pictures, and letters. When the city of Cleveland removed it from the park in 2016, Tamir's mother Samaria Rice agreed with the removal, but made sure it was preserved and gave it, on loan, to the Rebuild Foundation.[4] Displaced from its original site, the gazebo is now in a sense not "of" its place but parallel to it. This distancing, along with the politically and emotionally charged character of the structure, interrupts any simple notion of placemaking. Inaugurating it, Gates insisted it is not art: "The gazebo is not art, the gazebo is a gazebo."[5]

The gazebo draws attention to ways that race inflects ideas about land, "nature," and the leisure and labor associated with parks and gardens. Within its new context it sits within traditions of social practice and environmental art in Chicago that embrace themes of race, culture, geography, community, contestation, and history. The Rebuild Foundation engages in placemaking and institution building, creating cultural spaces like the Stony Island Arts Bank to house collections and exhibitions. The collections have grown up together with the spaces. At the outset, before creating the foundation, Gates purchased, renovated, and lived in a former candy store in the Greater Grand Crossing neighborhood. Following the financial crisis of 2007–8, he began acquiring and redeveloping additional buildings in the neighborhood. In his architectural and community development practice and in his individual artist practice, he addressed objects and materials viewed as obsolete—collecting, reinventing, and often transplanting them.[6]

Within a set of artistic and institutional practices that locate beauty and knowledge in what's overlooked and discarded, the gazebo's unassuming appearance sits uneasily with its tragic history. In this chapter I trace multiple trajectories to create a historical landscape for the gazebo. In one sense, it is a simple piece of park architecture. If we think of it as a place that simply, unhappily, happened to serve as the stage for a terrible crime, it might seem I am giving it more intensive analytical attention than it merits. But it takes on a deeper significance once we engage with ideas about parks, gardens, and open space, and their relationship to what is familiar and domestic, what seems distant and strange, and what obscured forms of violence lurk in these spaces. A closer look—expanding outward from the most immediate circumstances in which an officer took a young person's life—shows how profoundly embedded the gazebo and the garden are in histories of aesthetic ideas that serve as cover for social agendas that maintain and promote White supremacy.

Theaster Gates began to accumulate collections well before there was a Stony Island Arts Bank, in tandem with his work artfully renovating houses. His work has emphasized the reuse of buildings, materials, and entire collections that have been abandoned or discarded or are at risk of being lost altogether. Cen-

tral to the early collections were media that had become obsolete, or seemed so, through technological change layered with the effects of the financial crisis. Gates first purchased the unsold stock of the Prairie Avenue Bookshop, a storied architectural bookstore that was going out of business. Then he bought thousands of LPs from Dr. Wax, a record store in nearby Hyde Park that was also closing its doors for good. He acquired furniture and shelving from Chicago's shuttered schools. The University of Chicago's Visual Resources Collection offered him its entire stock of glass lantern slides, an image archive that had fallen entirely out of use by faculty and students. Johnson Publishing, the publisher of *Ebony* and *Jet* magazines, donated the company library. Gates also received fire hoses that he assembles into wall pieces: abstract, painting-like assemblages that allude to authorities' firehose attacks on protesters during the era of the Civil Rights Movement in the 1950s and '60s. Using recycled materials from other buildings, creating speculative histories as part of the fabulations of his art practice, Gates's work in Greater Grand Crossing invited the insertion of archival and quasi archival materials and their animation through intermittent cultural programming and his own art practice. Having established the Rebuild Foundation in 2010, he found the perfect headquarters for its cultural collections in a stately bank building that was itself slated for demolition. Following renovations, the Arts Bank opened in 2015. Less than a year later, Samaria Rice offered to loan the dismantled gazebo to the new institution.[7]

When the gazebo materials first arrived at the bank in 2017, the lumber filled up a small room in the bank building, arranged in neat rows like an abstract sculptural installation, flanked by the accompanying hardware (fig. 4.1). Piled alongside the lumber were the stuffed animals, notes, and decorations that people had added to it to commemorate Tamir while the gazebo still stood in Cleveland. It seemed to ask its visitors to adopt a contemplative attitude. Rebuild took several years to install the gazebo as a gazebo, following a lengthy period of debate and reflection. Some staff members questioned, in fact, whether it should be exhibited at all. They expressed concerns about the position of the bank as a cultural institution: sometimes it felt as if their work was to exhibit Blackness to majority White, wealthy audiences, and if what Blackness meant in this context was Black death, the staff members found it troubling.[8] They also expressed concerns about the institution's practice of cultivating relationships with Chicago police—a police department similar to Cleveland's in its use of deadly force. Dissent within the institution took many forms. Some of it crystallized around the gazebo.[9]

Rebuild's next public steps did not directly address the substance of the critiques but did speak to some of their concerns.[10] The process of implementing the reconstructed gazebo slowed. The organization developed an advisory group that included community representatives and activists. A new slate of programs

and community invitations facilitated consideration of how the gazebo might
make sense within an institution devoted, primarily, to preserving Black
archives. The gazebo was itself a kind of Black archive—but it sat uncomfort-
ably amid the collections already housed under the Arts Bank's roof. In the fall
of 2017 and spring of 2018, the foundation presented a series of public conversa-
tions entitled *Objects of Care* that considered how the materials from the gazebo
might relate to themes drawn from the institution's other collections. Along with
the Johnson Publishing and University of Chicago lantern slide archives, the
Arts Bank houses the Edward J. Williams Collection of racist memorabilia and
the record collection of Frankie Knuckles, a renowned Chicago house music DJ.
The idea was to spur community conversations around themes present in the
foundation's existing holdings that would help imagine how to make sense of
the gazebo in that context, to inform its potential installation at the Arts Bank.

In this context, I was asked to work with the University of Chicago Art His-
tory Department's lantern slide collection, which made sense given my history as
a student and faculty member there. As a student I had seen presentations that
included these slides, had even used them on occasion in my own early teach-
ing career, but I had never given them very much thought. The lantern slide—
originally used with a "magic lantern" apparatus—is an artifact of the way art

FIGURE 4.2
"Stourhead, Country–Seat. View of Garden with Bridge." University of Chicago
Glass Lantern Slide Collection, Rebuild Foundation.

history was taught in the mid-twentieth century (fig. 4.2), not only before there
were digital projection and PowerPoint presentations, but before there were
35 mm slides and their carousels. When I arrived at the University of Chicago
as a graduate student in 1993, this technology was already decidedly outmoded.
Faculty almost exclusively used 35 mm slides. The smaller, lighter slides had
come into use in the late 1960s and they allowed more readily automated slide
presentations: the speaker had a clicker and could advance the slides from the
podium, whereas the standard apparatus for lantern slides still required a projec-
tionist who inserted every single one, on cue, by hand. No one uses 35 mm slides
for teaching anymore, but the lantern slides disappeared first. They were bulkier
and heavier. They quickly became "archival" at the onset of the digital age.

What it means for an object to be "archival" might be defined as "no longer
in use, but not quite trash." My mission for Rebuild was to glean meaning from
their images, create a presentation with some prompts for discussion, think-
ing about what how these objects could speak to one another: the dismantled
gazebo; the dismantled technology of lantern slide projection. The slides became
archival when they were not only no longer in use, but took up space that was
needed for other purposes. The gazebo became archival because the city of
Cleveland planned to dismantle it to remove it from view—perhaps hoping to
prevent it from serving as a highly visible monument to Tamir's death. There

was no analogous murderous history being swept under the rug by the removal of the lantern slides. Or was there?

The experience of trying to create dialogue between these two "archives" launched me on a challenging trajectory as I thought about the evidence the lantern slides presented for the history of art history. At first blush, we can think about the merely technical function of visual comparison embodied in dual slide projection, central to the discipline of art history since the 1870s.[11] The mere fact of being able to put two images side by side could be value neutral, but in fact helped produce the traditional, teleological narrative of art history, based on linear notions of progress that privileged modern Europe. Comparison can and certainly does make other kinds of arguments possible. It also helped construct and illustrate a history that uses comparison of styles across time and geography to justify the ideology of European imperialism.

Yet this function of dual slide projection might seem so broadly applicable that it can only be of the most tenuous relevance to the gazebo in particular. This prompted some further questions: what is a garden gazebo? How does it relate to this broad sweep of the history of art? The next step for me was to delve deeper into the collection and see what it emphasized. Geographically, it was Europe first, North America second, and Asia third. Only half a drawer was devoted to all things African. None of this should be a surprise. In the story of the exclusions and hierarchies of art history, European and Euro-American cultures have often viewed Asia as a secondary, alternative aesthetic tradition, while denying a place entirely to African and other Indigenous cultures. Notably, as we will see, Asian cultures—or European ideas about them—have played key symbolic roles in the formation of the American racial enterprise.

The emphasis on certain types of artistic media in the drawers reveals some other things. We might expect that the quantities of art forms—such as the three broad Western categories of painting, sculpture, and architecture—will reflect their relative emphasis within the discipline of art history. For example, the fact that architecture held a central place within this collection of largely black-and-white images was entirely predictable. Traditionally, scholars have considered architecture to be especially suited to black-and-white reproduction: seen as a matter of *structure*, it loses less, and may benefit in certain ways, from the absence of "distracting" color. What surprised me, though, as I began to look at the collection was the prominence within it of *landscape architecture*, the design of the outdoor environment.[12]

In particular, this meant gardens, and not just any gardens but those of European, and mostly English, country houses in the eighteenth century. It was a very specific, very English set of names: The Leasowes, Stourhead, Dunham Massie, Hagley, Shugborough, Stowe, Kew Gardens. Some appeared as engravings, oth-

ers as photographs. With their landscaped lawns and small garden houses of various kinds, including gazebos, these spaces resonated more directly, though from a temporal remove, with the object at hand. They raised a new question, however: What were all those images of European gardens doing there? Certainly they must result from the teaching interests of one or more faculty members at some point in the past. On the other hand, prints, arts of the book, metalwork, furniture, textiles, ceramics—none of these categories of handiwork had anything like the quantity of slides devoted to them that gardens had. Why were gardens written so prominently into this archive of art history's canon?

If the primacy of European art in the American context functions to reinforce colonial hierarchies of value, I would venture that the garden, and specifically the European-style garden, modeled land use in the settler-colonial spaces of the Americas—a way of making sense of questions of control over land, real and metaphorical, that erased both the Indigenous inhabitants of the land and those forced to labor on it. In the United Kingdom, the characteristic "English garden" took shape during precisely the period in which colonial endeavors grew and flourished. Its incorporation of historical and "exotic," Orientalizing garden architecture—"pagodas" and "gazebos" serving as small shelters and viewing points—resonated with British imperialism.

Like other manifestations of imperialism, the English garden appropriated forms from the world over. In its earliest uses, "gazebo" refers to a small building—often at a high point in a garden or landscape—from which to glimpse surrounding lands.[13] William Halfpenny included some of the first depictions of buildings called gazebos in his *Rural Architecture in the Chinese Taste*, published in 1750 (fig. 4.3). The University of Chicago slide collection does not include the book's gazebo images, as far as I have been able to tell. But it does include a similar illustration from Halfpenny, "The Elevation of a Temple Partly in the Chinese Taste," as well as with photographs of many other small garden structures (figs. 4.4, 4.5). The word "gazebo," in fact, has no obvious relationship to any Chinese word—of course, this did not stop Europeans from using the word "pagoda," derived through Portuguese from Tamil, to describe Chinese temples. It has been speculated that the word "gazebo" is fake Latin—ostensibly meaning "I will gaze," which is consistent with its frequent use for elevated structures and cupolas. Or it might be an adaptation of the Arabic word "qasaba," which also came into English as "casbah." It also sounds a little like the Italian word "casino," little house, also used quite often in the early modern period for garden structures. Gazebos tend to be hexagonal or octagonal, like many structures known as pagodas, but in contrast to pagodas they are fully or partially open on each side. Some are more ornamented than the Cudell Park gazebo, with upturned eaves or a double-hipped roof, both of which may connote Chinese origins (sometimes via a Victorian architectural "translation"), sometimes a cupola. This imagery

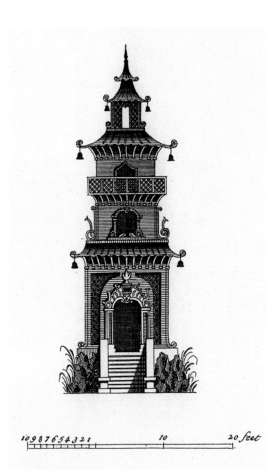

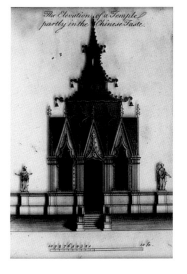

FIGURE 4.5
"Kew Gardens. Temple of Aeolus." University of Chicago
Glass Lantern Slide Collection, Rebuild Foundation.

derives ultimately from the immense popularity of gardens "à la chinoise" in eighteenth-century Europe.

Some of the patrons who commissioned English gardens owed their substantial fortunes in a very direct way to colonial ventures. As examples we could take Oldbury Court, purchased in the 1799 by the sugar baron Thomas Graeme, who was advised on garden design by the famed designer Humphry Repton, or Moccas Court, long the estate of the Cornewall family, who also owned a Grenada sugar plantation.[14] Even more famous and dramatic was William Beckford's Fonthill Abbey. Simon Gikandi has argued that Fonthill's art collections, architecture, and gardens, served as a kind of compensatory aesthetic project to cleanse the Beckford fortune of its "nasty" colonial and commercial origins in sugar and slavery. The project was itself also imperial, amassing objects from around the globe. Beckford collected albums of Indian miniature paintings, and a Chinese Qingbai porcelain vase, one of the earliest objects in Chinese porcelain to reach Europe, arriving originally in Rome in the fourteenth century. His gardens also included a sector known as the "American plantations."[15]

In all these gardens, small structures, built in a panoply of architectural styles, dot the hills and groves. There are classicizing temples, like the "Garden Temple of Lord Lyttelton" at Hagley Hall, and the "Temple of Aeolus" at Kew

Gardens. There are neogothic structures. There are also faux-Eastern buildings referred to as pagodas and, of course, gazebos, often hexagonal, like the Cleveland one. At Croome Court, whose proprietors, the earls of Coventry, were linked by marriage to slavery in the eighteenth century, there was a Chinese bridge based on Halfpenny's design.[16]

What is represented in these gardens? Control over land—and also leisure. The English garden appears, or is meant to appear, as an unlabored landscape. It is not farmland or evidently productive land, but an extended terrain designed for restful pleasures. And yet, what makes it possible is the labor of others, whether in distant colonial holdings, as for some owners, or in this space itself, for all.[17] The English type distinguished itself from the manicured and geometric French formal garden with its cultivated wildness, its ruins, its historical references to diverse architectural styles. As its owners mixed tea from the East and sugar from the West together with their local cows' milk, they enacted in the very taste in their mouths the geographic breadth of the British empire, on which the sun didn't set.[18] We might take as an example a portrait of the slave trader Elihu Yale with William Cavendish, the second Duke of Devonshire, and others, in the gardens of Chatsworth, Cavendish's estate (fig. 4.6). This portrait, owned by the Yale Center for British Art, displays a group of adult male aristocrats enjoying colonial products—tobacco and Madeira wine—attended by a Black boy in livery, with White British children frolicking in the garden under

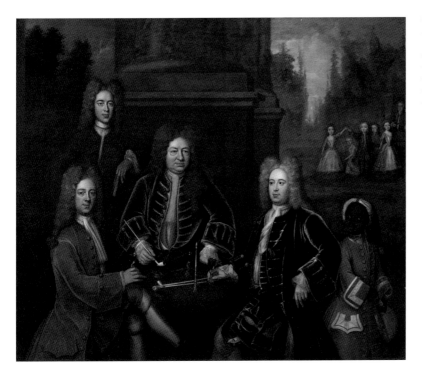

FIGURE 4.6
Attributed to John Verelst, *Elihu Yale with Members of his Family and an Enslaved Child*, ca. 1719. Oil on canvas, 79¼ × 92¾ in. (201.3 × 235.6 cm). Yale Center for British Art, Gift of Andrew Cavendish, eleventh Duke of Devonshire.

the watchful eye of a schoolmaster. In the garden, leisure—in its adult and child-hood forms—is foregrounded, labor is occluded or rendered "cute," but the racial delineations remain clear. Some children get to play, to be children; other children exist as props, as laboring bodies, or both.[19]

TASTE

One reason the lantern slide collection emphasized gardens might have been the significant role they played in aesthetic theory of the eighteenth and nine-teenth centuries. To modern eyes, accustomed as we are to the primacy of easel painting, it may be surprising how centrally landscape design figures in the aes-thetic system of the German philosopher Immanuel Kant, one of the period's preeminent writers on taste and beauty. Kant's writings, particularly the *Critique of Judgment*, helped ground the relatively new fields of art criticism and art his-tory in the nineteenth and twentieth centuries.

Kant himself gave pride of place to the beauty of nonhuman nature, but in the centuries that followed, art historians and critics have often taken the *Critique of Judgment* as foundational for the practice of judgment about art in particular. The mid-twentieth-century American critic Clement Greenberg drew heavily if selectively upon the writings of Kant, of whom he wrote that "there has been no greater thinker on art."[20] But Kant's distinctions support the emphasis given to gardens in the slide archive: he attributes a surprisingly high rank to garden design when he situates it as one of two divisions of painting, one of the three privileged art forms in Western art theory alongside sculpture and architecture.[21] The creation of beautiful gardens has, Kant states in the *Critique of Judgment*, "in view merely the entertainment of the Imagination in free play with Ideas, and the occupation of the aesthetical Judgment without any definite purpose."[22] In fact, the garden fulfills his requirements for aesthetic judgment *better* than archi-tecture, which is functional—tied to a purpose—hence, for Kant, *less free*.

To consider Kant is also to consider the relationship of his work to ques-tions of race and colonialism, and this will bring us far from the midwestern US and, too, from Germany. In the eighteenth-century global order in which Kant worked, the garden was also associated with colonial control over territory. The global reach of European colonial powers afforded the knowledge and authority to argue—as Kant does—that aesthetic judgments necessarily stake claims to *universal* validity. When I say an object is beautiful, he is saying, I don't just mean it's beautiful for me; to make a statement like this is to believe *everyone should agree*. You may be wrong—other people may actually disagree—but in order to make something that stands as an aesthetic judgment, you must believe your judgment is true for all.

While making this point, the German philosopher takes the time to consider the possibility that a rule for the beautiful can be derived from mathematical rules. He is not in favor of this idea: geometry and regularity—especially "stiff regularity"—are, he asserts, "repugnant to taste."[23] The enjoyment of stiff regularity lasts no time at all, and does not permit the free play of the imagination. In stating his position, Kant contrasts it with the account of garden aesthetics in the *History of Sumatra* that William Marsden, a historian and colonial administrator, had recently published. The Southeast Asian island, now part of Indonesia, was at the time subject to Dutch and British colonial rule.[24]

While it might seem strange for Kant to turn to an account of pepper gardens in Sumatra, it is one of many offhand references or footnotes that draw on his wide-ranging reading of accounts of European exploration. In these brief moments he displays the extent to which the intellectual armature of Enlightenment Europe developed together with colonial endeavors and their attendant violence. In this case, he bolsters his position by arguing against Marsden's account of the beauty of geometric regularity in Sumatran gardens. The real issue, for Kant, is that Marsden presents a view of aesthetic judgment that isn't universal. It relies on context: what matters to him is how beauty is perceived in relation to its surroundings. Marsden suggests that the beauty of wild, natural irregularity, as against geometric order, is a matter of its *relationship* to the surrounding vistas from which it is set off. On an island where wildness predominates, Marsden relates, he finds the sight of a pepper plantation beautiful by contrast, whereas in England he would have found a wild English garden appealing by contrast with the regularity of English boundary lines. Through the appeal to contrast, then, Marsden's position itself contrasts sharply with Kant's universalism. For him it is the divergence from the overall context that establishes aesthetic pleasure:

> The pepper gardens are planted in even rows, running parallel and at right angles with each other. Their appearance is very beautiful, and rendered more striking by the contrast they exhibit to the wild scenes of nature which surround them. In highly cultivated countries, such as England, where landed property is all lined out, and bounded and intersected with walls and hedges, we endeavor to give our gardens and pleasure grounds, the charm of variety and novelty, by imitating the wildnesses of nature, in studied irregularities. Winding walks, hanging woods, craggy rocks, falls of water, are all looked upon as improvements; and the stately avenues, the canals, and lawns of our ancestors, which afforded the beauty of contrast, in ruder times, are now exploded. This difference of taste is not merely the effect of caprice, nor entirely of refinement, but results from the change of circumstances.[25]

As Kant puts it in his note, "he hence infers that wild beauty, apparently irregular, only pleases as a variation from the regular beauty of which one has seen enough." Marsden further discusses what it might mean to import an English garden into Sumatra: "A man who should attempt to exhibit on Sumatra, the modern or irregular style of laying out grounds, would attract but little attention, as the unimproved scenes adjoining on every side, would probably eclipse his labors."[26] For Kant, Marsden's impression is a misapprehension, and taste is not in fact relative; had Marsden made the experiment of staying for a day in a pepper garden, he would soon have wearied of it.

In considering the pepper plantations of Sumatra, Marsden mobilizes questions of art and nature that were understandably of interest to Kant, along with key terms from the vocabulary of eighteenth-century aesthetics, such as the sublime, the picturesque, and the beautiful. His relativist argument—that taste is a matter of context—has potential to challenge Kant's universalism, and yet it is so fully laced with racism that it cannot be carried to its own conclusions. Marsden claims to identify failures of sensibility on the part of the Sumatrans through their resistance to certain types of aesthetic experience. In Sumatra, he writes, "nature has been extravagant, bestowing on many parts of the country, where human foot scarce ever trod, all that is adapted to raise the sentiment of sublimity in minds susceptible of the impression." But Marsden claims such minds are not to be found on the island: "Even where there are inhabitants," he writes, "to how little purpose has [Nature] been thus profuse in ornament! In passing through places, where my fancy has been charmed with more beautiful and truly picturesque scenes, than I remember ever to have met with before, I could not avoid regretting that a country so captivating to the eye should be allotted to a race of people who seem totally insensible of its beauties."[27] Marsden reflects not at all on the fact that this observation, if it had been true, would have merely been consistent with his own argument about the relationship between context and aesthetic value: the idea that whatever is unaccustomed pleases more than what is familiar.

His account of freedom and constraint in the pepper gardens in Sumatra also plays out in social and political terms. He ties his sense of the aesthetics of regularity in the gardens to the pleasure one might take in the "simple view of human industry" which, however, he claims is "scantily presented in that island." This pleasure would consist in the "social feelings that nature has inspired us with, and which make our breasts glow on the perception of whatever indicates the happiness of our fellow creatures." And yet nothing in the colonial cultivation of pepper suggests it was conducive to "happiness."[28] Why, indeed, should Sumatrans take an *aesthetic* interest in the regularity of their forcibly imposed planting patterns? European colonizers introduced the cultivation of pepper to the island,

and colonial overlords—the colonizers and the local rulers who worked together with them—used considerable violence and coercion to extract labor from the inhabitants.[29]

In Marsden's view, Sumatran people both fail to appreciate wildness *and* fail to cultivate the regularity of the garden sufficiently. First arguing for a relativist, contextual determination of aesthetic judgment, then charging Sumatrans with simply not having the mental stuff for it, Marsden twists his own argument into knots to maintain a position of White supremacy. His argument is contextual— but it assumes that in *whatever* context, the person making the aesthetic judgment is a White European man of a certain status who can enjoy global mobility. And if Kant's *Analytic* does not overtly pose the question whether the "free play with ideas" can occur in a situation of slavery or colonial servitude, still, I argue, the understated citation of Marsden carries these questions as an undercurrent into Kant's text—and indeed into the primacy Kant gives to landscape design.

This has been a long excursion into a context quite distant from that of twenty-first-century Cleveland or Chicago, or even from art, race, and ecology in the United States. And yet, there are links that go beyond the question of what Kant derived from Marsden. The global early modern world encompassed and connected the Americas and the colonial pepper trade in Asia. In the broadest sense, the pepper trade is closely linked to the colonization of the Americas: Christopher Columbus brought red chili peppers back to Spain, thinking he had found black pepper, which had a long history as a coveted commodity in Europe. Consider too, how the desire for pepper collapsed distances in the late eighteenth and early nineteenth century. A scant few years after Kant published his *Critique*, Captain Jonathan Carnes began sailing from Salem, Massachusetts to Sumatra, initiating a direct trade in pepper between the Indonesian island and the newly independent American republic. On Carnes's second trip, in 1799, he brought back Sumatran artifacts that formed the core of the "cabinet of curiosities" of the East India Marine Society: a double-stemmed pipe, a rhinoceros goblet.[30] Based in a European mode of aristocratic and scholarly collecting, this was an early instance of an American ethnographic museum, a contemporary sibling to Peale's first museum in Philadelphia. Carnes's treasures were soon joined by others, ostrich eggs, a Chinese soapstone pagoda, ceramic figurines.[31] The Marine Society's collections eventually formed a core collection of the Peabody Academy of Sciences, later merged with the Essex Institute to form the Peabody Essex Museum, which still holds one of the most extensive collections of Asian art in the United States.[32] Philadelphia merchants, too, carried on a vigorous trade with Asia. A Dutch merchant, Andreas Everardus van Braam Houckgeest, constructed a lavish "China Retreat" outside the city, in Bristol, Pennsylvania, in the 1790s.[33] In 1838 the Quaker merchant Nathan Dunn created a "Chinese

Museum" in Philadelphia, housed inside Peale's Museum. Peale's Museum itself displayed numerous "instruments and ornaments" from China, or said to be: a fan, guns, a plow.[34]

The point I want to pursue here is that in the colonies and early republic, trade with Asia and the collecting of objects from the continent triangulated readily with the settlers' longing gaze toward Europe; Asia was still a thorn in the side of Europe's sense of its own superiority even as a Europhilic aesthetic sensibility arose in the United States. Following the Revolution, the American former colonies, embargoed by the British empire, began establishing direct trade with Asian ports. As Jenny Purtle has pointed out, even an object as iconic as Paul Revere's silver Liberty Bowl (fig. 4.7) has stylistic origins in Asia.[35] This bowl commemorated members of the Massachusetts House of Representatives who refused to rescind their support for a letter protesting the 1767 British Townshend Acts, which taxed commodities from Great Britain (including tea originating in China, the object of the Boston Tea Party's rebellious action). In shape, it derives from the standard contours of export porcelain punchbowls made in Qing China; East India Marine Society members carried numerous examples back to Salem.[36] An example is the ceremonial punchbowl in the Peabody Essex Museum collection that was presented to officers of the ship

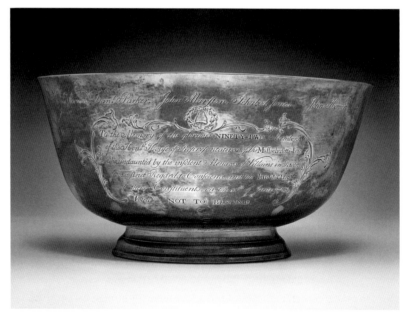

FIGURE 4.7
Paul Revere Jr., *Sons of Liberty Bowl*, 1768. Silver, 5$\frac{1}{2}$ × 11 in. (14 × 27.9 cm).
Museum purchase with funds donated by contribution and Bartlett
Collection—Museum purchase with funds from the Francis Bartlett Donation
of 1912.

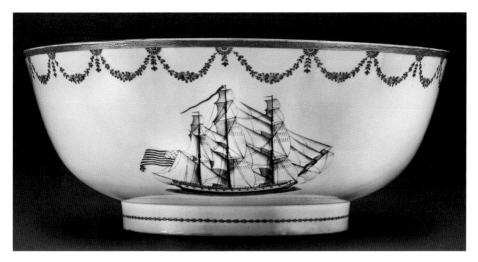

FIGURE 4.8
Artist in China, *Grand Turk Punch Bowl*, ca. 1786. Porcelain, 6¹/₂ × 16 in. (16.51 × 40.64 cm). Gift of Elias Hasket Derby Jr., 1801, E62499. Image courtesy of Peabody Essex Museum. Photo by Dennis Helmar.

The Grand Turk in Canton (Guangzhou) in 1786 (fig. 4.8). The fascination with the "other otherness" that Asian lands offered was part and parcel of the European encounter with the Americas, and as time went on, it continued to coexist with the racial hierarchies invented by settlers. As with their English counterparts, Chinese-inspired garden architecture, in particular the gazebo, became a feature of American leisurely gardens.[37]

RECREATING RACE

As the management of parks and gardens, public and private, developed in the United States, questions of order and freedom arose like those that had concerned Marsden and Kant, and often with similar colonial and racial undertones. I turn now to consider the way parks and gardens have operated in the specific context in which Tamir Rice was murdered: the landscape of Cleveland, Ohio, the west side neighborhood called Cudell, the nearby Cudell Center, with its park and gazebo, which stood in the park for about fifty years.[38] It's a form of minor architecture that could easily go unnoticed. What assumptions and aspirations about the uses of architecture and the relationship of human beings to buildings and green space were put into practice there? To say that the park and its ordinary-seeming shelter were an instrument of Tamir's death would relieve police and policing of too much responsibility, but the history of these kinds of spaces makes them, at the very least, accessories.

Cudell is named for Frank Cudell, a German immigrant architect responsible for much of the look of downtown Cleveland, with its many Beaux Arts buildings. The recreation center near where the gazebo stood also bears his name. Cudell's heirs gave the city the Shingle-style house that became the original Cudell House, a municipal center for fine arts and gardening founded in 1939. A booklet about the center, written by Federal Writers Project writers, documented the activities taking place there, declaring it already a "potent force in the community for wholesome, constructive recreation under skilled and responsible supervision" (fig. 4.9).[39] The West Side Garden Center, which also had its home at the Cudell House, had the mission "to promote such knowledge and love of gardening as will result in a more beautiful community."[40] From images in the booklet it would seem that the adults and young people served by the organization at that time were exclusively White. The neighborhood, indeed,

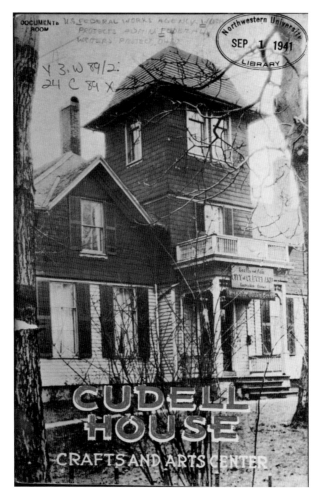

Cover of *Cudell House Crafts and Arts Center*, by Writers' Program (Ohio), Works Progress Administration, 1940.

was predominantly White (though never wealthy) until the last decades of the twentieth century. During the period from 1920 to 1960, the Black population of Cleveland ballooned from 35,000 to 255,000, nearly doubling between 1940 and 1950, but remained concentrated in the central and eastern parts of the city. During this period, redlining, the practice that prevented non-White, immigrant, and particularly Black residents from obtaining home loans for much of the twentieth century in the United States, designated Cudell for stiffer loan requirements and inevitably less investment. A redlining map of Cleveland (plate 8) shows how the area around the Cudell Center, area C20, was classified.[41] The area descriptions created by the US government's Home Owners' Loan Corporation in the 1930s labeled the area as "definitely declining," with "four colored families" noted, as well as a low percentage (20 percent) of "English, German, Hungarian and Bohemian" Whites and proximity to commerce and industry that brought values down. Today, Cudell's demographics include a higher proportion of Latine residents (around one-quarter) and lower proportion of African Americans (around one-third) compared to the city as a whole, and approximately the same proportion of Whites (around 40 percent). Cudell was also affected by the proximity of industry, and when the interstate highway system began construction in the 1950s, it ripped through the neighborhood, sealing its fate.

In 1965, after many years of planning, the city opened a new Cudell Recreation Center next to the Arts Center. The rec center was a modern building that cost a million dollars, an expenditure made in concert with the city's program of urban redesign known as "urban renewal." This investment in the construction of the rec center reflects the emphasis midcentury planners placed on the management of young people's leisure activities, evident already in the Cudell House book. An image of the Recreation Center reopening (fig. 4.10) after budget cuts had forced its temporary closure in 1971 makes it clear that White and Black young men both used the center, but what's striking is the way they are positioned. The supervisor directly greets the White teens, who stand in front of all the Black teens.

Two publications on leisure and green space sponsored by the city of Cleveland and its civic organizations in the mid-twentieth century can give a sense of what was at stake in the development of public parks, though we will have to read between the lines to understand the full story. In 1945 the city released a small publication entitled *Places for Playing* (fig. 4.11). While "places for playing" sounds idyllic, the title is excerpted from the longer and somewhat more ominous sentence: "Places for playing keep children from straying." *Places for Playing* begins with a statement about recreation and quickly moves to an appeal to the urgencies of the present moment of postwar change. Recreation—in all caps—"is becoming a more and more vital element of city life. It is not merely a matter of fun during leisure hours. It is a major factor in education—for good

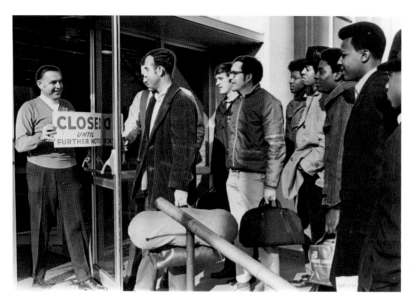

FIGURE 4.10
"Frank A. Misic, supervisor of
the Cudell Recreation Center,
takes down closed sign as a group
of young men wait to enter."
Photograph by Bernie Noble for the
Cleveland Press, January 9, 1971.

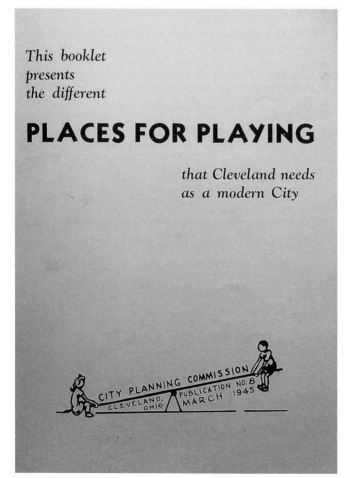

This booklet
presents
the different

PLACES FOR PLAYING

*that Cleveland needs
as a modern City*

CITY PLANNING COMMISSION
CLEVELAND, OHIO
PUBLICATION NO. 8
MARCH 1945

FIGURE 4.11
Cover of *Places for Playing*, City
Planning Commission, Cleveland,
Ohio, 1945.

citizenship and good living. RECREATION means health, relaxation, and community spirit—for adults as well as children. It will be increasingly needed in the postwar world."[42] In addition to concerns about youth criminality, the booklet asserts that "PLACES FOR PLAYING make families with children more willing to stay inside the City, which helps to check decentralization and maintain tax revenue and good property values." Needless to say, it is White families in this moment who were perceived to contribute to "good property values."

Following these statements, the brochure stresses that places for playing "keep children from straying" in that "1. They reduce juvenile delinquency. 2. They keep children off the streets." One illustration mentions children's physical safety from accidental injury and death, not only their delinquency or lack thereof. But the graphic is glossed with dire warnings about the "problem" of leisure, making no reference to simple safety. To avoid prison, we learn, boys— implicitly othered in terms of class and race or ethnicity—need to spend their spare time "under good leadership." The Cudell Center seemed to promise just this sort of guidance.

Over the decades the ideology of the design of open space changed. Where the 1945 booklet foresaw a system of differentiated spaces, on scales running from small playlots to playgrounds to playfields and large public parks, and with an emphasis on use by children, by the 1960s the emphasis was on large public spaces whose stated function was not (or not exclusively) play. In 1964 the all-White Junior League of Cleveland, in collaboration with the Cleveland Development Foundation (CDF), whose board was made up chiefly of heavy industry executives, sponsored the creation of an ambitious new report entitled *Open Space in Urban Design* (fig. 4.12). The CDF was directing Cleveland's particularly drastic urban renewal programs. Hanging over the report was the portentous implication that decay and strife had infested the city, which was to be rescued by good urban design, and in particular, the creation of "beautiful" open spaces. The introduction, by CDF president Upshur Evans of Standard Oil, began: "America is rebuilding. Across the nation, monumental construction projects are changing the faces of our cities and giving birth to new concepts of living." From this fairly neutral assessment of what is taking place, Evans goes on to a call to arms: "As we rebuild," he writes, "our immediate purpose must be clear: to destroy the ugly and outdated and replace it with the beautiful and new."

The authors of the report, Michael Rapuano, P. P. Pirone, and Brooks E. Wigginton, landscape architects and tree experts, were partisans of parks and plantings, of green spaces in the city. They introduce the report with an account of the challenges of the urban renewal era, and go on to discuss open space as civic space. "We must," they write in their first chapter, "approach the design of urban renewal projects with the idea that building masses should form and enclose open spaces which are of principal concern. The voids in architectural

8 Chatham Village, Pittsburgh, is an early example (ca. 1930) of medium density housing built about an interior green common which, after thirty years, has maintained its beauty and its value.

Landscape Architect: Ralph E. Griswold
Planners: Clarence Stein, Henry Wright
Photo: Clyde Hare for "Architectural Forum"

9 Stuyvesant Town in New York City is one of the very high density housing developments in the country, but the amenities of open space, views, and car-free areas for beauty, recreation and children's play are preserved and enhanced through thoughtful landscape planning.

Landscape Architects: Clarke & Rapuano
Architects: Irwin Clavan, Chief Architect
Photo: Gottscho-Schleisner

FIGURE 4.12
Page layout with images of Chatham Village, Pittsburgh; and Stuyvesant Town, New York. From *Open Space in Urban Design*, prepared for the Cleveland Development Foundation, 1964.

composition are more important than the masses when judged from the civic standpoint. This is the reverse of the usual approach which ranks building masses first and allows the remaining open spaces to fall where they may in meaningless broken fragments."[43] The authors prescribe a set of ideas about good urban design: that it should include open space, including plantings, for beautification, usefulness, the restoration of nonhuman nature, and the promotion of good behavior on the part of, especially, young people.[44] The way forward does not automatically require *more* open space; rather, it's a matter of "organizing and reassembling those idle useless bits and ends of vacant land left over from previous building into significant and useful areas located for maximum benefit." The language of idleness, ugliness, and spoilage recurs repeatedly.[45] "Our cities are full of idle back yards and half-used alleys. A view from a tall building in almost any large city reveals often very close by, blighted areas of junk-filled lots, vacant and rundown garages, shops and houses. There are many idle, ugly, useless open spaces. The central problem of the conservation and rehabilitation phases of urban renewal is one of reassembling, reorganizing and redesigning these idle fragments for new and meaningful uses."[46] The demolition agenda is to remove small structures and small open spaces that seem to serve no purpose, only "idleness," in order to create large buildings with sweeping plazas. Similar things occurred in the development of the green space around the Cudell Center between the 1950s and the 1970s. Houses were demolished and streets blocked off to create a green campus surrounding the new building, the original Cudell Center, and the nearby school. Should we see this drive to open space, well-intentioned as it may have been, carrying along with it the racial undercurrent made visible in the CDF's agenda?

Creation of better and more usable open space sounds very nice. But even before detecting political ideologies behind the drive toward unified space we might notice that it brushes aside the practicalities of a lived urban space. As Richard Sennett argues, against Enlightenment-inspired visions of "unity" for cities, "the visual designer who addresses the exterior physical fabric of [a] city is constantly dealing with parts which cannot, and should not, be bound together into a whole. Put schematically, the world of things—made by different hands at different times—is a revelation of otherness, of discontinuity, rather than of secret, elective affinities waiting to be joined."[47] Addressing architects who envision their work through the language of form and object—of beauty—he notes that this "religion of art" has as its consequence "an even greater indifference to the needs of people using buildings."[48] And while we might expect to applaud the planting of trees, the promotion of parks and plantings came at the expense of human beings who were pushed out of central city housing. In fact, planners pressed trees into service as a justification for demolishing homes, implicitly pitting humans and the preservation or restoration of elements of natural land-

scape against one another. Low-income residents of Cleveland were squeezed into already crowded areas, such as the neighborhood of Hough, where conditions contributed to an explosive uprising in 1966, or they were presented with the option of the ironically named Garden Valley, a development literally built upon a Republic Steel slag heap (fig. 4.13).[49]

Not only did urban renewal rip out large swaths of working-class residential housing, but it did so for the benefit of large institutions and foundation board members' own business interests. One chair of the CDF, Edward Sloan, told a journalist later that "It would be a mistake to think that the foundation ever had as its main concern housing. [T]he main thing was to make land available for industrial and commercial use."[50] It is striking, though it should not be surprising, that Standard Oil, in the person of Upshur Evans, was so deeply involved. The company was founded in Cleveland by John D. Rockefeller, America's first billionaire. It had expanded to become an international corporation, notably by developing a huge market for kerosene in China. (Later, successor companies would negotiate concessions to drill for oil in Sumatra.) Though it had been broken up into smaller companies in federal antitrust proceedings in 1911, its

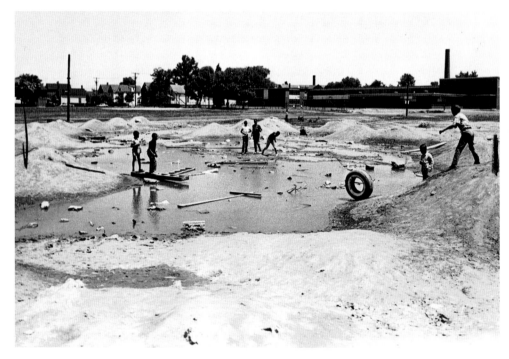

FIGURE 4.13
Children playing in a giant puddle surrounded by garbage, with Garden Valley housing development in the background. Photograph by Bill Nehez for *Cleveland Press*, 1965. The Cleveland Press Collection, Michael Schwartz Library, Cleveland State University.

FIGURE 4.14
Digital collage of clippings from *Cleveland Plain Dealer* classified pages
from the 1960s and 1970s, 2022, courtesy of the author.

continuing incarnation retained significant influence in Cleveland in particular. Urban renewal and suburbanization—in particular the growth of automobile suburbs that created more oil dependency—went hand in hand.

These automobile suburbs, more distant from the city, featured larger lots and hence more private green space. Throughout the 1960s and 70s, one could frequently find narrative advertising that promoted various gazebo designs in the Cleveland *Plain Dealer*'s real estate pages. These ads masquerading as articles offered pleasing ideas for suburban back yards: "Gazebo living," "The great gazebo," "Tepee gazebo outdoor lure," "Screen Gazebo Has Lazy-Bone Relaxing," "Entertain in style under the gazebo," they crow (fig. 4.14). Gazebo ads rubbed shoulders there with listings for houses in new suburban developments. In the landscape of the printed page the narrative ads serve as filler, but also as an enticement to an imagined life of leisure and green space to be had in one's private back yard for middle-class people, mostly White people, to whom the

requisite real estate was being marketed. With its mild exoticism—hinting just slightly of its origins in European park chinoiserie—the gazebo suggests an aspirational pseudoaristocracy for the suburban denizen with a back yard. Homeowners could also purchase designs from a mail-order catalog: in the 1970s and '80s, a Wisconsin company called Sun Designs sold a *Gazebo Study Plan Book* that presented designs available for purchase. Their names and forms gestured to England, continental Europe, and Asia, but also—with names like Monticello, Roanoke, and Dominion—to Virginia plantation days. This, too—a chapter in the history of White flight—is part of the story of the park gazebo.

WE ALL WANT TO WATCH

In the 1970s Cleveland seemed a microcosm of the troubles of urban America. The city had lost almost a quarter of its population, largely to White flight. The region was in ecological crisis; in 1969 the Cuyahoga River had demonstrated how polluted it was by catching on fire. (This had actually happened many times before, but in 1969 the timing was right to catch the imagination of a public newly concerned with environmental health.) Polluting industries were of course heavily concentrated in Cleveland. In 1978, the same Standard Oil that had been so deeply involved in urban renewal there published a series of lectures on the purported benefits of unfettered market capitalism delivered by the economist Milton Friedman.[51] Oil companies certainly stood to gain from Friedman's policy positions. His employer, the University of Chicago, and Standard Oil shared a founder: John D. Rockefeller had poured millions into the university in the early years of its reinvention in the 1890s. (In Cleveland, the largest park within the city limits is still named for the oil magnate.) These lectures formed the core of an influential TV series, *Free to Choose*, that Friedman created and broadcast in 1980, at the dawn of the Reagan years.

It is difficult to overstate the influence of Friedman's free market dogma on economic policy in the later twentieth century. In the US and elsewhere, his views laid the groundwork for dramatically lowered individual and corporate income taxes, the reduction of international trade barriers, industrial deregulation, and school privatization. The role Friedman played in establishing our current political landscape is immense. Here, I read an episode in his television series as a cultural text, teasing out some remarkable themes in its imagery and languages.

In each episode of the series, Friedman presents a filmic essay on some fundamental aspect of economy and society, followed by a seminar on his own proposals, held in Harper Library at the University of Chicago with a handpicked set of guests. Guests on the "Equality" episode include the White leftist political sci-

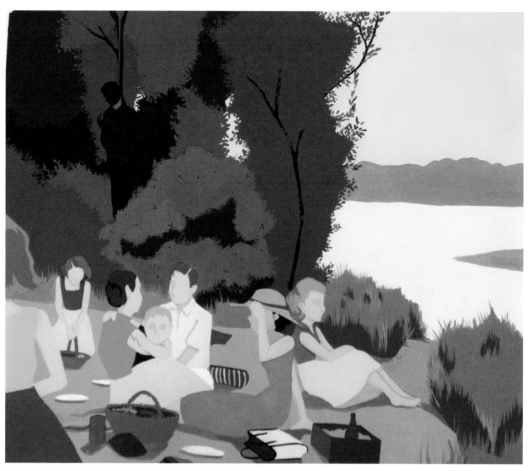

PLATE 1
Brittney Leeanne Williams, *Picnic*, © 2015 Brittney Leeanne Williams.
Acrylic on paper, 12 × 15 in. (30.5 × 38.1 cm). Image courtesy of the artist.

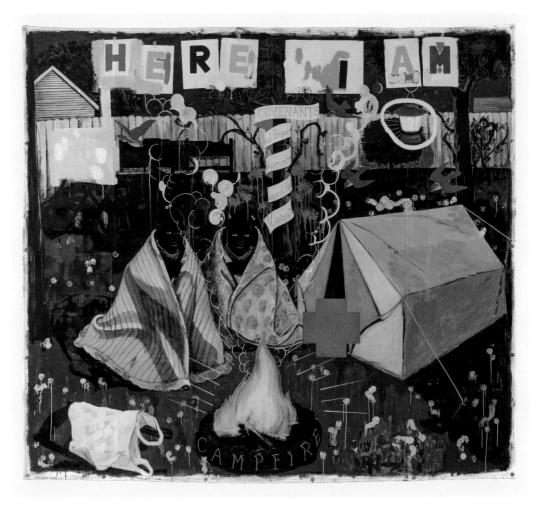

PLATE 2
Kerry James Marshall, *Campfire Girls*, 1995. Acrylic on canvas, 103 × 114 in.
(261.6 × 289.6 cm). © Kerry James Marshall, image courtesy of the artist
and Jack Shainman Gallery, New York.

PLATE 3
Brittney Leeanne Williams, *Naomi and Ruth: Mitosis*, 2020.
Oil on canvas, 36 × 72 in. (91.4 × 182.9 cm). © Brittney Leeanne Williams,
image courtesy of the artist.

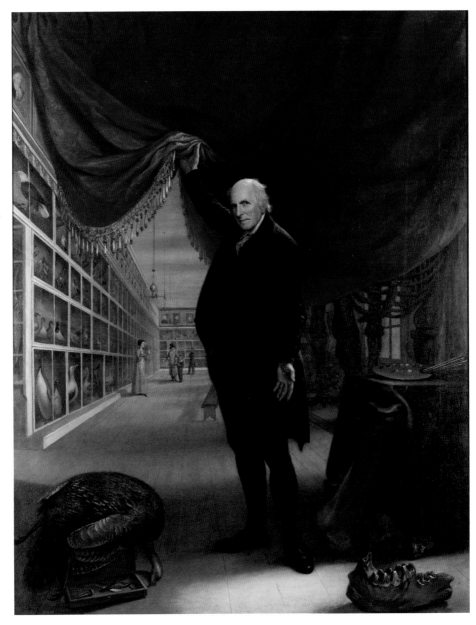

PLATE 4

Charles Willson Peale, *The Artist in His Museum*, 1822. Oil on canvas,
103³/₄ × 79⁷/₈ in. (263.5 × 202.9 cm). Courtesy of the Pennsylvania
Academy of the Fine Arts, Philadelphia, Gift of Mrs. Sarah Harrison
(The Joseph Harrison, Jr. Collection), 1878.1.2.

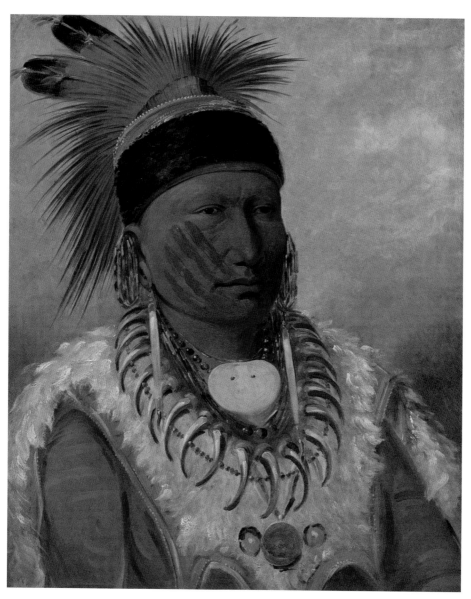

PLATE 5
George Catlin, *The White Cloud, Head Chief of the Iowas*, 1844/1845.
Oil on canvas, 27¹⁵/₁₆ × 22¹³/₁₆ in. (71 × 58 cm). National Gallery of Art,
Paul Mellon Collection, 1965.16.347.

PLATE 7

Barnett Newman, *Vir Heroicus Sublimis*, 1950, 1951. Oil on canvas, 95³/₈ in.
× 213¼ in. (242.2 × 541.7 cm). Gift of Mr. and Mrs. Ben Heller. © Barnett
Newman Foundation / Artists Rights Society (ARS), New York. Digital Image
© The Museum of Modern Art/Licensed by SCALA / Art Resource, NY.

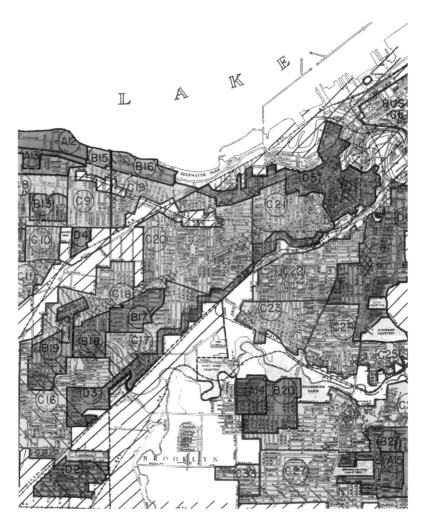

PLATE 8
Redlining Map of Cleveland by Mapping Inequality.
Licensed under CC BY–NC–SA 4.0.

PLATE 9
Amanda Williams, *Color(ed) Theory: Harold's Chicken Shack*, 2016.
Inkjet print on 100 percent rag photo paper, 22 × 32 in. (56 × 81 cm).
Image courtesy of the artist.

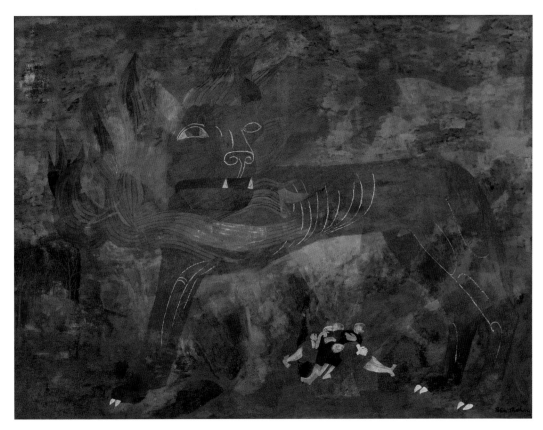

PLATE 10

Ben Shahn, *Allegory*, 1948. Tempera on panel, 36¹⁄₈ × 48¹⁄₈ in. (91.76 × 122.24 cm). Collection of the Modern Art Museum of Fort Worth, Gift of William P. Bomar Jr. In Memory of Mrs. Jewel Nail Bomar and Mr. Andrew Chilton Phillips. © 2023 Estate of Ben Shahn / Licensed by VAGA at Artists Rights Society (ARS), NY.

PLATE 11

Faheem Majeed, *Shacks and Shanties*, structure at 71st Street and East End Avenue, 2013. Photo by Jeanne Lieberman. Image courtesy of Faheem Majeed.

PLATE 12
Amanda Williams, *Currency Exchange, Safe Passage*, from the
Color(ed) Theory Suite, 2014–16. Inkjet print, 22 × 30 in. (55.9 × 76.2 cm).
Image courtesy of the artist.

PLATE 13

Alan Michelson, *Third Bank of the River*, 2009. Etched glass, 69 × 489 in.
(175.3 × 1,242.1 cm). Image courtesy of the artist

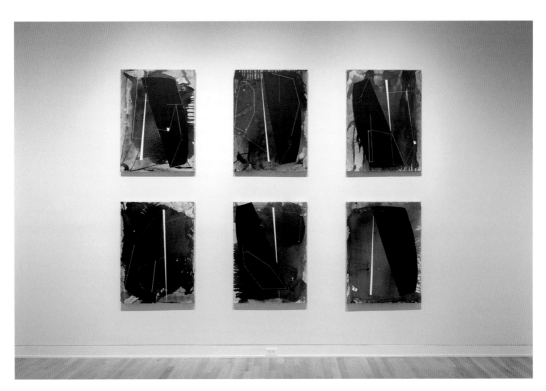

PLATE 14
Installation view of *Torkwase Dyson: Black Compositional Thought | 15
Paintings for the Plantationocene*, 2020. © Torkwase Dyson, image courtesy
Pace Gallery and the New Orleans Museum of Art: Photography by Sesthasak
Boonchai, R.2022.6.

PLATE 15
Dylan Miner, *Agamiing—Niwaabaandaan miinawaa Nimiwkendaan //
At the Lake—I see and I remember*, 2018. Commissioned by Blackwood
Gallery for *The Work of Wind: Air, Land, Sea*. Photo: Spiral Mountains Media.
Courtesy Blackwood Gallery.

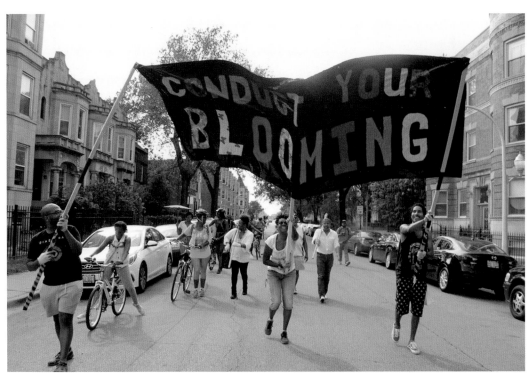

PLATE 16

Cauleen Smith, *Conduct Your Blooming*, 2016. Polyester, sequin–dot fabric, felt, cotton, and thread, 55 × 150 in. (139.7 × 381 cm). Photograph taken at the Procession of Black Love by Kate Sierzputowski. Image courtesy of the artist and photographer.

entist Frances Fox Piven and the conservative Black economist Thomas Sowell. Friedman typically included speakers of varying ideological backgrounds. But these very deliberate choices suggest how centrally the politics of race and gender infuse the episode's consideration of equality—how central, indeed, they are to the market theology that has come to be known as neoliberalism.

In "Equality," Friedman responds to claims that had been staked by the social movements of the preceding three decades, in particular the demand that the United States adhere to its stated principle of equality for all. If the market—in Friedman's view—is the peerless progenitor of All Good Things, an imagined critic asked, then why hasn't it produced equality? Immediately seeking to deflect any potential criticism of this position on grounds of racial or gender bias, Friedman mobilizes *difference* as a reason *equality* should not be a societal aim. He identifies the superior attributes of two individuals—who happen to be a White woman and a Black man—and presents these attributes as *nature's offer* of a public good in the form of consumer spectacle. The attributes are bodily:

> There is nothing fair about Muhammad Ali having been born with a skill that enables him to make millions of dollars one night. There is nothing fair about Marlene Dietrich having great legs that we all want to watch. There is nothing fair about any of that. But on the other hand, don't you think a lot of people who like to look at Marlene Dietrich's legs benefited from nature's unfairness in producing a Marlene Dietrich. . . . In the same way, it's unfair that Muhammad Ali should be a great fighter and should be able to earn millions. But would it not be even more unfair to the people who like to watch him if you said that in the pursuit of some abstract idea of equality we're not going to let Muhammad Ali get more for one night's fight than the lowest man on the totem pole can get for a day's unskilled work on the docks?

In other words, if Muhammad Ali did not have extraordinary fighting ability, and if Marlene Dietrich did not have beautiful legs, *viewers* would be deprived of the visual pleasures produced by the racialized and sexualized physical body in motion. Dietrich and Ali exist as bodies "we all want to watch." Absolute equality is undesirable because it would deny consumers a choice of entertainment. Sitting in front of bookshelves holding modern sculptures, decoration for his office (fig. 4.15), he exclaims, "What kind of a world would it be if everybody was an absolute identical duplicate of anybody else? You might as well destroy the whole world and just keep one specimen left for a museum."

What happens next in the film is stunning. The camera cuts to a hazy day at Monticello, Thomas Jefferson's Virginia estate. Birds and crickets chirp as dust motes catch the light and sparkle for the camera. The display of the gardens removes us from the narration for a moment—but only for a moment. "This

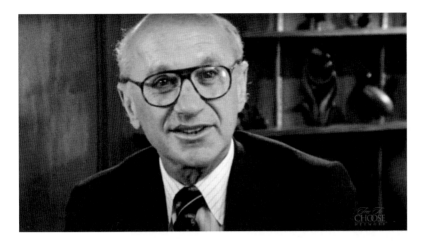

FIGURE 4.15
Free to Choose, episode
5, "Created Equal,"
directed by Graham
Massey, 1980. Friedman
in his office, still.

beautiful estate," Friedman's reedy voice intones, "its manicured lawns, its trees, its shrubs, was built by men and women who were taken by force in Africa and sold as slaves in America." Jamaica Kincaid, in her essay "Sowers and Reapers," tells us some of their names, quoting from Jefferson's *Garden and Farm Books*: "Ursula, George, Jupiter, Davy, Minerva, Caesar, Jamy; and the Hemings, Beverly, Betty, Peter, John, and Sally . . . It is they who sowed the peas, dug the trenches, and filled them with manure. It is they who planted and harvested the corn. And when Jefferson makes this entry in his 'Garden' book, on April 8, 1794—'our first dish of Asparagus'—it is they who have made it possible for him to enjoy asparagus."[52]

The captor who enslaved these people, Friedman explains, "wrote these words: 'We hold these truths to be self-evident. That all men are created equal. That they are endowed by their Creator with certain inalienable rights. That among these are life, liberty, and the pursuit of happiness.'" In a breathtaking juxtaposition of image and narration, the camera lingers over an advertisement for a slave auction—with images of slaves being sold on the block—at the precise moment Friedman's voiceover asks, "What did Thomas Jefferson mean by the words 'all men are created equal?'" (fig. 4.16).

The University of Chicago slide collection, as it happens, contains numerous images of Monticello: its classicizing Palladian architecture, with plans and various views, front and back; its gardens, including a square garden temple; its south entrance with stone lions; and the "service quarters" that housed the people Jefferson enslaved. These small outbuildings were similar in size to the garden pavilions, but their purpose could not be more different. There's even a shot of the tunnel connecting these barracks with the basement of the main house (fig. 4.17).

As Friedman has already invoked slavery, one might imagine that he will now explain that Jefferson was a slaveholder, that his notion of equality was

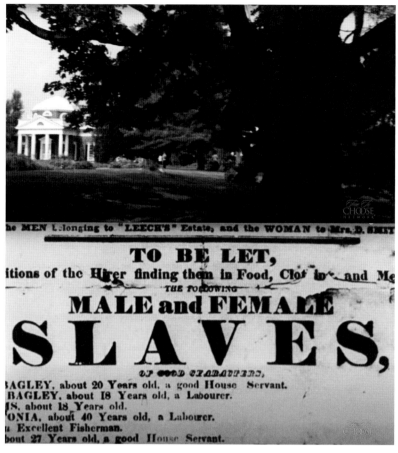

FIGURE 4.16
Free to Choose, episode 5, "Created Equal," directed by Graham Massey, 1980.
Monticello's gardens; slave auction broadside, sequential stills.

inconsistent, but that we must analyze his statement in historical context. But even *this* isn't Friedman's point. To explain why Jefferson could not have meant "equal" in the modern sense (or is it rather that he could not have meant "all men" in the modern sense?), he states instead that *Jefferson knew* that "*after all, he was himself a most remarkable person.*"

That is to say, he argues that we need not historicize Jefferson at all. Rather, we must accommodate ourselves to Jefferson's notion of equality, which must have included room for some persons to be "remarkable" and for others to be enslaved. It is damnably circular: his exploitation of the people he enslaved gave him the wealth and ease that enabled him to express his remarkableness, a remarkableness that allows him to justify the fact of keeping people enslaved. But Friedman is skating quickly over these ideas, and his next move is to footage of Asian sweatshop workers—who, Friedman claims, are able to "get ahead"

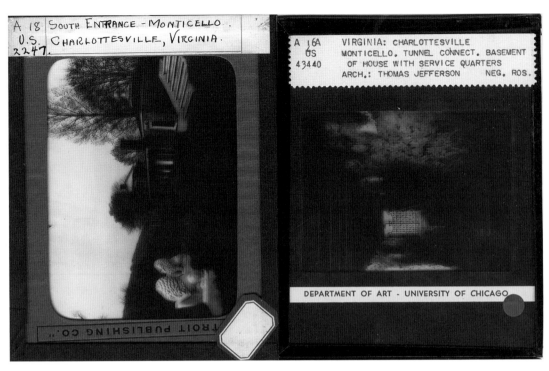

FIGURE 4.17
Left: "South Entrance—Monticello. Charlottesville, Virginia." University of
Chicago Glass Lantern Slide Collection, Rebuild Foundation. Right: "Virginia:
Charlottesville, Monticello. Tunnel Connect[ing] Basement of House with
Service Quarters." University of Chicago Glass Lantern Slide Collection,
Rebuild Foundation.

because their employers aren't subject to workplace safety regulations. In other
words, whether they are aware of it or not, their oppression is to their benefit.

To put it more bluntly, Friedman mobilizes the gardens of Thomas Jefferson's
estate of Monticello, the fact that they were created by enslaved people, as a way
to cast doubt upon the significance of equality in the US Constitution. Equality
for him is *not* an unmet aspiration of the founding fathers but simply not some-
thing they believed in, at least not by a modern definition. If Thomas Jefferson
owned slaves, the words "all men are created equal," Friedman implicitly argues,
has to be read in more limited terms, and not as a central goal toward which
policy should strive.[53]

Jefferson held his gardens dear; he wrote to Charles Willson Peale that "No
occupation is so delightful to me as the culture of the earth, and no culture
comparable to that of the garden. I am still devoted to the garden. But though
an old man, I am but a young gardener."[54] The brief but important appear-
ance the gardens of Monticello make in "Equality" can also remind us of the
role Jefferson played in determining the history of the physical landscape of

the US, defining land use and the policy of settler expansion. The expansionist land policy Jefferson pursued with the 1785 Land Ordinance encouraged what he saw as virtuous, independent smallholders, "yeoman farmers," a model that many have argued was carried over into the design of suburbs in the twentieth century.[55] Over cities and commerce, Jefferson prefers a land divided into small farms.[56] To observe again how racial difference in the US has been triangulated through ideas about Asia, I note that Jefferson found a model for an isolationist and agriculturalist society in China. In 1785, in a letter to the Dutch statesman Gysbert K. van Hogendorp, he wrote, "You ask what I think on the expediency of encouraging our States to be commercial? Were I to indulge my own theory, I should wish them to practice neither commerce nor navigation, but to stand, with respect to Europe, precisely on the footing of China. We should thus avoid wars, and all our citizens would be husbandmen."[57] Jefferson's reflections rested upon a view of China like that of Charles Gustavus Eckeberg, the Swedish author of *A Short Account of the Chinese Husbandry*, published in English in 1771. Eckeberg wrote that China's ability to stand alone was the result of profound natural riches: "the empire of nature is found in the greatest perfection in China."[58]

Thinking back to our understanding of the historical resonances of the gazebo, as a pseudo-Asian architectural form found in American parks and gardens, Jefferson's thinking on China might add another layer of meaning. A society based in small farms, not cities, would, he thought, be more easily governed. Jefferson articulated his preference for an agricultural basis of society in his *Notes on the State of Virginia*, published in the same year. In that text he argued strenuously against the potential growth of industry. He declared, "While we have land to labour then, let us never wish to see our citizens occupied at a work-bench, or twirling a distaff. Carpenters, masons, smiths, are wanting in husbandry: but, for the general operations of manufacture, let our work-shops remain in Europe. It is better to carry provisions and materials to workmen there, than bring them to the provisions and materials, and with them their manners and principles."[59] From a modern perspective it seems surprising that he rejects the idea of building up industry in the US. He suggests that it is preferable to undertake the expense of transporting raw materials to Europe and importing the finished products, rather than running the risks of social unrest that an artisan class—which, strikingly, he equates with disease—would harbor. "The loss by the transportation of commodities across the Atlantic," he writes, "will be made up in happiness and permanence of government. The mobs of great cities add just so much to the support of pure government, as sores do to the strength of the human body.[60] Cities, Jefferson argued in a letter of 1800 to Benjamin Rush, were "pestilential to the morals, the health and the liberties of man."[61]

Jefferson's 1785 land ordinance, the "Ordinance for ascertaining the mode of

disposing of lands in the Western Territory," imposed the grid of one-mile square plots that governed the distribution of property in the western United States, beginning with the Midwest. Chicago's street grid—among others—aligns with it. The ordinance provided that the gridded survey be completed before any land could be distributed (some parcels were given outright to Revolutionary soldiers, others sold for a dollar a parcel). The method draws on practices already in place in the Northern and Southern states and also reflects the influence of Enlightenment ideas of rationality on Jefferson and his circles. The regularity of the grid, it must be noted, could signal equality, with an initial division into equal plots—even if they can also be agglomerated or subdivided.[62] At the same time, this notional equality handed land over to White settlers specifically. The reproduction of European culture was also at stake: the ordinance provided for the establishment and financing of public schools based on land settlement, a linkage that would have many implications over its long history in the United States. Eventually, the process of surveying in a grid extended to the Pacific and set the stage for further extensions that would come with the 1862 Homestead Act.

Ohio, as it happens, was the first testing ground for this surveying process: it was the easternmost portion of the Northwest Territory. The starting point for the survey was the point where Ohio, Pennsylvania, and Virginia met.

PLACES FOR PLAYING

Let us head back to Ohio, then. There are many other ways I could talk about the Cudell neighborhood in the years since the 1960s and 1970s. These might include demographic change and race relations, the history of policing, the history of industry and its effects on the natural and human environment, who gets protected by the police, who is seen as "out of place," and how the broader climate of antiblackness expressed itself in that site. As I assemble diverse reference points for thinking about the gazebo as part of a history of landscape's relationship to labor and leisure, race and nature, I ask some final questions. If parks and gardens are spaces for play—both for the body and for the imagination—who actually gets to have that luxury, that leisure? Who gets to have—to use Kant's or Milton Friedman's term—that freedom?

The 1945 booklet *Places for Playing* describes park shelters as follows: "The shelter house, an essential feature, should serve as a center of control and as the major architectural feature of the playground."[63] This prompts more questions: Why is the shelter a "center of control"? Why is a park a setting that requires controlling? A place from which to view the landscape, a place to concentrate the use of space, a place that can be controlled? Why might a Black boy inhabiting a park be perceived as an unruly body—someone, or perhaps something,

in need of controlling—matter out of place? There was snow on the ground, and if the gazebo had not been there, in the park, would Tamir Rice be alive today? Why was he not afforded the chance to choose *idleness*, to be a kid, to play, even to misbehave, if he wanted to, and not be murdered for it? We know the answer to these questions is found in antiblackness. What would it mean to fully recode the outdoors, its spaces, its landscapes, to support Black life and not Black death?

Cleveland is also the site of the extended and poetic re-vision of landscape that appears in Dawoud Bey's series of large-scale photographs, *Night Coming Tenderly, Black*.[64] In these images Bey observes a series of deeply shadowed Ohio landscapes, imagining scenes from the perspective of a Black freedom-seeker escaping enslavement in the South. A tangled thicket with a fleeting light in the distance, an obstructed partial view of a house or fence, the agitated open water of Lake Erie in *Untitled #25 (Lake Erie and Sky)*—these scenes suggest ambiguous affects, the intertwining of hope and dread (fig. 4.18). Night obscures direction. Darkness can hide hostile presences, or offer cover, or both. Houses might offer hope of shelter, warmth, and food—if they are the right ones—but considerable risks if they are not.

FIGURE 4.18
Dawoud Bey, *Untitled #25 (Lake Erie and Sky)*, 2017.
Gelatin silver print, 17½ × 21⅞ in. (44.5 × 55.5 cm).
© Dawoud Bey. Courtesy of Stephen Daiter Gallery, Chicago.

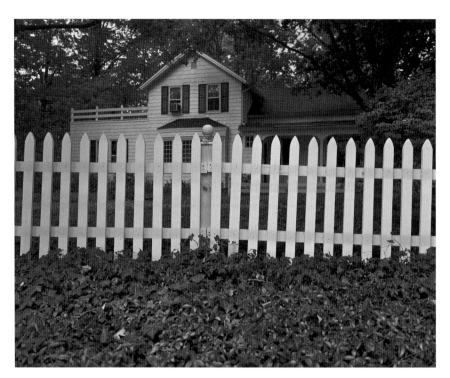

FIGURE 4.19
Dawoud Bey, *Untitled #1 (Picket Fence and Farmhouse)*, 2017.
Gelatin silver print, 17½ × 21⅞ in. (44.5 × 55.5 cm). © Dawoud Bey.
Courtesy of Stephen Daiter Gallery, Chicago.

In *Untitled #1 (Picket Fence and Farmhouse)*, the white picket fence and the traditional farmhouse architecture of a house built in the 1860s situate the viewer of this scene historically (fig. 4.19).[65] Bey brings the viewer close to the white picket fence placed as a barrier, and insists we give our attention to the tangle of greenery underfoot. He collapses historical time with the air conditioning unit visible on a window, creating a mythic temporality—no less true—that reminds us of how history informs the present, and vice versa. Bey suggests a different way of understanding what an image is, what the position of "the viewer" might be. Vision as longing, apprehension, desire for security and the chance to flourish and connect, even to reconnect: this is an entirely different emotional register from the commanding view that characterizes modern theories of perspective, a view based on, we might say, "mastery." As Steven Nelson points out, Bey does not establish a strictly referential documentary truth, even when he photographs sites that have significance to the historical Underground Railroad. The images, he writes, "exist instead as reflections on the experiences and agency of fugitive slaves, as well as openings onto a black world that troubles the conditions of white domination."[66] With his twilight palette of grays, Bey also educates

viewers in an understanding of a core American history of what the outdoors means and has meant. He replaces the "great outdoors" with the point of view of those excluded from its central mythic truisms.

I want to insist that the revisioning of these scenes—and the reframing of the gazebo—can matter, can have an impact, even as I acknowledge art's fragility as a mode of political engagement. When I first saw the disassembled gazebo in the Stony Island Arts Bank, it seemed to function equally well as art, archive, and memorial. It was almost as if, taken out of its functional existence and redisplayed as raw material, basic material stuff, it couldn't *hurt anyone* anymore, even if it could prompt a keen emotional response. For Gates it remains "one of the ways that the material world insists that something bad happened."[67] I wasn't sure, though, how I felt about its being reconstructed and placed in the landscaped lawn to the north of the building. To the extent that the gazebo at least conceptually holds some collective guilt in it, it felt risky, and raw, to situate it once again as a usable shelter in that space—in between park and art space, not exactly a park shelter but not exactly not. In art terms the gazebo might be thought of as a readymade, but one which brings along with it a heavy burden of accumulated pain and history. The function of the Arts Bank is not quite the same as the Cudell Center, but it is similar; whatever the benefits to the

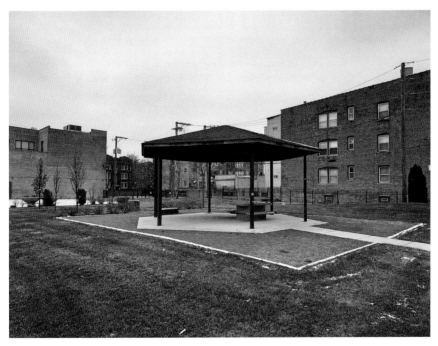

FIGURE 4.20
Cudell Park gazebo reinstalled at Arts Bank Lawn,
Rebuild Foundation, Chicago, 2022. Photo by author.

community provided by the bank, whatever society its programs hope to build, it gives no guarantee that it can protect another child from the same fate.

The meaning of this place is also about how young people might claim and use the space. One example is the way Bravesoul Movement, a hip-hop dance collaboration, occupied the space to hold an impromptu ceremony as a tribute to Tamir. Dancers and spectators circled the gazebo. An organizer invited the group to say whatever words might come to mind. As Julie Yost, the programming manager of the foundation at the time, told me: "The words came slowly at first, and then more quickly, 'Justice,' 'Hope,' 'Remember,' 'Black Boy Joy.' 'Two Seconds,' 'Tamir Rice,' 'Peace.' There was a minute of silence, and then a moment of noise. The entire group filled the gazebo with sound. It was an unexpected and powerful moment that gave me chills."[68]

It matters that Gates refused the designation of "art" for the gazebo, in contrast to other works he has made from found or donated materials. It is not for the market or gallery or museum. The gazebo as installed on the Arts Bank Lawn represents, as many participants at the dedication insisted, "a place for children to play." As Gates put it, "We were trying to make space for children to play, trying to remember Tamir, trying to make space so that the commemoration of Tamir would be done with the right level of dignity."[69] During the COVID-19 pandemic, things were quiet at the Arts Bank, and the gates remained locked as the mayor of Chicago kept beaches and playgrounds closed even when she allowed bars to reopen. What comes next for the gazebo? (fig. 4.20).

It is—it should be obvious—vital for children to be allowed to be children, a privilege that American society has accorded to White children, but often denies to Black children and children of color. (Think of the portrait of Elihu Yale and his friends.) However, the gazebo on the Arts Bank Lawn is not a play space. The lot is bounded by a metal fence, made accessible to passersby through gates on three sides. There are no other play structures in the lot, and the central approach to the gazebo is designed to elicit thoughtful reflection.[70] It may represent play, the need for spaces for play, but does so symbolically—as a critical intervention— more than it actually performs it. In this sense, in its very unartlikeness, it becomes artlike in spite of itself.

5
HOME

Color, Abstraction,
Estrangement, and the Grid

TO COME HOME SOONER OR LATER

In 2014 Amanda Williams started painting the town red (plate 9). And pink, and teal, and purple, and orange. To be more precise, it was Harold's Chicken Shack red—named for an iconic South Side Chicago restaurant chain—Pink Oil Moisturizer pink, Ultrasheen teal, Crown Royal bag purple, Flamin' Red Hots orange. In this project, called *Color(ed) Theory*, she drew on her experience as an architect, painter, and educator and on her own personal history. She identified a series of houses in the Chicago neighborhood of Englewood that were slated for demolition. Together with collaborators, she painted each in a bright hue that she identified with particular cultural significance for Black communities of Chicago's South Side, which is also where she grew up.

These vibrant monochromes create solid, opaque surfaces that afford the viewer no access. They break with the expectation of trim or details of a contrasting hue. With their doors and windows boarded up, the uniform color treatment blended the exterior features of each house together, creating the impression, with some variations, of a single, solid surface. When Williams fully covered the buildings in a single color they became like minimalist objects—like a Donald Judd cube, a solid, unbroken block of bright color, but more monumental. They were abstract, almost as abstract as you can get. They might remind us of Rachel Whiteread's 1993 *House*, a concrete cast of the interior of a demolished house in East London, or Gordon Matta-Clark's *Splitting*, in which he split a condemned house down the middle with a chainsaw.[1] But Williams's houses keep the viewer out—they maintain a sense of privacy for the interior even as they became objects of attention for community members and the art world alike.

Williams began this work while teaching at the Illinois Institute of Technol-

ogy, IIT, the historic home of Chicago's New Bauhaus—a place for modernist design par excellence. The work partakes in the idioms of abstract painting or sculpture, resonating deeply with the artworld's histories of modern art. Standing as simulacra of abstract sculptures visible in public, they also gesture toward the idiom of the monument. But what do they do with it?

There is a history to the monochrome house as political message in the hollowed-out neighborhoods of US cities. Beginning in 2005, a group of five artists in Detroit going under the name "Object Orange" painted abandoned houses that were in a dangerous state of disrepair a shade of safety orange in order to draw attention to them and push the city to demolish them. In Pittsburgh in 2014, the artist Dee Briggs painted a threatened house at 1404 Swissvale Avenue in gold paint, dubbing it the House of Gold. Recognizing that it would be demolished, she sought nevertheless to draw attention to the metaphorical "gold" that outsiders missed when they looked at the neighborhood's people and places, and used the occasion of the artwork as a way of enacting a "gentle" demolition.[2]

Williams added to this series of projects a palette of hues posed as an explicit alternative to the standard color wheel of academic color theory, the subject of classes she taught at IIT. She makes the point that "color" is not just a color wheel, in the context of racially segregated Chicago: it signifies race, and not only through skin color but by marking the visible retail landscape, the colors that visually designate an area as a Black neighborhood, or "urban," or "ghetto."[3] As she put it on her website, "colors possess socially constructed meanings and associations that are inextricably linked to the politics of race and class in America."[4] *Color(ed) Theory* draws attention to the history of racial capitalism and how it has shaped geographies and social ecologies, setting up social divisions that determine who gets to enjoy the benefits of "community." Williams's work, I suggest, gains its power not only from the symbolism of her color palette but also from the way ideas of home, race, and abstraction have played with and against one another over the past century, especially in the space of Chicago's South Side. In this chapter I trace a winding journey though these ideas before returning to *Color(ed) Theory* to see how they can inform our understanding of the project. What might happen to the characteristic preoccupations of modern art if we take the South Side of Chicago as a center and not a periphery?

ASCENDANCY

One part of my argument will be that *Color(ed) Theory* makes an important intervention in what it means for art to be "abstract." To pursue this line of thinking, I need to back up a little and address what abstraction means within art history. The monochrome—a field or object of a single color—is one mode of

abstraction. But abstraction can mean many different things. For much of the twentieth century it posed itself as the epitome of the modern, following a trajectory that started at the beginning of the century in Europe and found its center after World War II in New York City, with artists like Barnett Newman and his peers. As a dramatic break with tradition, it sometimes carried revolutionary, leftist politics along with it. But as it became established in the Cold War US, it developed into quite a different beast. From a rebellious and iconoclastic movement against entrenched tradition, it transformed into an official style. Alluding to this situation, Joan Marter referred in a 1994 essay to the "ascendancy of abstraction" that arose for public art in the mid-twentieth century. Her essay addresses the competition for the Monument to the Unknown Political Prisoner, launched in 1953 by the Institute of Contemporary Arts in London (but with substantial ties to the US Department of State). That competition signaled openness to abstraction from the outset, in the documents put forward in its call for proposals: "the organizers wish to emphasize that a symbolic or non-representational treatment of the subject will receive the same consideration as a more naturalistic treatment."[5] The choices made in the American portion of the competition reflected a pronounced preference for the abstract. As Marter also notes, the US State Department used the aesthetic trend of abstraction as part of a goal of "affirming the cultural supremacy of the United States and its allies," associating it with "the freedom of the individual . . . while figuration provoked associations with the Socialist Realism of the Communists and the Third Reich."[6]

The competition never resulted in the installation of a sculpture—it seems the initial major donor withdrew support. A trace subsists in the reconstructed maquette of the winner, Reg Butler, which was purchased by the Museum of Modern Art in New York. It had to be reconstructed because the original was damaged beyond repair in an attack by another artist, Laszlo Szilvassy, a Hungarian refugee who charged the winning entry with antihumanism. "Ascendancy," it turned out, did not mean unanimity. But abstraction did become the dominant mode of the US and European art worlds—and in popular media, with Jackson Pollock in *Life* magazine and Clement Greenberg on the Voice of America. Refusing the representation of the human form, or any identifiable form, of "nature," abstract art proclaimed its superiority as an expression of freedom, and its universality of address to a global public. In her classic feminist essay "The MoMA's Hot Mamas," Carol Duncan identifies the canonical narrative of modern abstraction on display at the Museum of Modern Art in New York: the artworks (and their spectators) "ritually perform a drama of enlightenment in which freedom is won by repeatedly overcoming and moving beyond the visible, material world."[7] A visible, material world signified, for her, by female bodies that are the objects from which painting—at least in the MoMA canonical narrative—frees itself.

In a sense, we might say that every representational artwork is also an abstraction. If it is based in observation, we could say that it operates by way of abstracting or translating qualities seen in the world, in the original object of depiction. In the case of painting, on a very basic level, it flattens the three dimensions observed in the world into two. Abstraction in a more radical sense might mean defining painting as, simply, this production of flatness, a return to its own basic principles. It might mean an assertion—like Barnett Newman's—of an even realer real; it might luxuriate in color, in the messiness of paint.

As a certain orthodoxy was forming in the middle twentieth century, a number of artists stood outside this current. Ben Shahn critiqued it in his 1957 book *The Shape of Content*, based on his Norton Lectures at Harvard. He described a trajectory in which the formalist position articulated by Clive Bell (who opined that "the representational element in art may or may not be harmful, but it is always irrelevant") was "once proffered as an isolated opinion" but is now "very dominant"—with its stress landing on the harmfulness, and not only irrelevancy, of content. As Shahn describes this "paint-alone point of view," it contends "that material alone is sufficient in painting" and "that any work of art should be devoid not only of subject, or of meaning, but even of intention itself."[8] Shahn alludes to monotone or near monotone paintings by Clyfford Still, Mark Rothko, and Ad Reinhardt, but he gives primacy to Kazimir Malevich: "there is always Malevich's 'White on White,' which still holds first place in the competitive race against content."[9] From this perspective, white seems to suggest blankness, a total emptying out.

In the nineteenth century, European and Euro-American painters posed repeated challenges to entrenched academic hierarchies of subject matter. These hierarchies put narrative on top, in the form of "history painting" that operated with the human form as its basic unit. Modern painters took new interest in deprecated genres like landscape, still life, and "genre painting" that often focused on working-class people and daily activities rather than grandiose historical or mythic personalities. A key question for the history of art is whether we should see this move as a reversal of hierarchy with a political purpose, or a flattening of subject matter and its significance altogether. Is the main point that artists intentionally selected humble subject matter, natural beings, basic necessities (the raw materials and food and drink of the still life), and nonelite people? Or are these changes more importantly a disregard for subject matter understood cognitively, in favor of optical experience that will evolve toward purely formal qualities? For some artists the overturning was political. But a history of art that finds its telos in formalism would see a drive toward the dethroning of naturalistic subject matter altogether.

In the US art world, it was in part the clout of Clement Greenberg (who notably said in one review of Shahn's work that "this art is not important, is essen-

tially beside the point as far as ambitious present-day painting is concerned"[10]) that sustained the midcentury emphasis on form and formalism. Where abstraction was the artist's method, formalism was the critic's. Greenberg relegated representational art—of whatever place or time—to an earlier stage of development, the cheap pleasures of kitsch, or the dangers of propaganda. It implied excessive "interest" in the sense that viewers were inclined to identify with the represented figures, an identification that prevented them from taking the properly *dis*interested aesthetic position, a position Greenberg derived from Kant. The best art of the present, in his view, was no longer concerned with representing nature—producing an illusion of three-dimensional space—and was now engaged in a project of creating its own alternate nature.[11]

But this alternative might still be understood in spatial terms. In her influential essay "Grids," Rosalind Krauss proposed the grid as the epitome of art's autonomy from "nature." This grid can be associated with Piet Mondrian, with Agnes Martin, and with numerous other artists (I've already alluded in the previous chapter to Barnett Newman's geometric canvases as the basis for a "grid of gender" in the way they were routinely photographed). "In the spatial sense," Krauss writes, "the grid states the autonomy of the realm of art. Flattened, geometricized, ordered, it is antinatural, antimimetic, antireal. It is what art looks like when it turns its back on nature."[12] When she refers to the "spatial sense," I think she means it only in the sense that paintings literally occupy space—she certainly does not want to imply that the grid *depicts* space. But it's a funny thing about the idea of a grid. What more common understanding of it was there than the plan of urban streets? If we may think of an abstract painting as one that has been *emptied* of figures, what remains may still be seen as a representation, however reduced, of the space those figures would otherwise occupy. In practical terms, indeed, numerous modernist painters took landscape—a genre that, already, declined to privilege the human form—as the starting point for distilling what they saw as essential or primal qualities of nature. To create, in other words, abstractions. Certainly, the rejection of painterly illusion, the emphasis in abstraction on the two-dimensional space of the painted surface, necessarily collapses the fictional three-dimensional space of linear perspective. Even if we are no longer looking out a window onto the world, we may still be looking at something we can characterize in spatial terms. The words we use to discuss even the most abstract painted surface—field, ground, surface, plane, block, expanse—evoke spatial metaphors. Malevich called what was left of painting when figuration receded "a desert." For him this was a spiritually bountiful place—but still a place.[13] And the promotion of the avant-garde traffics in ideas of conquest of territory. It is hard to escape.

The mid-twentieth century brought with it a new set of questions on this score. If Clement Greenberg saw in American painting of that era the continued

modernist ambition to fabricate a new "nature," Leo Steinberg saw a different kind of break. In "The Flatbed Picture Plane," he argued that Robert Rauschenberg had been the first artist to break with a view of the artwork as essentially like "nature" at all. The conception of the picture plane as a flatbed revised the sense that a picture represented a *world*, even an imaginary or entirely abstract one, on which a human viewer gazed.[14] Even abstract expressionism, Steinberg argued, retained a sense of art as imitation of "nature," when one understands nature at its core as the logical correlate of a standing human observer, such that Jackson Pollock's drip paintings, even if produced with the canvas on the ground, appear as "thickets" once mounted—as they are destined to be—on the wall. The flatbed picture plane invented by Rauschenberg associates the painting with the *work surface*, with actions and operations internal to art. "The painted surface," Steinberg argues, "is no longer the analogue of a visual experience of nature but of operational processes." It is about the work of art itself—not simply the "art work" but the *work*, the labor, of making it. Steinberg called it "post-Modern" long before this term became a household word. It is not merely art about art but a quintessentially *urban* mode of painting: "Rauschenberg's picture plane is for the consciousness immersed in the brain of the city." There is no longer an implication of "a prior optical event." Rauschenberg literally turned his bed into a painting, but could this *flat bed* not also be seen as a matter of thinking about nature in a different way—as land? Whether bedrock, roadbed, or garden bed, the idea of the flatbed also lends itself to geography.

ABSTRACTION AND HOME

But is this a geography in which we can be *at home*? If we look to the reception of abstraction in twentieth-century Chicago, in particular, the question of home and, conversely, that of the strange or foreign that oppose it, keep coming up. This was true already early in the century, when the International Exhibition of Modern Art—otherwise known as the 1913 Armory Show—came to Chicago's Art Institute. The mixed response emphasized, again and again, the foreignness of the artists whose works were on display.[15] That initial hesitation about the strangeness of modern art and its abstract images shifted over time, and a new interest in avant-garde art crystallized at the moment of Jean Dubuffet's 1951 lecture at the Arts Club, "Anticultural Positions." But it was only reluctantly that in 1967 Chicago became the site of one of the first major abstract public sculptures in the US, the one now known as the "Chicago Picasso." In her inaugural poem in its honor, Gwendolyn Brooks made the idea of home central to the public emotion the sculpture evoked. "Art hurts," she wrote. "Art urges voyages— / and it is easier to stay at home, / the nice beer ready."

Brooks does not say directly that she is addressing abstract art in particular, but abstraction is clearly at stake. As Brooks was writing her dedication the media was puzzling over the Picasso, trying to figure out what this "whatsit" was. She strikes a celebratory note when she suggests that art urges voyages—but she tempers it by the end of the poem, when she commands: "*Observe the tall cold* of a Flower which is as innocent and as guilty, as meaningful and as meaningless / as any other flower in the western field." For Brooks, Picasso's abstract sculpture doesn't engage the same warmhearted affection as the Wall of Respect (fig. 5.1), a mural of Black heroes and heroines created on the side of a Bronzeville building, which Brooks wrote about that same summer. A flower in "the western field": the West, or Midwest, of the Illinois prairie, but also the "field" of Western aesthetics. Abstraction here falls into a solipsistic realm of art for art's sake. Meaning is not the point; the flower is cold.

In 1970 Brooks's contemporary Margaret Burroughs, artist, writer, teacher, prison activist, and museum founder, interpreted abstraction in painting as, precisely, an *absence of Blackness* and a sense of estrangement from home. She cites a communication from Ernest Crichlow: "The black intellectual or artist in his training period goes off into that realm of white-oriented western esthetic . . . but he has to come home sooner or later, if only to sleep or to get his battery

FIGURE 5.1
Robert A. Sengstacke Jr., *Young Men Observing the Wall of Respect*, 1967.
Photograph. Courtesy of Images of Black Chicago: The Robert Abbott
Sengstacke Photography Archive, University of Chicago Visual Resources
Center LUNA Collection. Copyright Myiti Sengstacke–Rice.

recharged. When he comes back home, he is forced to deal with his own personal esthetics, even if he is determinedly non-black in all aspects and paints abstract expressionism in white-on-white!"[16] "White-on-white" is not the only way to do abstraction, but the association of chromatic whiteness with cultural or racial Whiteness, perhaps we could say *blankness*, helps Burroughs make her point. For her it is home—its spaces and domestic conditions but also the people in whom home is constituted, whether members of the household, or neighbors and broader community—that reminds artists of their identity.

What did "home" mean in relation to artistic practice during the years Brooks and Burroughs were writing? As I explore this question, I want to keep in mind the fact that the houses Williams painted were once somebody's home. There is another mode of abstraction operating here. It's the way all the unquantifiable aspects of home—its relationships and sense of belonging, how it is inhabited by those who live there, its relative safety and ease—are skimmed off, pared away, disregarded, as the home is "represented" in the recorded numerical values of real estate transactions. What if abstraction were the correlate in paint of the reduction of land to property? What happens when we consider the relationship of abstraction as artistic practice and the very notion of "home" and who gets to have one? This relationship, too, has a history.

Burroughs's own home holds special importance in the landscape of Black visual arts in Chicago; it was there that she built a collection and created an institution for it: the DuSable Museum of African American History. Before conceiving the idea of the DuSable, she helped create another institution almost directly across the street. In 1940, she joined together with other artists and community members to cofound the South Side Community Art Center under the auspices of the Federal Art Project, part of President Franklin Roosevelt's New Deal. She gathered small donations to assemble the funds to purchase the building, making it possible to give the arts a durable home on the South Side. Like many Bronzeville buildings, it had originally been a stately mansion for a wealthy White owner. A later owner broke it up into kitchenette apartments. In 1940, New Bauhaus designers who were faculty at the Institute of Design at the Illinois Institute of Technology collaborated with community members to renovate the interior. Following Bauhaus precepts of "truth to materials," they dispensed with historicizing ornament and imagined a gallery space paneled in wood planks, unplastered, showing off their tawny hue. The entryway with its staircase, front desk, and chairs displayed what modern technology could do with wood, smoothing it into modern curves and a satin finish (fig. 5.2).

The center's location placed it in the midst of Bronzeville, the near South Side neighborhood where African American residents of Chicago had first migrated and over time concentrated because White homeowners had established racist rental practices and restrictive covenants that applied to most of

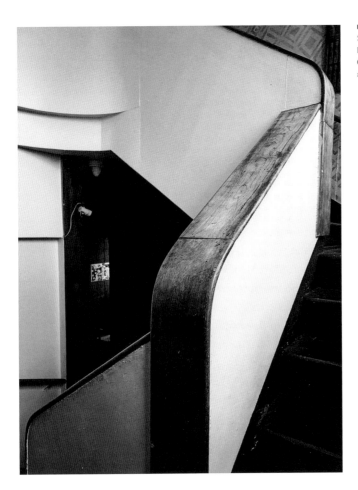

FIGURE 5.2
South Side Community Art Center, New Bauhaus staircase created by Illinois Craft Project artists, 1940. Photo by author.

the rest of the city. Regardless of resources, Black Chicagoans (many of them recent arrivals from the South) were excluded from the chance to build wealth through homeownership, and many were systematically forced into crowded and unsafe living conditions. During the 1940s and '50s, highway construction, the expansion of Michael Reese Hospital and IIT, and new high-rise public housing developments—modernist, geometric, abstract—cut large swaths through existing housing stock. The geography of manufacturing was changing and jobs were leaving the city, trends that reconfigured the relationship between workplaces and residential neighborhoods. More and more Black Chicagoans began pursuing the right to live elsewhere in the city, outside of Bronzeville, fighting battles in the courts and in their homes and streets. The playwright Lorraine Hansberry recalled the experience of living in a hostile White neighborhood as her father pursued housing justice through a case that eventually went to the Supreme Court (as *Hansberry v. Lee*):

That fight also required our family to occupy disputed property in a hellishly hostile "white neighborhood" in which literally howling mobs surrounded our house. One of their missiles almost took the life of the then eight year old signer of this letter. My memories of this "correct" way of fighting white supremacy in America include being spat at, cursed and pummeled in the daily trek to and from school. And I also remember my desperate and courageous mother, patrolling our household all night with a loaded German luger, doggedly guarding her four children, while my father fought the respectable part of the battle in the Washington court.[17]

Even as African Americans moved (often, as in the Hansberrys' case, at their real physical peril) into neighborhoods that had been exclusively or predominantly White, the Federal Housing Administration, created by President Roosevelt to support low- and middle-income home buyers, refused to insure mortgage loans in these changing neighborhoods, simply because they were changing. Until 1968 there was no Fair Housing Act. The absence of mortgage insurance meant that Black buyers simply could not get mortgages. If they did not have enough cash to pay in full, the remaining option was something called "contract buying." Contract buying meant the buyer paid in installments, essentially borrowing from the sellers who were often abusive speculators. Buyers were subjected to hidden fees, rate changes, and harassment by inspection and worse, leading many people to lose their home and savings.[18]

The home is typically understood in the United States as the private space par excellence. But with so many obstacles thrown in the path to a safe and secure place to call home, activists who fought for housing rights made a point of dissolving boundaries between private and public as a political strategy. A gentle manifestation of this is the annual "open houses" in which residents of Kenwood, a well-to-do and racially integrated neighborhood, displayed their homes to the public in the 1950s and '60s. Sharing the organizers' aim of demonstrating how well integration worked there, a number of artists participated as hosts, presented demonstrations of their art practices, and exhibited work.[19] Other "open houses" served the more direct political goal of displaying slum conditions or a crime scene—sometimes they were the same thing—to public view. Members of CORE (the Congress of Racial Equality) held "slum open houses" in order to display housing conditions to the White and middle-class public.[20] The Illinois Black Panthers famously held guided tours of the West Side apartment in which spokesman Fred Hampton was killed by FBI and police operatives in 1969, making the home a place for political education.[21] Members of the West Side organization FORUM, Full Opportunity Redirected to Uplift Mankind, documented poor conditions in housing projects with video, then hosted viewing parties of

their tapes to which they invited the public.[22] These events might be understood as part of a broader strategy that we now call tactical media, where the physical or virtual home tour becomes a creative medium for political action.

Asserting claims to space was a key component of activism in the same period. Some organizers confronted landlords at their own home with the evidence of the conditions they oversaw. Other housing activists used the street to create media spectacle. Activists drew attention to the eviction of rent-striking tenants of Old Town Gardens on the Near North Side simply by sitting on furniture that had been put out on the sidewalk.[23] In 1970, members of the Contract Buyers' League created an even more dramatic spectacle, bringing household belongings that sheriff's deputies had dumped on a far South Side street and transporting them to Civic Center Plaza (later to be renamed Daley Plaza).[24] As with FORUM's video documentation, artists and activists deployed the new medium of video tactically to make housing conditions visible around the city. The organization Communications for Change helped tenant protesters in Uptown use video to document their attempt at presenting a mouse- and roach-covered cake to the manager of their public housing building.[25]

As we consider Margaret Burroughs's assertion, then, we have to keep in mind that the very idea of "home" was politically charged. Having a stable place to live was not a given, but people created a sense of home where they could. Her own museum-building practice, beginning in 1960, mobilized her home as a resource to create a lasting institution. She drew on the expertise, collections, and artworks of collaborators and herself traveled to Africa to amass a collection that she displayed to ever-enlarging audiences of friends, schoolchildren, and visitors. In talking about the need for the artist to return "home," therefore, she spoke about something that held richly layered meaning for her. Within her opposition of abstraction and home, we can discern several assumptions. First, the reference to an artist's "own personal esthetics" implies a situated, perhaps embodied, aesthetic sensibility. To be Black implies (in this view) a contradiction with white-on-white abstraction. Second, the idea of "home": we can understand it metaphorically, but the phrase "if only to sleep" suggests it must also be understood literally. For a Black artist these surroundings might generate their own uniquely avant-garde material, according to Romare Bearden: "I don't need to go looking for happenings, the absurd, or the surreal," he stated, because things were going on right outside his studio window "that neither Dali nor Beckett nor Ionesco would have thought possible."[26] But Burroughs also raises questions about whether it was possible to operate as an abstract artist "who happened to be Black" in the mid-twentieth century. Much as there were African American painters in the nineteenth century who excelled at unpeopled (hence not legibly "Black") landscapes—Robert Duncanson, Henry Ossawa Tanner, Edward Bannister—there were African American artists in the

twentieth century who saw abstraction as a liberatory practice, whether or not it also expressed something specifically about Blackness.[27] One might have imagined, in the context of abstraction's ascendancy, that this mode could allow artists to receive critical praise precisely because the subject matter of their work would not immediately provoke racist responses. But in mid-twentieth-century abstraction, artistic value also became highly subjective and malleable, and institutions of criticism and interpretation developed more importance in setting critical tone. Value—untethered from the more recognizable standards that had governed representational art—often appeared as the vibrations a work inspired in the appropriate critic's sensibilities. It was highly dependent on rhetoric, on the capacity of a writer to produce a description and make an argument about it, and dependent too upon appealing narratives produced about the artist-hero. The expert interpreters in whose hands the question of quality was placed were also guardians of White patriarchy, and of a certain set of artists handpicked to uphold it. There was perhaps no more powerful exponent of the language of abstraction in the mid-twentieth century than Norman Lewis, who harnessed it to produce intense, expressive works that squarely confronted American identity and White supremacy, works like *Alabama* and *American Totem*, both from 1960. And yet at midcentury Black artists were, as if by definition, excluded from the positions of key protagonists in the tales of abstract art.[28]

HE (WHO MIGHT HAVE BEEN AN ARCHITECT)

In Ben Shahn's lucid counterarguments on behalf of representational image making he brings up a puzzlingly vehement attack on one of his works—a painting called *Allegory* (plate 10)—by the critic Henry McBride. In a review of the Whitney show in which *Allegory* was exhibited, McBride "launched," as Shahn writes, "into a strange and angry analysis of the work, attributing to it political motives, suggesting some symbolism of Red Moscow . . . completing his essay by recommending that I, along with the Red Dean of Canterbury, be deported."[29] While McBride's emphasis was on Shahn's use of the color red, in disparaging Shahn's work he also taps into stylistic associations with socialist realism in Soviet art and hence with communism. Shahn had used symbolic imagery and personal memories of a house fire in his native Lithuania (his family left in 1906) to enrich a vision of a brilliantly blazing red lion-monster, etched with thin lines of pale blue, a vision of "the emotional tone that surrounds disaster." It was partly an allusion to a childhood experience of his own, but the painting was inspired in the first instance by a story from Chicago: "The immediate source of the painting of the red beast was a Chicago fire in which a colored man had lost his four children."[30] Shahn does not give details of the event in this text, but it

was one that had become a closely followed story in the national news media. In 1947, the West Side father James Hickman, following a fire that killed most of his children—they were trapped in their attic room—shot and killed his landlord's agent.[31] The agent had threatened to set the building on fire over conflicts with the tenants, and then, it seems certain, followed through on his threat. This act of infamy stands out among the literally incendiary acts of many a Chicago landlord because of the loss of human life, and children's lives in particular.[32]

Harper's commissioned Shahn to produce illustrations for John Bartlow Martin's essay about the case, which served to illuminate the situation of rampant housing discrimination in Chicago. Shahn based his drawings on a meticulous reading of the story.[33] In his drawings, Shahn entered into the interior life of his subjects. He created scenes of a mother and baby, a man and woman working in the fields of Mississippi, scenes of Hickman testifying, sitting dejected, and of the building in flames. He used considerable economy of line in creating his linear figures, relying on expanses of the white of the page for emotional resonance. He lightly indicated subjects' racial identity with their features and hair. Shahn picked moments that are emotionally devastating in the context of the story as a whole, like the piled up bodies of the dead children that he reprised in *Allegory* (fig. 5.3) or the depiction of the little girl, now dead, who wasn't old enough to go to school but pretended to study in imitation of her older siblings (fig. 5.4).

If Shahn stood as one of the more vocal American advocates for artistic pluralism at mid-century (and for it he stood accused of "unimportance" by Clement Greenberg), it is notable that his work intersected more than once with the housing struggles of Black Chicago. His second foray concerned a place called the Mecca (fig. 5.5), or Mecca Flats, a building that was home to thousands of Chicagoans, mostly African American, in the first half of the twentieth century. Its history intertwines with that of the Illinois Institute of Technology's College of Architecture, where Amanda Williams was teaching while working on *Color(ed) Theory*, and highlights a prominent tension between modernist theory and the lived experience of Black Chicagoans. The College of Architecture sits within Mies van der Rohe's famous Crown Hall, and Crown Hall sits on the former site of the Mecca.

Originally erected in 1892 for visitors to Chicago's Columbian Exposition of the following year, the Mecca was heralded at the time as state-of-the-art luxury. It had a U-shaped layout, with its apartments flanking two covered atria that stood on either side of the long courtyard, which was open to the street. It provided for density and ventilation (and easy exit in case of emergency; it was only about twenty years since the Great Chicago Fire). Stacked corridors with elaborately designed cast iron railings ran along both sides of each atrium, facilitating sociability, as residents could lounge outside their apartments in any weather

FIGURE 5.3

Ben Shahn, *Untitled* [Paper was made
to burn, coal and rags, not people.
People wasn't made to burn.], 1948.
Pen and ink on wove paper, reworked
with white pigment, 13³/₄ × 11³/₄ in.
(34.9 × 29.8 cm). The David and Alfred
Smart Museum of Art, The University
of Chicago; Gift of Leon and Marian
Despres. © 2023 Estate of Ben Shahn /
Licensed by VAGA at Artists Rights
Society (ARS), NY. Photograph ©
2022 courtesy of The David and Alfred
Smart Museum of Art, The University
of Chicago.

FIGURE 5.4

Ben Shahn, *Untitled* [. . . and Velvena
was playing at studying though she was
only four.], 1948. Pen and ink on wove
paper, reworked with white pigment,
13³/₄ × 11³/₄ in. (34.9 × 29.8 cm). The
David and Alfred Smart Museum of
Art, The University of Chicago; Gift
of Leon and Marian Despres. © 2023
Estate of Ben Shahn / Licensed by
VAGA at Artists Rights Society (ARS),
NY. Photograph © 2022 courtesy of The
David and Alfred Smart Museum of Art,
The University of Chicago.

FIGURE 5.5
"The inner court with a glass roof is feature of each wing of the U–shaped
Mecca apartment buildings." *Life* magazine, October 1951. Wallace Kirkland /
The LIFE Picture Collection/Shutterstock.

to see and be seen. Mecca Flats itself had originally admitted White tenants
only, but that changed over the course of the Great Migration. As housing pres-
sure in Bronzeville intensified, the building first allowed Black residents in 1911,
becoming a destination for Black middle- and working-class people, including a
substantial number of artists and musicians.

IIT obtained the building in 1941.[34] It was the year after IIT designers had
helped renovate the interior of the South Side Community Art Center. Fifteen
years later, at the same address, the institute inaugurated what has become a
classic of modernist architecture, S. R. Crown Hall, designed by Mies van der
Rohe, at that time director of the School of Architecture. Mies brought the name
"Bauhaus" with him when he fled Nazi Germany. In the name of the celebrated
Weimar architecture school are the words "Bau" (building) and "Haus" (house)—
meaning not the act of building a house, but a house for building, a place to
teach architecture. (As we think about the significance of IIT and the Institute
of Design to the history of modern art, it might be worth noting that according
to the major textbook *Art since 1900*, the only significant art "date" in Chicago in
the twentieth century was the death of founding director László Moholy-Nagy:

it's literally the only Chicago event in the timeline.[35]) The name S. R. Crown refers to Sol Crown, an original cofounder of the construction materials business, Material Service Corporation, through which his surviving brother, Henry Crown, eventually established the fortune that supported the building's construction. (Their family—like William Zorach's and Ben Shahn's—originally came from Lithuania. Their father changed the family name from Krinsky to Crown when Sol and Henry were children.) Crown Hall is a low-slung glassy rectangle, but its tripartite structure with a central bay of floor to ceiling windows, seems to make a nod to the Mecca, reprising the basic composition of a central courtyard open to the street (open only visually in Crown Hall's case) with parallel closed atria on either side (fig. 5.6). We could say that in paring it down, simplifying it to bare geometry, it abstracts the Mecca's design.

The grid—to repeat Rosalind Krauss's line—is "what art looks like when it turns its back on nature" and no grid is griddier than a Mies van der Rohe building. Soon after the Mecca's purchase, IIT sought to remove the tenants and demolish the building, but a legislative and legal effort mounted by State Senator Christopher Wimbish, an African American graduate of Northwestern University's Law School, stopped the process. Among other things, Wimbish appealed to the fact that forty of the residents were away fighting for their country in World War II. Over the next decade, residents continued to resist displacement.[36] Blocked in its plans for immediate demolition, IIT allowed the building to deteriorate. They ceased maintenance and lowered rents, which encouraged subleasing and multiplied numbers of occupants; they failed to address code

FIGURE 5.6
Crown Hall. Photograph by Joe Ravi is licensed under CC BY–SA 3.0.

violations; by not rerenting vacant apartments, they attracted squatters.[37] Yet the people living there still fought to stay. For them, Mecca Flats was no utopia, but it was home.

Planners at IIT, seeking to clear land for the institute's campus, hastened to take advantage of the city's urban renewal program, which amounted to a massive effort to displace Black residents in favor of institutional expansion, real estate development, and aesthetic modernism. A photocollage created under Mies van der Rohe displays the projected intervention of modern buildings into the fraying historic neighborhood (fig. 5.7). As the architectural historian Daniel Bluestone puts it, "Order and harmony confronted the hodgepodge of high and low, wide and narrow, wood and brick, commercial and residential buildings."[38] Planning documents published in these years make canny use of a modern aesthetic of order to make their case for demolition and redevelopment. Reports by the Chicago Housing Authority and Chicago Plan Commission overlay colored squares (white, black, red, or the sky blue of blueprints) onto maps of city blocks that they describe as "dirty," "idle," "waste," and "blight," and "slums that breed disease, crime, and disaster" (fig. 5.8).[39] They deploy consummately rectilinear

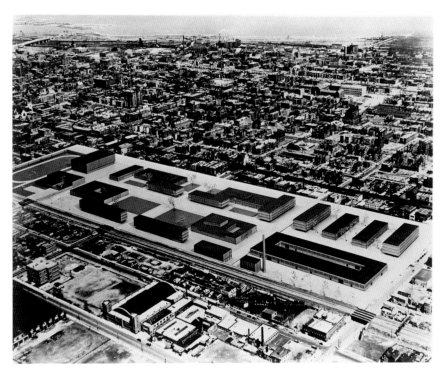

FIGURE 5.7
Hedrich–Blessing, *Models of Proposed Illinois Institute of Technology Campus Buildings Superimposed on Aerial Photographs of the South Side of Chicago*, 1961. HB–24253-A, Chicago History Museum, Hedrich–Blessing Collection.

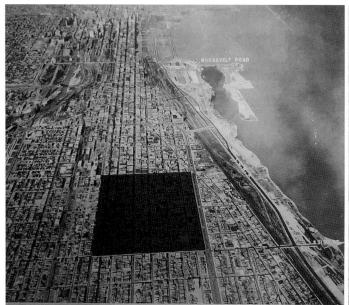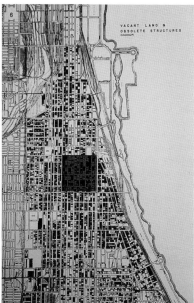

FIGURE 5.8
Images with colored squares (red on left in original; blue on right)
superimposed on South Side topography. From *A Redevelopment Proposal
for the Central South Side: Chicago* (Chicago: Chicago South Side Planning
Board, 1950).

tables and graphs—another orderly grid. They assemble mathematical abstractions that allow them to make determinations that are not visibly about race—but are actually about race. Tables of numbers of children per family, persons per room, schoolchildren per classroom demonstrate with consummate objectivity why certain neighborhoods can be considered "blighted" and thus readily subjected to the wrecking ball.

When in 1950 John Bartlow Martin—the same author who had written the story on James Hickman for *Harper's*—continued his study of the housing situation in Chicago with a story on Mecca Flats, Ben Shahn also illustrated it (or rather, provided "pictorial comment," as the caption has it). Martin called Mecca Flats "one of the most remarkable Negro slum exhibits in the world," suggesting an element of voyeurism in his reportage: the building and its inhabitants constitute *an exhibit*, what today we might call ruin porn, a sorry portrait of vice and degradation that allowed White middle-class readers to believe themselves benevolently enlightened. Whereas Martin's account of James Hickman made him a tragic hero—and Shahn's images represented family members in their full humanity—Martin represented the Mecca's collective identity as overwhelmingly deviant from midcentury, middle-class norms. Even as Martin documents poor conditions in the building, he seems reticent about placing the blame

squarely on IIT, whose buildings he describes as "sleek brick-and-glass." Daniel Bluestone has argued that Martin's story helped perpetuate a myth of fall from grace, from state-of-the-art luxury to degraded slum dwelling. This myth inevitably fed, he suggests, into a national narrative for the building in which the only possible outcome was demolition. It became an embarrassment to Chicago.

To be sure, the liberal Martin recognizes the need for new places to live that were at least minimally acceptable. "I found a place to buy at a real estate office way up on the North Side," one of the residents of longest standing, Corene Griffin, told him, "but no other colored people live right there, and I don't want to get bombed on." She wasn't exaggerating: Whites did firebomb the homes of Black newcomers to neighborhoods they thought belonged to them. Sitting with Martin in her tidy apartment, Griffin observes astutely that the city of Chicago was building "streets and superhighways and recreation—not houses."[40] Having been told she will be "placed," she retorts, "*Place* us! I don't [want to] be placed anywhere myself. They might place me in some mudhole somewhere."[41] IIT hired social workers who assisted in moving the tenants out, and the institution finally succeeded in tearing the massive building down in 1952.

No grid is griddier. The grid lines of modernist architecture rhyme with the abstraction of humans into statistics that took place in its buildings, such as the high-rise housing projects that grew up nearby along State Street: Robert Taylor Homes, Stateway Gardens—a name you might recall from Kerry James Marshall's *Gardens* series, if you did not know it already. In a similar way, the grid lines of roads and streets in the western expansion of the US represent the settler logic that measured out stolen land in order to distribute it to homesteading Whites. And just as in western expansion, in this case, to produce the new order, builders first had to clear land of its existing occupants, an ordeal that accounts for the fifteen years that separate the acquisition of the Mecca and the completion of Crown Hall. On the flip side, modern architecture—sleek brick and glass—could also mean modern homes for wealthy White people who decorated their walls with abstract paintings as part of their sense of modern design. Indeed, Robert Smithson called the kind of art Clement Greenberg promoted "interior decorating." To him they were "paintings . . . just sort of put in to living rooms as backdrop."[42]

MIES RETIRES FROM GRACE

In 1968, sixteen years after the fall of the Mecca, Gwendolyn Brooks used two quotations from Martin's piece as epigraphs for her collection of poems *In the Mecca*, the collection in which her poem about the Picasso appears.[43] The first line of the long eponymous poem addresses Mies van der Rohe directly: "Mies

van der Rohe retires from grace." Placing her stories of imagined residents in the context of the Mecca's demise, she insists firmly on juxtaposing it with Crown Hall. Modernist abstraction, for Brooks, rests on the denial of Black lives. In contrast with Martin, her imagined portraits of Mecca residents, as she put it in her autobiography, included "a streak or two streaks of sun" in "even the grimmest" lives.[44] She mingles pleasure or contentment and frustration and danger, or what she calls, in "The Sermon on the Warpland," "seeds for the coming hell and health together." Brooks recounts tall tales and minor anecdotes of tenants' lives, their desires and ambitions, their pettiness, and their quotidian sadness. She builds inexorably to a devastating family tragedy by way of many minor ones.

The second part of the collection, "After Mecca," includes several short poems. One is devoted to Medgar Evers and one to Malcolm X. Three recount tales of the Blackstone Rangers, the South Side street gang, including one about the gang's young women, the Rangerettes. Brooks weaves architecture and aesthetics throughout the poems. Along with her two "Sermons on the Warpland," she included her two dedications to works of public art—the Chicago Picasso and the Wall of Respect, a mural of Black heroes and heroines created on the side of a Bronzeville building in 1967. The Wall's creation was a proud monument to Black achievement. Brooks herself was on it. Like her vision of the Mecca, it represented Black collective identity—in its making, in the represented figures it assembled on the wall, and in the individuals who gathered around it in the dedicatory event that Brooks recounts in her poem. Members of the OBAC Visual Artists Workshop, fourteen artists who included painters, photographers, and one designer, divided the wall into sections to celebrate Black heroes in the realms of politics, music, athletics, drama, literary pursuits, and religion.[45] Sylvia Abernathy, the designer who came up with the layout, had, like several other group members, trained at IIT. Her design took advantage of the wall's specific features and created a pattern of abstract fields of color: white, red, gray, and black. These rectilinear color fields divided the mural into its sections and provided backgrounds for portraits. Abstraction and representation worked in tandem.

And the Wall was action, not only representation: it was an occupation, it was about claiming space. It was important to the artists that they did not seek permission to paint. This act of occupying space unfurled in the context of rapidly changing neighborhoods. Like the houses Williams painted, this space was "available" because of urban renewal. The absentee owner was only holding the property in expectation of selling it off at the most opportune time, and paid no attention to what went on there. Opposite, a few of the artists working with community members created a second mural, the provocative Wall of Truth. A sign posted above a doorway declared, "WE THE PEOPLE OF THIS COMMUNITY CLAIM THIS BLDG. In Order To Preserve What Is OURS" (fig. 5.9).

As we saw with Margaret Burroughs and the DuSable Museum, to have

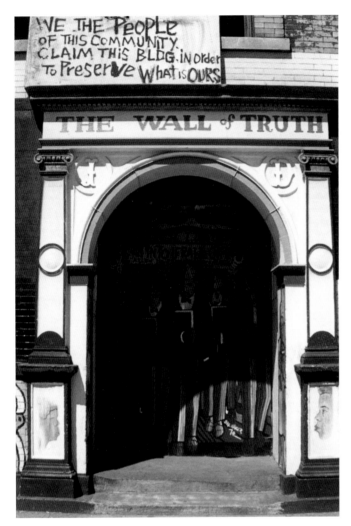

FIGURE 5.9
William Walker, Eugene "Eda" Wade, and community members, Wall of Truth, 1969. Photo by Mark Rogovin, courtesy of Michelle Melin Rogovin and the Mark Rogovin Estate.

a home also made other things possible. Claiming space, creating space, and asserting rights to space were all part and parcel of the activities of Black artists at that time. They had few venues available in the White art world. Artists found opportunities where they could make them, in Black institutions and businesses, in street art fairs, in the storefront galleries they created for themselves, and, especially, in their own homes. Creating spaces for one another and for themselves was a form of place holding; it was a means of survival for them as creative practitioners, but it also intervened in racial landscapes, maintaining Black space in threatened communities and creating visibility in neighborhoods that African Americans were newly entering, often in the face of violence from Whites—much like what Corene Griffin feared, and what Lorraine Hansberry

described in the letter quoted above. It is worth stopping for a moment to consider what her letter was responding to. In it, she was tackling the argument that Black people seeking justice should be patient and work within the system rather than engaging in civil disobedience or more radical measures. Countering this position, or at the very least adding an additional dimension to it, she points out the considerable human costs of following the process considered "correct." Her father had tried to make change respectably, through the legal system, pursuing his case up through the courts to the point of reaching the Supreme Court. But the trauma the family experienced while trying to work within the system left indelible marks. It was no wonder, then, that others took more interventionist approaches.

In her collection of poems, Brooks repeatedly unleashes possibilities of aesthetic feeling and artistic expression for people who don't think of themselves as artists. She voices a collective audience's respectful ambivalence about the Picasso statue, and a different community's esteem for the Wall of Respect and its surroundings. Some of the OBAC artists, in the course of creating the mural, came to know its neighbors as observers with distinct opinions on artistic choices and as creators in their own right. One woman called the painter Jeff Donaldson over to offer a critique of his representation of Nina Simone. In addition to opinions, he noted, "she had all kinds of collages and doilies that she starched so they took on sculptural forms. Art was all around the house and the walls were painted different colors."[46] He took her advice; he repainted the portrait.

Likewise, Brooks casts a sympathetic eye on the protagonist of "In the Mecca," Sallie Smith, as she reflects that she would like to "decorate." Yet Sallie's dwelling is "sick," rundown, and she sadly concludes that to decorate would be like putting "a pomade atop a sewage" and impossible because "First comes correctness, *then* embellishment!"[47] As if in response, in the "Second Sermon on the Warpland," Brooks issues a call to "stylize the flawed utility."[48] For if the kitchen is not "correct," that is not a reason not to embellish it; perhaps there is all the more reason to do so. The walls of the abandoned building may not be sound, but they may be painted, perhaps *must* be painted, in fact, to make them sound—to make them resound. Mecca resident Alfred "could have been an architect" but chafes in the perceived mediocrity of his high school teaching job. But in the short poem "Boy breaking glass," the title character *creates*, even though his name has been stolen from him: "if not a note, a hole." His "broken window is a cry of art": breaking it, he too *does architecture*, and more successfully than Alfred, a grown man constrained by propriety.[49] This sense of raw creation culminates in "The Sermon on the Warpland," where Brooks calls for an architecture of Blackness, more precisely of Black love:

Build now your Church, my brothers, sisters. Build
never with brick nor Corten nor with granite.
Build with lithe love. With love like lion-eyes.[50]

Here Brooks shows her cards a little more on the Picasso, which had been con-
structed of Cor-Ten steel. Brick and granite are the materials of architecture. This
church is not a brick-and-mortar building, but a community founded on love.
"Conduct your blooming in the noise and whip of the whirlwind," she urges, in
the "Second Sermon." Black life is a whirlwind, she suggests, but one in which
blooming can still be conducted—in which a building (of love) can be built.

BLACK ON BLACK, WHITE ON WHITE

Early in this chapter, I cited Rosalind Krauss's essay "Grids." But I did not men-
tion the surprise I experienced on rereading the essay in 2022 when I finally
noticed the metaphor she chose to describe how the grid led the visual arts into
a kind of dead end. She wrote—at the top of the first page of the essay—that
"the fortress [the arts] constructed on the foundation of the grid has increas-
ingly become a ghetto."[51] Now consider what it means for her to choose the word
"ghetto" rather than, say, "island" or "desert" or "isolated enclave." Any of them
could suggest that visual art has become sequestered out of view of the lively
cultural and critical dialogues taking place around other art forms. But the most
obvious sense of the word "ghetto" in the 1970s on the Upper West Side of New
York—where Krauss taught at Hunter College—was not a rarefied enclave of
solipsistic intellectuals, or even the Jewish ghettos of Europe; it was "*the Black
ghetto*." If a grid has transformed itself into a ghetto, does that not once again
underline the grid's affinity with the street plan of a city? Mondrian's *Broadway
Boogie-Woogie* makes that connection to the grid, though he doesn't travel all the
way up Broadway. Or perhaps it is an abstract, gridded high-rise building, based
in modernist architectural principles, a utopia turned dystopian? What does it
mean for Krauss to conjure this specter to think about the grid in visual art?[52]

In *1971: A Year in the Life of Color*, Darby English notes that Black abstract paint-
ers around 1971 "enthusiastically investigated structures of color" and argues
that these explorations were fundamentally about relationality, synecdochically
breaking down "color lines" in both chromatic and social arenas. In asserting
aesthetic freedom, Black painters were not simply replaying the century's earlier
drive to abstraction. Rather, modernism for them was a "deterrent to cultural clo-
sure," a tactic to resist being sequestered in a monolithic, racialized artistic sensi-
bility.[53] To counterbalance Margaret Burroughs's assertions about the Whiteness
of abstraction, we could indeed cite numerous Black artists in the twentieth cen-

tury and beyond who pursued abstract practices of creation. Here, color and not geometry is abstraction's vital sign.

English also addresses the academic construct of the "Black ghetto" in his account of the *DeLuxe Show*, an exhibition of works by a multiracial group of modernist artists held in a vacant movie theater in the Fifth Ward of Houston. Almost (but not quite) paraphrasing Margaret Burroughs, he notes that Black nationalist politics, in contrast to the works and projects that he favors, "calculated cultural significance in terms of an individual or object's contiguity with 'home' and the immediately surrounding local area, and the ghetto both emblematized home and compelled locality in rare ways."[54] For English, the lines around the ghetto drawn by sociological expertise reinforce the same stiffened positions of Black nationalism he sees as detrimental to art's restless drive to break down boundaries.

If these lines produce a monologic—and monochromatic—space-as-body politic, might we see such shapes on a map as the production of an abstract artwork? In Chicago the spaces designated for urban renewal, as we have seen, were marked out with squares on maps. Comparing the upheaval of urban renewal to young people's acts of illegal mark making, the graffiti writer Lavie Raven said in an interview, "They built the Dan Ryan Expressway with a political purpose and an economic purpose in mind, and removed many thousands of people, right? That was a huge mark on the Earth's surface, but no one is ever going to say it that way. . . . They made restrictive covenants to keep black people from living next to white people; they created the black belt so that black people couldn't move out. Then those people didn't have jobs or resources and it's completely depleted, and then you're like, 'Oh, look at that crazy abyss.' That abyss is the graffiti of those in power."[55]

As Leigh Raiford argues, "Blackness in its visualizable specificity itself becomes an abstraction, a removal away from 'the human.' Such abstraction also extends to the violence enacted through the technologies by which the state orders itself and its subjects. . . . Maps and grids then are often records of power and domination; they are projections of belonging and subjection."[56] And yet, as Raiford also urges, abstraction and its politics cannot be reduced to one single position—despite the best efforts of Greenberg and company. Abstraction can be contemplative, gestural, athletic; it can emphasize lush materiality or the absence thereof. It can mean freedom from strictures of the past—or simplification, distillation, a translation of form into geometric structure, an ascetic approach that denies itself details, or a proliferation of them.

But at the very least, race, and Blackness, travel alongside abstraction, weave their questions through it. If Clement Greenberg never said anything, good or bad, about a Black artist, could it be that Blackness constituted the outside to the very definition of modern art, a necessary support (as European modernism

plundered non-White cultures for inspiration) but an impossible position for the "modern artist" to occupy?[57] As modernist artists looked for inspiration to—that is, appropriated—design qualities of African, Oceanic, and Native American arts, they saw the "primitive" as the prior and the primal, something innocent, true, and above all *past*, to which they desired a "return."[58] It might be that for some critics and curators, the idea of evaluating artworks on the basis of formal properties, and not traditional norms or representational content, seemed to promise a genuine leveling of cultural hierarchies. It would ostensibly put works from different cultures on an equal footing. And yet it absolved European artists of reckoning with cultural difference and their position within colonizing regimes. For example, Carl Einstein wrote approvingly of African sculpture in *Negerplastik* (*African Sculpture*): "The fact that I consider more reliable than all possible ethnographic or other knowledge is this: the African sculptures themselves! We will bracket out subject matter and the contextual associations related to it, and instead analyze these objects as formal constructs." Does African subject matter *in particular* require this? Does content get downgraded specifically when that content would be culturally African? "We shall try to determine whether we can extrapolate from the sculptures' formal properties a total concept of form that is homologous with that of artistic form."[59]

Perhaps we can say that race unsettles abstraction. A recent revelation about the origins of nonobjective painting—abstraction degree zero—suggests that this dependence on racial difference, at least in one case, could have been a more disturbing matter than just the familiar, run-of-the-mill cultural appropriation. We recall that in discussing American painters seen as the paragon of abstraction in *The Shape of Content*, Shahn noted that Malevich still retained his paramount position: "there is always Malevich's 'White-on-White,' which still holds first place in the competitive race against content." Margaret Burroughs seems, too, to allude to this title in the quotation I discussed above. But Malevich also and perhaps more famously produced a *Black Square* painting that is heralded as the leading edge of absolute abstraction. What's strange—or perhaps not so strange—is that the painting appears to contain a crude racist joke.

One hundred years after its creation, in 2015, researchers studying Malevich's famous 1915 painting, *Black Square*, uncovered two brightly colored Cubist-inspired compositions underneath its black paint, enabling us to understand the process by which the artist obliterated previous works on his way to producing the iconic black painting. (I use "iconic" advisedly; Malevich grew up with the tradition of Russian Orthodox icon painting and expressed admiration for it.) More startling than this, however, was the offensive inscription revealed underneath the top paint layer of the white border around the black square. While the painting is often reproduced as a black square only, the thick white border is clearly visible, for example, in the installation photograph of the 1915–16 "Last

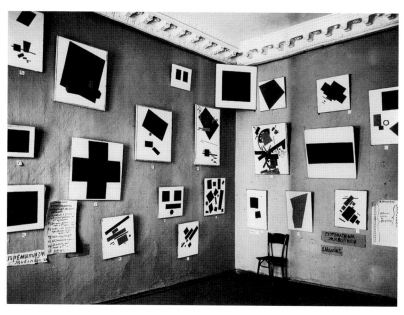

FIGURE 5.10
Installation shot including Kazimir Malevich's *Black Square* (1915). Last
Futurist Exhibition of Paintings 0,10, 1915–1916, Petrograd (St. Petersburg).

Futurist Exhibition of Paintings 0,10," where it appears—looking like nothing
so much as a 35 mm slide, though they weren't invented until 1935—displayed
diagonally across the upper corner of the room (fig. 5.10). That racist inscription,
"Battle of negroes in a dark cave," has barely cause a ripple on the surface of
modernist art history. *Black Square* has long represented the absolute reduction
of content, a revolutionary ushering in of a new way of seeing. Now it suddenly
proclaims itself as fully representational in a way that harbors a crudely White
supremacist (and not just Suprematist) joke.[60]

To view a black painting as representational, of course, you only need dark-
ness. You don't need the dehumanizing phrase "battle of negroes" at all. Assum-
ing this inscription's presence is confirmed, some art historians might still be
inclined to treat the inscription as incidental to the painting's achievement, a
bit of an embarrassment but not one we really need to talk about. And yet, in a
way, this revelation wasn't necessary to start this conversation. The inscription,
if present, must have come from a source that has a prior claim to being the har-
binger of total abstraction: Paul Bilhaud's 1882 "joke" painting *Combat de nègres
dans un tunnel*, one of several monochromatic concept-pictures reproduced by
Alphonse Allais in 1897 as *Combat de nègres dans une cave, pendant la nuit*: "Battle of
negroes in a cave at night."[61]

The Bilhaud/Allais images themselves have not been taken seriously as set-
ting out the stakes of absolute abstraction. But why not? Perhaps we should have

considered them together with Malevich's painting all along. The joke reprised itself repeatedly in the decades leading up to 1915. In 1910, following upon Bilhaud and Allais, their associate Emile Cohl, a cartoonist, reiterated the joke in a short film. Cohl's film centered on a series of monochromatic works whose verbal description in the film's intertitles followed the same pattern, with slight variations. The main action of the film occurs in a painter's studio as he hosts a visitor who gazes on a series of monochromatic rectangular paintings in turn. The film frames were individually hand-colored to provide the color of each canvas, while the rest of the action remains in black and white, and each time the visitor looks closely at a painting, we see the action of its description come to life through Cohl's animation. For Cohl, the black canvas is "Negroes mining coal, at night, in a tunnel in Périgord Noir"—a truffle-producing region of France called "black" for its forests of walnut trees.[62]

The myth of Malevich's square would have it that painting until this point maintained at least an attenuated relationship between figure and ground. In the mythic narratives of modernism, Malevich's square abolished that distinction by pushing abstraction to its limit. But what if the distinction had already been abolished, not by cool geometry but by voluptuously ridiculous scenarios that dissolve into abstraction through freak chromatic accidents? "Récolte de la tomate par des cardinaux apoplectiques au bord de la mer Rouge"—Harvest of tomatoes by apoplectic cardinals by the Red Sea—presents an imagined scene of red-clad, red-faced individuals harvesting red fruit by the Red Sea. If actually, literally enacted, this scene would not, of course, look anything like a uniform red rectangle. To imagine it literally, we have to imagine a rather pathetic genre scene made even more pathetic by rhyming hues that would inevitably be an imperfect match. To be abstract the painting has to be imagined not as emptied of representation but, in its every inch, *full* of objects of the given color. It may seem a tedious exercise in futility to spell this out in detail when the idea of the painting is obviously a joke. But it matters because the joke "black" painting is actually different from the others. Since all light has been evacuated by the staging of the content at night and in a tunnel or a cave, it *doesn't actually matter* what color skin the figures have. And this makes the dehumanizing effect of the title even more offensive. Unlike most of the other figures in the series (cardinals in red robes, pale girls in communion dresses, military recruits in blue), the Black figures in the black painting are socially undifferentiated. They don't, apparently, wear clothes, they don't interact with objects, they do nothing but fight with one another. They simply *are* their bodies. In the dark, and of the dark, they are *abstracted*.

How do these questions bump up against the long twentieth century's critical debate about the politics of abstraction versus representation? Does the refusal of representation require a crude mockery of representation, of bodies, of dif-

ference? The White male body—the figure, so central to French painting that a male figure study was known as an "académie"—was the key unit of European representation for centuries leading up to the production of these works. But other bodies remained a constant undercurrent. Carol Duncan's argument about the narrative of abstraction suggests that it is women's bodies that are being transcended by the move to nonrepresentational art—but not without being disfigured first; and not without first being presented as primal, as the territory the male artist joyously commands.

On the flip side, abstraction in art might also enable an artist to inhabit practices and processes that are inimical to their survival, in order to better understand them and counter them. Torkwase Dyson writes about her understanding of abstraction: "Taking these histories into account, I begin to understand that surviving abstraction through abstraction is my environmental project today.... Abstract drawing enables a pointed discussion of these structural histories and our participation in them. It can also prepare our minds to compose with space and materiality that will define our future."[63] As Raiford glosses it, "To turn to abstraction . . . is to turn to the problem of whiteness."[64] As the exhibition text for her 2020 exhibition *Black Compositional Thought | 15 Paintings for the Plantationocene* explains, Dyson's mode of abstraction alludes to "the networks of industrialized white supremacist power that shape our political landscape: histories of spatial segregation, policing and vagrancy laws, and other 'exclusions of subjectivity' that often hide in the abstractions of machines, maps, and data."[65]

PLACE HOLDING

I have traveled a long way from Amanda Williams's *Color(ed) Theory* project, but along paths that meet again there. Her work resonates with Bauhaus and midcentury abstraction, and at the same time with Chicago's tradition of community murals, with activist practices that work to intervene in the built environment, with the question of what constitutes a home. As we saw, Margaret Burroughs starkly contrasted Blackness and abstraction, but many Black artists in the twentieth century and beyond have pursued abstract practices of creation. Free jazz and improvisation provided models for many visual artists, evoking a distinctive sense of freedom: personal aesthetic freedom layered with the specific significance of freedom for Black Americans.[66] For some artists, this might also mean freedom from having one's work overdetermined by race, at least aspirationally—since the White art world has always found ways to define and constrain artists of color.

In transforming uninhabited houses into abstract monochromatic sculptures, could Williams be participating in a practice of abstraction like Dyson's?

The choice of site was significant. This part of Englewood was already battered by decades of racially discriminatory disinvestment that flowed from the Federal Housing Administration's refusal to insure mortgages in Black neighborhoods. The most recent episode in this history was the financial crisis that began in 2007 as a result of unscrupulous mortgage lending—providing mortgages under conditions that practically made default inevitable—to feed investors' appetite for mortgage-backed securities. This riskier debt was insured through "credit default swaps" (CDSes) that were issued by sellers that were often "undercapitalized." This means that banks and other financial companies didn't have enough money to pay out on all the defaults that were to come—they depended on their ability to sell ever more of these financial instruments in order to have sufficient funds to make a payout for assets that might enter into default. This therefore created a market for ever-riskier investments based on borrowers who could not handle the debt they were offered. Abstraction layered upon abstraction: property was represented by a dollar amount, a mortgage was represented by a calculation of risk, and that risk was bundled with other risky investments into an instrument on which complex operations were performed that could themselves be constituted as derivatives to be traded in financial markets. These derivatives were a fantasy—so far removed from the underlying homes and parcels of land that their buyers and sellers could not understand (if they even cared to) the potential human effects of the construction of risk in which they were trafficking.

Remaining as the backdrop for these events is American racial capitalism, whose violent and dehumanizing abstractions impose a ruthless calculus of numerical value. In the Middle Passage, as Hortense Spillers points out, the bodies of kidnapped African people were accounted in terms of standard measurements by age and gender for the space they were allowed to occupy (six feet by sixteen inches for adult men, for example).[67] In their accounting, enslavers erased from the record everything distinctive about the human beings whose existence was reckoned with these measurements: their individuality, the texture of their personhood that persisted even as they were brutalized, their family connections and language and culture.

The financial crisis left Englewood devastated, and by the early 2010s the neighborhood was also in the process of being further hollowed out by a powerful combination of economic and political interests. Norfolk Southern Railroad had been quietly buying up properties—and by "quietly" I mean that they used shell companies to avoid detection—with the goal of eventually clearing a large swath of property to expand their rail yard. (In 2023, Norfolk Southern also appeared in the news as the rail company that caused a toxic spill in East Palestine, Ohio.) By the time their plans were revealed, the company owned large quantities of real estate in the neighborhood, including both vacant prop-

erties and lots with buildings on them, and had begun demolition. Many of the houses Williams painted were directly in the path of the railroad. Some residents refused to sell and fought back, and their story is also documented in a film directed by David Schalliol called *The Area* (2018). The railroad finally turned to the legal procedure of eminent domain to seize the remaining properties, citing the public interest of alleviating rail congestion in the city and environmental benefits of railroads over highways. By now, almost all the affected residents have been forced to leave, and all the houses Williams painted are gone (fig. 5.11). In an aerial view, city blocks have temporarily grown over in green, though ghost lot lines and other traces of human habitation remain visible. Presumably they will not be green for long.

Like the artists who created the Wall of Respect and Wall of Truth, Williams chose buildings slated for demolition, and didn't get the permission of the property owners or the city. (The vivacious colors she chose, too, are reminiscent of the "coolade colors" preferred by the AFRICOBRA artists, many of whom first worked together on the Wall of Respect.) She assembled teams of volunteers—trusted friends and family and larger volunteer groups—to do the work. As with other mural projects, the process of creation attracted passersby. It prompted questions and conversations about the community and its needs and resources, and about the value of houses in the neighborhood, both economic and personal. Drawing attention to these structures, the bright colors made them special, made

FIGURE 5.11
Former site of Flamin' Red Hots house. Chicago, 2022. Photo by author.

people notice them, and attracted onlookers in the community—and outside of it as well. Suddenly, they had value. With this project, Williams posed questions about how value is produced and assessed according to economic imperatives, on the one hand, and individual, family, and community needs on the other. The work did not stop demolition, it did not develop any new and lasting sense of community, and it had no ambition to conduct "placemaking" in a durable sense. But it served as a complex reminder of the disruption and dismantling of place. Perhaps rather than dissolving structures into abstraction, it bodied them forth in the fullness of lush color. It paused a few houses in poetry for a moment.

Earlier in this chapter, I gave examples of the kinds of interventions culture workers made into the housing struggles of the 1960s and '70s. Other modes of creative activist engagement with housing issues in Chicago followed over the years. Since the time of the Wall of Respect, activists have continued to address themselves, directly and indirectly, to the city's massive inequities in the organization of space, using a variety of techniques to occupy space and garner visibility. Artists have often taken part in this grassroots activity, and activists have used considerable creativity in making statements and interventions.[68] The assertive occupation of space, the establishment and maintenance of collectives, the popular distribution of visual ideas and political feeling, have a history of cutting across artist and activist practices. In 1991, the nonprofit Randolph Street Gallery held an exhibition entitled *Counter Proposals: Adaptive Approaches to a Built Environment*, which inspired the creation of a Chicago branch of the Atlanta organization Mad Housers, a group that builds small shelters for people experiencing homelessness.[69] As Tor Faegre described the process, "The hut was constructed in sections in the gallery and then assembled on a strip of wasteland along the Metra commuter tracks. A homeless man who had lived in an abandoned warehouse nearby became the hut's first resident. The volunteers resolved then and there to start a Chicago chapter of the Mad Housers."[70] In 2005, the Chicago Housing Authority plans to push residents out of public housing in order to demolish its high-rise buildings inspired another group of activists and designers, calling themselves 3rd Rail, to create a pseudomarketing campaign called *This is CHAos*. The city's plans were long on marketing and benefits to real estate speculators, and short on follow-through to help tenants find other options. Responding to the marketing campaign, 3rd Rail placed convincing, well-designed posters on bus shelters around the city that shined a light on the corruption and abuses.[71]

There are other creative projects that make it their mission to cultivate community in Englewood and nearby neighborhoods. To the south and east in the Woodlawn neighborhood, the group Blacks in Green is building meditation gardens, training workers in solar installation, and envisioning a walkable ecovillage (begun in collaboration with the architect Michael Sorkin before his death

from COVID-19). Meanwhile, Grow Greater Englewood has developed a heritage trail, promotes sustainable food economies and green businesses, and teaches youth creative and life-sustaining skills. RAGE (Resident Association of Greater Englewood) paints murals, distributes school supplies, and promotes grassroots civic action. And in the neighborhood where *Color(ed) Theory* unfolded, the Sweet Water Foundation, a project of the artist Emmanuel Pratt and scores of collaborators, maintains an urban farm that offers low-cost produce and hosts residencies, classes, and workshops with an intensive focus on ecology, urban agriculture, and economic development. Explicitly addressing questions of how we define the "public" and the commons, Sweet Water has transformed abandoned buildings into classrooms and galleries. In its centerpiece, the Think Barn, Sweet Water in 2021 presented a historical survey of the racial politics of land use in the United States and in Chicago (fig. 5.12). It also undertakes practical interventions like creating a stop sign at an intersection where it was needed for safety and the city failed to provide one (fig. 5.13). Where *Color(ed) Theory* took impermanence as an opportunity to create spectacular imagery that could travel far and wide, Sweet Water avails itself of limited resources, identifies knowledge and know-how already existing in the community, and reinvests time, labor, and materials in a specific site and the people who move through it.

Faheem Majeed's 2013 project *Shacks and Shanties* was, like Williams's, avowedly ephemeral, creating temporary structures in vacant lots, cobbled

FIGURE 5.12
Sweet Water Foundation, Think Barn. Chicago, 2021. Photo by author.

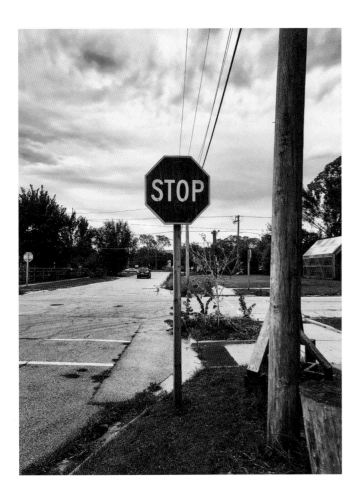

FIGURE 5.13
Sweet Water Foundation, stop sign.
Chicago, 2021. Photo by author.

together out of found materials, to serve as platforms for performance. Under Majeed's direction, vacant South Side lots were activated by artists, performers, and neighbors, sparking conversations and reflections on community (plate 11).[72] Majeed has followed this project up with The Floating Museum, a collaborative project that temporarily occupies space around the city, traveling widely in an effort to create new relationships with art and public space. A recent example is their *Founders Inflatable*, a giant inflatable "monument" with four faces: Jean Baptiste Point DuSable and Kitihawa, the Potawatomi woman who married him, along with former Mayor Harold Washington and a young child. These activities might be put in dialogue with more overtly activist takeovers of "empty" space. One recent example is #LetUsBreathe Collective's "Freedom Square" occupation of 2016. Activists set up an encampment in a lot near the Homan Square "interrogation warehouse," an infamous police facility where an investigation had recently revealed years of police misconduct involving thousands of suspects. In their camp, envisioned as "a community block party and occupation to

imagine a world without police," activists and community members cooked and freely offered food and organized classes, a library, and performances.[73] More recently, in June 2020, a group of activists convened a daylong "tent city" to push the Obama Foundation to develop a Community Benefits Agreement for its Presidential Center.[74]

Williams's project, in alluding to the mural tradition, also worked within an idiom associated historically with political contestation, the seizing of space and visibility for liberatory struggles. In a more critical vein, one could object that Williams refrained from stating any political aims, that she used the existence of these houses in a state of suspension—uninhabited and not yet demolished—as an available canvas on a grand scale, but without explicitly joining the community's struggle for control over space. Many of the items represented in Williams's color palette are associated with poverty, or with coping strategies for it that are themselves oppressive: currency exchanges, cigarettes, alcohol. But poverty and stereotype don't exhaust their meaning: Williams poses them as a shared, vivacious language of color. When home as a physical place is precarious for all the reasons I have been discussing, portable consumer goods can help construct a sense of home.[75] The scale of the houses monumentalizes the colors themselves, according them cultural seriousness as markers of shared experience. That the colors may also be complex and ambivalent—a starting point for critique—is clearest in the case of "safe passage" yellow (plate 12). This color is of more recent vintage than the others and refers to the street signs that were put up to mark the monitored paths of schoolchildren crossing gang territory to get to school. The program began in 2010, but became especially politically charged in the years immediately following the city's closure of fifty schools under Mayor Rahm Emanuel in 2013, an act that forced children to cross gang lines in much greater numbers. The school closures and the demolition of the houses, the evisceration of the neighborhood, go hand in hand.

The photographs Williams produced document a way station in the fate of these houses. Each was once someone's home. But divorced from the site, the photos operate in the realm of representation. They document the project as artwork and—ideally—draw attention to the economic and cultural meanings embedded in it. I do think Williams courts a certain risk in the way the beautiful imagery of the houses plays to audiences outside the community. Might these images aestheticize the dismantling of neighborhoods, decontextualizing the houses as objects and thereby obscuring the historical violence that brought them to this state? Do they risk reinforcing and normalizing an association of Blackness with poverty and destruction? What do they communicate?

These questions still hover around the work. In fact they are part and parcel of what makes it "good to think with," but I want to underline what I see as a key point: these colors don't merely serve to produce abstraction; they engage

deeply with its history, serving as a kind of counterabstraction that insists upon the community meanings that are lost in the moment of demolition, demolition whose history is itself thoroughly intertwined with the history of abstraction within modernism. At the same time, the opacity of the color suggests interior depth without insisting on revelations of private lives and loss—indeed, it reinforces their privacy.

Color(ed) Theory did not make any places. It asserted its own ephemerality, or perhaps dramatized the impending fact of destruction. But it does not take an elegiac or mournful tone. As with community murals, the experience of the collective act of painting, the community conversations among neighborhood residents and visitors around those painting events form part of the work of art. Williams does not explicitly represent the act of painting collectively and the conversations that surrounded each painting event in this way: she does not turn the participants into art or make them her medium. In the interval between painting and demolition the house might hold symbolic potential for the surrounding community in a different way, not with any hope of staving off demolition, but with the imaginative possibilities it opens up. A man who drove by the Crown Royal house asked Williams if she was the painter, and wanted to know if Prince was coming to town. Perhaps in that moment, the house served a function that takes part in what I am calling place holding: serving as a placeholder for something yet to come. Perhaps in that moment (and others), the house said with Gwendolyn Brooks: "Conduct your blooming in the noise and whip of the whirlwind."

6
WALLS AND BORDERS

Place Holding

IN THE STREETS

In the film *What the Fuck Are These Red Squares*, produced by the Chicago collective Kartemquin, a group of art students discuss the state and purpose of artmaking in the early 1970s. The film highlights the tension between aesthetics and political action. In a "revolutionary seminar" held at the School of the Art Institute of Chicago, art students, on strike because of recent National Guard and police killings of students at Kent State and Jackson State Universities, confront questions about the place of art in society, specifically the place of art in systems of value, and—a question felt acutely in the moment—their participation in it. The question of value arises through a certain tension the students feel: to become a successful artist is to produce for a market, to contribute to an elitist social system, to be implicated in a hierarchical system of values.

The title phrase appears when a White male student is asking "if we all agree that we as artists who are sensitive to the political situation should continue to make art?" He says, "Abbie Hoffman was here and looked around and said 'what the fuck are these red squares around here? You oughta be in the streets!'" We can't know exactly what the red squares were, but we can imagine their genealogy in objects like Barnett Newman's red rectangle or Malevich's black or white squares, in the cubes and parallelepipeds of minimalist sculpture. Should an artist be continuing to make red squares when students are being shot by the National Guard? Should an artist be in the streets?

Under these circumstances some artists dug in and kept making art for the market. Some transformed themselves into activists. And some headed for the hills—seeking a space outside the market and traditional artmaking, but one that was also more inward-looking and philosophical and not overtly political.

Concurrently with the political crises of midcentury, writings on art were heralding changes in the very definition of art. Leo Steinberg proposed the idea of the "flatbed" picture plane, thinking of painting as a workspace rather than a view of a world, but—as I suggested in chapter 5—if we think of it as an aerial view, it could also represent an expanse of land, or territory.[1] Perhaps this way of thinking about the picture plane has something to do with the particularity of Euro-American art's relationship to the territorial space of the nation. The land could also be a work surface. The phenomenon of land art, indeed, collapses any strict distinction between nature viewed, on the one hand, and the work surface as something like an artist's studio work table—site of operations that are internal to art and exclusive of nature.

In this chapter I look to artists who have engaged consciously with land use and its histories, starting from critiques of 1960s and 1970s land art, and acknowledging the ways in which boundaries and divides have been constructed artificially, and historically, in the North American continent. The creators of these works are particularly sensitive to questions of boundaries, borders, and walls: they explore how works of public sculpture might inhabit these spaces and call them into question. Their works situate themselves in edge zones, moving along boundaries when they can't cross them, worrying the surfaces of carceral, toxic, and border landscapes of the present, seeking to find room ultimately for an imagination of something different.

In 1965, in the early days of conceptual art, Alan Sonfist proposed what has been understood as one of the first works of land art, *Time Landscape* in New York City, conceived as a kind of time travel and as a new kind of public monument. Over the next decade Sonfist planted a plot of land with precolonial plants— suggesting a return to the period before European colonization, but also posing a divide between human habitation and nature. He may have intended to critique the environmental effects of colonization and subsequent industrialization and urban population growth, but also implied that the land was uninhabited prior to the arrival of Europeans. Twenty-five years later and a short walk away in Lower Manhattan, Alan Michelson's public installation *Earth's Eye* redressed this oversight. Michelson placed markers cast in concrete to trace a ghostly outline of what was once the freshwater Collect Pond. The name "Collect" derives from the Dutch name for the pond, Kalck Hoek (Chalk Hook), which referred to the shell middens on the shore—the results of Indigenous people's long-standing habitation of land and water.[2] In stark contrast, European settlers first polluted the pond and then drained it in the early nineteenth century, clearing the way for the construction of a prison—a squat building with an Egyptian Revival portico that became infamous as "The Tombs." The original prison and its early twentieth-century replacement are gone, but court buildings still ring the site.

Michelson's markers reclaimed the space symbolically, bearing representa-

tions of objects and beings associated with the web of life that the pond sustained. Michelson availed himself of the opportunity of a residency at Snug Harbor Cultural Center and made casts—physical impressions—of his discoveries around a small pond on Snug Harbor's property: "In the process," he wrote, "I captured the tracks of a blue heron, a pond denizen, but also pieces of broken bottles and other trash. My project expanded to also include castings of offsite objects related to the natural and social history of the Collect, things like oyster shells, reeds, deer and raccoon tracks, flint corn, antique ice skates, and an anchor."[3] The cast blocks served as a memorial to Collect Pond's buried ecological and social history, including its thriving millennia under Indigenous stewardship. Drawing attention to lost ecologies and to the networks of relations that connected human and other beings, *Earth's Eye* subtly overturned the preconceptions of the genre Sonfist had helped initiate.

In the meantime, land art had largely moved out of cities, taking artists to rural and desert landscapes to shape terrain into giant "earthworks" that required heavy machinery to create, aerial photography to comprehend, and automotive pilgrimages to consume.[4] On the surface, in its rhetoric, land art seemed to rhyme with the ecological consciousness of the 1960s and '70s, but its relationship to ecology was troubled. Land art, as it trekked outward from urban areas and (with some exceptions) to the west, began to suggest a logic of seeing the land, or at least large swaths of it in the West, as "virgin territory," ready to be touched by the inspired imprint of a "master" artist. Created from within the tradition of modern art that looked to Europe for its ancestry, land art relied upon settler colonialism for its very being, even as its heady technospiritualism appropriated Indigenous mark making, such as the rock art of the Southwest US.[5]

Robert Smithson, whose work was central to the constitution of land art as a genre, is sometimes associated with environmental attitudes, even activism. But in an interview conducted in 1969 by the Danish team of artist Stig Brøgger and the writer Erik Thygesen, Smithson specifically disavowed activist approaches, distancing himself from Abbie Hoffman and the Art Workers Coalition by name. "There are lots of protest groups and things like that," he says, but "they seem to be the other side of the existing political coin." In other words, their actions are contained within existing logics and not intervening in them. The interviewers press him on the idea that an artist (the example is filmmaker Jean-Luc Godard) could work in multiple languages, could be "out in the street at the same time," and Smithson diverts the conversation, clearly uninterested in political militancy. The alternative he holds to is a form of primitivism, asserting that "the moral thing" would be to dispense with modernity's emphasis on science and technology "and into a more fundamental, more elemental, primitive kind of condition."[6]

In the years since Smithson's first major pieces (such as *Spiral Jetty*, installed

in the Great Salt Lake in Utah in 1970), land art and earthworks have incited vigorous discussion and critique. Some of the most trenchant critiques have come from artists. In 2011–13, the filmmaker and interdisciplinary artist Cauleen Smith created three linked films that responded critically to specific canonical works of the medium and to the historical phenomenon of land art in general. Explaining why she turned to this work of critical engagement, Smith describes being annoyed on learning that, in the midst of the social upheaval of the 1970s, land artists failed to consider "the fundamental question about the stewardship of the Earth or to whom the land belongs," opting instead to focus on "the tension between the monumental and the immaterial."[7] To her, "taking on Land Art was a step along the way to confronting the stakes of being human in the 21st century."[8]

The first effort in the trilogy was *Remote Viewing*, which drew parallels between land art pieces—Smithson's *Partially Buried Woodshed* and Michael Heizer's *Double Negative*—and the physical erasure of a Black schoolhouse in Sheridan, Arkansas in the 1950s (fig. 6.1).[9] In the midst of the Civil Rights Movement, in order to avoid integrating the schools, Whites in the town conspired to fire Black factory workers from their jobs and evict Black families from their homes. To erase the memory of the town's lone Black school, they bulldozed it into a hole in the ground. Reverend James L. Seawood tells the story: "I remember one day, mother and I got into the old station wagon because mother had

FIGURE 6.1
Remote Viewing, directed by Cauleen Smith, 2011. Digital film for projection, 15 minutes running time. Film still courtesy of the artist.

heard that the school was going to be torn down. We went inside the school, we got whatever records we could find, we put them in the back of the station wagon. Then, a big bulldozer came and dug a deep hole, and after digging this deep hole, just pushed our beloved school in the hole and covered it up ... and it was as though it was ... never there."[10] As a project about memory, architecture, and absence, Smith's film resonates with *Ghost of the Liberty Street Church*, a project by the collaborative Spectres of Liberty that produced a ghostly reconstruction of the Liberty Street Baptist Church, an important and barely remembered site for the history of abolition in Troy, New York (fig. 6.2). But the story of the school's burial in the earth is even more disturbing, and Smith layers onto this history a reflection on the history of land art, creating a rhyme between the earth-moving operation she reenacts and those of Smithson, Heizer, and their fellows. She asks us to think about *what was there* before land art could do its work, to understand the physical work of land art as an erasure of memory in its own right. What are the unseen marks on the landscape, what was the emptying out that had to operate first, before land art could be possible?

The second film in Smith's series was *The Grid*, shot in Malibu Creek State Park west of Los Angeles, also in 2011. In the fifteen-minute film, Smith and an

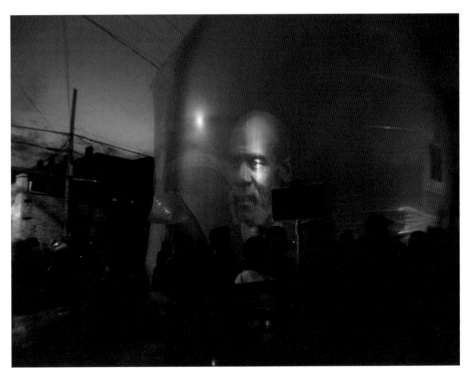

FIGURE 6.2
Spectres of Liberty, *Ghost of the Liberty Street Church*, 2008. Plastic, tape, wind, video projection. Image courtesy of Olivia Robinson.

FIGURE 6.3
The Grid, directed by Cauleen Smith, 2011. Digital film for projection,
16 minutes running time. Film still courtesy of the artist.

actor, Alem Brhan Sapp, do their best to impose a grid on the park's irregular savanna in the glow of the afternoon sun. Smith refers to the film as a "failure" because the grid could not be successfully imposed. But in fact, the failure of the grid speaks volumes. The pair hammers garden stakes into the ground with wooden mallets, carefully tying forensic tape to the stakes' coiled tops and unwinding lengths of the tape to make the grid. The bright pink of the forensic tape, unrolling in closeups, contrasts sharply with what is otherwise a palette of green, gold, and brown. The wind stymies the human actors' efforts, causing the tape to billow up; as they climb over and under the fallen limbs of a gigantic valley oak, they doggedly try to make the stiff geometric grid work (fig. 6.3). Smith's description suggests something Edenic about the casting of man, woman, tree: "We were definitely in semiwild, idyllic space and I just put this male and female figure around a tree. All these icons of fertility and eternal life and regenerative ideas. Then the grid—a grid always represents death to me. I just can't get past it. It's about plots, plotting, and forensics."[11] We have already seen the grid Smith addresses in its acts of measurement and expansion, in Jefferson's 1785 Land Ordinance and Lincoln's 1862 Homestead Act, in the Miesian grid of Crown Hall, in Barnett Newman's grid of gender. The grid abstracts: violating the specificity of the land's own features, it constructs the nonhuman world as an object of

property and produces artificial boundaries. But Smith's choice of words is especially interesting. Plot and plotting have multiple meanings. They can refer to acts of scheming, or a story's narrative arc, to tracing data on a graph—sequences of data or events. But they can also refer to plots of land, or cemetery plots. The intersection between these fields of meaning might be a notion of inexorable arrangement and control over space. And forensics embeds similar elements, insisting in its etymology (Latin *fores, forum*) upon the relationship between judicial processes and public, outdoor space. All these are bound up in the construction of the park. In this context it is striking that Smith and her crew were asked by the park rangers to take care not to have any actual physical impact on the land. The park is to be preserved, untouched, for the public: it presents itself ideologically as natural, but actually enshrines a snapshot of the interaction of humans and extrahuman nature. But this land too had to be emptied out before it could be a state park. It was already a product of the grid.

The third film in Smith's series came two years later: *Songs for Earth and Folk*, commissioned by the Chicago Film Archive. In it, she splices together archival footage from the CGA's collection to imagine the dialogue of a world in crisis, dramatizing the insouciance of human beings with respect to their use and abuse of the earth. For this project, Smith collaborated with the multigenre, unclassifiable rock band The Eternals, led by Damon Locks. The Eternals' soundtrack is the first thing you notice about *Songs for Earth and Folk*: a high-pitched buzz, a lower drone, and a desultory scrape, scrape, scrape of a drumstick across a metal bell.[12] The camera pans across a cracked desert landscape. An animated Earth speaks to Folk—human beings—but they don't listen. Earth speaks in a typewriter font: "I've been going through some changes. But don't worry about me" (fig. 6.4). The edge of a sandbank collapses, bit by bit, breaking up again and again into cascades of sand as the synthesizer embarks on a deep, frantically accelerating, repetitive motif, the sound of filmic foreboding. "I've been thinking that it's time—" Earth's words read. There's a pause and Earth continues: "so very time"—another pause—"for you to leave." The title "Folk:" hovers momentarily over scenes of rapidly moving machines, then disappears. It seems as if Folk has nothing to say. For two minutes, we see busy scenes of human activity: a film reeling, an oil rig drilling, air traffic controllers at work. The same frantic synth motif plays. Then: "Sorry," Folk says, devastatingly obtuse. "Did you say something?"

BACK TO THE LAND

White and mainstream environmental discourses on a basic level have often failed to recognize the very different valences that the natural environment,

FIGURE 6.4
Songs of Earth and Folk, directed by Cauleen Smith, 2013. Digital film for
projection, 11 minutes running time. Film still courtesy of the artist.

nonhuman nature, and the "great outdoors" have in the context of American
histories of oppression. Conservationist discourse might, for example, lament
disproportionately low attendance at national parks by African Americans, with-
out acknowledging differential histories in relation to the land and the colonial
assumptions embedded in "preservation" discourse to begin with. A number
of authors have addressed these issues in depth. Carolyn Finney's *Black Faces,
White Spaces*, for example, looks specifically at the question of national parks,
addressing the history of racialized violence enacted in outdoor spaces, from
enslavement to lynching and beyond, that made the outdoors a place of terror for
many African Americans.[13] Christina Sharpe, in her *In the Wake: On Blackness and
Being*, notes that "the weather is the totality of our environments; the weather is
the total climate; and that climate is anti-black."[14] Poets, too, have addressed the
problem of a "nature" whose history is infused with violence. In this situation
Dionne Brand finds "land to light on"—that is, with no sense of ownership, but
the possibility of respite—while Tiana Clark writes, as I noted in my introduc-
tion, "I can't talk about the trees without the blood."[15] And for Indigenous people,
the construction of a national park violated cultural linkages to the land and
removed means of subsistence just as surely as a suburban subdivision did.

Abuse of the idea of "nature" also appears in the way racial "science" has his-
torically been mobilized to produce exclusion, hierarchy, and segregation, divi-
sions that also play out over spatial demarcations and differing constructions
of land use. To think further about how boundaries continue to operate ideo-

logically in relation to race in the United States, we might look to contemporary Disney films marketed to children and teens.[16] The 2016 Disney animated film *Zootopia* and the 2015–19 *Descendants* trilogy, also produced by Disney, address American race relations in allegorical ways that specifically bring questions of nature and space to the fore.[17] The *Descendants* series allegorizes or alludes to American racial politics by imagining a world—the "United States of Auradon"—populated by the descendants of the heroes and villains of past Disney films. More specifically, Auradon is a fairy-tale utopia of heroes and heroes' kids, one that owes its idyllic character to the fact that both the villains and the younger generation of their children, "villain kids" (or "VKs"), have been cordoned off and housed with their families in a gritty, sleazy urban underworld called the "Isle of the Lost." (Much could be said about the way race does and doesn't figure moral standing in the multiracial—and in many cases racially ambiguous—cast, in which the centrality of Whiteness is still consistently preserved.) In *Descendants*, the idea that education can override "nature" is presented as an innovation in the old carceral order. Ben, the young heir apparent of the idyllic Auradon, initiates a limited program to bring a few select VKs, who as he points out are not responsible for their parents' wrongdoing, to be inculcated into socially correct behavior at Auradon Prep. Of course, the many VKs who are left behind are also blameless, a problem that the series begins to address in the sequels: how to maintain the saccharine "goodness" of Auradon's constructed and defended space while allowing for the value of fairness and equality to prevail?

In *Zootopia* the society at large, in its overt messaging, has advanced to the point of claiming that "nature," in the sense of predetermined racial characteristics, can be transcended. The eponymous capital city Zootopia struggles to make its ideals a reality, however, and relies on policing and—in the extreme case—imprisonment. Zootopia is an elaborate architectural fantasy, a liberal, multicultural utopia, an experiment in creating an architecture of diverse climates in which mammals of different species, predators and prey, and differing habitats can live peacefully together. As the pop star Gazelle (voiced by Shakira) puts it, "Zootopia is a unique place. It's a crazy, beautiful, diverse city where we celebrate our differences." Yet difference only goes so far; while the society officially claims species can transcend their original "natures" (implicitly through the artifice of the utopian setting), it also expresses skepticism about this possibility at every turn. When tensions arise the allegorical reference to race becomes very clear, as the bunny character Judy Hopps says to her friend Nick Wilde, a fox, "you're not *that* kind of predator." In *Zootopia*, divisions are constructed out of mammal types, predators and prey, a divide that calls up the racialized mythology of the "superpredator."[18] When Judy Hopps is presumed, as a bunny, to be unfit to be a cop, gender also seems to be at stake. But it is more like race when

predators are presumed—wrongly, as it turns out—to be criminally inclined as a result of biology.

Zootopia and the *Descendants* series, produced in the same decade by the same corporation, have a number of things in common. In each case it turns out that know-how from the hinterland (also associated with "bad" kids who make "good," the reformed bully Gideon Grey's surprising botanical expertise and the VKs' pluck, fighting ability, and magical knowledge) is necessary to save the threatened center. And both represent liberal utopias that claim to welcome diversity into their midst (a bunny can be a cop, VKs can be trained to "be good") but rely on carceral logics of exclusion (a secret asylum at the edge of Zootopia, not to mention the fact that the protagonist is a cop; the Isle of the Lost, essentially a prison island). Another recent Disney movie series, *Zombies*, operates according to a similar formula, setting up structural differences between suburbs and slums, wilderness and industry, and divisions between character types that allegorize race (slum dwelling zombies are African American, forest dwelling werewolves are Native). These examples illustrate how nature as racial identity and nature as a system of distinct and divided spaces (the urban ghetto and the pastoral; the utopian city and the rural hinterland) remain linked in cultural imaginaries.

In spite of what the American mythology of the natural landscape would have us believe, rural landscapes cannot be equated with simplicity, nor do they reflect a state untouched by human hands. In the experimental documentary *Around Crab Orchard* by Sarah Kanouse, the story and images revolve around how to detect secrets—of many kinds but especially the secrets of the landscape. How can we comprehend what cannot be seen? Kanouse narrates an innocent trip to a local wildlife refuge—Crab Orchard National Wildlife Refuge in Southern Illinois—that ends with a knock on her door from the FBI. Having taken photos of some low-slung white buildings that incited her curiosity, she has unwittingly fallen afoul of heightened concerns about domestic terrorism in the wake of 9/11. The FBI came calling because she was taking pictures—because she was trying to see something that was not supposed to be seen. Because these barriers to visibility carry with them the threat of violence, of the use of force, they cannot simply be transcended, as the film helps us to understand. Instead of through or into Crab Orchard, the film has to look *around* it—hence the title—using research tools like archival documents and interviews, but also analogies and imagined reconstructions. Kanouse literalizes the metaphor of reconstruction, allowing the camera to linger over her hands as she pieces together simple models of the white buildings out of foam core and rubber cement (fig. 6.5).

One thing that often can't be seen, but can nonetheless be studied, is the toxins. During World War II, the site that is now a wildlife refuge was used as a munitions factory, the Illinois Ordnance Plant. And so the water at Crab Orchard

FIGURE 6.5
Around Crab Orchard, directed by Sarah Kanouse, 2012.
1 hour 10 minutes running time. Film still courtesy of the director.

teems with toxins: PCBs, THMs, lead, arsenic, and more. In the immediate vicinity are other traces of toxic extraction and manufacturing, some of them quite visible indeed. On the northeast side of Carbondale a wooded lane is chained off to prevent trespassers on the site of an old plant that made creosote to seal railroad ties, where dioxin leaches into the earth. Fields of yellowed, dead grass and streams that run bright orange surround the former Will Scarlet strip mine, in Williamson County, closed in 1987 and still, despite ecological restoration work, oozing acid. Orange liquid also flows around Peabody Energy's 160-acre impoundment structure for coal ash in Cottage Grove, a town in Saline County. This toxic mound is two hours' drive from the very different mounds at Cahokia, site of an ancient Indigenous city, but it's just a few minutes to the peaceful and awesome Garden of the Gods, part of the Shawnee National Forest, with its towering rock formations, sandstone spires called "hoodoos." The remains of toxic extraction followed by reclamation for "nature" plays itself out over and over again. At Crab Orchard, land was designated a wildlife refuge because it wasn't safe for human use. It becomes something like a *replica* of wildness, an archive of nature, while being thoroughly, invisibly, contaminated.[19]

Or perhaps it is a wildlife refuge to camouflage what else goes on there. The buildings Kanouse encountered, it turned out, are owned by the defense contractor General Dynamics, and represent part of the long history of military uses of the site. General Dynamics is a successor to Material Service, the Crown family business (the same Crown as Crown Hall), which merged with it in 1959. The

Crown family still owns 10 percent of the corporation. (Members of the family sit on the boards of trustees of both the University of Chicago and Northwestern University, the two institutions where I have spent most of my career.)

The reach of General Dynamics is profound. When my grandfather died in 1995, I was in graduate school. I missed his memorial service because I was had made plans to travel and thought he would want me to honor those plans. For my grandfather's service I sent a reading, a translation I lovingly made of a poem by the sixteenth-century French poet Joachim du Bellay. Pining for home, Du Bellay writes of the old age he longs for: home in his little village, at rest from his travels. "Happy is he who, like Ulysses, has traveled well . . . and then comes home, with all his experience, to live out his years among family." Had I been in Maine that summer to attend the service I might have noticed the big local news: in 1995, the largest local employer, Bath Iron Works, the shipbuilding company founded by Thomas Hyde, was acquired by General Dynamics. Local is global, and global is local. General Dynamics has contracts with Homeland Security, and with the Forest Service, which is part of the US Department of Agriculture. Former Secretary of Defense James Mattis was on the board of General Dynamics before he joined the Trump administration, and rejoined it after he left.

Central and southern Illinois are traditionally farm country, but the economy of the region has changed over the years. The number of farms in the United States peaked in 1935—a Depression-era spike that temporarily masked a slow, steady decline that grew steeper after World War II. While the total acreage devoted to farming remained approximately the same, the style of farming shifted proportionally from small family farms to larger "factory" farms. Correspondingly, the rural population has declined. The dwindling of manufacturing jobs that had also employed people in rural areas added to a crisis situation in these communities. But a solution seemed to be in the offing: the construction of a prison landscape for rural America. As young White people were going "back to the land" in the 1970s, the US prison population was also beginning to grow steadily—and then, by the mid-1980s, steeply. As Tracy Huling, founder of the Prison Public Memory Project, puts it, "The acquisition of prisons as a conscious economic development strategy for depressed rural communities and small towns in the United States has become widespread. Hundreds of small rural towns and several whole regions have become dependent on an industry which itself is dependent on the continuation of crime-producing conditions."[20]

In the course of her investigation of the invisible in *Around Crab Orchard*, Kanouse comes upon a puzzling spot on the grid of the wildlife refuge's map, a square that seems to have been cut right out of the corner of it—the federal prison at Marion, Illinois. The prison has held mobsters like John Gotti, gang leaders like Jeff Fort of the Blackstone Rangers, and political prisoners such as Leonard Peltier and the less famous antiauthoritarian activist Bill Dunne, sen-

tenced to eighty years for the attempted jail break of prisoner Artie Ray Dufur. Having noticed both the unpleasant smell of the prison's tap water and the fact that prison guards drank only bottled water, Dunne struggled for years to make his complaints about the toxicity of the water heard. The water, of course, came from the wildlife refuge. He tested water by holding scraps of white cloth under faucets and sent a stream of letters to anyone who would read them. In Kanouse's film, Nicholas Brown reads Dunne's letters about the toxic water. In 2020, COVID-19 has—or should have—taught us that prisoners are especially vulnerable to the toxins in "the environment," if we didn't already know. Landscapes of the carceral and toxic landscapes are often the very same landscapes, or thickly entwined with one another. What does it mean when we cannot penetrate their boundaries but can only move around the outside?

For most people, prison walls seem to present an impenetrable barrier, whether from the outside or from the inside. These walls themselves became an artistic medium for Maria Gaspar, an interdisciplinary artist from Chicago, in her *96 Acres Project*.[21] Originally trained as a muralist, Gaspar drew upon the energies of the strong local tradition in mural painting and public arts as she engaged with the walls of the Cook County Department of Corrections (usually referred to as the Cook County Jail). Covering more than eight city blocks—ninety-six acres—the jail is one of the largest pretrial detention centers in the United States. Much like the way Kanouse points to a blank square on the map that appears carved out of the wildlife refuge, Gaspar's title emphasizes the use of space, of territory, involved in siting a prison in a particular place.[22] The *96 Acres Project* (96acres.org), active from 2012 to 2016, brought together artists working in a variety of media to conduct projects that address the walls of the jail, the people who circulate in and out of it, and the surrounding neighborhoods of Little Village, also known as South Lawndale, on the West Side of Chicago. Drawing on the energies of Chicago's restorative justice and activist artist movements, she created a broad and intergenerational collaboration that produced performances, installations, audio and film projects, and public art interventions around the jail while working closely with inmates to make their stories heard.

Gaspar builds on a history of artists engaging across prison walls. From Margaret Burroughs to the organizers of Chicago's Prison + Neighborhood Art/Education Project (P+NAP), artists have worked in and out of prisons: teaching classes, collaborating by correspondence, finding ways to bring their students' work out into the open, reporting on conditions inside. The project Tamms Year Ten began as an aesthetic gesture of sending poems to prisoners at the Tamms Supermax prison in Illinois, until the prisoners wrote back saying that poetry was nice, but could the group do some legislative work on their behalf? The Chicago Torture Justice Memorials project, likewise, worked with survivors and currently incarcerated people, as well as family members and community activ-

ists, first to create an exhibition, then to push successfully for a city ordinance that requires education and services for survivors of Chicago police torture, curriculum for schoolchildren to learn about its history, and a monument to survivors—a process that is still in progress as I write.

To be a mural artist is never just about decorating walls, but in Gaspar's work, it is also about engaging deeply with the very idea of a wall. Not only the walls but the regulations and restrictions of the jail become part of the medium of the work itself. Seeking creative ways to think, talk, and visualize across barriers to visibility and knowledge, Gaspar pursued a study of those walls, in material, concrete terms: the way they look and what they represent to those who have to look at them day in and day out (whether because they dwell within them or just outside). This is especially evident in her viscerally challenging piece *Haunting Raises Specters*, which was presented at the Jane Addams Hull-House Museum in 2015 (fig. 6.6). The ghostly installation was a movable, translucent curtain on which an image of the full length of the 850-foot-long north-facing wall of the Cook County Jail, with all its cracks and stains, had been printed. Hanging on a curving track system, the curtain flowed lightly with the breeze and enfolded visitors who moved through and around it into smaller spaces created by the shape of the track. It was easy to lose the sense of which side of the "wall" you

FIGURE 6.6
Maria Gaspar, *Haunting Raises Specters (by A.G.)*, 2015. Digitally printed dye substrate, aluminum curtain–track system, beaded chain, grommets. 10 × 160 ft. (3 × 48.8 m). Installation at Jane Addams Hull–House Museum, 2015. Photo courtesy of the artist.

were supposed to be on. Positioning the museumgoer in an ambiguous and disoriented space with respect to the "walls" of the jail, *Haunting* offers a reflective counterpoint within the ecology of Gaspar's individual and collective work around the jail.

One of the most powerful interventions in *96 Acres* was the project undertaken by young people from Yollocalli Arts Reach. Inspired by Gaspar, making creative use of decades of accumulated city dirt that created a substrate for their work, the young people used stencils to power-wash phrases like "What's your role?" and "This is not a rehearsal" onto the walls of the jail and surrounding sidewalks (fig. 6.7). In a state where graffiti writing can land you in that very jail for months or years, the project made simple but ingenious use of the fact that the students were technically cleaning rather than defacing the walls. The words themselves were poetic and powerful, amplified by the creative use of dirt and its erasure.

Gaspar often works with sound, as a medium that can pierce walls and other boundaries, both complementing and, at times, contravening what is seen with the eyes. This was especially evident in her project *Radioactive: Stories from Beyond the Wall*, which began as part of *96 Acres* and took on a life of its own. The word "radioactive" in the title layers multiple references. It compounds "radio"—a broadcast medium that travels across distances, through walls—and "active," for activism. While suggesting that the social death of incarceration renders subjects metaphorically "radioactive," that is, untouchable, it conversely hints at

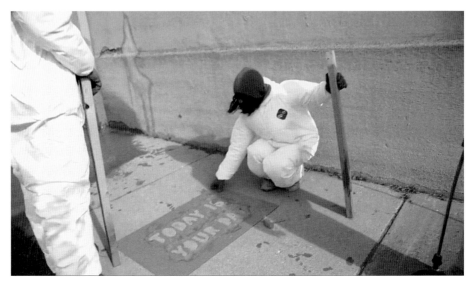

FIGURE 6.7
Maria Gaspar. *Today Is Not Just Another Day*. Sidewalk stenciled with power wash. Yollocalli Arts Reach project conducted at Cook County Jail, Chicago, 2014. Video footage shot by Scrappers Film Group. Part of Gaspar's *96 Acres* project.

energy that radiates, that is transformative.[23] In this collaboration, Gaspar and her colleague Michael De Anda Muñiz led workshops with Cook County Jail residents, inviting them to create texts in which they each wrote about (often in the voice of) a physical element of the jail itself—electrical lines, mirrors, cells, surveillance cameras, floors, coffee, windows, somebody's old shoe. The participants worked together to create audiovisual works based on one another's texts, recording readings and producing stunning line drawings and instructions for animating them. A professional animator assembled the visual materials into a film that was projected onto the walls of the jail, while the audio narration, produced as a radio broadcast, played concurrently over speakers at the site. Punctuated by passing cars (police vehicles, city buses, and, at least one night, a steady stream of cars and trucks bearing the Mexican flag and honking in celebration of Mexican independence, September 16), the words and images evoked rich metaphors of confinement, dehumanization, visibility, invisibility, and power.

BORDER ZONES

The idea of moving alongside a barrier, tracing its edges without being able to penetrate it, also appears in artworks that address themselves to the obstacles to movement constituted by national boundaries, especially those that memorialize the violence inflicted on Indigenous people in the formation of the modern North American borders and the derogation of self-defined Indigenous boundaries. For example, in his 2009 *Third Bank of the River*, Alan Michelson layers Indigenous history with a view of the modern landscape.[24] This etched glass panorama, more than forty feet long and composed of digitally stitched photographs, was commissioned by the General Services Administration and is permanently displayed at the US Port of Entry in Massena, New York, at the border with Canada. The panorama represents three miles of the four banks of the Saint Lawrence River at Three Nations Crossing: those of Massena, New York, and Cornwall, Ontario, and those of the island between them, known as Cornwall Island, Akwesasne Mohawk territory located within Canada. The four shorelines are stacked in an arrangement that echoes the Two Row Wampum, a famous Haudenosaunee treaty belt, including its characteristic purplish blue and white palette of beads made from the shells of the quahog and whelk (plate 13). The Indigenous designer of the woven belt represented the two parties to the 1613 treaty, the Haudenosaunee and the Dutch, with two parallel purple rows, symbolizing the parallel course of two vessels on a river, a canoe and a sailing ship. Symbolically, each party agreed to remain in its own vessel and not try to steer or interfere with the other's—a promise that, over time, Europeans failed to uphold again and again. As Michelson, himself Mohawk, puts it on his website, "The

FIGURE 6.8
Alan Michelson, *Mespat*, 2001. Video, turkey feathers, monofilament, steel
Original sound track by Michael J. Schumacher 132 × 168 × 12 in. (335.2 ×
426.7 × 30.5 cm). Image courtesy of the artist.

belt continues to function as a meaningful symbol to the Akwesasne Mohawk,
whose land predates and straddles the complex border."[25] In the book *Shifting
Grounds: Landscape in Contemporary Native American Art*, and in an article that pre-
ceded it, "Running the 'Medicine Line': Images of the Border in Contemporary
Native American Art," Kate Morris discusses this and other works by Michelson.
In the earlier (2001) video installation *Mespat*, Michelson drew inspiration from
the same nineteenth-century river panoramas that sparked Thoreau's reflections
on the heroic medievalism of the western wild. Shot from the water, *Mespat*'s
video footage tracks horizontally along the three-and-a-half-mile-long extent of
the banks of Newtown Creek, a tributary—a tidal creek, or estuary—of the East
River in New York City that forms part of the boundary between Brooklyn and
Queens (fig. 6.8). The word "mespat," the same word as Maspat or Maspeth—site
of an early European settlement and now a neighborhood in Queens at the end of
the estuary—is also the name of the Mespeatches tribe. It is a Lenape placename,
meaning a swampy place, a "place with bad water." The creek is now a Super-
fund site, a different kind of bad, the result of years of pollution with industrial
wastewater and sewage and a massive long-term oil spill, the Greenpoint spill.
By the mid-1800s, as the EPA report on the site explains, "more than 50 refineries

were located along [the estuary's] banks, including oil refineries, petrochemical plants, fertilizer and glue factories, sawmills, and lumber and coal yards."[26] Many of these refineries were incorporated into John D. Rockefeller's Standard Oil by the late nineteenth century, and after the antitrust breakup of the company in 1911, it was Standard Oil's successors—Mobil and later ExxonMobil—that were to cause the bulk of the spillage.

Michelson had initially intended to base his video on Rikers Island, the site of New York City's primary jail complex. But as Michelson put it, "the jail complex was clinical and benign-looking," and, in search of more visually compelling subject matter, he decided to explore the industrial landscape of the banks of the estuary.[27] As with *Around Crab Orchard*, the toxic and the carceral are linked, though the prison's relationship to the genealogy of the project is not visible in the final product—the prison complex did not lend itself to the kind of visibility Michelson hoped for. But he alludes to broader questions of visibility, as well as deeper history, by layering his video onto a screen woven of turkey feathers, the material of traditional Lenape capes or mantles.

The passage along the river in the video can be thought of, like the panoramas that inspired it, as an extended horizontal. The artist collective Postcommodity's *A Very Long Line* and *Repellent Fence* share this formal character and similar themes with *Third Bank of the River* and *Mespat*. As with *Third Bank*, the extended horizontal borrows its shape from the act of moving along an international border. *A Very Long Line* (2016) presents an immersive four-channel video installation in which each screen displays video—shot at varying speeds—moving along sections of border fence between Douglas, Arizona, and Agua Prieta in the Mexican state of Sonora (fig. 6.9). The viewer is surrounded by this movement along—and not through—the border, along with reverberating sounds suggestive of modes of transportation, cars, trucks, trains: buzzing, hissing, squealing, clacking. As with *Mespat*, the movement recalls nineteenth-century river panoramas; in thinking of the elongated horizontal, we could also imagine Barnett Newman's *The Wild* turned on its side. The same is true of the border between the United States and Mexico, subject of devastating border security theater in recent years.

Postcommodity constituted *Repellent Fence* (2015) through a series of giant floating balloons temporarily installed in the same borderlands between Douglas and Agua Prieta (fig. 6.10). The iconography of the balloons was based on a type of bird repellent balloon ("yellow scare-eyes," thought to scare birds away because they look like a large predator's eyes). As Kade Twist, one of the group members, observed in an interview, "the iconography of the 'open eyes' on the balloons" also represents "one of the oldest indigenous symbols in the hemisphere, stretching from Central America all the way to Canada and into Alaska."[28] In their interactions with the residents on each side of the border, the group found that the balloons could serve as a way of making connections across the

FIGURE 6.9
Postcommodity, *A Very Long Line*, 2016. Four-channel video with
sound, installation view at the Art Gallery of York University, 2018.
Photo credit: Yuula Benivolski. Image courtesy of Bockley Gallery.

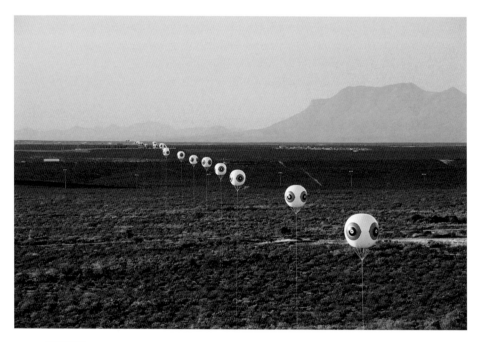

FIGURE 6.10
Postcommodity, *Repellent Fence/Valla Repelente*, 2015.
Installation view at US/Mexico border, Douglas, AZ / Agua Prieta
SON, 2015. Photo credit: Michael Lundgren. © Postcommodity.
Courtesy: Postcommodity and Bockley Gallery.

dividing line that cut through the territory of the Tohono O'odham (near Tucson, Arizona, on the US side).[29] And yet, they still look like giant eyes. They may be humorous more than hostile, but still, they seem to be *looking*.

General Dynamics provides services to migrant detention camps, including those that incarcerated children under the Trump administration. It also provides border surveillance technology. Visibility for me but not for thee: in 2018 GD deployed the Relocatable-Remote Video Surveillance System at the Texas border on behalf of the Department of Homeland Security. As the firm's website puts it, "Adaptable to multiple environments, the Relocatable-RVSS is a multi-sensor surveillance system that allows for flexible and rapid deployments. This provides U.S. Border Patrol Agents with advanced real-time situational awareness and the ability to predict, detect, track, deter, respond and resolve threats in remote locations. Throughout the pilot's testing, the Relocatable-RVSS proved effective in increasing officer safety, intelligence and mission effectiveness and was adaptive to wide-ranging operational needs."[30]

In engaging in a kind of mimicry of the oppressive operations of the surveillance state at the border, we might imagine that Postcommodity is not just calling attention to them in a critical way, but seeking to inhabit them in order to understand them. This could run in parallel with the artist Torkwase Dyson's understanding of how a practice of abstraction can work in her paintings: inhabiting murderous processes of abstraction and their effects on landscapes and waterscapes under the "Plantationocene," they seek a deeper understanding of them. In the series based on her concept of "Black compositional thought," Dyson layers abstract linear forms with deep black and blue paint, calling to mind the violence of abstraction insofar as it concerns extraction of materials and labor. Thin white diagrammatic lines derive from the architectures of extractive industries—oil rigs or slave ships. Deep, flat black suggests the shape of a ship's sail; drips, spatters, washes of blue evoke liquidity, the thick and messy materiality of sky, water, oil, and bodies turned liquid assets (plate 14).

Another way of working back and forth across a border appears in the "platforms" Dylan Miner created for an exhibition and festival, *The Work of Wind: Air, Land, Sea*, organized by the Blackwood Gallery of the University of Toronto at Mississauga. For this 2018 project, *Agamiing—Niwaabaandaan miinawaa Nimiwkendaan // At the Lake—I see and I remember*, Miner constructed platforms of planks of reclaimed old-growth wood with a copper frame—they look a bit like shipping pallets—and placed them in a series of locations in the Southdown Industrial Area in Mississauga, Ontario, to the south and west of Toronto, near the western end of Lake Ontario (plate 15). As Jayne Wilkinson put it, the platforms "required viewers to spend time at various sites, often only metres from security fencing, and with the knowledge that industrial pollutants are seeping into the earth, air and lake beside you." The platforms served as "an offer-

ing of rest."[31] As the exhibition text explains, the use of copper alludes both to mining ("early capitalist mineral extraction in the Great Lakes region") and to "the sacred use of copper within many Indigenous communities." The text continues: "Rematriating old-growth wood (and copper) back to the land, Miner's work also explores the non-linear temporal concept of *aaniikoobijinag* (ancestors/descendants)—this work serves to bring the past into the present/future, or the present into the past/future, or the future into past/present. In addition to mediating between earth, water, and skyworlds, Miner's platforms also serve to create a space to look at and remember the ecological destruction wrought by industry. Animated throughout the exhibition, Miner's platforms serve as micro-ecologies within the larger industrial environment."[32]

In the context of ongoing discussions of monument removal, they might also be thought of as empty plinths, ready to be filled with temporary monuments responsive to present concerns. In an email, Miner also referred to the platforms as "docks or portals, thinking also about transporting folx across time // space, as well as looking at sites of violence."[33] The project thus involves creating space for spatial and temporal imagination: to contemplate the damage done, but also, potential, to think the border out of existence. Miner grew up in and lives in eastern Michigan and is Métis—a nation of mixed Indigenous and European heritage that is recognized as an Indigenous people in Canada, but not in the United States. He traces his heritage to the island known in Ojibwe as Bootaagani-minis and as Drummond Island in English, off the Upper Peninsula of Michigan in Lake Huron. The island is now part of the state of Michigan, following negotiations of the disputed border between Britain and the United States in the War of 1812. The border between Canada and the United States in the Great Lakes, whether Lake Superior, Lake Huron, Lake Erie, or Lake Ontario, cuts across the water with sharp straight lines that make seemingly arbitrary angles evoking Dyson's abstract linear compositional forms. The lines are not exactly arbitrary, because they are the product of surveying, negotiations, agreements. But they, of course, excluded any consideration of Indigenous sovereignty. The border makes a big detour to loop around Bootaagani-minis, displaying its artifice, its lack of natural relationship to the physical particulars of the topography it constrains, as well as its historical violence to Indigenous people.

In his essay "Gaagegoo Dabakaanan miiniwaa Debenjigejig (No Borders, Indigenous Sovereignty)," Miner suggests a practice of *imagining away* the border. What would it mean to imagine a border or wall or boundary out of existence? Or to draw one back into being? In 1923 the Cayuga chief Deskaheh traveled to Geneva to speak to the League of Nations on Indigenous people's rights. He was denied an audience. But he traveled on a Haudenosaunee passport, and the passport was accepted for entry into Switzerland. The passport was a creative assertion of rights that, at least temporarily, brought sovereignty

into being. Haudenosaunee people have presented their own passports repeatedly ever since, knowing full well that they will not always be accepted by the border authorities of other nation-states. But when they are not accepted—as when UK authorities refuse to allow Haudenosaunee lacrosse players to take part in the international competitions for the game their ancestors invented—the act of presenting them itself is a form of direct action that circulates knowledge and builds political engagement. This act might not be art, but it is parallel to the practices of art, running alongside them like the beads on the wampum belt. Along with the passport claim, we might consider the 1914 lawsuit filed by the Pokagon Band of Potawatomi for land on Chicago's lakefront as a use of the instrument of law as tactical media. The Supreme Court dismissed the band's efforts at holding the settler-colonial state to its own rules of engagement, but though the status quo did not change, nevertheless the settler-colonial position was revealed to be absurd, as the Settler Colonial City Project pointed out.[34]

In October 2021, a collective called Whose Lakefront, in a project initiated by JeeYeun Lee, "painted" a line of red sand along the historical edge of the lakefront as part of the Chicago Architecture Biennial, drawing attention to the artificially constructed land to the east of that line and the cultural institutions (the Art Institute of Chicago, the Museum of Contemporary Art Chicago, the Field Museum) that sit atop it. Crossing the Michigan Avenue bridge (called DuSable Bridge), if one were to look at the southwest bridge tender's house, one might catch a glimpse of a 1928 relief sculpture by Henry Hering entitled *Defense*, which represents—from the settler point of view—the successful Potawatomi attack on Fort Dearborn in the War of 1812 (fig. 6.11).[35] Hering adapted the composition from François Rude's *The Departure of the Volunteers of 1792 (La Marseillaise)*; recall the shot of its winged victory from the Gavras video for "No Church in the Wild." Hering's borrowing subtly conflates revolt against tyranny with settler expansionism.

Art cannot by itself break down every wall. But imagining them out of existence offers possibilities for making change that was previously unthinkable. Miner writes,

> I have been accused of imagining or wishing away the settler nation-state. At first I didn't fully know what this critique even meant, but have grown to embrace this criticism as coming from a very limited way of being in the world. As I've heard this response to my work a few times now, I think it means that my line of thought imagines that we can somehow live as if the settler-colonial nation-state is not always in control. While I understand the limits of settler colonial and capitalist hegemony, I wonder why we cannot live in ways that are not fully contained by it. . . . [I] intentionally work in ways that creatively seek to dismantle the nation-state, while also imagining a world without them.[36]

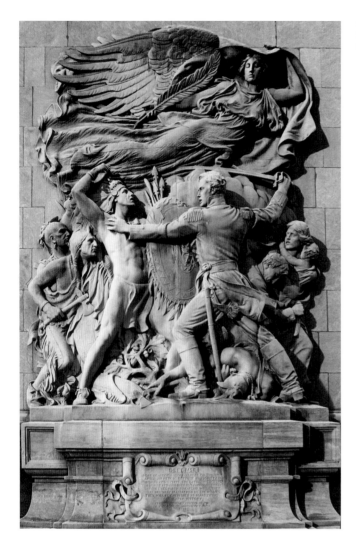

FIGURE 6.11
Henry Hering, *The Defense*, 1928. Photo
© 2010, Jeremy Atherton.

The idea of the portal creates an opening to a sense of possibility. As Kelly Hayes and Mariame Kaba suggest with respect to abolition, "We live in a society that has been locked into a false sense of inevitability . . . It's time for a jailbreak of the imagination in order to make the impossible possible."[37] As with the Haudenosaunee passports, artists working against the prison industrial complex refuse to accept the social death meted out to prisoners. Acting *as if* the Haudenosaunee nation is a fully sovereign nation (because it is), acting *as if* the land on the lakefront belongs by right to the Potawatomi (because it does), acting *as if* the prisoner is a social person and not mere flesh (because they are)— perhaps these states of affairs can only be brought into being by insisting that they already exist.

Sometimes the border is a body of water, but water is always more than a border. As a space of transport, water connects. As a force, it seeps through cracks and dissolves boundaries and crashes through walls. Water leaks, cracks and splotches can be readily seen on the reproductions Maria Gaspar makes of the Cook County Jail, as in her JAHHM piece or her wall installation piece *Unblinking Eyes, Watching*, a composite of photographs of the walls of the jail.[38] Consider it an animated force, an intimate, a relative. "Water is life," Mní Wičóni, asserts the movement that began fighting in 2016 to stop the Dakota Access Pipeline (DAPL), the proposed (and now begun) oil pipeline running through the territory of the Standing Rock Sioux tribe.[39] Often represented as an environmental movement, it does represent environmental concerns but is even more centrally a movement for Indigenous territorial sovereignty.[40] The two are intertwined. The threat of the pipeline to the water supply is a matter of life and death. While it predates the struggle at Standing Rock, Rebecca Belmore's video installation, *Fountain*, presented at the Venice Biennale of 2005, powerfully evoked the power and danger of water.[41] *Fountain* comprises a video projected in a darkened room against a wall of running water. The video begins with a camera sweeping across a beach littered with debris (it was shot at Iona Beach, adjacent to a sewage treatment plant near Vancouver, British Columbia).[42] Fire surges up in one spot. The artist struggles, nearly submerged in a body of dark water against a dark sky, as if trying to escape something that is pulling her under the waves. She *labors* with a bucket, which she seems to be trying to fill, grunting with the seemingly futile effort, the water working with and against her body. Finally, she pulls it up out of the water, onto the shore, and throws the water at the camera: it turns blood red.

Belmore is Anishinaabe and Canadian. Rather than attempt to read specifically "Indigenous" meanings into her work, I want to think about a kind of universalizing call an Indigenous position might be making possible in it. Water may be ubiquitous and universal, but in this piece, it is also violent. It floods one's consciousness. The artist's body labors against it and it is that labor, that effort, that forms the center of this work. In *Fountain*, water is suggestive of things that link human beings together. About *Fountain*, Belmore said: "I think *Fountain* is, on one level . . . a very simple piece, because it's just addressing this idea of water, and you know the bottom line is as human beings we all need water, and I think the future of water is something that we should think about, as a planet, as a planet of human beings."[43] In *Fountain*, elemental water foregrounds the stark intensity of struggles for survival. Nature is not always nice. The artist's body labors against the water, though at the same time *with* it. We

are mostly water; we labor against ourselves. The perverse intimacy of this struggle suggests consideration of our entanglements with the earth, with the elements, as actor and acted-upon, dangerous and endangered.

Triangle Trade, a 2017 collaborative short film by Jérôme Havre, Cauleen Smith, and Camille Turner, begins with water too, with efforts to escape the water and find oneself on land. I say "oneself," awkwardly, because I'm talking about a puppet, not a person. The swimming figure who lugs himself up onto the shore—or seems to, since he's manipulated by puppeteers—is one of three puppet avatars of the creators of the film that alternately assume responsibility for the surreal narrative, each in solitude within an exquisitely desolate landscape. The artifice is apparent, the work it takes to animate the scene, as human hands—hands that are firm, tender, attentive—manipulate the puppets.

The wet, hot, icy world in which the puppets find themselves serially is made of the same kind of stuff they are: papier-mâché, heavy corrugated paper, tulle, sequins, plaster, sheets of colored plastic. Messy, chaotic, visually and aurally arresting, foregrounding the artifice needed to produce it, the piece allows us no illusion that the protagonists are in full, autonomous control of themselves. And yet, as the shredded blue plastic sheets of water spit the "Jérôme" puppet out onto the shore, as the puppet seems to heave himself up, once, twice, three times, from the sand, I feel the breath expand in my own lungs. Someone moves the puppet and the puppet moves me.

From his aloneness, "Jérôme's" interior voice questions (in French) what it means to be part of a community. In the film, the three puppets are African diasporic subjects, isolated from one another, holding both a troubled relationship to the physical landscape of the "New World" and a surreal relationship to survival. They find themselves in landscapes that are beautifully bejeweled but impassive, alienating. "I don't mean to be ungrateful, but this is not what I was expecting," the "Camille" puppet keens as she wanders in an icy landscape. "Am I the only one?" she wonders. "Where is everybody?" The "Cauleen" puppet perches at the edge of a volcano. Amid these landscapes, the volcano serves as a space radically outside the violence of property.

As "Cauleen" sits beside the volcano, a high-pitched voice intones an echoing chant of welcome: "I just watch the earth make itself. The earth owns herself. I just choose to live on her. Welcome to my volcano. Her most feral and free emissions. This volcano belongs to the earth. . . . Welcome to my volcano: infertile, glassy, opaque, black, new and eternal. Everyone, everyone is welcome here. You have to be able to give it or leave it. If the lava oozes over the dotted line, do you give it? Do I leave it? Who can have it? Who needs it?"[44] The figure positions herself in an alert, watchful awe. The volcano maintains its autonomy, resonating with the independent voice of the earth that appears in *Songs for Earth and Folk*. In her interview on land art with Carolyn Lazard, Smith said, "These works did

push me even closer toward trying to understand my own relationship to the land, being the descendant of captive Africans, and being cargoed onto the North American continent—a land that was inhabited and stewarded by a people who endured obscene genocide. The work that I am making right now is attempting to reconcile the kind of dislocation that comes from actually not having any kind of homeland at all—from being a people who made ourselves in the fires of survival in the "New World."[45]

In *Triangle Trade*, the figures slowly make their way toward one another—a destination they cannot know at the outset—and cluster together in the shadow of the volcano. The title *Triangle Trade* alludes to the historical triangle trade that brought enslaved Africans to the Americas and exported crops produced in the Americas to Europe. But it also evokes the "triangle" of three collaborators and their representatives in the film. Speaking about the project in an interview with Christopher Borrelli, Cauleen Smith described this symbolic relationship: "Who owns North America? Native Americans. There's nowhere to go where you're not a part of a colonial project. A volcano is the only uncontested land."[46] The volcano's danger and undesirability make it perversely attractive. The radical outsideness and aloneness of the impassive volcano dismantles ideas about land as property that cannot escape entanglement with the abusive dehumanization of human populations. But community shapes itself at the edges through a shared relationship to danger. Alongside a final eruption of the volcano, in muddy, ropy spurts and pink bubbles, the three puppets devise quiet ways to encounter one another (fig. 6.12).

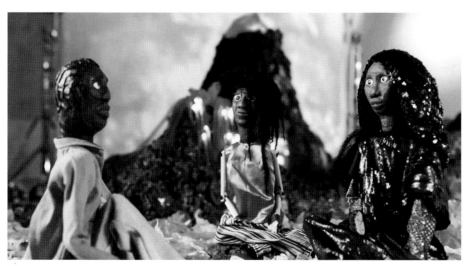

FIGURE 6.12
Cauleen Smith, Jérôme Havre and Camille Turner,
Triangle Trade, 2017. Digital film for projection,
15 minutes running time. Film still courtesy of Cauleen Smith.

This may seem a melancholy position on which to end, but it bears some relationship to Smith's most recent work, which includes creating flags for "unconquerable territories," places or ideas or images that "that cannot be colonized, such as the dawn, the night, and the elusive green flash; instead, these zones can be occupied only through thought and imagination."[47] Another collaborative project she spearheaded, the *Procession of Black Love*, traveled through the Washington Park neighborhood of Chicago in 2015.[48] The procession served as a response to an exhibition of works by artist Ti-Rock Moore at a nearby gallery, which included a replica of the slain Michael Brown—the young Black man shot and killed by police in Ferguson, Missouri, in 2014. Arguing that the artwork served as a form of symbolic reinjury—the negative—Smith chose to respond to the spectacle of Black death with a celebration of Black love (plate 16). The procession included flowers, banners, and an ice-cream truck offering free ice cream. One of the banners bears the phrase "Conduct Your Blooming." Remember this quotation from Gwendolyn Brooks's "Second Sermon on the Warpland": "Conduct your blooming in the noise and whip of the whirlwind."

This too is an act of place holding, temporary as it may be. Taking the streets in protest or in celebration, demanding to be seen, but holding a place, too, for a future that may never come and yet, imperatively, must be imagined.

Acknowledgments

This book developed over many twists and turns and accumulated myriad and pleasurable debts of gratitude along the way. At the University of Chicago Press, I owe thanks to Susan Bielstein for her initial encouragement to think this could be a book, and her thoughtful shepherding of the review process over several years. Among the many others at the press who have helped this project come about are Dylan Montanari and Victoria Barry, who both helped in many ways, but especially with the process of finalizing images and reproduction permissions. Karen Levine stepped into the project in medias res and quickly became a supportive sounding board. Stephen Twilley managed the production process adeptly, Trevor Perri's careful copyediting saved me from many an error and awkward turn of phrase, and Isaac Tobin contributed the gorgeous design. I am deeply grateful to the two anonymous readers for the University of Chicago Press for their many excellent critiques and suggestions.

Before I ever thought this might be a book, and as it grew into one, I had opportunities to develop parts of it as lectures at the Stony Island Arts Bank, MIT, Boston University, the University of Vermont, Case Western Reserve University, Washington University in Saint Louis, and McGill University. Each one of these occasions was precious and generative, as were remote audiences I spoke with through the Evanston Art Center, the Kunsthistorisches Institut Florenz, and the University of Groningen Art History Summer School. For these opportunities, I can't thank the institutions and the individuals involved enough, especially those who had to navigate the complexities of COVID-19 schedule changes, remote technologies, and in-person mitigations. Among the colleagues who invited and hosted me and asked great questions from the audience—listed alphabetically—are Hannah Baader, Erin Benay, Alice Boone, Elizabeth Browne, Kate Bussard, Leslie Danoff, Jackson Davidow, Cara Feeney, Jesse Feiman, Elina Gertsman,

Anna-Rosja Haveman, Kelley Helmstutler Di Dio, Chriscinda Henry, Joost Keizer, Karl Kusserow, Jillianne Laceste, Ann-Sophie Lehmann, Angela Miller, Ariella Minden, Chloé Pelletier, Heike Rass, Ana María Reyes, Leslie _Scattone, Claudia Swan, Rebecca Uchill, Louise Vanlee, Jessica Varner, Eva Waterbolk, and Gregory Williams. (And thanks, too, to Gabe Adugna for showing up at my BU talk to reconnect after so many years!) Suzanne Blier gave generous help in identifying African objects, and Patrice Rankine's invitation to visit his class helped me make refinements in the very final stages. For commissioning essays that served as earlier iterations of some of the ideas included here, I am grateful to Anne Leonard, Larry Norman, and the Smart Museum at the University of Chicago (for chapter 2), and to Risa Puleo, Mey-Yen Moriuchi, and Lesley Shipley (for chapter 6). Daniel Tucker and Jason Hill read the entire manuscript at different stages and offered a wealth of insightful and important suggestions; I am just sorry I wasn't equal to all the ideas they so generously offered. I also owe deep gratitude to Stephen Campbell, Christopher Heuer, W. J. T. Mitchell, Jennifer Nelson, Robert Nelson, Elizabeth Petcu, and the many colleagues who read and commented on elements of this project presented on Academia.edu (James Clifton, Sarah Guérin, Elizabeth Rodini, Brian Sandberg, Larry Silver, Claudia Swan, Benjamin Tilghman, Joyce Tsai, and Namita Wiggers), at the Critical Theory workshop at Northwestern University, and within the Newer Laocoöns group. Along the way I benefited enormously from an accountability writing group organized by the legendary Mariame Kaba, and from opportunities to work on this project (among others) at the Alice Kaplan Institute for the Humanities at Northwestern, the American Academy in Rome, the Kunsthistorisches Institut Florenz, and the Villa I Tatti. Conversations with Hannah Feldman, Maria Gaspar, Sarah Kanouse, Sarah Lewison, David Lusenhop, Nicole Marroquin, Dylan Miner, Emmanuel Pratt, Risa Puleo, Cauleen Smith, Krista Thompson, Brittney Leeanne Williams, Ivy Wilson, Jessica Winegar, and Kelly Wisecup provided key references and information as well as inspiration. I learned, always, so much from students in my University of Chicago and Northwestern classes (Black Ecology and several iterations of Art, Ecology, Politics), especially advisees Hanne Graversen, Bethany Hill, and Jessica Hough. Michael W. Phillips Jr. created the bibliography with amazing proficiency and speed. I owe a particular debt to my PhD advisee and research assistant Kat Caribeaux for obtaining images and permissions, making film stills, researching the ultimate fate of the Peale Museum's Indigenous artifacts, and related important tasks. I am deeply grateful for the permission to reproduce artworks kindly granted by artists and other rightsholders. I learned so much from all the informal conversations that helped challenge my thinking, including those with interlocutors I've surely overlooked by accident: this book is much better for it, and all remaining faults are mine.

I cannot fully express my gratitude to Mike and Oliver for the boundless love, support, and patience they have always given me. I am grateful, too, to family and friends for their supportive presence, whether near or far.

I dedicate this book to the memory of Lauren Berlant, whose example inspires me and whose thinking has left its mark all over mine.

Notes

INTRODUCTION

1. Gwendolyn Brooks, "The Chicago Picasso," *In the Mecca* (New York: Harper and Row, 1968), 40.

2. On American monuments see most recently Erin Thompson, *Smashing Statues: The Rise and Fall of America's Public Monuments* (New York: W. W. Norton, 2022). On vernacular memorials, see Erika Doss, *Memorial Mania: Public Feeling in America* (Chicago: University of Chicago Press, 2010). On monuments (including "temporary" ones) viewed from an international perspective, see Mechtild Widrich, *Performative Monuments: The Rematerialisation of Public Art* (Manchester: Manchester University Press, 2014) and *Monumental Cares: Sites of History and Contemporary Art* (Manchester: Manchester University Press, 2023).

3. Sylvia Wynter, "Unsettling the Coloniality of Being/Power/Truth/Freedom: Towards the Human, After Man, Its Overrepresentation—An Argument," *CR: The New Centennial Review* 3, no. 3 (Fall 2003): 317.

4. On artists' engagement with the Confederate flag, see Evie Terrono, "Performance, Political Discourse, and the Problematics of the Confederate Flag in Contemporary Art," *Public Art Dialogue* 8, no. 2 (2018): 142–83. Terrono begins her essay by recounting Newsome Bass's flagpole-scaling feat.

5. Colette Gaiter, "Bree Newsome's Confederate Flag Pole Climb Was an Artistic Statement," *Time*, July 3, 2015, https://time.com/3944951/bree-newsome-confederate-flag/.

6. The projections were created by lighting designer Dustin Klein. Dina Weinstein, "Shining a Light," *Richmond Magazine*, June 10, 2020, https://richmondmagazine.com/arts-entertainment/shining-a-light/.

7. See, among others, Janet Dees, ed., *A Site of Struggle: American Art Against Anti-Black Violence* (Princeton, NJ: Princeton University Press, 2022); Nicholas Mirzoeff, *The Appearance of Black Lives Matter* (Miami: [NAME] Publications, 2017).

8. M. M. Manring, *Slave in a Box: The Strange Career of Aunt Jemima* (Charlottesville: University of Virginia Press, 1998), 8.

9. Southern Poverty Law Center, "Whose Heritage? Public Symbols of the Confed-

eracy." February 1, 2019, https://www.splcenter.org/20190201/whose-heritage-public
-symbols-confederacy. See also Catherine Clinton, ed., *Confederate Statues and Memorial-
ization* (Athens, GA: University of Georgia Press, 2019) and Thompson, *Smashing Statues.*

10. Eve Ewing, "I'm a Black Scholar Who Studies Race. Here's Why I Capitalize
'White,'" *ZORA*, July 2, 2020, https://zora.medium.com/im-a-black-scholar-who-studies
-race-here-s-why-i-capitalize-white-f94883aa2dd3.

11. On the Chicago monuments and recommendations for their removal, see Chicago
Monuments Project, *Final Report*, August 2022, https://www.chicago.gov/content/dam
/city/depts/dca/cmp/cmpreport.pdf.

12. Jamaica Kincaid, "Sowers and Reapers," *New Yorker*, January 22, 2001, 41–45.

13. Settler Colonial City Project, "Unceded Land," 2019, accessed December 16, 2022,
https://settlercolonialcityproject.org/Unceded-Land.

14. Angela Miller, *Empire of the Eye: Landscape Representation and American Cultural Poli-
tics, 1825–1875* (Ithaca: Cornell University Press, 1993), 6.

15. Asher B. Durand, *Letters on Landscape Painting* (Madrid: Fundación Juan March,
2010 [1855]).

16. Lucy Lippard, *The Lure of the Local: Senses of Place in a Multicentered Society* (New York:
New Press, 1997), 100.

17. Lippard, *Lure of the Local*, 101.

18. For opposing views on Lacy and *Culture in Action*, see Miwon Kwon, *One Place after
Another: Site-Specific Art and Locational Identity* (Cambridge, MA: MIT Press, 2002), and
Sharon Irish, *Suzanne Lacy: Spaces Between* (Minneapolis: University of Minnesota Press,
2010).

19. Greg Sholette, "Reimagining Monuments to Make Them Resonate Locally
and Personally," *Hyperallergic*, November 6, 2017. https://hyperallergic.com/408996
/reimagining-monuments-to-make-them-resonate-locally-and-personally/. "Ogimaa
Mikana: Reclaiming/Renaming," website, accessed December 24, 2022, https://
ogimaamikana.tumblr.com. Ian Elsner, Luther Gray, and Freddi Williams Evans, "Freddi
Williams Evans and Luther Gray are Erecting Historic Markers on the Slave Trade in
New Orleans," episode 42 of *Museum Archipelago*, podcast, accessed December 23, 2022,
https://www.museumarchipelago.com/42.

20. James E. Young, "The Counter-Monument: Memory against Itself in Germany
Today," *Critical Inquiry* 18, no. 2 (Winter 1992): 272. Some alternative monuments have
drawn controversy, such as a proposed installation by Steve Locke that would have
acknowledged the role of funds from the slave trade that helped found Boston's Faneuil
Hall, which the artist withdrew following opposition from the NAACP.

21. I am profoundly grateful to Alan Michelson for his help refining my account of
this and other works. Alongside the imagery projected onto Richmond's Lee statue, the
projection also recalls Krzysztof Wodiczko's *Homeless Projection: A Proposal for the City of
New York*, in which the artist proposed to project images of quotidian objects associated
with homelessness onto recently refurbished neoclassical monuments in Union Square
Park. In an essay on the project, Rosalyn Deutsche discusses it as an opportunity to
disrupt the smooth operations of ideologies surrounding public space, its history, and
access to it. Deutsche, "Krzysztof Wodiczko's *Homeless Projection* and the Site of Urban
'Revitalization,'" 3–48, in *Evictions: Art and Spatial Politics* (Cambridge, MA: MIT Press,
1996).

22. A well-known critique is Mieke Bal and Norman Bryson, "Semiotics and Art His-
tory," *Art Bulletin* 73, no. 2 (June 1991): 174–208.

23. Eve Tuck and K. Wayne Yang, "Decolonization Is Not a Metaphor," *Decolonization: Indigeneity, Education & Society* 1, no. 1 (2012): 1–40.

24. On the overlapping geographies of Black and Indigenous Studies, I have learned from Tiffany Lethabo King, *The Black Shoals: Offshore Formations of Black and Native Studies* (Durham, NC: Duke University Press, 2019). Of crucial importance on Blackness, gender, and geography is Katherine McKittrick, *Demonic Grounds: Black Women and the Cartographies of Struggle* (Minneapolis: University of Minnesota Press, 2006).

25. Carolyn Dean, "The Trouble with (the Term) Art," *Art Journal* 65, no. 2 (Summer 2006): 24–32.

26. For more on language, see P. Gabrielle Foreman et al. "Writing about Slavery / Teaching About Slavery: This Might Help," community-sourced document, accessed December 24, 2022, https://docs.google.com/document/d/1A4TEdDgYslX -hlKezLodMIM71My3KTN0zxRv0IQTOQs/.

27. Wynter, "Unsettling the Coloniality." See also John Opie, "Renaissance Origins of the Environmental Crisis," *Environmental Review: ER* 11, no. 1 (Spring 1987): 16: "Western society sought to exploit nature to reach for higher things. The claim to do with nature as one pleased, even to ignore it, was enormously gratifying following the disastrous fourteenth century. The collapse of authoritative religious faith [meant that] the creature with a mind and a plan was king."

28. This field has grown considerably in recent years. A few key texts include Alan C. Braddock and Christoph Irmscher, eds., *A Keener Perception: Ecocritical Studies in American Art History* (Tuscaloosa: University of Alabama Press, 2009); Mark Cheetham, *Landscape into Eco Art: Articulations of Nature since the '60s* (University Park, PA: Pennsylvania State University Press, 2018); T. J. Demos, *Against the Anthropocene: Visual Culture and Environment Today* (London: Sternberg Press, 2017); and Karl Kusserow, ed., *Picture Ecology: Art and Ecocriticism in Planetary Perspective* (Princeton, NJ: Princeton University Press, 2021). See also the "Conversation Piece" entitled "The Arts, Environmental Justice, and the Ecological Crisis" coordinated by Sria Chatterjee and published by *British Art Studies*, accessed November 28, 2022, https://britishartstudies.ac.uk/issues/issue-index/issue-18/arts-environmental -justice-ecological-crisis. My own prior work in this area (on which I draw here and there in this book) is in Christopher Heuer and Rebecca Zorach, eds., *Ecologies, Agents, Terrains*, Clark Studies in the Visual Arts (New Haven, CT: Yale University Press, 2018).

29. Nathan Hare, "Black Ecology," *The Black Scholar* 1, no. 6 (April 1970): 2–8, 4.

30. On the "crying Indian" ad campaign, see Finis Dunaway, *Seeing Green: The Use and Abuse of American Environmental Images* (Chicago: University of Chicago Press, 2015). On the myth of the "ecological Indian," see Paul Nadasdy, "Transcending the Debate over the Ecologically Noble Indian: Indigenous Peoples and Environmentalism," *Ethnohistory* 52, no. 2 (Spring 2005): 291–331; Jessica Horton, "Indigenous Artists against the Anthropocene," *Art Journal*, 76, no. 2 (2017): 50; and Andrew Curley, "Beyond Environmentalism: #NODAPL as Assertion of Tribal Sovereignty," in *Standing with Standing Rock: Voices from the #NODAPL Movement*, ed. Nick Estes and Jaskiran Dillion (Minneapolis: University of Minnesota Press, 2019), 158–68. See also Kay WalkingStick, "Native American Art in the Postmodern Era," *Art Journal* 51, no. 3 (Autumn 1992): 15–17.

31. Tiana Clark, "The Ayes Have it," in *I Can't Talk About the Trees Without the Blood*, 35–37, 36 (Pittsburgh: University of Pittsburgh Press, 2018).

32. On the song, see David Margolick, *Strange Fruit: The Biography of a Song* (New York: Ecco Press, 2001) and Angela Davis, *Blues Legacies and Black Feminism* (New York: Vintage Books, 2011), in particular 181–97.

33. Clark, "What the Blood Does," 80, in *I Can't Talk About the Trees Without the Blood*.

34. Katherine R. Lynes, "'a responsibility to something besides people': African American Reclamation Ecopoetics," *African American Review* 48, no. 1/2 (Spring/Summer 2015): 50.

35. Lynes, "'a responsibility,'" 55.

36. In this, Williams echoes both the limitations and the opportunities that traverse W. E. B. Du Bois's "double consciousness." See W. E. B. Du Bois, *Souls of Black Folk* (Chicago: A. C. McClurg, 1903).

37. Museum of Contemporary Art Chicago, "Gallery Text Downloads," accessed November 26, 2022, https://media.mcachicago.org/pdf/IQL4JHQH/labels.pdf.

38. Before formal desegregation in the 1960s, African American girls could become Camp Fire Girls, but often in de jure or de facto segregated troops. On the racial politics of the organization, see Jennifer Helgren, *The Camp Fire Girls: Gender, Race, and American Girlhood, 1910–1980* (Lincoln: University of Nebraska Press, 2022).

39. Kerry James Marshall, email to author, January 2023.

40. Executive Office of the President, "Promoting Beautiful Federal Civic Architecture," December 23, 2020, https://www.federalregister.gov/documents/2020/12/23/2020-28605/promoting-beautiful-federal-civic-architecture.

41. On the sources of the images, see Ben Davis, "The New White Nationalism's Sloppy Use of Art History, Decoded," *Artnet News*, March 7, 2017, https://news.artnet.com/art-world/identity-evropa-posters-art-symbolism-881747.

42. See also Amanda Kolson Hurley, "Trump's Bizarre Plan to Make Architecture Classical Again," *The Atlantic*, February 8, 2020, https://www.theatlantic.com/ideas/archive/2020/02/trumps-plan-make-architecture-classical-again/606286/.

43. Sarah Bond, "Whitewashing Ancient Statues: Whiteness, Racism and Color in the Ancient World," *Forbes*, April 27, 2017, https://www.forbes.com/sites/drsarahbond/2017/04/27/whitewashing-ancient-statues-whiteness-racism-and-color-in-the-ancient-world/.

44. Charmaine Nelson, "White Marble, Black Bodies and the Fear of the Invisible Negro: Signifying Blackness in Mid-Nineteenth-Century Neoclassical Sculpture," *RACAR: Revue d'art canadienne / Canadian Art Review* 27, no. 1/2 (2000): 88.

45. Nicolas Lampert, *A People's Art History of the United States: 250 Years of Activist Art and Artists Working in Social Movements* (New York: New Press, 2013); Lauret Savoy, *Trace: History, Race, and the American Landscape* (Berkeley: Counterpoint, 2015); and Rebecca Solnit, *Storming the Gates of Paradise: Landscapes for Politics* (Berkeley: University of California Press, 2007). I cite Lippard's book above.

46. Important bibliography in this area includes Rosalyn Deutsche, *Evictions: Art and Spatial Politics* (Chicago: Graham Foundation for Advanced Studies in the Fine Arts; Cambridge: MIT Press, 1996); Mary Jane Jacob, *Culture in Action: A Public Art Program of Sculpture in Chicago* (Seattle: Bay Press, 1995); Grant Kester, *Conversation Pieces: Community and Communication in Modern Art* (Berkeley: University of California Press, 2004); Kwon, *One Place after Another*; Suzanne Lacy, *Mapping the Terrain: New Genre Public Art* (Seattle: Bay Press, 1995); Malcolm Miles, *Art, Space and the City: Public Art and Urban Futures* (London: Routledge, 1997); Tom Finkelpearl, *Dialogues in Public Art* (Cambridge, MA: MIT Press, 2000) and other work by Finkelpearl; Harriet F. Senie and Sally Webster, eds., *Critical Issues in Public Art: Content, Context, Controversy* (Washington, D.C.: The Smithsonian Institution, 2014).

47. See Don Mitchell, *The Right to the City: Social Justice and the Fight for Public Space* (New York: Guilford Press, 2003).

48. See again Lippard, *The Lure of the Local*, and other works.

49. In the web-based booklet *Burnham Wildlife Corridor Gathering Places*, 2017, the Park District refers to the project as an "artistic and socially responsive placemaking effort," accessed December 16, 2022, https://www.slideshare.net/AasiaMohammadCastaed /gathering-spaces-along-chicagos-south-lakefront.

50. I use "warm" in the same sense as Raymond Williams's characterization of the term "community" as "warmly persuasive." Williams, *Keywords: A Vocabulary of Culture and Society* (Oxford: Oxford University Press, 1983 [1976]), 76.

51. D. W. Winnicott, "The Newborn and his Mother," in *Winnicott On the Child*, 32–42 (Cambridge, MA: Perseus, 2002). Originally published as "The Neonate and His Mother," *Acta Paediatrica Latina* 17, supplement (1964): 17. An early academic example is found in Jennifer Musial, "Engaged Pedagogy in the Feminist Classroom and Yoga Studio," *Feminist Teacher* 21, no. 3 (2011): 212–28.

52. William Cronon, *Nature's Metropolis: Chicago and the Great West* (New York: W. W. Norton, 1991), xiii.

53. Thomas Dyja, *The Third Coast: When Chicago Built the American Dream* (New York: Penguin, 2013), xxiii.

CHAPTER ONE

1. Brett Stevens, "Antifa Attacks Peaceful Alt Right Protest, *New York Times* Trots Out N-Word," *Amerika*, February 28, 2017, http://www.amerika.org/politics/antifa-attacks -peaceful-alt-right-protest-new-york-times-trots-out-n-word/. The post was edited to read "We were there only to meet a few new faces and enjoy the Minneapolis Institute of Art's beautiful collection." "AltRight MN Response to Violent Leftist Attack at Minneapolis Institute of Art," February 28, 2017, *Alt Right MN* (blog), https://altrightmn.wordpress .com/2017/02/28/altright-mn-response-to-violent-leftist-attack-at-minneapolis-institute -of-art/.

2. Randy Kennedy, "Two Groups Scuffle amid Art inside a Minneapolis Museum," *New York Times*, February 27, 2017, https://www.nytimes.com/2017/02/27/arts/design/anti -trump-protest-minneapolis-institute-of-art.html.

3. There is a large literature on museums, their history, and their contemporary ideological role. See for example Tony Bennett, *The Birth of the Museum: History, Theory, Politics* (New York: Routledge, 1995); on Fred Wilson's *Mining the Museum*, Darby English, *How to See a Work of Art in Total Darkness* (Cambridge, MA: MIT Press, 2007); and contemporary activist projects like Occupy Museums and Decolonize This Place. With his piece *Public Enemy*, in 1991, the artist David Hammons launched a critique of the AMNH sculpture decades before it was finally removed. Holland Cotter, "We Don't Have to Like Them. We Just Need to Understand Them," *New York Times*, June 24, 2020. See also Lucy Lippard, *The Lure of the Local: Senses of Place in a Multicentered Society* (New York: New Press, 1997), 101.

4. See, for example, Carol Duncan and Alan Wallach, "The Universal Survey Museum," *Art History* 3, no. 4 (December 1980): 448–69.

5. It is striking that Alan Wallach barely touches on Peale's Museum (which, granted, sits uneasily in the category of the art museum) or the Pennsylvania Academy of Fine Arts and its cast collection in his arguments about early museums and cast collections in *Exhibiting Contradiction: Essays on the Art Museum in the United States* (Amherst: University of Massachusetts Press, 1998).

6. Eve Tuck and K. Wayne Yang, "Decolonization Is Not a Metaphor," *Decolonization: Indigeneity, Education & Society* 1, no. 1 (2012): 6.

7. Charleston Library Society, "Mission and History," accessed December 16, 2022, https://charlestonlibrarysociety.org/our-history/. On the Manigault family, see also Maurie D. McInnis, *The Politics of Taste in Antebellum Charleston* (Chapel Hill: University of North Carolina Press, 2015).

8. See Myron F. Wehtje, "Charles Willson Peale and His Temple," *Pennsylvania History: A Journal of Mid-Atlantic Studies* 36, no. 2 (April 1969): 161–73. "Communication," *Poulson's American Daily Advertiser* 49, no. 3 (August 2, 1820).

9. Charles Willson Peale, "To the Citizens of the United States of America," *The Pennsylvania Packet*, February 19, 1790. Ellen Fernandez-Sacco, "Framing 'The Indian': The Visual Culture of Conquest in the Museums of Pierre Eugene Du Simitiere and Charles Willson Peale, 1779–96," *Social Identities* 8, no. 4 (2002): 583. William John Potts, "Du Simitiere, Artist, Antiquary, and Naturalist, Projector of the First American Museum, with Some Extracts from His Note-Book," *The Pennsylvania Magazine of History and Biography* 13, no. 3 (October 1889): 348. At his death in 1784, the collections were sold to pay his debts.

10. *Poulson's American Daily Advertiser* 39, no. 2 (March 1, 1810).

11. *Poulson's American Daily Advertiser* 38, no. 2 (August 23, 1809).

12. *Poulson's* 39, no. 2.

13. *Poulson's* 39, no. 2.

14. Potts, "Du Simitiere, Artist, Antiquary, and Naturalist," 348.

15. On the stationery, see Allison M. Stagg, "*Nature*: A Nineteenth-Century Engraving Linking Charles Willson Peale, James Akin, and Peale's Mastodon," *Panorama: Journal of the Association of Historians of American Art* 7, no. 1 (Spring 2021): https://journalpanorama .org/article/nature/.

16. On art and illusion in the early republic (and on this painting in particular), see Wendy Bellion, *Citizen Spectator: Art, Illusion, and Visual Perception in Early National America* (Chapel Hill: University of North Carolina Press, 2012).

17. Among many similar articles authored by Peale, see Charles Willson Peale, "Mammoth," *The Philadelphia Gazette and Daily Advertiser*, December 24, 1801.

18. See Barbara Maria Stafford, *Artful Science: Enlightenment, Entertainment and the Eclipse of Visual Education* (Cambridge, MA: MIT Press, 1994).

19. See Amy Morris, "Geomythology on the Colonial Frontier: Edward Taylor, Cotton Mather, and the Claverack Giant," *The William and Mary Quarterly* 70, no. 4 (October 2013): 701–24.

20. Peale, "Mammoth."

21. Jefferson to Meriwether Lewis, before June 20, 1803. Thomas Jefferson Papers, Library of Congress. https://www.loc.gov/exhibits/lewisandclark/transcript57.html.

22. Rembrandt Peale, *An Account of the Skeleton of the Mammoth* (London: E. Lawrence, 1802).

23. Jennifer Roberts, *Transporting Visions: The Movement of Images in Early America* (Berkeley: University of California Press, 2014).

24. My translation. "Que l'harmonieux Buffon, que le Systematique [De Pauw], que tous les exagerateurs de ces hommes celebres viennent nous dire aujourd['hui] que l'amerique est la fausse couche du Globe terrestre, Et que les hommes y Sont de grands enfans, la plupart imbeciles: on leur repondra: Lisez Franklin, conversez avec Peale, Et voyez clans le Museum les heros et les Sages americains dont le Pinceau de Peale nous a transmit les portraits fideles." The editor of Peale's letters was unable to identify the name De Pauw, but this seems clear from the context. Philippe Rose Roume, "Letter

to Charles Willson Peale, 4 Jan. 1802," in *The Selected Papers of Charles Willson Peale and His Family*, vol. 2, ed. Lillian Miller (New Haven, CT: Yale University Press, 1983), 381–86. In addition to writing this letter to Peale, Roume also lobbied unsuccessfully for the French Academy to acquire one of the mastodon skeletons.

25. See Ellen Fernandez Sacco, "Racial Theory, Museum Practice: The Colored World of Charles Willson Peale," *Museum Anthropology* 20, no. 2 (September 1996): 25–32. Rachael Guest, "Slavery, Racism, and Charles Willson Peale," *Polychromes* (blog), May 5, 2019, https://polychromes.blogspot.com/2019/05/slavery-racism-and-charles-willson -peale.html. Guest cites Miller, ed., *Selected Papers* 1, 20. Charles Willson Peale's father left England under a cloud—he was able to choose emigration rather than being put to death for embezzlement—and remade his identity upon arrival in colonial America. One of the positions he obtained was as a schoolmaster, with his salary paid at least partly through taxation of the slave trade.

26. Charles Coleman Sellers, *Mr. Peale's Museum: Charles Willson Peale and the First Popular Museum of Natural Science and Art* (New York: W. W. Norton, 1980), 22. See Gwendolyn DuBois Shaw, "'Moses Williams, Cutter of Profiles': Silhouettes and African American Identity in the Early Republic," *Proceedings of the American Philosophical Society* 149, no. 1 (March 2005): 25.

27. Guest, "Slavery, Racism"; Miller, ed., *Selected Papers*, vol. 1, 135.

28. Hortense Spillers, "Mama's Baby, Papa's Maybe: An American Grammar Book," in "Culture and Countermemory: The 'American' Connection," special issue, *Diacritics* 17, no. 2, (Summer 1987): 64–81.

29. Oliver Jensen, "The Peales," *American Heritage*, April 1955.

30. Guest, "Slavery, Racism," Derogatory comments about Williams made by Peale's son Rembrandt reveal some of the Peale family attitudes about the people they enslaved. Because Williams was born three years before the Abolition Act was voted into law, Peale could have kept him enslaved until his death. Pennsylvania's new law put George Washington in a quandary when he lived temporarily in Philadelphia while it served as the new nation's capital city. He carefully moved his captives back and forth to Virginia to avoid allowing them to establish residency in Pennsylvania and also made efforts to keep this fact from becoming public.

31. See again Shaw, "Moses Williams." By 1808, after Moses Williams's manumission, an unnamed attendant was paid eight cents per portrait. Thomas Green Fessenden, *The Register of the Arts, or a Compendious View of Some of the Most Useful Modern Discoveries and Inventions* (Philadelphia: C. and A. Conrad, 1808), 357n. Wendy Bellion discusses the physiognotrace in terms of the sense of authenticity and direct representation— qualities that can also be understood politically—that its indexical technique (the fact of directly tracing the body) suggests. Wendy Bellion, "Heads of State: Profiles and Politics in Jeffersonian America" in *New Media, 1740–1915*, ed. Lisa Gitelman and Geoffrey B. Pingree (Cambridge, MA: MIT, 2003), 31–59.

32. On Moses Williams's costumed ride, see Sellers, *Mr. Peale's Museum*, 142 and 346n16. On Lenape elders' discussions with Thomas Jefferson about fossil bones, see Adrienne Mayor, "Place Names Describing Fossils in Oral Traditions," *Geological Society London Special Publications* 273, no. 1 (January 2007): 245–61.

33. Yvette R. Piggush, "Visualizing Early American Art Audiences: The Pennsylvania Academy of the Fine Arts and Allston's 'Dead Man Restored,'" *Early American Studies* 9, no. 3 (Fall 2011): 730.

34. Piggush, "Visualizing," 730.

35. "A visiting British traveler, Augustus John Foster, noticed, however, that even the higher admission fee did not compel visitors to treat the casts respectfully as the property of a wealthy gentleman. Foster reported he saw "some lines written with a pencil . . . in a female hand upon the legs of the gods Cupid and Mercury." Piggush, "Visualizing," 730.

36. Piggush ("Visualizing," 730) notes that Peale complained that the Academy was using the nudity of the casts to titillate viewers and was not using ticket prices to exclude uneducated viewers. The description of the Pennsylvania Academy's founding in the state act that established it focused on its collection of sculpture, but the academy was also steadily enriched with paintings donated by a variety of members and friends. "A number of persons desirous of promoting the cultivation of the fine arts in this country have associated themselves, procured a lot of ground in the city of Philadelphia, and made considerable progress in erecting a building thereon, for the reception and exhibition of statuary." *Acts of the General Assembly of the Commonwealth of Pennsylvania* (Octoraro: Francis Bailey, 1805), chap. 182, 609. The plaster casts of canonical sculpture Smith provided were considered indispensable for the training of young artists; the also supported the academy's identity as a collecting institution. E. P. Richardson, "Allen Smith, Collector and Benefactor," *The American Art Journal* 1 no. 2 (Autumn 1969): 5–19. See also "Catalogue of Statues and Busts in the Pennsylvania Academy of the Fine Arts" included in Thomas Green Fessenden, *The Register of the Arts, or a Compendious View of Some of the Most Useful Modern Discoveries and Inventions* (Philadelphia: C. and A. Conrad, 1808), 345–54. The anonymous author of the catalogue is described as a lady "who, after consulting the best authorities, has arranged her ideas and descriptions with all that grace, which feminine genius is so prone to display on every topick that awakens the imagination." In the same volume (p. 360), Smith's casts are described as being held in the museum "until they form part of an American academy of the fine arts."

37. See Kenneth Morgan, "Slave Sales in Colonial Charleston," *The English Historical Review* 113, no. 453 (Sept. 1998): 905–27.

38. Richardson, "Allen Smith," 10.

39. Maurie D. McInnis, *In Pursuit of Refinement: Charlestonians Abroad, 1740–1860* (Charleston: University of South Carolina Press, 1999), 45.

40. Derek Gillman, *The Idea of Cultural Heritage* (Cambridge: Cambridge University Press, 2006), 56. Taking the opportunity to lash out at the postrevolutionary French for having "fallen back whole centuries in barbarism" and at the new republic for having "throw[n] itself into the embraces of the common enemy" (i.e., France), the judge ostentatiously takes the high road in ordering that the artworks be handed back to the academy, suggesting that the pursuit of the arts will have a salutary effect on American morals. See also John Henry Merryman, "The Marquis De Somerueles: Vice-Admiralty Court of Halifax, Nova Scotia Stewart's Vice-Admiralty Reports 482 (1813)," *International Journal of Cultural Property* 5, no. 2 (1996): 319–29.

41. George Catlin, *Letters and Notes on the Manners, Customs, and Condition of the North American Indians*, vol. 1 (New York: Wiley and Putnam, 1841), 16.

42. Catlin, *Letters and Notes*, 19.

43. Catlin, *Letters and Notes*, 62.

44. Catlin, *Letters and Notes*, 62. "Over and through these groups of domes and battlements (as one is compelled to imagine them), the sun sends his long and gilding rays,

at morn or in the evening; giving life and light, by aid of shadows cast to the different glowing colours of these clay-built ruins; shedding a glory over the solitude of this wild and pictured country, which no one can realize unless he travels here and looks upon it." Elsewhere he refers to "sublime structure of a colossal city;—with its walls—its domes—its ramparts—its huge porticos and galleries—its castles—its fosses and ditches" that appear to have been begun by a "giant mason" and then abandoned into "sublime ruins" (69).

45. Catlin, *Letters and Notes*, 69.

46. Catlin, *Letters and Notes*, 23.

47. Catlin, *Letters and Notes*, 9.

48. Matthew N. Johnston, *Narrating the Landscape: Print Culture and American Expansion in the Nineteenth Century* (Norman: University of Oklahoma Press, 2016), 146–62.

49. Catlin, *Letters and Notes*, 9.

50. Catlin, *Letters and Notes*, 2.

51. Catlin, *Letters and Notes*, 2.

52. Catlin, *Letters and Notes*, 3.

53. Catlin, *Letters and Notes*, 31.

54. Catlin, *Letters and Notes*, 58.

55. Catlin, *Letters and Notes*, 83.

56. Catlin, *Letters and Notes*, 101.

57. Catlin, *Letters and Notes*, 43.

58. Catlin, *Letters and Notes*, 36.

59. François-Jean de Chastellux, *Voyages de M. le Marquis de Chastellux dans l'Amérique septentrionale, dans les années 1780, 1781 & 1782*, vol. 1 (Paris: Prault, 1788), 28.

60. Jacques Pierre Brissot de Warville, *Nouveau voyage dans les Etats-Unis de l'Amérique septentrionale, fait en 1788* (Paris: Buisson, 1791), vol. 1, 178.

61. Brenda Milkofsky, "Connecticut and the West Indies: Sugar Spurs Trans-Atlantic Trade," ConnecticutHistory.org, January 27, 2021, https://connecticuthistory.org/connecticut-and-the-west-indies-trade/.

62. "Affidavit of Singweh, an *Amistad* African," 1839, transcript, Lewis Tappan Papers, Manuscript Division, Library of Congress. Quoted in *Slavery and the Making of America*, https://www.thirteen.org/wnet/slavery/experience/responses/docs3.html.

63. Many scholars have addressed how nineteenth-century American landscape painting expressed political ideologies about national identity and westward expansion. See, for example, Angela Miller, *Empire of the Eye: Landscape Representation and American Cultural Politics, 1825–1875* (Ithaca: Cornell University Press, 1993), and the exhibition catalog *The West as America: Reinterpreting Images of the Frontier, 1820-1920*, ed. William H. Truettner (Washington and London: Smithsonian Institution Press for the National Museum of American Art, 1991).

64. W. J. T. Mitchell, "Imperial Landscape," in Mitchell, ed., *Landscape and Power* (Chicago: University of Chicago Press, 1994), 5–34. On landscape, mapping, and colonialism in Canada and the Caribbean, see Charmaine Nelson, *Slavery, Geography and Empire in Nineteenth-Century Marine Landscapes of Montreal and Jamaica* (London: Routledge, 2017).

65. Tuck and Yang, "Decolonization Is Not a Metaphor," 6.

66. James Fenimore Cooper, *The Last of the Mohicans: A Narrative of 1757* (New York: Macmillan, 1921 [1826]), 194.

67. Tuck and Yang, "Decolonization Is Not a Metaphor," 15.

68. "A Word about Museums," *The Nation*, July 27, 1865.

69. Simon Gikandi, *Slavery and the Culture of Taste* (Princeton, NJ: Princeton University Press, 2011), 106.

70. Wallach, "Long-Term Visions, Short-Term Failures: Art Institutions in the United States, 1800–1860," *Exhibiting Contradiction*, 9–21, emphasizes the nineteenth-century construction of a notion of "high art" as a matter of distinction from popular entertainment.

CHAPTER TWO

1. George Catlin, *Letters and Notes on the Manners, Customs, and Condition of the North American Indians*, vol. 1 (New York: Wiley and Putnam, 1841), 62.

2. Catlin, *Letters and Notes*, 15.

3. Henry David Thoreau, "Walking," *Excursions* (Boston: Ticknor and Fields, 1863), 181. I cite from this edition; the essay was originally published in *The Atlantic Monthly* 9, no. 56 (June 1862): 657–74.

4. An initial exploration of "No Church in the Wild" appears in Rebecca Zorach, "Classicism, Conflict, and the White Body," in *Classicisms*, ed. Larry F. Norman and Anne Leonard (Chicago: Smart Museum of Art, 2017), 111–25.

5. On the biblical idea of wilderness in Black American culture, see also Melvin Dixon, *Ride Out the Wilderness: Geography and Identity in Afro-American Culture* (Urbana: University of Illinois Press, 1987).

6. On Thoreau and the wild, see also Jane Bennett, *Thoreau's Nature: Ethics, Politics, and the Wild* (Boston: Rowman & Littlefield, 2002).

7. Thoreau, "Walking," 154.

8. Thoreau, "Walking," 179.

9. See Friedrich Nietzsche, *The Birth of Tragedy* (any edition). Thoreau uses the word "blight" on p. 186.

10. Thoreau, "Walking," 183. This follows upon a lament about excessive civilization as it manifested in nineteenth-century New England: "A township where one primitive forest waves above, while another primitive forest rots below,—such a town is fitted to raise not only corn and potatoes, but poets and philosophers for the coming ages. In such a soil grew Homer and Confucius and the rest, and out of such a wilderness comes the Reformer eating locusts and wild honey."

11. Thoreau, "Walking," 154.

12. Thoreau, "Walking," 156.

13. Thoreau, "Walking," 156.

14. Thoreau, "Walking," 155.

15. Thoreau, "Walking," 179, "A tanned skin is something more than respectable, and perhaps olive is a fitter color than white for a man,—a denizen of the woods. 'The pale white man!' I do not wonder that the African pitied him. Darwin the naturalist says, 'A white man bathing by the side of a Tahitian was like a plant bleached by the gardener's art, compared with a fine, dark green one, growing vigorously in the open fields." "'How near to good is what is fair!'/ So I would say,– / How near to good is what is wild!'"

16. Thoreau, "Walking," 182–83.

17. Thoreau, "Walking," 159.

18. Thoreau, "Walking," 160.

19. Richard J. Schneider, "Thoreau's Panorama of the Mississippi: Its Identity and Significance," *The Thoreau Society Bulletin* 245 (Fall 2003): 5–6.

20. See Susan Tenneriello, *Spectacle Culture and American Identity, 1815–1940* (New York: Palgrave, 2013).

21. Thoreau, "Walking," 176.

22. See Lisa Lyons, "Panorama of the Monumental Grandeur of the Mississippi Valley," *Design Quarterly* 101/102 (1976): 32–34, on the Dickeson-Egan panorama, which emphasizes Indigenous sites. On Kara Walker's reinterpretation of one of the scenes, see Vivien Green Fryd, "Kara Walker's *About the title*: The Ghostly Presence of Transgenerational Trauma as a "Connective Tissue" Between the Past and Present." *Panorama: Journal of the Association of Historians of American Art* 2, no. 1 (Summer 2016), https://editions.lib.umn.edu/panorama/article/kara-walkers-about-the-title-the-ghostly-presence-of-transgenerational-trauma-as-a-connective-tissue-between-the-past-and-present/.

23. *Champney's Great Original Picture of the River Rhine*, handbill, Bee Press, ca. 1849. Mrs. H. J. Lewis describes it in similar terms: "Amid the numerous daubs that have infested the city of Boston for a year or two past, it is really delightful to welcome a painting of genuine merit. The Rhine-land with its poetic legends, giving a charm to each picturesque ruin, is before you, now glowing in the setting sun, and anon hallowed by the soft moonlight. Little villages here and there nestle below some frowning mountain, whose summit bears a dilapidated castle, a remnant of far other days. The peasants are at work in their vineyards, horses with their riders are beautifully portrayed, processions are moving to the shrine of some revered saint, and altogether the exhibition is one of profound interest." "Books," *The Universalist and Ladies Repository* 17 (Boston: A. Tompkins, 1849), 351.

24. Joseph Earl Arrington, "The Story of Stockwell's Panorama," *Minnesota History* 33, no. 7 (Autumn 1953): 286. James T. Lloyd, *Lloyd's Steamboat Directory, and Disasters on the Western Waters* (Cincinnati: J. T. Lloyd, 1856), 173.

25. Arrington, "The Story of Stockwell's Panorama," 286.

26. *Description of Banvard's Panorama of the Mississippi River, Painted on Three Miles of Canvas. . . .* (Boston: John Putnam, 1847), 27. Michael Chaney notes the "mild" treatment of slavery in Banvard's panorama in his book *Fugitive Vision: Slave Image and Black Identity in Antebellum Narrative* (Bloomington: Indiana University Press, 2008), 120. By contrast, Henry Lewis created a panorama of the Mississippi without traveling to the South at all. Bertha L. Heilbron, "Making a Motion Picture in 1848: Henry Lewis on the Upper Mississippi," *Minnesota History: A Quarterly Magazine* 17, no. 2 (June 1936): 131–58. On John Banvard's panorama, see also John Hanners, "'The Great Three-Mile Painting': John Banvard's Mississippi Panorama," *The Journal of American Culture* (1981): 28–42, and Ried Holien, "John Banvard's Brush with Success," *South Dakota Magazine*, revised version published September/October 1997, https://www.southdakotamagazine.com/john-banvard-brush-with-success.

27. *Description of Banvard's Panorama*, 31.

28. *Description of Banvard's Panorama*, 30.

29. Thoreau, "Walking," 169.

30. Thoreau, "Walking," 177.

31. Thoreau, "Walking," 192.

32. Thoreau, "Walking," 169.

33. Thoreau, "Walking," 172. "The man of the Old World sets out upon his way. Leaving the highlands of Asia, he descends from station to station toward Europe. Each of

his steps is marked by a new civilization superior to the preceding, by a greater power of development."

34. Andrew Menard, "Nationalism and the Nature of Thoreau's 'Walking,'" *The New England Quarterly* 85, no. 4 (December 2012): 591–621.

35. Lydia Willsky-Ciollo, "Apostles of Wilderness: American Indians and Thoreau's Theology of the Wild," *The New England Quarterly* 91, no. 4 (December 2018): 551–91.

36. Thoreau, "Walking," 202.

37. See for example Jozen Cummings, "Five Things We Learned About Jay-Z's New Book at the New York Public Library," *The Wall Street Journal*, November 16, 2010, https://www.wsj.com/articles/BL-SEB-53972; Dan-el Padilla Peralta, "From Damocles to Socrates: The Classics in/of Hip-Hop," *Eidolon*, June 8, 2015, https://eidolon.pub/from-damocles-to-socrates-fbda6e685c26.

38. Gavras's use of classicizing statuary may have been inspired in a personal way by the director's own Greek background during a time of mass protests against austerity measures in Greece. Gavras's father is Greek; Gavras holds dual citizenship in France and Greece. In addition, the police badges present the Greek letters Epsilon, Lambda, Alpha, Sigma, which (assuming an aspiration) is either a strange way of spelling "Hellas" (Greece), or "Hélas"—"Alas" in French.

39. The writing of the song was in the first instance inspired—according to The-Dream, who sang the heavily auto-tuned bridge—by the friendly competition between the two main artists. While wrapping up *Watch the Throne*, Kanye heard Jay-Z's track "Holy Grail" and wanted it for the album, but Jay-Z was reserving it for his solo album, so the two collaborated on a new track designed to be similar to "Holy Grail." The-Dream, verified comment on "No Church in the Wild," Genius, http://genius.com/314340.

40. The repeated guitar riff is a slowed down, hence lower-pitched, sample from a song by Phil Manzanera of Roxy Music; the drum beat is sampled from "Sunshine Help Me," by Spooky Tooth.

41. The final line of this reflection reminds us that Socrates's wisdom was "all for Plato," committed to writing only under Plato's name, followed by "screech"—perhaps a reference to the screech of tires as the narrator's car stops.

42. See "No Church in the Wild," Genius, accessed November 27, 2022, https://genius.com/Jay-z-and-kanye-west-no-church-in-the-wild-lyrics, and John Hare, "Religion and Morality, *Stanford Encyclopedia of Philosophy*, September 27, 2006, revised August 8, 2019, https://plato.stanford.edu/entries/religion-morality/.

43. The second and third iterations of the hook are introduced by the syncopated command "Preach." The rappers associate themselves with gods and the song is also peppered with references to scripture and the Christian god.

44. The High5Collective video was released in September 2011. See https://vimeo.com/75975836; https://www.huffpost.com/entry/jay-z-kanye-west-no-church-in-the-wild_n_950494. For a time, it was unavailable—the artists and producers never asked the group to take it down, but it was affected by a takedown request connected to another of the group's videos.

45. Kyle Salazar, email to author, August 3, 2020.

46. High5Collective existed as a production company from 2011 to 2015 and included members Jordan Riggs, Kyle Salazar, Zachary "Cairo" Groll, Scott Stanley, and Mitchell Dequilettes. (Kyle Salazar, email to author.) High5 released an official video for "Thinkin about You," by Frank Ocean—who played a key role in writing this track—in the same

month they released the unofficial video for "No Church," and they did notify him that they were planning a video for the latter. (Jordan Riggs, email to author, November 25, 2022.) *Watch the Throne* was released on August 8, 2011, and the High5Collective video had appeared by September 6, 2011, date of the first articles about it. On the experience of teaching the *Euthyphro* along with "No Church in the Wild" and the High5Collective video, see Barbara Brotman, "Educational Experiment," *Chicago Tribune*, March 14, 2013, https://www.chicagotribune.com/news/ct-xpm-2013-03-14-ct-met-cps-humanities -20130314-story.html.

47. Jordan Riggs, email to author.

48. See Bénédicte Boisseron, *Afro-Dog: Blackness and the Animal Question* (New York: Columbia University Press, 2018) and Martin Berger's analysis of the interpretations given to a famous photograph of a dog attacking a passerby during a protest, in "The Formulas of Documentary Photography" in *Seeing Through Race* (Los Angeles: University of California Press, 2011), 9–57.

49. Boisseron, *Afro-Dog*, 104.

50. "Dogs," Thomas Jefferson Encyclopedia, accessed January 27, 2023, https://www .monticello.org/research-education/thomas-jefferson-encyclopedia/dogs/#fn-src-14. On this point the encyclopedia cites a letter by Jefferson to Edmund Bacon, December 26, 1808, Thomas Jefferson papers, Huntington Library. George Washington to Anthony Whitting, 16 December 1792. Founders Online, National Archives, https://founders .archives.gov/documents/Washington/05-11-02-0315, and *The Papers of George Washington, Presidential Series*, vol. 11, *16 August 1792–15 January 1793*, ed. Christine Sternberg Patrick (Charlottesville: University of Virginia Press, 2002), 519–24.

51. Mark Godfrey argues persuasively—also citing unpublished work by Benjamin Buchloh—that it functioned this way in some of Barnett Newman's work. Mark Godfrey, "Barnett Newman's Stations and the Memory of the Holocaust," *October* 108 (Spring 2004): 35–50.

52. On *The Wild*, see Lisa Frye Ashe, "On Barnett Newman's 'The Wild,'" *Art Journal* 73, no. 1 (Spring 2014): 30–43; Yve-Alain Bois, "*The Wild* and Company," *October* 143 (Winter 2013), Abstraction: 95–125; Kenneth R. Allan, "Barnett Newman's *The Wild*: Painting as Spatial Intervention," *October* 143 (Winter 2013): 71–94; Michael Schreyach, "Barnett Newman's 'Sense of Space': A Noncontextualist Account of Its Perception and Meaning," *Common Knowledge* 19, no. 2 (2013): 351–79.

53. Bois, "*The Wild* and Company," 125.

54. See Rebecca Solnit, "Every Corner Is Alive: Eliot Porter as an Environmentalist and an Artist," in *Storming the Gates of Paradise: Landscapes for Politics* (Berkeley: University of California Press, 2007), 302–42.

55. On Newman's interest in Northwest Coast art, see Bill Anthes, "'Our Inter-American Consciousness': Barnett Newman and the Primitive Universal," chapter 3 in Anthes, *Native Moderns: American Indian Painting, 1940–1960* (Durham, NC: Duke University Press, 2006), 59–88, and W. Jackson Rushing, "The Impact of Nietzsche and Northwest Coast Indian Art on Barnett Newman's Idea of Redemption in the Abstract Sublime," in "New Myths for Old: Redefining Abstract Expressionism," special issue, *Art Journal* 47, no. 3 (Autumn 1988): 187–95.

56. *Pre-Columbian Stone Sculpture* brochure in American Museum of Natural History, Dept. of Anthropology correspondence with Barnett Newman and Betty Parsons, 1944–1946, Archives of American Art, Smithsonian Institution.

57. Letter, Newman to Harry L. Shapiro, Sept. 23, 1946. Dept. of Anthropology correspondence.

58. Loan form, Dept. of Anthropology correspondence.

59. *Northwest Coast Indian Painting* brochure, unpaginated, AMNH Catalog No: 16 / 956, in Dept. of Anthropology correspondence.

60. *The Ideographic Picture* exhibition, Betty Parsons Gallery, 1947 Jan. 20–Feb. 8. Exhibition announcement, Betty Parsons Gallery records and personal papers, Archives of American Art.

61. W. Jackson Rushing, "The Impact of Nietzsche and Northwest Coast Indian Art on Barnett Newman's Idea of Redemption in the Abstract Sublime," in "New Myths for Old: Redefining Abstract Expressionism," special issue, *Art Journal* 47, no. 3 (Autumn 1988): 189.

62. Bois, "The Wild," 125.

63. See Michael Leja, "Barnett Newman's Solo Tango," *Critical Inquiry* 21, no. 3 (Spring 1995): 556–80.

64. *The Ideographic Picture* exhibition announcement, Archives of American Art.

65. *Northwest Coast Indian Painting*.

66. *Northwest Coast Indian Painting*.

67. Zakkiyah Iman Jackson, *Becoming Human: Matter and Meaning in an Antiblack World* (New York: New York University Press, 2020), 3.

68. Jackson, *Becoming Human*, 4.

69. Spillers, "Mama's Baby," 79.

CHAPTER THREE

1. "Sagadahoc County," in Doubleday Postal History, accessed December 16, 2022, http://www.doubledaypostalhistory.com/postmaster/Maine/Sagadahoc.pdf. Hazel Young, *Islands of New England* (Boston: Little, Brown, 1954), 131, has 1914 but most sources seem to agree it was 1916.

2. William Zorach, *Art is My Life: The Autobiography of William Zorach* (Cleveland: The World, 1967), 34.

3. My attributions are based on discussions of these works in the Ross Archive. On the Fang sculpture, Ross cites Yaëlle Biro, "When, How, and Why Modern Art Came to New York," in *Tribal Art*, special issue 3 (2012), 70, figure P. The Lagoons (Kyaman or Akye) Nkpasopi figure can be confidently identified with one in the Barnes Foundation collection, documented in Christa Clarke, *African Art in the Barnes Foundation: The Triumph of L'Art nègre and the Harlem Renaissance* (New York: Skira Rizzoli, 2015), 172 (#30a). It also appears in John Warne Monroe, *Metropolitan Fetish: African Sculpture and the Imperial French Invention of Primitive Art* (Ithaca: Cornell University Press, 2019), 119, fig. 3.11. See *Ross Archive of African Images*, accessed January 19, 2023, https://web.library.yale.edu/collection/ross-archive-african-images.

4. William Zorach, *Art Is My Life*, 112.

5. William Zorach, *Art Is My Life*, 93.

6. William Zorach, *Art Is My Life*, 175.

7. See the Reparations at UChicago Working Group (RAUC), Caine Jordan, Guy Emerson Mount, and Kai Parker, "A Case for Reparations at the University of Chicago," white paper, 2017, accessed December 24, 2022, https://app.box.com/s/bd9w85wam0pzwtowngapkf66vojn9bwy.

8. "A Case for Reparations at the University of Chicago," *Black Perspectives*, May 22, 2017, https://www.aaihs.org/a-case-for-reparations-at-the-university-of-chicago/, citing John W. Boyer, *The University of Chicago: A History* (Chicago: University of Chicago Press, 2015), 5–66.

9. University of Chicago, *Catalogue of the Alumni of the University of Chicago* (Chicago: Henson Bros., 1892), https://www.lib.uchicago.edu/ead/pdf/olduofc-0009-003.pdf.

10. See Peter Burke, *The Fabrication of Louis XIV* (New Haven, CT: Yale University Press, 1994).

11. On the Republic of New Afrika, see Edward Onaci, *Free the Land: The Republic of New Afrika and the Pursuit of a Black Nation-State* (Chapel Hill: University of North Carolina Press, 2020).

12. Lisa Scott writes, "While white, middle class young people wanted to divest themselves from material wealth, African Americans, long familiar with poverty, had no interest in voluntarily ridding themselves of accumulated property." Lisa A. Scott, "Hippie Communes of the West Coast: A Study of Gender Roles and the Evolution of the Counterculture's Definition of Freedom," *Papers & Publications: Interdisciplinary Journal of Undergraduate Research* 6, article 6 (2017).

CHAPTER FOUR

1. Sarah Lewis discusses the gazebo in "Groundwork: Race and Aesthetics in the Era of Stand Your Ground Law," *Art Journal* 79, issue 4 (Winter 2020): 92–113.

2. Darcel Rocket, "Tamir Rice Gazebo Memorial reconstructed with help from Rebuild Foundation: 'For every Tamir that we know, there's probably 20 or 30 that we don't,'" *Chicago Tribune*, July 1, 2019, https://www.chicagotribune.com/entertainment/ct-ent-tamir-rice-gazebo-reconstructed-20190625-20190701-mux66svup5ctrdm65wgcuuurha-story.html.

3. Tom McCarthy, "Tamir Rice: video shows boy, 12, shot 'seconds' after police confronted child," *The Guardian*, November 26, 2014, https://www.theguardian.com/us-news/2014/nov/26/tamir-rice-video-shows-boy-shot-police-cleveland.

4. On the end of the gazebo's time in Cleveland, see Daniel McGraw, "How Should Tamir Rice Be Remembered?" *Andscape*, August 23, 2016, https://andscape.com/features/how-should-tamir-rice-be-remembered/.

5. Dan Gunn, "No Justice, No Peace: Open Engagement 2017 (1/2)," May 1, 2017, accessed December 16, 2022, https://chicagoartistwriters.com/no-justice-no-peace-open-engagement-2017-12/.

6. See Hesse McGraw, "Theaster Gates: Radical Reform with Everyday Tools," *Afterall: A Journal of Art, Context and Enquiry* 30 (Summer 2012): 86–99.

7. Monica Davey, "Cleveland Gazebo Where Tamir Rice Was Shot Will be Moved to Chicago," *New York Times*, September 16, 2016, https://www.nytimes.com/2016/09/16/us/tamir-rice-cleveland-chicago.html.

8. Darren Wallace, interview with author, June 2022.

9. Christian Belanger and Mari Cohen, "Cracks in the Foundation," *South Side Weekly*, May 23, 2017, https://southsideweekly.com/cracks-in-theaster-gates-rebuild-foundation/.

10. I am grateful to Isis Ferguson for sharing with me a presentation about the gazebo and the thought process behind the programming that surrounded it. Personal communication, December 2, 2022.

11. For a study of the generic conventions of traditional art history slide lectures made possible by lantern slides, see Robert S. Nelson, "The Slide Lecture, or the Work of Art 'History' in the Age of Mechanical Reproduction," *Critical Inquiry* 26 no. 3 (Spring 2000): 414–34. The slide as "magic lantern" technology might also be put in historical relation to the visual legerdemain of Peale's Museum.

12. On race and landscape architecture in the US context, see Kofi Boone, "Black Landscapes Matter," *World Landscape Architect*, June 3, 2020, https://worldlandscapearchitect.com/black-landscapes-matter-by-kofi-boone/.

13. For example, Wetenhall Wilkes, "Bellville, A Poem," 76, in *An Essay on the Pleasures and Advantages of Female Literature* (London, 1741), and Charles Smith, *The Antient and Present State of the County and City of Cork* (Dublin, 1750), 217.

14. Susanne Seymour et. al., "Estate and Empire: Sir George Cornewall's Management of Moccas, Herefordshire and La Taste, Grenada, 1771–1819," *Journal of Historical Geography* 24, no. 3 (July 1998): 313–51.

15. Simon Gikandi, "Aesthetic Reflection and the Colonial Event: The Work of Art in the Age of Slavery," *The Journal of the International Institute* 4, no. 3 (Summer 1997), http://hdl.handle.net/2027/spo.4750978.0004.306.

16. Sarah McGee, "How Worcester's Croome Court Is Linked to Slavery and Colonialism," *Worcester News*, May 13, 2021, https://www.worcesternews.co.uk/news/19298100.worcesters-croome-court-linked-slavery-colonialism/, and Jeremy Milln, "Chinese Bridge, Croome Park, Worcestershire: Archaeological Report," May 2014, accessed December 16, 2022, https://www.academia.edu/7092994/Chinese_Bridge_at_Croome.

17. In Ann Bermingham's *Landscape and Ideology: The English Rustic Tradition, 1740–1850* (Berkeley: University of California Press, 1989), she studies, for example, Thomas Gainsborough's portrait of Mr. and Mrs. Andrews, in which an expanse of well-tended fields makes clear the fruit of someone else's labors without making the laborers visible.

18. Rebecca Solnit makes a similar point in *Orwell's Roses* (London: Granta Books, 2021), 161.

19. On this portrait, see Marcia Pointon, "Slavery and the Possibilities of Portraiture," in *Slave Portraiture in the Atlantic World*, ed. Agnes Lugo-Ortiz and Angela Rosenthal (Cambridge: Cambridge University Press, 2013), 41–70. On British landscape painting, see John Barrell, *The Dark Side of the Landscape: The Rural Poor in English Painting 1730–1840* (Cambridge: Cambridge University Press, 1983), and Bermingham, *Landscape and Ideology*.

20. Clement Greenberg, "'Americanism' Misplaced: Review of *Preface to an American Philosophy of Art* by A. Philip McMahon" [1946], in *The Collected Essays and Criticism*, vol. 2, *Arrogant Purpose, 1945–1949*, ed. John O'Brian (Chicago: University of Chicago Press, 1986), 66.

21. Robert Smithson, in "Sedimentation of the Mind," also gives a central place to the garden. Alluding to Michael Fried's arguments about theatricality—the notion that art "degenerates" as it approaches theater—Smithson counters that art degenerates as it approaches gardening. In Smithson's text he leaves more ambiguous whether or not this is a good thing—while he rejects the pastoral, he suggests that situating sculptures ("industrial ruins") in gardens places them in "time" rather than "history"—which would seem to put them in sympathy with his interests in deep time. In Jack Flam, ed., *Robert Smithson: The Collected Writings* (Berkeley: University of California Press, 1996), 105.

22. Immanuel Kant, *Critique of Judgment*, trans. J. H. Bernard (New York: Free Press, 2008), 168.

23. Kant, *Critique of Judgment*, 80 and 80n32.

24. Marsden was the son of an Irish merchant who went to work for the British East India Company before being employed as a secretary by the British Navy and writing a series of scholarly tomes. William Marsden, *A History of Sumatra*, 2nd ed. (London, 1784).

25. Marsden, *History of Sumatra*, 112–13.

26. Marsden, *History of Sumatra*, 112–13. Marsden then suggests that building a Renaissance-style garden there instead, one based in geometric ornamental forms, would produce more aesthetic contrast and thus be more pleasing.

27. Marsden, *History of Sumatra*, 70.

28. Marsden writes, "In order to bind the native chiefs to the observance of their original promises and profession, and to establish a plausible claim in opposition to the attempts of rival European powers to interfere in the trade of the country, Contracts, attended with much form and solemnity, were entered into with the former; by which they engaged to oblige all their dependants [*sic*] to cultivate pepper, and to secure to us the exclusive purchase of it." Marsden, *History*, 103. Judgments about the laziness of Sumatrans coexist comfortably for him with an acknowledgment that they correctly judged pepper cultivation to be unprofitable. Marsden, *History*, 106.

29. Barbara Watson Andaya, "Women and Economic Change: The Pepper Trade in Pre-Modern Southeast Asia," in "Women's History," special issue, *Journal of the Economic and Social History of the Orient* 38, no. 2, (1995): 165–90. Pepper was introduced in the fifteenth century, and its cultivation was in full swing in the eighteenth century. As its cultivation developed as a major local industry, Sumatran authorities made agreements with colonial powers to compel family units to grow pepper and to grow it in quantity. To increase the labor pool, Europeans also imposed the use of slavery, including enslaved people from Madagascar and the Indian subcontinent. Anna Winterbottom, "Transportation and Transplantation: Slave Knowledge and Company Plantations," *Hybrid Knowledge in the Early East India Company World* (New York: Palgrave, 2016), 163–95.

30. See George Schwartz, *Collecting the Globe: The Salem East India Marine Society Museum* (Amherst: University of Massachusetts Press, 2020). The society's collection was open only to White visitors until the end of the Civil War. See also Donald Kenneth Schwartz, "Peele's Pepper: The Role of the Peele Family and Salem, Massachusetts in the American Pepper Trade with Sumatra in the period 1795–1815" (MA thesis, University of Colorado, 1988).

31. Schwartz, *Collecting*; Patricia Johnston, "Global Knowledge in the Early Republic: The East India Marine Society's Curiosities Museum," in *East-West Interchanges in American Art: A Long and Tumultuous Relationship*, ed. Cynthia Mills, Lee Glazer, and Amelia A. Goerlitz (Washington, DC: Smithsonian Institution Scholarly Press, 2012), 68–79.

32. Franklin Parker, "George Peabody and the Peabody Museum of Salem," *Curator: The Museum Journal* 10 (1967): 137–53.

33. See Dawn Odell, "Ekphrasis and the Global Eighteenth Century: A.E. van Braam Houckgeest's Collection of Chinese Art," in *Ekphrastic Image-Making in Early Modern Europe, 1500–1700*, ed. Arthur J. Di Furia and Walter Melion (Leiden: Brill, 2022), 808–35.

34. Thomas Green Fessenden, *The Register of the Arts, or a Compendious View of Some of the Most Useful Modern Discoveries and Inventions* (Philadelphia: C. and A. Conrad, 1808), 357.

35. Jenny Purtle, "The *Liberty Bowl*: China, Silver, Tea, and Revolution in Britain's American Colonies circa 1775," paper given at the Association for Asian Studies, Boston, March 2007.

36. Punch itself was a global product, based on the Hindi word for five—the number of ingredients—and adopted by the British, often involving rum and the juice of citrus fruit.

37. Andrew Jackson Downing, *Treatise on the Theory and Practice of Landscape Gardening* (New York: Wiley and Putnam, 1841), written for a North American audience, presents an extensive case study of an English estate in which a "Chinese temple" figures prominently.

38. James McKnight, a senior landscape architect in the Mayor's Office of Capital Projects, wasn't able to find plans for it in the city's archives; he cited a 1994 satellite photograph—visible on Google Earth—that appears to show its presence there, while a previous photo from 1985 is too blurry to tell. (James McKnight, email to author, February 17, 2022). McGraw, "How Should Tamir Rice Be Remembered?" refers to the gazebo's age as "about 50 years."

39. Workers of the Writers Program of the Works Projects Administration in the State of Ohio, *Cudell House Crafts and Arts Center* (Cleveland, Works Projects Administration: 1940), 9.

40. Workers, *Cudell House*, 19.

41. Robert K. Nelson, LaDale Winling, Richard Marciano, Nathan Connolly, et al., "Mapping Inequality," *American Panorama*, ed. Robert K. Nelson and Edward L. Ayers, accessed November 21, 2022, https://dsl.richmond.edu/panorama/redlining/#loc=11/41.49/-81.858&city=cleveland-oh&area=C20.

42. Donald W. Athearn, *Places for Playing in Cleveland: Standards for Public Recreation Areas* (Cleveland: City of Cleveland Planning Commission, 1945).

43. Michael Rapuano, P. P. Pirone, and Brooks E. Wigginton, *Open Space in Urban Design* (Cleveland: Cleveland Development Foundation, 1964), 15–16.

44. Rapuano et al., *Open Space*, mention concerns about vandalism, 31, 51, 52.

45. Conversely, the authors refer to the types of open spaces they like—the Capitoline in Rome or St. Mark's Square in Venice—as "works of art" where beauty and utility go hand in hand (Rapuano et al., *Open Space*, 17). Similarly, large parks and nature preserves may be "self-contained, polished works of civic art."

46. Rapuano et al., *Open Space*, 16.

47. Richard Sennett, *The Conscience of the Eye: The Design and Social Life of Cities* (New York: W. W. Norton, 1990), 88.

48. Sennett, *The Conscience of the Eye*, 117.

49. See Todd M. Michney, "White Civic Visions Versus Black Suburban Aspirations: Cleveland's Garden Valley Urban Renewal Project," *Journal of Planning History* 10, no. 4 (2011): 282–309.

50. Roldo Bartimole, "Keeping the Lid On: Corporate Responsibility in Cleveland," *Business and Society Review* 5 (Spring 1973): 96–103.

51. Milton Friedman, *The Economics of Freedom* (Cleveland: Standard Oil Company of Ohio, 1978).

52. Jamaica Kincaid, "Sowers and Reapers," *New Yorker*, January 22, 2001, 43.

53. For a thoughtful account of a visit to Monticello and how guides now represent Jefferson's involvement in enslavement, see Clint Smith, *How the Word Is Passed* (Boston: Little, Brown, 2021).

54. Thomas Jefferson to Charles Willson Peale, August 20, 1811. *Papers of Thomas Jef-*

ferson, *Retirement Series* 4, ed. J. Jefferson Looney (Princeton, NJ: Princeton University Press, 2008), 93.

55. See George Geib, "The Land Ordinance of 1785: A Bicentennial Review," *Indiana Magazine of History* 81, no. 1 (March 1985): 1–13. See also Hannah Higgins, *The Grid Book* (Cambridge, MA: MIT, 2009): 71, and Sekou Cooke and Nadia M. Anderson, "Jefferson, Hip-Hop, and the Oppressive Grid." *106th ACSA Annual Meeting Proceedings, The Ethical Imperative*, accessed December 24, 2022, https://www.acsa-arch.org/chapter/jefferson-hip -hop-and-the-oppressive-grid/.

56. A. Whitney Griswold, "The Agrarian Democracy of Thomas Jefferson," *The American Political Science Review* 40, no. 4 (August 1946): 657–81.

57. Thomas Jefferson, letter to Gysbert K. van Hogendorp, October 13, 1785, in *Papers of Thomas Jefferson* 8, ed. Julian P. Boyd (Princeton, NJ: Princeton University Press, 1953). See also Dave Wang, "Thomas Jefferson's Incorporating Positive Elements from Chinese Civilization," *Virginia Review of Asian Studies* 145 (2012): 143–57.

58. Charles Gustavus Eckeberg, *A Short Account of the Chinese Husbandry*, published with Peter Osbeck, *A Voyage to China and the East Indies* (London: Benjamin White, 1771), 271.

59. Thomas Jefferson, *Notes on the State of Virginia* (Paris, 1785), query 19.

60. Jefferson, *Notes*, query 19.

61. Thomas Jefferson, Letter to Benjamin Rush, September 23, 1800, *Papers of Thomas Jefferson* 32, ed. Barbara B. Oberg (Princeton, NJ: Princeton University Press, 2005).

62. See the relationship between the grid and equality suggested in Thomas A. Markus, "Is There a Built Form for Non-Patriarchal Utopias?" in *Embodied Utopias: Gender, Social Change, and the Modern Metropolis*, ed. Amy Bingaman, Lise Sanders, and Rebecca Zorach (Routledge, 2002). Hannah Higgins argues that "each grid has its own texture, uniqueness, individuating features, capacities for creative enactment, and relationship to other grids, as much as each person combines and utilizes a grid for him- or herself." Higgins, *The Grid Book*, 276. For Rosalind Krauss, the grid is "what art looks like when it turns its back on nature." "Grids," *October* 9 (Summer 1979), 50; the essay is reprinted in *The Originality of the Avant-Garde and Other Modernist Myths* (Cambridge, MA: MIT Press, 1986), 9–22. See also Jason Weems, *Barnstorming the Prairies: How Aerial Vision Shaped the Midwest* (Minneapolis: University of Minnesota Press, 2015).

63. Athearn, *Places for Playing*.

64. On *Night Coming Tenderly*, see *Dawoud Bey: Two American Projects*, ed. Corey Keller and Elizabeth Sherman (New Haven, CT: Yale University Press, 2020); on the quiet of the photographs, see Tina Campt, "The Slow Lives of Still-Moving Images," *A Black Gaze: Artists Changing How We See* (Cambridge, MA: MIT Press, 2021), 109–43.

65. The house in this photograph is the William Quilliams House, 884 Quilliams Road, Cleveland Heights. I thank David Lusenhop for pointing me to it.

66. Steven Nelson, "Dawoud Bey's Historical Turn," in *Dawoud Bey: Two American Projects*, 20.

67. Gunn, "No Justice."

68. Julie Yost, personal communication.

69. Darcel Rockett, "Tamir Rice Gazebo Memorial Reconstructed with Help from Rebuild Foundation: 'For Every Tamir That We Know, There's Probably 20 or 30 That We Don't,'" *Chicago Tribune*, June 25, 2019, https://www.chicagotribune

.com/entertainment/ct-ent-tamir-rice-gazebo-reconstructed-20190625-20190701
-mux66svup5ctrdm65wgcuuurha-story.html.

70. For a discussion of other Black gardens with a contemplative focus, see Georgina Reed, "Rest, Repose and Race: Leslie Bennett and Black Sanctuary Gardens," *The Plant Hunter*, June 25, 2020, https://theplanthunter.com.au/gardens/rest-repose-and-race-leslie -bennett-black-sanctuary-gardens.

CHAPTER FIVE

1. On *House*, see for example Grant Kester, *Conversation Pieces: Community and Communication in Modern Art* (Berkeley: University of California Press, 2004), especially pages 18–24.

2. See "Detroit Artists Paint Town Orange to Force Change," NPR, December 7, 2006, https://www.npr.org/2006/12/07/6592634/detroit-artists-paint-town-orange-to-force -change; Dave Willis, "House of Gold Makes a Statement in Wilkinsburg," *Pittsburgh City Paper*, June 24, 2015, https://www.pghcitypaper.com/pittsburgh/house-of-gold-makes-a -statement-in-wilkinsburg/Content?oid=1760780; and "House of Gold," website, accessed December 24, 2022, http://www.house-of-gold.com.

3. Architectural abstraction, racial oppression, and an ironic, culturally specific color palette came together in an earlier project as well. In a project that formed part of *Culture in Action*, curated in Chicago by Mary Jane Jacob in 1993, as Michael Kimmelman explained in a caustic review, "Kate Ericson and Mel Ziegler . . . asked a group of residents of Ogden Courts Apartments, a housing project, to help them design a paint chart, each color relating to some event in the history of public housing or some aspect of life in such housing—Urban Renewal Lime, Cabrini Green, Pruitt-Igoe Dust." Michael Kimmelman, "Of Candy Bars and Public Art," *New York Times*, September 26, 1993.

4. Amanda Williams, "Color(ed) Theory Series," Studio website, accessed December 24, 2022, https://awstudioart.com/section/373029-Color-ed-Theory-Series.html.

5. Joan Marter, "The Ascendancy of Abstraction for Public Art: The Monument to the Unknown Political Prisoner Competition," in "Sculpture in Postwar Europe and America, 1945–59," special issue, *Art Journal* 53, no. 4, (Winter 1994): 30.

6. Marter, "Ascendancy," 28.

7. Carol Duncan, "The MoMA's Hot Mamas," in "Images of Rule: Issues of Interpretation," special issue, *Art Journal* 48, no. 2, (Summer 1989): 171.

8. Ben Shahn, *The Shape of Content* (Cambridge, MA: Harvard University Press, 1957), 58.

9. Duncan, "Hot Mamas," 171.

10. Clement Greenberg, "Art," *The Nation*, November 1, 1947. This judgment echoes with that levied on Gwendolyn Brooks by the white-identified poet and critic Louis Simpson in 1963: "I am not sure it is possible for a Negro to write well without making us aware he is a Negro; on the other hand, if being a Negro is the only subject, the writing is not important." At that time, apparently, the Jamaica-born Simpson did not know that his own paternal grandmother was Black. Mervyn Rothstein, "Louis Simpson, Poet of Everyday Life, Dies at 89," *New York Times*, September 17, 2012, https://www.nytimes .com/2012/09/18/arts/louis-simpson-a-pulitzer-prize-winning-poet-dies-at-89.html.

11. Much more could be said here about Clement Greenberg, and scholarship on his work is copious. Recent works include Thierry de Duve, *Clement Greenberg between*

the Lines, trans. Brian Holmes (Chicago: University of Chicago Press, 2010) and Caroline Jones, *Eyesight Alone: Clement Greenberg's Modernism and the Bureaucratization of the Senses* (Chicago: University of Chicago Press, 2008).

12. Rosalind E. Krauss, "Grids," 50.

13. Kazimir Malevich, "Suprematism," in *Modern Artists on Art*, ed. Robert L. Herbert (Englewood Cliffs: Prentice-Hall, 1964), 92–102. Quoted in Robert Smithson, "Sedimentation of the Mind," 109.

14. Leo Steinberg, "The Flatbed Picture Plane," lecture at the Museum of Modern Art, New York in 1968; first published in "Reflections on the State of Criticism," *Artforum*, March 1972; in *Other Criteria: Confrontations with Twentieth-Century Art* (Chicago: University of Chicago Press, 2007 [1972]), 61–98.

15. Andrew Martinez, "A Mixed Reception for Modernism: The 1913 Armory Show at the Art Institute of Chicago," *Art Institute of Chicago Museum Studies* 19, no. 1 (1993), *One Hundred Years at the Art Institute: A Centennial Celebration*, 30–57, 102–5.

16. Margaret Burroughs, "To Make a Painter Black," in *The Black Seventies*, ed. Floyd Barbour (Boston: P. Sargent, 1970), 135.

17. Lorraine Hansberry, "To the Editor," *New York Times*, April 23, 1964, quoted in *To Be Young, Gifted, and Black* (New York: Signet Classics, 2011 [1969]), 51–52.

18. These conditions and the struggle against them are chronicled in Beryl Satter, *Family Properties: Race, Real Estate, and the Exploitation of Black Urban America* (New York: Macmillan, 2009). See also Keeanga-Yamahtta Taylor, *Race for Profit: How Banks and the Real Estate Industry Undermined Black Homeownership* (Chapel Hill: University of North Carolina Press, 2019).

19. For a discussion of the Kenwood open houses along with citations, see Rebecca Zorach, "Making Space," *Art in Chicago: A History From the Fire to Now*, ed. Maggie Taft and Robert Cozzolino (Chicago: University of Chicago Press, 2018), 193.

20. "CORE To Hold Open House In Slum Bldg," *Chicago Defender*, April 11, 1964.

21. John Kifner, "Chicago Panther Mourned: Raid Scene Visited," *New York Times*, December 10, 1969, 37.

22. Michael L. Culbert, "W. Sider Hit-Run Victim: En Route FORUM Parley," *Chicago Daily Defender*, October 19, 1972, 35; Culbert, "Films of 'Hip Black Dudes': Good or Bad Image?" *Chicago Daily Defender*, September 30, 1972, 6.

23. AP Wirephoto (iz1601cek-stf), 1966, print in author's collection.

24. A photo also appeared in the *Chicago Daily News*, March 31, 1970. Toni Anthony, "Jail Fr. Clements In Evictions: Nab Fr. Clements In Evictions," *Chicago Daily Defender*, March 31, 1970; Anthony, "Joe Robichaux On CBL Spot," *Chicago Daily Defender*, Apr 6, 1970.

25. Communications for Change, "Social and Political Intervention Scrapbook," Media Burn Archive, accessed December 24, 2022, http://mediaburn.org/video/social-and-political-intervention-scrapbook/.

26. Untitled review, *Time*, October 16, 1964, 59.

27. On Blackness and spatial politics in nineteenth-century genre painting, see Ivy Wilson, *Specters of Democracy: Blackness and the Aesthetics of Nationalism in the Antebellum US* (Oxford: Oxford University Press, 2011).

28. Black abstraction has received renewed attention in recent exhibitions such as the Baltimore Museum of Art's 2019–20 *Generations: A History of Black Abstract Art*, and in work by contemporary scholars and theorists such as Torkwase Dyson, Darby English, and Leigh Raiford (all discussed later in this chapter). Kellie Jones discusses Norman

Lewis's black paintings in *EyeMinded: Living and Writing Contemporary Art* (Durham, NC: Duke University Press, 2011), 483–90. See also Philip Brian Harper, *Abstractionist Aesthetics: Artistic Form and Social Critique in African American Culture* (New York: New York University Press, 2015).

29. Shahn, *Shape*, 26.

30. Shahn, *Shape*, 32, 26.

31. In the Hickman case, Leon Despres—later the famously independent alderman of Hyde Park—was cocounsel for the defense. After an all-White jury could not come to a unanimous decision, the prosecution, rather than retry the case, struck a plea deal with the defendant that resulted in two years' probation but no further jail time. Despres later donated Shahn's original drawings for the *Harper's* article to the Smart Museum.

32. On landlord arson nationwide in the 1970s, see "The Nation: Arson for Hate and Profit," *Time*, Monday, Oct. 31, 1977.

33. John Bartlow Martin, "The Hickman Story," *Harper's*, August 1948.

34. It was first purchased by a member of the institute's board, who donated it. Daniel Bluestone, "Chicago's Mecca Flat Blues," *Journal of the Society of Architectural Historians* 57, no. 4 (Dec. 1998): 394.

35. I discuss the textbook's many exclusions in Rebecca Zorach, "Art & Soul: An Experimental Friendship between the Street and a Museum," *Art Journal* 70, no. 2 (2011), 66–87.

36. On the Mecca and the development of IIT's campus, see Thomas Dyja, *The Third Coast: When Chicago Built the American Dream* (New York: Penguin, 2013).

37. Bluestone, "Mecca Flat Blues," 398.

38. Bluestone, "Mecca Flat Blues," 396.

39. The quotations derive from Chicago Housing Authority, *Chicago Can Build*, report (Chicago: Chicago Housing Authority, 1950), 1–3, which include similar images. Sarah Whiting discusses similar planning documents in her "Bas-Relief Urbanism: Chicago's Figured Field," in *Mies in America*, ed. Phyllis Lambert (New York: Harry N. Abrams, 2001), 654.

40. Martin, "The Strangest Place in Chicago," *Harper's*, December 1950, 97.

41. Martin, "The Strangest Place in Chicago," *Harper's*, December 1950, 97.

42. Robert Smithson, "Robert Smithson Interview with Stig Broegger and Erik Thygesen," 1969, Holt Smithson Foundation, accessed December 1, 2022, https://holtsmithsonfoundation.org/robert-smithson-interview-stig-broegger-and-erik-thygesen.

43. See John Lowney, "'A Material Collapse That Is Construction': History and Counter-Memory in Gwendolyn Brooks's *In the Mecca*," *MELUS* 23, no. 3 (1998): 3–20.

44. Lowney, "Material Collapse"; Gwendolyn Brooks, *Report from Part One* (Detroit: Broadside Press, 1972), 189.

45. See Romi Crawford, "Black Photographers Who Take Black Pictures," in *The Wall of Respect: Public Art and Black Liberation in 1960s Chicago* ed. Abdul Alkalimat, Romi Crawford, and Rebecca Zorach (Evanston: Northwestern University Press, 2017), 193–211.

46. Margo Natalie Crawford, "Black Light on the Wall of Respect," in *New Thoughts on the Black Arts Movement*, ed. Lisa Gail Collins and Margo Natalie Crawford (New Brunswick, NJ: Rutgers University Press, 2006), 26.

47. Gwendolyn Brooks, "In the Mecca," in *In the Mecca* (New York: Harper & Row, 1968), 8.

48. Brooks, "Second Semon on the Warpland," in *In the Mecca*, 51.

49. Brooks, "Boy Breaking Glass," in *In the Mecca*, 36.

50. Brooks, "The Sermon on the Warpland," in *In the Mecca*, 50.

51. Krauss, "Grids," 50.

52. In chapter 2 of Dan Charnas's *Dilla Time*, he discusses the imposition of the grid of land on the Midwest and Detroit in particular, suggesting an analogy with characteristics of European musical composition as imposed as a model in American musical culture, and positing J Dilla's musical innovation as a way of grappling with the spatial as well as musical grid. Dan Charnas, *Dilla Time: The Life and Afterlife of J Dilla, the Hip-Hop Producer Who Reinvented Rhythm* (New York: MCD Picador, 2022).

53. Darby English, *1971: A Year in the Life of Color* (Chicago: University of Chicago Press, 2016), 41.

54. English, *1971*, 252.

55. Lavie Raven and Rebecca Zorach, "Our Kids Didn't Invent Guns: Lavie Raven Interviewed by Rebecca Zorach," in *Art Against the Law*, ed. Rebecca Zorach (Chicago: School of the Art Institute of Chicago, 2014), 123–24.

56. Leigh Raiford, "Burning All Illusion: Abstraction, Black Life, and the Unmaking of White Supremacy," *Art Journal* 79, no. 4 (Winter 2020): 76–91, republished in *Art Journal Open*, January 14, 2021, http://artjournal.collegeart.org/?p=15113#fnref-15113-20.

57. Huey Copeland, "One-Dimensional Abstraction," *Art Journal* 78, no. 2 (2019): 117. Krista Thompson points out Greenberg's disturbing allusion to slavery in his canonical essay "Avant-Garde and Kitsch" in her "A Sidelong Glance: The Practice of African Diaspora Art History in the United States," *Art Journal* 70, no. 3 (2011): 23. In his recent book *Value in Art: Manet and the Slave Trade*, speaking of the nineteenth century, Henry M. Sayre refers to the "questions of race that lie . . . at the very heart of the modernist enterprise" (Chicago: University of Chicago Press, 2022), xix.

58. For a recent overview of European primitivism with respect to Picasso, see Suzanne Blier, *Picasso's Demoiselles: The Untold Origins of a Modern Masterpiece* (Durham, NC: Duke University Press, 2019).

59. Carl Einstein, "Negro Sculpture," trans. Charles W. Haxthausen and Sebastian Zeidler, *October* 107 (Winter 2004): 122–38.

60. In 2016 the African American artist Ellen Gallagher created a project that responds to the Malevich discovery, consisting of four textured paintings entitled *Negroes Battling in a Dark Cave*. See "Ellen Gallagher: Are We Obsidian?" Art Institute of Chicago, accessed December 24, 2022, https://www.artic.edu/exhibitions/9078/ellen-gallagher-are-we-obsidian.

61. On Bilhaud, Allais, and the Incohérents, see James Smalls, "Visualizing Racial Antics in Late Nineteenth-Century France," in *Black and Blackness in European Art of the Late Nineteenth Century*, ed. Adrienne L. Childs and Susan H. Libby (London: Routledge, 2014), 145–74.

62. Denys Riout, "Le peintre néo-impressionniste: Une adaptation anticipatrice," *1895* 53 (2007): 258–71.

63. Torkwase Dyson, "Black Interiority: Notes on Architecture, Infrastructure, Environmental Justice, and Abstract Drawing." *Pelican Bomb*, January 9, 2017, http://pelicanbomb.com/art-review/2017/black-interiority-notes-on-architecture-infrastructure-environmental-justice-and-abstract-drawing.

64. Raiford, "Burning All Illusion."

65. New Orleans Museum of Art, *Black Compositional Thought | 15 Paintings for the Plantationocene*, accessed December 16, 2022, https://noma.org/exhibitions/torkwase-dyson -black-compositional-thought-15-paintings-from-the-plantationocene/#about.

66. Naomi Beckwith and Dieter Roelstraete, eds., *The Freedom Principle: Experiments in Art and Music, 1965 to Now*, exhibition catalog (Chicago: University of Chicago Press, 2015). In 1966, Ed Bullins's play *The Theme Is Blackness* restaged Malevich, as it were, by making the audience sit in the dark: abstract, Black, and thoroughly political. See Lisa Gail Collins and Margo Natalie Crawford, *New Thoughts on the Black Arts Movement* (New Brunswick: Rutgers University Press, 2006), 10.

67. Hortense Spillers, "Mama's Baby, Papa's Maybe: An American Grammar Book," in "Culture and Countermemory: The 'American' Connection," special issue, *Diacritics* 17, no. 2, (Summer 1987): 64–81. See also Katherine McKittrick, "Mathematics Black Life," in "States of Black Studies," special issue, *The Black Scholar* 44, no. 2, (Summer 2014): 16–28.

68. A sense of the continuum from activist art to creative activism appears in Arthur Waskow's term "creative disorder." Arthur Waskow, *From Race Riot to Sit-In* (New York: Doubleday, 1966).

69. Bill Stamets, "Guerrilla Housing," *Chicago Reader*, November 28, 1991, https://www .chicagoreader.com/chicago/guerrilla-housing/Content?oid=878714/. The city removed the houses built by the Mad Housers: Don Terry, "Homeless Prefer Huts to Chicago's Public Housing," *New York Times*, June 13, 1992, https://www.nytimes.com/1992/06/13/us /homeless-prefer-huts-to-chicago-s-public-housing.html.

70. Tor Faegre, "Mad Housers," *AREA Chicago* 10 (2010), archived February 27, 2019, https://areachicagoarchive.wordpress.com/2019/02/27/mad-housers/.

71. See Daniel Tucker, "Artists Imagining the City: Activist Art about Housing Issues in Chicago at the Start of the Twenty-First Century," *Art & the Public Sphere* 4, nos. 1 and 2 (2015): 69–82; Tucker, "Chaos Agents," *AREA Chicago* 13 (April 2013), archived March 3, 2019, https://areachicagoarchive.wordpress.com/2019/03/03/chaos-revisited/.

72. See Jeanne Lieberman, "Conversation Pieces," *South Side Weekly*, October 30, 2013, https://southsideweekly.com/conversation-pieces/.

73. Derrick Clifton, "How Protests in Ferguson Inspired the Occupation of Freedom Square," *Chicago Reader*, August 9, 2016, https://chicagoreader.com/columns-opinion/how -protests-in-ferguson-inspired-the-occupation-of-freedom-square/.

74. Maxwell Evans, "Activists Build Tent City to Show What Could Happen without Affordable Housing around Obama Library," *Block Club Chicago*, June 12, 2020, https:// blockclubchicago.org/2020/06/12/activists-build-tent-city-to-show-what-could-happen -without-affordable-housing-around-obama-library/.

75. Farhan Samanani and Johannes Lenhard, "House and Home," *Cambridge Encyclopedia of Anthropology*, December 9, 2019, https://www.anthroencyclopedia.com/entry/house -and-home. I learned too late of Claudette Lauzon's *The Unmaking of Home in Contemporary Art* (Toronto: University of Toronto Press, 2017).

CHAPTER SIX

1. Leo Steinberg, "The Flatbed Picture Plane," lecture at the Museum of Modern Art, New York in 1968; first published in "Reflections on the State of Criticism," *Artforum*, March 1972; in *Other Criteria: Confrontations with Twentieth-Century Art* (Chicago: University of Chicago Press, 2007 [1972]), 61–98.

2. Alan Michelson, "Pond to Prison," in *Up River Syllabus*, PDF published in conjunction with *Up River Studies: Carcerality and the American Sublime*, exhibition at CCS Bard, April 2–May 29, 2022. Unpaginated.

3. Michelson, "Pond to Prison." I thank Alan Michelson for drawing my attention to this essay and to other information about *Earth's Eye*.

4. On the automotive pilgrimage, see Erin Hogan, *Spiral Jetta* (Chicago: University of Chicago Press, 2008).

5. A large body of scholarship exists on land art. Recent works include Amanda Boetzkes, *The Ethics of Earth Art* (Minneapolis: University of Minnesota Press, 2010), Mark Cheetham, *Landscape into Eco Art: Articulations of Nature since the '60s* (Philadelphia: University of Pennsylvania Press, 2018), James Nisbet, *Ecologies, Environments, and Energy Systems in Art of the 1960s and 1970s* (Cambridge, MA: MIT Press, 2014), and his *Second Site* (Princeton, NJ: Princeton University Press, 2021). A much-cited classic text is Rosalind Krauss, "Sculpture in the Expanded Field," *October* 8 (Spring 1979), 30–44.

6. Robert Smithson, "Robert Smithson Interview with Stig Broegger and Erik Thygesen," 1969, Holt Smithson Foundation, accessed December 1, 2022, https://holtsmithsonfoundation.org/robert-smithson-interview-stig-broegger-and-erik-thygesen.

7. Leslie Hewitt, "Cauleen Smith," *Bomb Magazine* 115 (Summer 2011), https://bombmagazine.org/articles/cauleen-smith/. On land art and Thoreau, see also Antonia Rigaud, "Disorienting Geographies: Land Art and the American Myth of Discovery," *Miranda* [online] 6 (2012), accessed December 1, 2022, http://journals.openedition.org/miranda/2955.

8. Carolyn Lazard, "Destroying Narratives: Cauleen Smith and Carolyn Lazard in Conversation," *Mousse Magazine* 55, September 16, 2016.

9. Smith heard the story in Reverend James L. Seawood's StoryCorps interview. "Reverend James Seawood," *StoryCorps*, aired February 20, 2009, https://storycorps.org/stories/reverend-james-seawood/.

10. "Reverend James Seawood."

11. Hewitt, "Cauleen Smith."

12. Damon Locks, personal communication.

13. Carolyn Finney, *Black Faces, White Spaces: Reimagining the Relationship of African Americans to the Great Outdoors* (Chapel Hill: University of North Carolina Press, 2014). In a more general way, see Dianne D. Glave and Mark Stoll, *To Love the Wind and Rain: African Americans and Environmental History* (Pittsburgh: University of Pittsburgh Press, 2011).

14. Christina Sharpe, *In the Wake: On Blackness and Being* (Durham NC: Duke University Press, 2016), 104.

15. Dionne Brand, *Land to Light On* (Toronto: McLelland and Stewart, 1997).

16. On the corporate history and structure of Disney and its production processes, see Janet Wasko, *Understanding Disney: The Manufacture of Fantasy* (Cambridge: Polity, 2020). On the highly controversial 1946 film *Song of the South*, see Jason Sperb, *Disney's Most Notorious Film: Race, Convergence, and the Hidden Histories of Song of the South* (Austin: University of Texas Press, 2012). Much of the scholarship on recent Disney films addresses the Disney princess phenomenon. See Johnson Cheu, ed., *Diversity in Disney Films: Critical Essays on Race, Ethnicity, Gender, Sexuality, and Disability* (Jefferson, NC: McFarland, 2013); Amy M. Davis, ed., *Discussing Disney* (Bloomington: Indiana University Press, 2019); Lauren Dundes, ed., *The Psychosocial Implications of Disney Movies* (Basel: MDPI, 2019).

17. On animals as a vehicle for depicting racial difference (including in early Disney) see Jeff Chang, "The Animals and the Kids," in *Who We Be: A Cultural History of Race in Post-Civil Rights America* (New York: St Martin's Press, 2014), 18–21.

18. On *Zootopia*, arguments similar to mine have been made about the film's allegorization of race in a putatively race-blind world. See Julie Passanante Elman, "Slothful Movements: Disability, Acceleration, and Capacity Feminism in Disney's Zootopia (2016)," *Feminist Media Studies* 22, no. 4 (2022): 914–31; Sarah Nilsen, "Living in Zootopia: Tracking the Neoliberal Subject in a Colorblind World," in *The Myth of Colorblindness: Race and Ethnicity in American Cinema*, ed. Sarah E. Turner and Sarah Nilsen (London: Palgrave Macmillan, 2019), 61–88.

19. I thank Sarah Lewison and Georgia De La Garza for their illuminating tours of the region around Carbondale.

20. Tracy Huling, "Building a Prison Economy in Rural America," in *Invisible Punishment: The Collateral Consequences of Mass Imprisonment*, ed. Marc Mauer and Meda Chesney-Lind (New York: The New Press, 2002), 197. On prisons, Blackness, and geography, see the work of Ruth Wilson Gilmore, including *Golden Gulag: Prisons, Surplus, Crisis, and Opposition in Globalizing California* (Berkeley: University of California Press, 2007) and most recently *Abolition Geography: Essays towards Liberation* (London: Verso, 2022), and Katherine McKittrick, "On Plantations, Prisons, and a Black Sense of Place," *Social & Cultural Geography* 12, no. 8 (2011): 947–63.

21. My discussion of Gaspar's work in this chapter draws on my "Abolition Art: Contemporary Imaginings Against the Carceral State," in *Routledge Companion to Art and Activism in the Twenty-First Century*, ed. Mey-Yen Moriuchi and Lesley Shipley (New York and London: Routledge, 2022), 216–229. See also Nicole Fleetwood, *Marking Time: Art in the Age of Mass Incarceration* (Cambridge, MA: Harvard University Press, 2020), 50–52.

22. It also might allude to Laurie Palmer's project *Three Acres on the Lake*, a project in which the artist sought proposals for a monument to Jean Baptiste Point DuSable in an unused three-acre downtown plot slated for that purpose. Palmer's project has had an important impact on socially engaged art practices in Chicago. Laurie Palmer, ed., *3 Acres on the Lake: DuSable Park Proposal Project* (Chicago: WhiteWalls, 2003).

23. Gaspar was guided in her thinking by Walter Benjamin's work with radio and Theodor Adorno's assertion that "everything which fell under the scrutiny of [Benjamin's] words was transformed, as though it had become radioactive." Gaspar, interview with author, July 2021. See Theodor Adorno, *Prisms*, trans. Samuel and Shierry Weber (Cambridge, MA: MIT Press, 1983), 229, and Walter Benjamin, *Radio Benjamin*, ed. Lecia Rosenthal, trans. Jonathan Lutes (London: Verso, 2014).

24. See Mark Watson, "Unsettled Borders and Memories: A 'Local' Indigenous Perspective on Contemporary Globalization," *Journal of Aesthetics and Culture* 7 (May 2015): 1–19.

25. Alan Michelson, "Third Bank of the River," personal website, accessed December 24, 2022, https://www.alanmichelson.com/third-bank-of-the-river/.

26. United States Environmental Protection Agency. "Newtown, Queens, Brooklyn, New York Cleanup Activities," accessed December 24, 2022, https://cumulis.epa.gov /supercpad/SiteProfiles/index.cfm?fuseaction=second.Cleanup&id=0206282#bkground.

27. Kate Morris, *Shifting Grounds: Landscape in Contemporary Native American Art* (Seattle: University of Washington Press, 2019), 149.

28. Bill Kelley Jr., "Reimagining Ceremonies: A Conversation with Postcommodity," *Afterall* 39 (Summer 2015): 33.

29. Kelley, "Reimagining," 33.

30. "General Dynamics Conducts Successful Border Security Technology Pilot in Texas." General Dynamics, website, January 31, 2018, https://www.gd.com/Articles/2018 /01/31/general-dynamics-conducts-successful-border-security-technology-pilot-texas.

31. Jayne Wilkinson, "A Year in Contradictions," *canadianart*, December 26, 2018.

32. Dylan Miner, *Agamiing—Niwaabaandaan miinawaa Nimiwkendaan // At the Lake—I see and I remember*. In *The Work of Wind: Air, Land, Sea* (Blackwood Gallery brochure), 2018, accessed December 24, 2022, https://workofwind.ca/project/agamiing-niwaabaandaan -miinawaa-nimiwkendaan-at-the-lake-i-see-and-i-remember/.

33. Dylan Miner, email to author, July 30, 2020.

34. Settler Colonial City Project, "Unceded Land," (2019), accessed December 18, 2022, https://settlercolonialcityproject.org/Unceded-Land.

35. The people actually defending their home in this case were the Potawatomi. The dead Potawatomi man whose head and upper body are visible beneath the legs of the prominent White soldier was the subject of an illuminating conversation by artist Andrea Carlson (Ojibwe) and scholar Jenny L. Davis (Chickasaw) presented by the Center for Native Futures in May 2021, https://www.artdesignchicago.org/adcnow/events/that -image-of-a-dead-man-on-dusable-bridge/.

36. Dylan Miner, "Gaagegoo Dabakaanan miiniwaa Debenjigejig (No Borders, Indigenous Sovereignty)," in *We Are Aztlán! Chicanx Histories in the Northern Borderlands*, ed. Jerry García (Seattle: Washington State University Press, 2017), 57–71.

37. Mariame Kaba and Kelly Hayes, "A Jailbreak of the Imagination: Seeing Prisons for What They Are and Demanding Transformation," *Truthout*, May 3, 2018, https:// truthout.org/articles/a-jailbreak-of-the-imagination-seeing-prisons-for-what-they-are -and-demanding-transformation/.

38. Maria Gaspar, *Unblinking Eyes, Watching*, 2019, digital composite photograph printed to scale on vinyl adhesive, 40 × 26 in., personal website, accessed December 24, 2022, https://mariagaspar.com/unblinking-eyes-watching.

39. Nick Estes, "Fighting for Our Lives: #NoDAPL in Historical Context." *Indian Country Today*, October 16, 2016, updated September 13, 2018, https://indiancountrytoday .com/archive/fighting-for-our-lives-nodapl-in-historical-context-YX3pCqnxqoydUYA -njiwDw; Anna M. Brígido-Corachán, "Material Nature, Visual Sovereignty, and Water Rights: Unpacking the Standing Rock Movement," *Studies in the Literary Imagination* 50, no. 1 (Spring 2017), 69–90; Edward Valandra, "Mni Wiconi, Water Is [More Than] Life," *Standing with Standing Rock: Voices from the #NoDAPL Movement*, ed. Nick Estes and Jaskiran Dhillon (Minneapolis: University of Minnesota Press, 2019), 71–89.

40. Kai Bosworth, "'They're Treating Us like Indians!': Political Ecologies of Property and Race in North American Pipeline Populism," *Antipode* 53, no. 3 (September 5, 2018).

41. On Belmore's *Fountain* and other work, see Charlotte Townsend-Gault, "Rebecca Belmore and James Luna on Location at Venice: The Allegorical Indian Redux," *Art History* 29, no. 4 (September 2006): 721–55. See also Jessica Horton, "Drones and Snakes," *Art in America*, October 3, 2017, https://www.artnews.com/art-in-america/features/drones-and -snakes-63299/, and Horton, "Indigenous Artists against the Anthropocene," *Art Journal* 76, no. 2 (2017): 48–69. My discussion of Belmore's *Fountain* and of *Welcome to My Volcano*

derives from my "'Welcome to My Volcano': New Materialism, Art History, and Their Others," in *Ecologies, Agents, Terrains*, ed. Christopher Heuer and Rebecca Zorach, Clark Studies in the Visual Arts (New Haven, CT: Yale University Press, 2018), 147–66.

42. Robert Enright, "The Poetics of History: An Interview with Rebecca Belmore," *Border Crossings* 95 (August 2005), https://bordercrossingsmag.com/article/the-poetics-of -history-an-interview-with-rebecca-belmore.

43. Elisha Burrows, *Rebecca Belmore: Fountain*, documentary, 2011. Formerly at https:// vimeo.com/18764906.

44. Jérôme Havre, Cauleen Smith, and Camille Turner, dir., *Triangle Trade* (2017), HD video.

45. Carolyn Lazard, "Destroying Narratives."

46. Christopher Borrelli, "The Complicated Exodus of Art World Star Cauleen Smith," *Chicago Tribune*, August 18, 2017, http://www.chicagotribune.com/entertainment/ct-ae -cauleen-smith-0820–20170819-column.html.

47. "Cauleen Smith: We Already Have What We Need." MASS MoCA, website, accessed December 24, 2022, https://massmoca.org/event/cauleen-smith/.

48. On the Procession, Kate Sierzputowski, "A Procession of Black Love Responds to Controversial Michael Brown Exhibition in Chicago," *Hyperallergic*, September 7, 2015, https://hyperallergic.com/234957/a-procession-of-black-love-responds-to-controversial -michael-brown-exhibition-in-chicago/; and Ayana Contreras, *Energy Never Dies: Afro-Optimism and Creativity in Chicago* (Urbana: University of Illinois Press, 2021), 48–50.

Bibliography

"An Act to Incorporate the Pennsylvania Academy of the Fine Arts." *Acts of the General Assembly of the Commonwealth of Pennsylvania*, chapter 182, 609–10. Octoraro: Francis Bailey, 1805.

Adorno, Theodor. *Prisms*, translated by Samuel and Shierry Weber. Cambridge: MIT Press, 1983.

"Affidavit of Singweh, an AMISTAD African," 1839, Library of Congress, Manuscript Divisions. Quoted in *Slavery and the Making of America*. PBS. Accessed December 16, 2022. https://www.thirteen.org/wnet/slavery/experience /responses/docs3.html.

Allan, Kenneth R. "Barnett Newman's *The Wild*: Painting as Spatial Intervention." *October* 143 (Winter 2013): 71–94.

Alt Right MN. "AltRight MN Response to Violent Leftist Attack at Minneapolis Institute of Art." February 28, 2017. https://altrightmn.wordpress.com /2017/02/28/altright-mn-response-to-violent-leftist-attack-at-minneapolis -institute-of-art/.

American Museum of Natural History, Dept. of Anthropology correspondence with Barnett Newman and Betty Parsons, 1944–1946. Archives of American Art, Smithsonian Institution.

Andaya, Barbara Watson. "Women and Economic Change: The Pepper Trade in Pre-Modern Southeast Asia." In "Women's History," special issue, *Journal of the Economic and Social History of the Orient* 38, no. 2, (1995): 165–90.

Anthes, Bill. "'Our Inter-American Consciousness': Barnett Newman and the Primitive Universal," in *Native Moderns: American Indian Painting, 1940–1960*, 59–88. Durham, NC: Duke University Press, 2006.

Anthony, Toni. "Jail Fr. Clements In Evictions: Nab Fr. Clements In Evictions." *Chicago Daily Defender*, March 31, 1970.

———. "Joe Robichaux On CBL Spot." *Chicago Daily Defender*, April 6, 1970.

AP Wirephoto (iz1601cek-stf), 1966, print in author's collection.

Arrington, Joseph Earl. "The Story of Stockwell's Panorama." *Minnesota History* 33, no. 7 (Autumn 1953): 284–90.

Ashe, Lisa Frye. "On Barnett Newman's 'The Wild.'" *Art Journal* 73, no. 1 (Spring 2014): 30–43.

Athearn, Donald W. *Places for Playing in Cleveland: Standards for Public Recreation Areas*. Cleveland: City of Cleveland Planning Commission, 1945.

Bal, Mieke, and Norman Bryson. "Semiotics and Art History." *Art Bulletin* 73, no. 2 (June 1991): 174–208.

Barrell, John. *The Dark Side of the Landscape: The Rural Poor in English Painting 1730–1840*. Cambridge: Cambridge University Press, 1983.

Bartimole, Roldo. "Keeping the Lid On: Corporate Responsibility in Cleveland." *Business and Society Review* 5 (Spring 1973): 96–103.

Beckwith, Naomi, and Dieter Roelstraete, eds. *The Freedom Principle: Experiments in Art and Music, 1965 to Now*, exhibition catalog. Chicago: University of Chicago Press, 2015.

Belanger, Christian, and Cohen, Mari. "Cracks in the Foundation." *South Side Weekly*, May 23, 2017. https://southsideweekly.com/cracks-in-theaster-gates-rebuild-foundation/.

Bellion, Wendy. *Citizen Spectator: Art, Illusion, and Visual Perception in Early National America*. Chapel Hill: University of North Carolina Press, 2012.

———."Heads of State: Profiles and Politics in Jeffersonian America." In *New Media, 1740–1915*, edited by Lisa Gitelman and Geoffrey B. Pingree, 31–59. Cambridge, MA: MIT, 2003.

Benjamin, Walter. *Radio Benjamin*, edited by Lecia Rosenthal, translated by Jonathan Lutes. London: Verso, 2014.

Bennett, Jane. *Thoreau's Nature: Ethics, Politics, and the Wild*. Boston: Rowman and Littlefield, 2002.

Bennett, Tony. *The Birth of the Museum: History, Theory, Politics*. New York: Routledge, 2013.

Berger, Martin. "The Formulas of Documentary Photography." In *Seeing Through Race*, 9–57. Los Angeles: University of California Press, 2011.

Berlant, Lauren. *The Female Complaint: The Unfinished Business of Sentimentality in American Culture*. Durham, NC: Duke University Press, 2008.

———. *The Queen of America Goes to Washington City: Essays on Sex and Citizenship*. Durham, NC: Duke University Press, 1997.

Bermingham, Ann. *Landscape and Ideology: The English Rustic Tradition, 1740–1850*. Berkeley: University of California Press, 1989.

Betty Parsons Gallery records and personal papers, Archives of American Art, Smithsonian Institution.

Biro, Yaëlle. "When, How, and Why Modern Art Came to New York." *Tribal Art*, special issue 3 (2012): 64–71.

Blier, Suzanne. *Picasso's Demoiselles: The Untold Origins of a Modern Masterpiece*. Durham, NC: Duke University Press, 2019.

Bluestone, Daniel. "Chicago's Mecca Flat Blues." *Journal of the Society of Architectural Historians* 57, no. 4 (Dec., 1998): 382–403.

Boetzkes, Amanda. *The Ethics of Earth Art*. Minneapolis: University of Minnesota Press, 2010.

Bois, Yve-Alain. "*The Wild* and Company." *October* 143 (Winter 2013), Abstraction: 95–125.

Boisseron, Bénédicte. *Afro-Dog: Blackness and the Animal Question*. New York: Columbia University Press, 2018.

Bond, Sarah. "Whitewashing Ancient Statues: Whiteness, Racism and Color in the Ancient World." *Forbes*, April 27, 2017. https://www.forbes.com/sites /drsarahbond/2017/04/27/whitewashing-ancient-statues-whiteness-racism -and-color-in-the-ancient-world/.

Boone, Kofi. "Black Landscapes Matter." *World Landscape Architect*, June 3, 2020, https://worldlandscapearchitect.com/black-landscapes-matter-by-kofi -boone/.

Borrelli, Christopher. "The Complicated Exodus of Art World Star Cauleen Smith." *Chicago Tribune*, August 18, 2017. http://www.chicagotribune.com /entertainment/ct-ae-cauleen-smith-0820-20170819-column.html.

Bosworth, Kai. "'They're Treating Us like Indians!': Political Ecologies of Property and Race in North American Pipeline Populism." *Antipode* 53, no. 3 (September 5, 2018).

Boyer, John W. *The University of Chicago: A History*. Chicago: The University of Chicago Press, 2015.

Braddock, Alan C., and Christoph Irmscher, eds. *A Keener Perception: Ecocritical Studies in American Art History*. Tuscaloosa: University of Alabama Press, 2009.

Brand, Dionne. *Land to Light On*. Toronto: McLelland and Stewart, 1997.

Brígido-Corachán, Anna M. "Material Nature, Visual Sovereignty, and Water Rights: Unpacking the Standing Rock Movement." *Studies in the Literary Imagination* 50, no. 1 (Spring 2017): 69–90.

Brissot de Warville, Jacques Pierre. *Nouveau voyage dans les Etats-Unis de l'Amérique septentrionale, fait en 1788*. Paris: Buisson, 1791.

Brooks, Gwendolyn. *In the Mecca*. New York: Harper and Row, 1968.

———. *Report from Part One*. Detroit: Broadside Press, 1972.

Brotman, Barbara. "Educational Experiment." *Chicago Tribune*. March 14, 2013. https://www.chicagotribune.com/news/ct-xpm-2013-03-14-ct-met-cps -humanities-20130314-story.html.

Burke, Peter. *The Fabrication of Louis XIV*. New Haven, CT: Yale University Press, 1994.

Burroughs, Margaret. "To Make a Painter Black." In *The Black Seventies*, edited by Floyd Barbour, 129–137. Boston: P. Sargent, 1970.

Burrows, Elisha, dir. *Rebecca Belmore: Fountain*. 2011. Formerly at https://vimeo.com/18764906.

Campt, Tina. "The Slow Lives of Still-Moving Images." In *A Black Gaze: Artists Changing How We See*, 109–43. Cambridge, MA: MIT Press, 2021.

"A Case for Reparations at the University of Chicago." *Black Perspectives*, May 22, 2017. https://www.aaihs.org/a-case-for-reparations-at-the-university-of-chicago/.

"Catalogue of Statues and Busts in the Pennsylvania Academy of the Fine Arts," in Thomas Green Fessenden, *The Register of the Arts, or a Compendious View of Some of the Most Useful Modern Discoveries and Inventions*, 345–54. Philadelphia: C. and A. Conrad, 1808.

Catlin, George. *Letters and Notes on the Manners, Customs, and Condition of the North American Indians*. Vol. 1. London: 1841.

"Cauleen Smith: We Already Have What We Need." MASS MoCA, website. Accessed December 24, 2022. https://massmoca.org/event/cauleen-smith/.

Champney's Great Original Picture of the River Rhine. Handbill. Bee Press, ca. 1849.

Chaney, Michael. *Fugitive Vision: Slave Image and Black Identity in Antebellum Narrative*. Bloomington: Indiana University Press, 2008.

Charleston Library Society, "Mission and History." Accessed December 16, 2022. https://charlestonlibrarysociety.org/our-history/.

Charnas, Dan. *Dilla Time: The Life and Afterlife of J Dilla, the Hip-Hop Producer Who Reinvented Rhythm*. New York: MCD Picador, 2022.

Chastellux, François-Jean de. *Voyages de M. le Marquis de Chastellux dans l'Amérique septentrionale, dans les années 1780, 1781 & 1782*. Vol. 1. Paris: Prault, 1788.

Chatterjee, Sria, ed. "Conversation Piece: The Arts, Environmental Justice, and the Ecological Crisis." *British Art Studies* 18 (November 30, 2020). https://britishartstudies.ac.uk/issues/issue-index/issue-18/arts-environmental-justice-ecological-crisis.

Cheetham, Mark. *Landscape into Eco Art: Articulations of Nature since the '60s*. University Park, PA: Pennsylvania State University Press, 2018.

Cheu, Johnson, ed. *Diversity in Disney Films: Critical Essays on Race, Ethnicity, Gender, Sexuality, and Disability*. Jefferson, NC: McFarland, 2013.

Chicago Housing Authority, *Chicago Can Build*, report. Chicago: Chicago Housing Authority, 1950.

Chicago Monuments Project, *Final Report*, August 2022. https://www.chicago.gov/content/dam/city/depts/dca/cmp/cmpreport.pdf.

Chicago Park District. *Burnham Wildlife Corridor Gathering Places*. June 6, 2017.

https://www.slideshare.net/AasiaMohammadCastaed/gathering-spaces-along-chicagos-south-lakefront.

Chicago Plan Commission, *A Plan to Guide Redevelopment of the South Central Area of Chicago*. Chicago: Chicago Plan Commission, 1950.

Clarke, Christa. *African Art in the Barnes Foundation: The Triumph of L'Art nègre and the Harlem Renaissance*. New York: Skira Rizzoli, 2015.

Clifton, Derrick. "How Protests in Ferguson Inspired the Occupation of Freedom Square." *Chicago Reader*, August 9, 2016. https://chicagoreader.com/columns-opinion/how-protests-in-ferguson-inspired-the-occupation-of-freedom-square/.

Clinton, Catherine, ed. *Confederate Statues and Memorialization*. Athens, GA: University of Georgia Press, 2019.

Collins, Lisa Gail, and Margo Natalie Crawford, eds. *New Thoughts on the Black Arts Movement*. New Brunswick, NJ: Rutgers University Press, 2006.

"Communication." *Poulson's American Daily Advertiser* 49, no. 3 (August 2, 1820).

Communications for Change (organization). "Social and Political Intervention Scrapbook." Media Burn Archive. Accessed December 24, 2022. http://mediaburn.org/video/social-and-political-intervention-scrapbook/.

Contreras, Ayana. *Energy Never Dies: Afro-Optimism and Creativity in Chicago*. Urbana: University of Illinois Press, 2021.

Cooke, Sekou, and Nadia M. Anderson. "Jefferson, Hip-Hop, and the Oppressive Grid." *106th ACSA Annual Meeting Proceedings, The Ethical Imperative*. Accessed December 24, 2022. https://www.acsa-arch.org/chapter/jefferson-hip-hop-and-the-oppressive-grid/.

Cooper, James Fenimore. *The Last of the Mohicans: A Narrative of 1757*. New York: Macmillan, 1921 [1826].

Copeland, Huey. "One-Dimensional Abstraction." *Art Journal* 78, no. 2 (2019): 116–18.

"CORE To Hold Open House in Slum Bldg." *Chicago Defender*, April 11, 1964.

Cotter, Holland. "We Don't Have to Like Them. We Just Need to Understand Them." *The New York Times*, June 24, 2020. https://www.nytimes.com/2020/06/24/arts/design/theodore-roosevelt-statue.html.

Crawford, Margo Natalie. "Black Light on the Wall of Respect." In *New Thoughts on the Black Arts Movement*, edited by Lisa Gail Collins and Margo Natalie Crawford, 23–42. New Brunswick, NJ: Rutgers University Press, 2006.

Crawford, Romi. "Black Photographers Who Take Black Pictures." In *The Wall of Respect: Public Art and Black Liberation in 1960s Chicago*, edited by Abdul Alkalimat, Romi Crawford, and Rebecca Zorach, 193–211. Evanston: Northwestern University Press, 2017.

Cronon, William. *Nature's Metropolis: Chicago and the Great West*. New York: W. W. Norton, 1991.

Culbert, Michael L. "Films of 'Hip Black Dudes': Good or Bad Image?" *Chicago Daily Defender*, September 30, 1972, 6.

———. "W. Sider Hit-Run Victim: En Route FORUM Parley." *Chicago Daily Defender*, October 19, 1972, 35.

Cummings, Jozen. "Five Things We Learned About Jay-Z's New Book at the New York Public Library." *The Wall Street Journal*, November 16, 2010. https://www.wsj.com/articles/BL-SEB-53972.

Curley, Andrew. "Beyond Environmentalism: #NoDAPL as Assertion of Tribal Sovereignty." In *Standing with Standing Rock: Voices from the #NoDAPL Movement*, edited by Nick Estes and Jaskiran Dillion, 158–68. Minneapolis: University of Minnesota Press, 2019.

Davey, Monica. "Cleveland Gazebo Where Tamir Rice Was Shot Will be Moved to Chicago." *New York Times*, September 16, 2016. https://www.nytimes.com/2016/09/16/us/tamir-rice-cleveland-chicago.html.

Davis, Amy M., ed. *Discussing Disney*. Bloomington: Indiana University Press, 2019.

Davis, Angela. *Blues Legacies and Black Feminism*. New York: Vintage Books, 2011.

Davis, Ben. "The New White Nationalism's Sloppy Use of Art History, Decoded." *Artnet News*, March 7, 2017. https://news.artnet.com/art-world/identity-evropa-posters-art-symbolism-881747.

Dean, Carolyn. "The Trouble with (the Term) Art." *Art Journal* 65, no. 2 (Summer 2006): 24–32.

Dees, Janet, ed. *A Site of Struggle: American Art Against Anti-Black Violence*. Princeton, NJ: Princeton University Press, 2022.

Demos, T. J. *Against the Anthropocene: Visual Culture and Environment Today*. London: Sternberg Press, 2017.

Descendants, directed by Kenny Ortega. Disney Channel Original Productions, 2015.

Description of Banvard's Panorama of the Mississippi River, Painted on Three Miles of Canvas. . . . Boston: John Putnam, 1847.

"Detroit Artists Paint Town Orange to Force Change," NPR, December 7, 2006, https://www.npr.org/2006/12/07/6592634/detroit-artists-paint-town-orange-to-force-change.

Deutsche, Rosalyn. *Evictions: Art and Spatial Politics*. Cambridge, MA: MIT Press, 1996.

———. "Krzysztof Wodiczko's Homeless Projection and the Site of Urban 'Revitalization.'" In *Evictions: Art and Spatial Politics*, 3–48. Cambridge, MA: MIT Press, 1998.

Dixon, Melvin. *Ride Out the Wilderness: Geography and Identity in Afro-American Culture*. Urbana: University of Illinois Press, 1987.

Doss, Erika. *Memorial Mania: Public Feeling in America*. Chicago: University of Chicago Press, 2010.

Downing, Andrew Jackson. *Treatise on the Theory and Practice of Landscape Gardening*. New York and London: Wiley and Putnam, 1841.

Du Bois, W. E. B. *Souls of Black Folk*. Chicago: A. C. McClurg, 1903.

Dunaway, Finis. *Seeing Green: The Use and Abuse of American Environmental Images*. Chicago: University of Chicago Press, 2015.

Duncan, Carol. "The MoMA's Hot Mamas." In "Images of Rule: Issues of Interpretation," special issue, *Art Journal* 48, no. 2, (Summer 1989): 171–78.

Duncan, Carol, and Alan Wallach. "The Universal Survey Museum." *Art History* 3, no. 4 (December 1980): 448–69.

Dundes, Lauren, ed. *The Psychosocial Implications of Disney Movies*. Basel: MDPI, 2019.

De Duve, Thierry. *Clement Greenberg between the Lines*, translated by Brian Holmes. Chicago: University of Chicago Press, 2010.

Dyja, Thomas. *The Third Coast: When Chicago Built the American Dream*. New York: Penguin, 2013.

Dyson, Torkwase. "Black Interiority: Notes on Architecture, Infrastructure, Environmental Justice, and Abstract Drawing." *Pelican Bomb*, January 9, 2017. http://pelicanbomb.com/art-review/2017/black-interiority-notes-on-architecture-infrastructure-environmental-justice-and-abstract-drawing.

Eckeberg, Charles Gustavus. *A Short Account of the Chinese Husbandry,* published with Peter Osbeck, *A Voyage to China and the East Indies*. London: Benjamin White, 1771.

Einstein, Carl. "Negro Sculpture." Translated by Charles W. Haxthausen and Sebastian Zeidler. *October* 107 (Winter 2004): 122–38.

"Ellen Gallagher: Are We Obsidian?" Art Institute of Chicago. Accessed December 24, 2022. https://www.artic.edu/exhibitions/9078/ellen-gallagher-are-we-obsidian.

Elman, Julie Passanante. "Slothful Movements: Disability, Acceleration, and Capacity Feminism in Disney's Zootopia (2016)." *Feminist Media Studies* (2020): 1–18.

Elsner, Ian, Luther Gray, and Freddi Williams Evans. "Freddi Williams Evans and Luther Gray are Erecting Historic Markers on the Slave Trade in New Orleans." Episode 42 of *Museum Archipelago*. Podcast. MP3 audio. Accessed December 23, 2022. https://www.museumarchipelago.com/42.

Emani, Gazelle. "Jay-Z, Kanye West's 'No Church in the Wild' Gets a High 5 Collective Video." *HuffPost*, September 6, 2011. https://www.huffpost.com/entry/jay-z-kanye-west-no-church-in-the-wild_n_950494.

English, Darby. *1971: A Year in the Life of Color*. Chicago: University of Chicago Press, 2016.

———. *How to See a Work of Art in Total Darkness*. Cambridge, MA: MIT Press, 2007.

Enright, Robert. "The Poetics of History: An Interview with Rebecca Belmore." *Border Crossings* 95 (August 2005). https://bordercrossingsmag.com/article /the-poetics-of-history-an-interview-with-rebecca-belmore.

Estes, Nick. "Fighting for Our Lives: #NoDAPL in Historical Context." *Indian Country Today*, October 16, 2016, updated September 13, 2018. https:// indiancountrytoday.com/archive/fighting-for-our-lives-nodapl-in-historical -context-YX3pCqnxq0ydUYA-njiwDw.

Evans, Maxwell. "Activists Build Tent City to Show What Could Happen without Affordable Housing Around Obama Library." *Block Club Chicago*, June 12, 2020. https://blockclubchicago.org/2020/06/12/activists-build-tent-city-to -show-what-could-happen-without-affordable-housing-around-obama -library/.

Ewing, Eve. "I'm a Black Scholar Who Studies Race. Here's Why I Capitalize 'White,'" *ZORA*, July 2, 2020. https://zora.medium.com/im-a-black-scholar -who-studies-race-here-s-why-i-capitalize-white-f94883aa2dd3.

Executive Office of the President. "Promoting Beautiful Federal Civic Architecture." Executive Order 13967. December 23, 2020. https://www .federalregister.gov/documents/2020/12/23/2020-28605/promoting-beautiful -federal-civic-architecture.

Faegre, Tor. "Mad Housers." *AREA Chicago* 10 (2010), archived February 27, 2019. https://areachicagoarchive.wordpress.com/2019/02/27/mad-housers/.

Fernandez-Sacco, Ellen. "Framing 'The Indian': The Visual Culture of Conquest in the Museums of Pierre Eugene Du Simitiere and Charles Willson Peale, 1779–96." *Social Identities* 8, no. 4 (2002): 571–618.

———. "Racial Theory, Museum Practice: The Colored World of Charles Willson Peale." *Museum Anthropology* 20, no. 2 (September 1996): 25–32.

Fessenden, Thomas Green. *The Register of the Arts, or a Compendious View of Some of the Most Useful Modern Discoveries and Inventions*. Philadelphia: C. and A. Conrad, 1808.

Finkelpearl, Tom. *Dialogues in Public Art*. Cambridge, MA: MIT Press, 2000.

Finney, Carolyn. *Black Faces, White Spaces: Reimagining the Relationship of African Americans to the Great Outdoors*. Chapel Hill: University of North Carolina Press, 2014.

Fleetwood, Nicole R. *Marking Time: Art in the Age of Mass Incarceration*. Cambridge, MA: Harvard University Press, 2020.

Foreman, P. Gabrielle et al. "Writing about Slavery/Teaching About Slavery: This Might Help." Community-sourced document. Accessed December 24, 2022. https://docs.google.com/document/d/1A4TEdDgYslX -hlKezLodMIM71My3KTN0zxRvoIQTOQs/.

Friedman, Milton. *The Economics of Freedom*. Cleveland: Standard Oil Company of Ohio, 1978.

Fryd, Vivien Green. "Kara Walker's *About the title*: The Ghostly Presence of Transgenerational Trauma as a 'Connective Tissue' Between the Past and Present." *Panorama: Journal of the Association of Historians of American Art 2*, no. 1 (Summer 2016). https://editions.lib.umn.edu/panorama/article/kara -walkers-about-the-title-the-ghostly-presence-of-transgenerational-trauma -as-a-connective-tissue-between-the-past-and-present/.

Gaiter, Colette. "Bree Newsome's Confederate Flag Pole Climb Was an Artistic Statement." *Time*, July 3, 2015. https://time.com/3944951/bree-newsome -confederate-flag/.

Gaspar, Maria. *Unblinking Eyes, Watching*. 2019. Digital composite photograph printed to scale on vinyl adhesive, 40 × 26 in. Personal website. Accessed December 24, 2022. https://mariagaspar.com/unblinking-eyes-watching.

Geib, George. "The Land Ordinance of 1785: A Bicentennial Review." *Indiana Magazine of History* 81, no. 1 (March 1985): 1–13.

"General Dynamics Conducts Successful Border Security Technology Pilot in Texas." General Dynamics, Website, January 31, 2018. https://www.gd.com /Articles/2018/01/31/general-dynamics-conducts-successful-border-security -technology-pilot-texas.

Gikandi, Simon. "Aesthetic Reflection and the Colonial Event: The Work of Art in the Age of Slavery." *The Journal of the International Institute* 4, no. 3 (Summer 1997). http://hdl.handle.net/2027/spo.4750978.0004.306.

———. *Slavery and the Culture of Taste*. Princeton, NJ: Princeton University Press, 2011.

Gillman, Derek. *The Idea of Cultural Heritage*. Cambridge: Cambridge University Press, 2006.

Gilmore, Ruth Wilson. *Abolition Geography: Essays towards Liberation*. London: Verso Books, 2022.

———. *Golden Gulag: Prisons, Surplus, Crisis, and Opposition in Globalizing California*. Berkeley: University of California Press, 2007.

Glave, Dianne D., and Mark Stoll. *To Love the Wind and Rain: African Americans and Environmental History*. Pittsburgh: University of Pittsburgh Press, 2011.

Godfrey, Mark. "Barnett Newman's Stations and the Memory of the Holocaust." *October* 108 (Spring 2004): 35–50.

Greenberg, Clement. "'Americanism' Misplaced: Review of *Preface to an American Philosophy of Art* by A. Philip McMahon" [1946]. In *The Collected Essays and Criticism*. Vol. 2, *Arrogant Purpose, 1945–1949*, edited by John O'Brian, 66. Chicago: University of Chicago Press, 1986.

———. "Art." *The Nation*, November 1, 1947.

Griswold, A. Whitney. "The Agrarian Democracy of Thomas Jefferson." *The American Political Science Review* 40, no. 4 (August 1946): 657–81.

Guest, Rachael. "Slavery, Racism, and Charles Willson Peale." *Polychromes* (blog),

May 5, 2019, https://polychromes.blogspot.com/2019/05/slavery-racism-and
-charles-willson-peale.html.

Gunn, Dan. "No Justice, No Peace: Open Engagement 2017." *Chicago Artist Writers*, May 1, 2017. https://chicagoartistwriters.com/no-justice-no-peace-open
-engagement-2017-12/.

Hanners, John. "'The Great Three-Mile Painting': John Banvard's Mississippi
Panorama." *The Journal of American Culture* (1981): 28–42.

Hansberry, Lorraine. "To the Editor." *New York Times*, April 23, 1964. Reprinted in
To Be Young, Gifted, and Black, 51–52. New York: Signet Classics, 2011 [1969].

Hare, John. "Religion and Morality." *Stanford Encyclopedia of Philosophy*, September 27, 2006, revised August 8, 2019. https://plato.stanford.edu/entries
/religion-morality/.

Hare, Nathan. "Black Ecology." *The Black Scholar* 1, no. 6 (April 1970): 2–8.

Harper, Philip Brian. *Abstractionist Aesthetics: Artistic Form and Social Critique in
African American Culture*. New York: New York University Press, 2015.

Havre, Jérôme, Cauleen Smith, and Camille Turner, dir. *Triangle Trade*. 2017. HD
video.

Heilbron, Bertha L. "Making a Motion Picture in 1848: Henry Lewis on the
Upper Mississippi." *Minnesota History: A Quarterly Magazine* 17, no. 2 (June
1936): 131–58.

Helgren, Jennifer. *The Camp Fire Girls: Gender, Race, and American Girlhood, 1910–
1980*. Lincoln: University of Nebraska Press, 2022.

Heuer, Christopher, and Rebecca Zorach, eds. *Ecologies, Agents, Terrains*, Clark
Studies in the Visual Arts. New Haven, CT: Yale University Press, 2018.

Hewitt, Leslie. "Cauleen Smith." *Bomb Magazine* 115 (Summer 2011). https://
bombmagazine.org/articles/cauleen-smith/.

Higgins, Hannah. *The Grid Book*. Cambridge, MA: MIT, 2009.

High5Collective (Jordan Riggs, dir.). *No Church in the Wild*. September 2011.
https://vimeo.com/75975836.

Hogan, Erin. *Spiral Jetta*. Chicago: University of Chicago Press, 2008.

Holien, Ried. "John Banvard's Brush with Success." *South Dakota Magazine*, September/October 1997. Revised version accessed December 24, 2022. https://
www.southdakotamagazine.com/john-banvard-brush-with-success.

Horton, Jessica. *Art for an Undivided Earth: The American Indian Movement Generation*. Durham, NC: Duke University Press, 2017.

———. "Drones and Snakes," *Art in America*, October 3, 2017. https://www.artnews
.com/art-in-america/features/drones-and-snakes-63299/.

———. "Indigenous Artists against the Anthropocene." *Art Journal* 76, no. 2 (2017):
48–69.

"House of Gold." Website. Accessed December 24, 2022. http://www.house-of
-gold.com.

Huling, Tracy. "Building a Prison Economy in Rural America." In *Invisible Punishment: The Collateral Consequences of Mass Imprisonment*, edited by Marc Mauer and Meda Chesney-Lind, 197–213. New York: The New Press, 2002.

Hurley, Amanda Kolson. "Trump's Bizarre Plan to Make Architecture Classical Again." *The Atlantic*. February 8, 2020. https://www.theatlantic.com/ideas /archive/2020/02/trumps-plan-make-architecture-classical-again/606286/.

Irish, Sharon. *Suzanne Lacy: Spaces Between*. Minneapolis: University of Minnesota Press, 2010.

Jackson, Zakkiyah Iman. *Becoming Human: Matter and Meaning in an Antiblack World*. New York: New York University Press, 2020.

Jacob, Mary Jane. *Culture in Action: A Public Art Program of Sculpture in Chicago*. Seattle: Bay Press, 1995.

Jefferson, Thomas. "Instructions to Meriwether Lewis, before June 20, 1803." In *Papers of Thomas Jefferson*, vol. 40, edited by Barbara B. Oberg. Princeton, NJ: Princeton University Press, 2013.

———. "Letter to Benjamin Rush, September 23, 1800." In *Papers of Thomas Jefferson*, vol. 32, edited by Barbara B. Oberg. Princeton, NJ: Princeton University Press, 2005.

———. "Letter to Charles Willson Peale, August 20, 1811." *Papers of Thomas Jefferson, Retirement Series*, vol. 4, edited by J. Jefferson Looney. Princeton, NJ: Princeton University Press, 2008.

———. "Letter to Gysbert K. van Hogendorp, October 13, 1785." In *Papers of Thomas Jefferson*, vol. 8, edited by Julian P. Boyd. Princeton, NJ: Princeton University Press, 1953.

———. *Notes on the State of Virginia*, query 19. Paris, 1785.

Jensen, Oliver. "The Peales." *American Heritage*, April 1955.

Johnston, Patricia. "Global Knowledge in the Early Republic: The East India Marine Society's Curiosities Museum." In *East-West Interchanges in American Art: A Long and Tumultuous Relationship*, edited by Cynthia Mills, Lee Glazer, and Amelia A. Goerlitz, 68–79. Washington, DC: Smithsonian, 2012.

Johnston, Matthew N. *Narrating the Landscape: Print Culture and American Expansion in the Nineteenth Century*. Norman: University of Oklahoma Press, 2016.

Jones, Caroline. *Eyesight Alone: Clement Greenberg's Modernism and the Bureaucratization of the Senses*. Chicago: University of Chicago Press, 2008.

Jones, Kellie, *EyeMinded: Living and Writing Contemporary Art*. Durham, NC: Duke University Press, 2011.

Kaba, Mariame, and Kelly Hayes. "A Jailbreak of the Imagination: Seeing Prisons for What They Are and Demanding Transformation." *Truthout*, May 3, 2018. https://truthout.org/articles/a-jailbreak-of-the-imagination-seeing -prisons-for-what-they-are-and-demanding-transformation/.

Kant, Immanuel. *Critique of Judgment*, translated by J. H. Bernard. New York: Free Press, 2008.

Keller, Corey, and Elizabeth Sherman, eds. *Dawoud Bey: Two American Projects*. San Francisco: SFMOMA; and New Haven, CT: Yale University Press, 2020.

Kelley Jr., Bill. "Reimagining Ceremonies: A Conversation with Postcommodity." *Afterall* 39 (Summer 2015): 27–35.

Kennedy, Randy. "Two Groups Scuffle amid Art inside a Minneapolis Museum." *New York Times*, February 27, 2017. https://www.nytimes.com/2017/02/27/arts/design/anti-trump-protest-minneapolis-institute-of-art.html.

Kester, Grant. *Conversation Pieces: Community and Communication in Modern Art*. Berkeley: University of California Press, 2004.

Kifner, John. "Chicago Panther Mourned: Raid Scene Visited." *New York Times*, December 10, 1969, 37.

Kimmelman, Michael. "Of Candy Bars and Public Art." *New York Times*, September 26, 1993.

Kincaid, Jamaica. "Sowers and Reapers." *New Yorker*, January 22, 2001, 41–45.

King, Tiffany Lethabo. *The Black Shoals: Offshore Formations of Black and Native Studies*. Durham, NC: Duke University Press, 2019.

Krauss, Rosalind E. "Grids." *October* 9 (Summer 1979): 50–64. Reprinted in *The Originality of the Avant-Garde and Other Modernist Myths*, 9–22. Cambridge, MA: MIT Press, 1986.

———. "Sculpture in the Expanded Field," *October* 8 (Spring 1979), 30–44. Reprinted in *The Originality of the Avant-Garde and Other Modernist Myths*, 277–90. Cambridge, MA: MIT Press, 1986.

Kusserow, Karl, ed. *Picture Ecology: Art and Ecocriticism in Planetary Perspective*. Princeton, NJ: Princeton University Press, 2021.

Kwon, Miwon. *One Place After Another: Site-Specific Art and Locational Identity*. Cambridge, MA: MIT Press, 2002.

Lacy, Suzanne. *Mapping the Terrain: New Genre Public Art*. Seattle: Bay Press, 1995.

Lampert, Nicolas. *A People's Art History of the United States: 250 Years of Activist Art and Artists Working in Social Movements*. New York: New Press, 2013.

Lazard, Carolyn. "Destroying Narratives: Cauleen Smith and Carolyn Lazard in Conversation." *Mousse Magazine* 55, September 16, 2016.

Leja, Michael. "Barnett Newman's Solo Tango." *Critical Inquiry* 21, no. 3 (Spring 1995): 556–80.

Lewis, H. J. "Books." *The Universalist and Ladies Repository* 17, 350–51. Boston: A. Tompkins, 1849.

Lewis, Sarah. "Groundwork: Race and Aesthetics in the Era of Stand Your Ground Law." *Art Journal* 79, no. 4 (Winter 2020): 92–113.

Lieberman, Jeanne. "Conversation Pieces." *South Side Weekly*, October 30, 2013. https://southsideweekly.com/conversation-pieces/.

Lippard, Lucy. *The Lure of the Local: Senses of Place in a Multicentered Society.* New York: New Press, 1997.

Lloyd, James T. *Lloyd's Steamboat Directory, and Disasters on the Western Waters.* Cincinnati: James T. Lloyd, 1856.

Lowney, John. "'A Material Collapse That Is Construction': History and Counter-Memory in Gwendolyn Brooks's *In the Mecca.*" *MELUS* 23, no. 3 (1998): 3–20.

Lynes, Katherine R. "'a responsibility to something besides people': African American Reclamation Ecopoetics." *African American Review* 48, no. 1/2 (Spring/Summer 2015): 49–66.

Lyons, Lisa. "Panorama of the Monumental Grandeur of the Mississippi Valley." *Design Quarterly* 101/102 (1976): 32–34.

Malevich, Kazimir. "Suprematism," in Robert L. Herbert, ed., *Modern Artists on Art*, 92–102. Englewood Cliffs: Prentice-Hall, 1964.

Manring, M. M. *Slave in a Box: The Strange Career of Aunt Jemima.* Charlottesville: University of Virginia Press, 1998.

Margolick, David. *Strange Fruit: The Biography of a Song.* New York: Ecco Press, 2001.

Markus, Thomas A. "Is There a Built Form for Non-Patriarchal Utopias?" In *Embodied Utopias: Gender, Social Change, and the Modern Metropolis*, ed. Amy Bingaman, Lise Sanders, and Rebecca Zorach, 15–32. London: Routledge, 2002.

Marsden, William. *A History of Sumatra*, 2nd ed. London, 1784.

Marter, Joan. "The Ascendancy of Abstraction for Public Art: The Monument to the Unknown Political Prisoner Competition." In "Sculpture in Postwar Europe and America, 1945–59." Special issue, *Art Journal* 53, no. 4 (Winter 1994): 28–36.

Martin, John Bartlow. "The Hickman Story." *Harper's*, August 1948.

——. "The Strangest Place in Chicago." *Harper's*, December 1950.

Mayor, Adrienne. "Place Names Describing Fossils in Oral Traditions." *Geological Society London Special Publications* 273, no. 1 (January 2007): 245–61.

McCarthy, Tom, "Tamir Rice: Video Shows Boy, 12, Shot 'Seconds' after Police Confronted Child," *The Guardian*, November 26, 2014. https://www.theguardian.com/us-news/2014/nov/26/tamir-rice-video-shows-boy-shot-police-cleveland.

McGee, Sarah. "How Worcester's Croome Court Is Linked to Slavery and Colonialism." *Worcester News*, May 13, 2021. https://www.worcesternews.co.uk/news/19298100.worcesters-croome-court-linked-slavery-colonialism/.

McGraw, Daniel. "How Should Tamir Rice Be Remembered?" *Andscape*, August 23, 2016. https://andscape.com/features/how-should-tamir-rice-be-remembered/.

McGraw, Hesse. "Theaster Gates: Radical Reform with Everyday Tools." *Afterall: A Journal of Art, Context and Enquiry* 30 (Summer 2012): 86–99.

McInnis, Maurie D. *The Politics of Taste in Antebellum Charleston*. Chapel Hill: University of North Carolina Press, 2015.

———. *In Pursuit of Refinement: Charlestonians Abroad, 1740–1860*. Charleston: University of South Carolina Press, 1999.

McKittrick, Katherine. *Demonic Grounds Black Women and the Cartographies of Struggle*. Minneapolis: University of Minnesota Press, 2006.

———. "Mathematics Black Life." In "States of Black Studies." Special issue, *The Black Scholar* 44, no. 2, (Summer 2014): 16–28.

———. "On Plantations, Prisons, and a Black Sense of Place." *Social & Cultural Geography* 12 no. 8 (2011): 947–63.

Menard, Andrew. "Nationalism and the Nature of Thoreau's 'Walking.'" *The New England Quarterly* 85, no. 4 (December 2012): 591–621.

Merryman, John Henry. "The Marquis de Somerueles: Vice-Admiralty Court of Halifax, Nova Scotia Stewart's Vice-Admiralty Reports 482 (1813)." *International Journal of Cultural Property* 5, no. 2 (1996): 319–29.

Michelson, Alan. "Third Bank of the River." Personal website. Accessed December 24, 2022. https://www.alanmichelson.com/third-bank-of-the -river/.

Michney, Todd M. "White Civic Visions Versus Black Suburban Aspirations: Cleveland's Garden Valley Urban Renewal Project." *Journal of Planning History* 10, no. 4 (2011): 282–309.

Miles, Malcolm. *Art, Space and the City: Public Art and Urban Futures*. London: Routledge, 1997.

Milkofsky, Brenda. "Connecticut and the West Indies: Sugar Spurs Trans-Atlantic Trade." ConnecticutHistory.org, January 27, 2021. https:// connecticuthistory.org/connecticut-and-the-west-indies-trade/.

Miller, Angela. *Empire of the Eye: Landscape Representation and American Cultural Politics, 1825-1875*. Ithaca: Cornell University Press, 1993.

Milln, Jeremy. "Chinese Bridge, Croome Park, Worcestershire: Archaeological Report." National Trust Report SNA66183. May, 2014. Accessed December 24, 2022. https://www.academia.edu/7092994/Chinese_Bridge_at _Croome.

Miner, Dylan. *Agamiing—Niwaabaandaan miinawaa Nimiwkendaan // At the Lake—I see and I remember*. In *The Work of Wind: Air, Land, Sea* (Blackwood Gallery brochure), 2018. Accessed December 24, 2022. https://workofwind.ca /project/agamiing-niwaabaandaan-miinawaa-nimiwkendaan-at-the-lake-i -see-and-i-remember/.

———. "Gaagegoo Dabakaanan miiniwaa Debenjigejig (No Borders, Indigenous Sovereignty)." In *We Are Aztlán! Chicanx Histories in the Northern Borderlands*,

edited by Jerry García, 57–71. Seattle: Washington State University Press, 2017.

Mitchell, Don. *The Right to the City: Social Justice and the Fight for Public Space*. New York: Guilford Press, 2003.

Mitchell, W. J. T. "Imperial Landscape." In *Landscape and Power*, ed. Mitchell. Chicago: University of Chicago Press, 1994.

Mirzoeff, Nicholas. *The Appearance of Black Lives Matter*. Miami: [NAME] Publications, 2017.

Monroe, John Warne. *Metropolitan Fetish: African Sculpture and the Imperial French Invention of Primitive Art*. Ithaca: Cornell University Press, 2019.

Morgan, Kenneth. "Slave Sales in Colonial Charleston." *The English Historical Review* 113, no. 453 (September 1998): 905–27.

Morris, Amy. "Geomythology on the Colonial Frontier: Edward Taylor, Cotton Mather, and the Claverack Giant." *The William and Mary Quarterly* 70, no. 4 (October 2013): 701–24.

Morris, Kate. "Running the 'Medicine Line': Images of the Border in Contemporary Native American Art." *American Indian Quarterly* 35, no. 4 (Fall 2011): 152–56.

———. *Shifting Grounds: Landscape in Contemporary Native American Art*. Seattle: University of Washington Press, 2019.

Museum of Contemporary Art Chicago. "Gallery Text Downloads." Accessed November 26, 2022. https://media.mcachicago.org/pdf/IQL4JHQH /labels.pdf.

Musial, Jennifer. "Engaged Pedagogy in the Feminist Classroom and Yoga Studio." *Feminist Teacher* 21, no. 3 (2011): 212–28.

Nadasdy, Paul. "Transcending the Debate over the Ecologically Noble Indian: Indigenous Peoples and Environmentalism." *Ethnohistory* 52, no. 2 (Spring 2005): 291–331.

"The Nation: Arson for Hate and Profit." *Time*, October 31, 1977.

Nelson, Charmaine A. *Slavery, Geography and Empire in Nineteenth-Century Marine Landscapes of Montreal and Jamaica*. London: Routledge, 2017.

———. "White Marble, Black Bodies and the Fear of the Invisible Negro: Signifying Blackness in Mid-Nineteenth-Century Neoclassical Sculpture." *RACAR: Revue d'art canadienne / Canadian Art Review* 27, no. 1/2 (2000): 87–101.

Nelson, Robert K., LaDale Winling, Richard Marciano, Nathan Connolly, et al. "Mapping Inequality." *American Panorama*, edited by Robert K. Nelson and Edward L. Ayers. Accessed November 21, 2022. https://dsl.richmond.edu /panorama/redlining/#loc=11/41.49/-81.858&city=cleveland-oh&area=C20.

Nelson, Robert S. "The Slide Lecture, or the Work of Art 'History' in the Age of Mechanical Reproduction." *Critical Inquiry* 26 no. 3 (Spring 2000): 414–34.

Nelson, Steven. "Dawoud Bey's Historical Turn." In *Dawoud Bey: Two American*

Projects, edited by Corey Keller and Elizabeth Sherman, 15–20. San Francisco: SFMOMA; New Haven, CT: Yale University Press, 2020.

New Orleans Museum of Art. *Black Compositional Thought | 15 Paintings for the Plantationocene*. Accessed December 16, 2022. https://noma.org/exhibitions /torkwase-dyson-black-compositional-thought-15-paintings-from-the -plantationocene/#about.

Nilsen, Sarah. "Living in Zootopia: Tracking the Neoliberal Subject in a Colorblind World." In *The Myth of Colorblindness: Race and Ethnicity in American Cinema*, edited by Sarah E. Turner and Sarah Nilsen, 61–88. London: Palgrave Macmillan, 2019.

Nisbet, James. *Ecologies, Environments, and Energy Systems in Art of the 1960s and 1970s*. Cambridge, MA: MIT Press, 2014.

———. *Second Site*. Princeton, NJ: Princeton University Press, 2021.

"No Church in the Wild." Lyrics. LyricFind. Accessed November 27, 2022.

Odell, Dawn. "Ekphrasis and the Global Eighteenth Century: A. E. van Braam Houckgeest's Collection of Chinese Art." In *Ekphrastic Image-Making in Early Modern Europe, 1500–1700*, edited by Arthur J. Di Furia and Walter Melion, 808–35. Leiden: Brill, 2022.

"Ogimaa Mikana: Reclaiming/Renaming." Website. Accessed December 24, 2022. https://ogimaamikana.tumblr.com.

Onaci, Edward. *Free the Land: The Republic of New Afrika and the Pursuit of a Black Nation-State*. Chapel Hill: University of North Carolina Press, 2020.

Opie, John. "Renaissance Origins of the Environmental Crisis." *Environmental Review: ER* 11, no. 1 (Spring 1987): 2–17.

Padilla Peralta, Dan-el. "From Damocles to Socrates: The Classics in/of Hip-Hop." *Eidolon*, June 8, 2015. https://eidolon.pub/from-damocles-to-socrates-fbda6e685c26.

Parker, Franklin. "George Peabody and the Peabody Museum of Salem." *Curator: The Museum Journal* 10 (1967): 137–53.

Peale, Charles Willson. "Mammoth." *The Philadelphia Gazette and Daily Advertiser*, December 24, 1801.

———. "To the Citizens of the United States of America." *The Pennsylvania Packet*, February 19, 1790.

Peale, Rembrandt. *An Account of the Skeleton of the Mammoth*. London: E. Lawrence, 1802.

Piggush, Yvette R. "Visualizing Early American Art Audiences: The Pennsylvania Academy of the Fine Arts and Allston's 'Dead Man Restored.'" *Early American Studies* 9, no. 3 (Fall 2011): 716–47.

Pointon, Marcia. "Slavery and the Possibilities of Portraiture." In *Slave Portraiture in the Atlantic World*, edited by Agnes Lugo-Ortiz and Angela Rosenthal, 41–70. Cambridge: Cambridge University Press, 2013.

Potts, William John. "Du Simitiere, Artist, Antiquary, and Naturalist, Projector of the First American Museum, with Some Extracts from His Note-Book." *The Pennsylvania Magazine of History and Biography* 13, no. 3 (October 1889): 341–75.

Poulson's American Daily Advertiser 38, no. 2, August 23, 1809.

Poulson's American Daily Advertiser 39, no. 2, March 1, 1810.

Puleo, Risa, ed. *Walls Turned Sideways: Artists Confront the Justice System.* Houston: [NAME] Publications, 2018.

Purtle, Jenny. "The *Liberty Bowl*: China, Silver, Tea, and Revolution in Britain's American Colonies circa 1775." Paper given at the Association for Asian Studies, Boston, March 2007.

Raiford, Leigh. "Burning All Illusion: Abstraction, Black Life, and the Unmaking of White Supremacy." *Art Journal* 79, no. 4 (Winter 2020): 76–91. Republished in *Art Journal Open*, January 14, 2021. http://artjournal.collegeart.org/?p=15113 #fnref-15113-20.

Rapuano, Michael, P. P. Pirone, and Brooks E. Wigginton. *Open Space in Urban Design.* Cleveland: Cleveland Development Foundation, 1964.

Raven, Lavie, and Rebecca Zorach. "Our Kids Didn't Invent Guns: Lavie Raven Interviewed by Rebecca Zorach." In *Art Against the Law*, edited by Rebecca Zorach, 119–26. Chicago: School of the Art Institute of Chicago, 2014.

A Redevelopment Proposal for the Central South Side: Chicago. Chicago: Chicago South Side Planning Board, 1950.

Reed, Georgina. "Rest, Repose and Race: Leslie Bennett and Black Sanctuary Gardens." The Plant Hunter, June 25, 2020. https://theplanthunter.com.au /gardens/rest-repose-and-race-leslie-bennett-black-sanctuary-gardens/.

Reparations at UChicago Working Group (RAUC), Caine Jordan, Guy Emerson Mount, and Kai Parker. "A Case for Reparations at the University of Chicago," white paper, 2017. Accessed December 24, 2022. https://app.box.com/s /bd9w85wamopzwt0wngapkf66vojn9bwy.

Richardson, E. P. "Allen Smith, Collector and Benefactor." *The American Art Journal* 1, no. 2 (Autumn 1969): 5–19.

Rigaud, Antonia. "Disorienting Geographies: Land Art and the American Myth of Discovery." *Miranda* [Online] 6 (2012). Accessed December 1, 2022. https:// journals.openedition.org/miranda/2955.

Riout, Denys. "Le peintre néo-impressionniste: Une adaptation anticipatrice." *1895* 3, no. 53 (2007).

Roberts, Jennifer. *Transporting Visions: The Movement of Images in Early America.* Berkeley: University of California Press, 2014.

Rockett, Darcel. "Tamir Rice Gazebo Reconstructed with Help from Rebuild Foundation." *Chicago Tribune*, July 1, 2019. https://www.chicagotribune.com /entertainment/ct-ent-tamir-rice-gazebo-reconstructed-20190625-20190701 -mux66svup5ctrdm65wgcuuurha-story.html.

Ross Archive of African Images. Accessed January 19, 2023. https://web.library
.yale.edu/collection/ross-archive-african-images.

Rothstein, Mervyn. "Louis Simpson, Poet of Everyday Life, Dies at 89." *New York
Times*, September 17, 2012. https://www.nytimes.com/2012/09/18/arts/louis
-simpson-a-pulitzer-prize-winning-poet-dies-at-89.html.

Roume, Philippe Rose. "Letter to Charles Willson Peale. January 4, 1802." In *The
Selected Papers of Charles Willson Peale and His Family*, vol. 2, ed. Lillian Miller,
381–86. New Haven, CT: Yale University Press, 1983.

Rushing, W. Jackson. "The Impact of Nietzsche and Northwest Coast Indian
Art on Barnett Newman's Idea of Redemption in the Abstract Sublime." In
"New Myths for Old: Redefining Abstract Expressionism." Special issue, *Art
Journal* 47, no. 3 (Autumn 1988), 187–95.

Samanani, Farhan, and Johannes Lenhard. "House and Home." In *Cam-
bridge Encyclopedia of Anthropology*, December 9, 2019. https://www
.anthroencyclopedia.com/entry/house-and-home.

Satter, Beryl. *Family Properties: Race, Real Estate, and the Exploitation of Black Urban
America*. New York: Macmillan, 2009.

Savoy, Lauret. *Trace: History, Race, and the American Landscape*. Berkeley: Counter-
point, 2015.

Sayre, Henry. *Value in Art: Manet and the Slave Trade*. Chicago: University of Chi-
cago Press, 2022.

Schneider, Richard J. "Thoreau's Panorama of the Mississippi: Its Identity and
Significance." *The Thoreau Society Bulletin* 245 (Fall 2003): 5–6.

Schwartz, Donald Kenneth. "Peele's Pepper: The Role of the Peele Family and
Salem, Massachusetts in the American Pepper Trade with Sumatra in the
period 1795–1815." Master's thesis, University of Colorado, 1988.

Schwartz, George. *Collecting the Globe: The Salem East India Marine Society Museum*.
Amherst: University of Massachusetts Press, 2020.

Scott, Lisa A. "Hippie Communes of the West Coast: A Study of Gender Roles
and the Evolution of the Counterculture's Definition of Freedom." *Papers &
Publications: Interdisciplinary Journal of Undergraduate Research* 6, article 6 (2017).

Schreyach, Michael. "Barnett Newman's 'Sense of Space': A Noncontextualist
Account of Its Perception and Meaning." *Common Knowledge* 19, no. 2 (2013):
351–79.

Seawood, James. "Reverend James Seawood," *StoryCorps*, first aired February 20,
2009, Accessed December 16, 2022. https://storycorps.org/stories/reverend
-james-seawood/.

Sellers, Charles Coleman. *Mr. Peale's Museum: Charles Willson Peale and the First
Popular Museum of Natural Science and Art*. New York: W. W. Norton, 1980.

Senie, Harriet F., and Sally Webster, eds., *Critical Issues in Public Art: Content, Con-
text, Controversy*. Washington, DC: The Smithsonian Institution, 2014.

Sennett, Richard. *The Conscience of the Eye: The Design and Social Life of Cities*. New York: W. W. Norton, 1990.

Seymour, Susanne, et al. "Estate and Empire: Sir George Cornewall's Management of Moccas, Herefordshire and La Taste, Grenada, 1771–1819." *Journal of Historical Geography* 24, no. 3 (July 1998): 313–51.

Sharpe, Christina. *In the Wake: On Blackness and Being*. Durham NC: Duke University Press, 2016,

Shaw, Gwendolyn DuBois. "'Moses Williams, Cutter of Profiles': Silhouettes and African American Identity in the Early Republic." *Proceedings of the American Philosophical Society* 149, no. 1 (March 2005): 22–39.

Sholette, Greg. "Reimagining Monuments to Make Them Resonate Locally and Personally." *Hyperallergic*, November 6, 2017. https://hyperallergic.com/408996/remagining-monuments-to-make-them-resonate-locally-and-personally/.

Sierzputowski, Kate. "A Procession of Black Love Responds to Controversial Michael Brown Exhibition in Chicago." *Hyperallergic*, September 7, 2015. https://hyperallergic.com/234957/a-procession-of-black-love-responds-to-controversial-michael-brown-exhibition-in-chicago/.

Smalls, James. "Visualizing Racial Antics in Late Nineteenth-Century France." In *Black and Blackness in European Art of the Late Nineteenth Century*, edited by Adrienne L. Childs and Susan H. Libby, 145–174. London: Routledge, 2014.

Smith, Charles. *The Antient and Present State of the County and City of Cork*. Dublin, 1750.

Smith, Clint. *How the Word Is Passed*. Boston: Little, Brown, 2021.

Smithson, Robert. "Robert Smithson Interview with Stig Broegger and Erik Thygesen," 1969. Holt Smithson Foundation. Accessed December 1, 2022. https://holtsmithsonfoundation.org/robert-smithson-interview-stig-broegger-and-erik-thygesen.

———. "Sedimentation of the Mind." In *Robert Smithson: The Collected Writings*, edited by Jack Flam. 100–13. Berkeley: University of California Press, 1996.

Solnit, Rebecca. "Every Corner Is Alive: Eliot Porter as an Environmentalist and an Artist." In *Storming the Gates of Paradise: Landscapes for Politics*, 302–42. Berkeley: University of California Press, 2007.

———. *Orwell's Roses*. London: Granta Books, 2021.

———. *Storming the Gates of Paradise: Landscapes for Politics*. Berkeley: University of California Press, 2007.

Southern Poverty Law Center. "Whose Heritage? Public Symbols of the Confederacy." February 1, 2019. https://www.splcenter.org/20190201/whose-heritage-public-symbols-confederacy.

Sperb, Jason. *Disney's Most Notorious Film: Race, Convergence, and the Hidden Histories of Song of the South*. Austin: University of Texas Press, 2012.

Spillers, Hortense. "Mama's Baby, Papa's Maybe: An American Grammar Book." In "Culture and Countermemory: The 'American' Connection." Special issue, *Diacritics* 17, no. 2 (Summer 1987): 64–81.

Stafford, Barbara Maria. *Artful Science: Enlightenment, Entertainment and the Eclipse of Visual Education*. Cambridge, MA: MIT Press, 1994.

Stagg, Allison M. "*Nature*: A Nineteenth-Century Engraving Linking Charles Willson Peale, James Akin, and Peale's Mastodon." *Panorama: Journal of the Association of Historians of American Art* 7, no. 1 (Spring 2021). https://journalpanorama.org/article/nature/.

Stamets, Bill. "Guerrilla Housing." *Chicago Reader*, November 28, 1991. https://www.chicagoreader.com/chicago/guerrilla-housing/Content?oid=878714/.

Steinberg, Leo. "The Flatbed Picture Plane." First published in "Reflections on the State of Criticism." *Artforum* 10, no. 7 (March 1972): 37–49; reprinted in *Other Criteria: Confrontations with Twentieth-Century Art* (Chicago: University of Chicago Press, 2007 [1972]), 61–98.

Stevens, Brett. "Antifa Attacks Peaceful Alt Right Protest, *New York Times* Trots Out N-Word." *Amerika*, February 28, 2017. http://www.amerika.org/politics/antifa-attacks-peaceful-alt-right-protest-new-york-times-trots-out-n-word/.

Taylor, Keeanga-Yamahtta. *Race for Profit: How Banks and the Real Estate Industry Undermined Black Homeownership*. Chapel Hill: University of North Carolina Press, 2019.

Tenneriello, Susan. *Spectacle Culture and American Identity, 1815–1940*. New York: Palgrave, 2013.

Terrono, Evie. "Performance, Political Discourse, and the Problematics of the Confederate Flag in Contemporary Art." *Public Art Dialogue* 8, no. 2 (2018): 142–83.

Terry, Don. "Homeless Prefer Huts to City's Public Housing." *New York Times*, June 13, 1992. https://www.nytimes.com/1992/06/13/us/homeless-prefer-huts-to-chicago-s-public-housing.html.

The-Dream. Verified comment on "No Church in the Wild." Genius. Accessed December 24, 2022. http://genius.com/314340.

Thompson, Erin. *Smashing Statues: The Rise and Fall of America's Public Monuments*. New York: W. W. Norton, 2022.

Thompson, Krista. "A Sidelong Glance: The Practice of African Diaspora Art History in the United States." *Art Journal* 70, no. 3 (2011): 6–31.

Thoreau, Henry David. "Walking." In *Excursions*. Boston: Ticknor and Fields, 1863.

Townsend-Gault, Charlotte. "Rebecca Belmore and James Luna on Location at Venice: The Allegorical Indian Redux." *Art History* 29 no. 4 (September 2006): 721–55.

Truettner, William H., ed. *The West as America: Reinterpreting Images of the Frontier, 1820-1920*. Washington and London: Smithsonian Institution Press for the National Museum of American Art, 1991.

Tuck, Eve, and K. Wayne Yang, "Decolonization Is Not a Metaphor." *Decolonization: Indigeneity, Education & Society* 1, no. 1 (2012): 1–40.

Tucker, Daniel. "Artists Imagining the City: Activist Art about Housing Issues in Chicago at the Start of the Twenty-first Century." *Art & the Public Sphere* 4, nos. 1 & 2 (2015): 69–82

——. "Chaos Agents." *AREA Chicago* 13 (2013). *AREA Chicago Archive*, March 3, 2019. https://areachicagoarchive.wordpress.com/2019/03/03/chaos-revisited/.

Settler Colonial City Project, "Unceded Land," 2019, Accessed December 18, 2022. https://settlercolonialcityproject.org/Unceded-Land.

United States Environmental Protection Agency. "Newtown, Queens, Brooklyn, New York Cleanup Activities." Accessed December 24, 2022. https://cumulis.epa.gov/supercpad/SiteProfiles/index.cfm?fuseaction=second.Cleanup&id=0206282#bkground.

University of Chicago. *Catalogue of the Alumni of the University of Chicago*. Chicago: Henson Bros., 1892. https://www.lib.uchicago.edu/ead/pdf/olduofc-0009-003.pdf.

Up River Syllabus, PDF published in conjunction with *Up River Studies: Carcerality and the American Sublime*, exhibition at CCS Bard, April 2–May 29, 2022.

Untitled review [on Romare Bearden], *Time*, October 16, 1964, 59.

Valandra, Edward. "Mni Wiconi: Water Is [More Than] Life." In *Standing with Standing Rock: Voices from the #NoDAPL Movement*, edited by Nick Estes and Jaskiran Dhillon, 71–89. Minneapolis: University of Minnesota Press, 2019.

Waldheim, Charles and Katerina Rüedi Ray. *Chicago Architecture: Histories, Revisions, Alternatives*. Chicago: University of Chicago Press, 2005.

WalkingStick, Kay. "Native American Art in the Postmodern Era." *Art Journal* 51, no. 3 (Autumn 1992): 15–17.

Wallach, Alan. *Exhibiting Contradiction: Essays on the Art Museum in the United States*. Amherst: University of Massachusetts Press, 1998.

Wang, Dave. "Thomas Jefferson's Incorporating Positive Elements from Chinese Civilization." *Virginia Review of Asian Studies* 145 (2012): 143–57.

Watson, Mark. "Unsettled Borders and Memories: A 'Local' Indigenous Perspective on Contemporary Globalization." *Journal of Aesthetics and Culture* 7 (May 2015): 1–19.

Waskow, Arthur. *From Race Riot to Sit-In*. New York: Doubleday, 1966.

Wasko, Janet. *Understanding Disney: The Manufacture of Fantasy*. Cambridge: Polity, 2020.

Weems, Jason. *Barnstorming the Prairies: How Aerial Vision Shaped the Midwest*. Minneapolis: University of Minnesota Press, 2015.

Wehtje, Myron F. "Charles Willson Peale and His Temple." *Pennsylvania History: A Journal of Mid-Atlantic Studies* 36, no. 2 (April 1969): 161–73.

Weinstein, Dina. "Shining a Light." *Richmond Magazine*, June 10, 2020. https://richmondmagazine.com/arts-entertainment/shining-a-light/.

Whiting, Sarah. "Bas-Relief Urbanism: Chicago's Figured Field." In *Mies in America*, edited by Phyllis Lambert, 642–91. New York: Harry N. Abrams, 2001.

Widrich, Mechtild. *Monumental Cares: Sites of History and Contemporary Art*. Manchester: Manchester University Press, 2023.

———. *Performative Monuments: The Rematerialisation of Public Art*. Manchester: Manchester University Press, 2014.

Wilkes, Wetenhall. "Bellville, A Poem." In *An Essay on the Pleasures and Advantages of Female Literature*. London, 1741.

Wilkinson, Jayne. "A Year in Contradictions." *canadianart*, December 26, 2018.

Williams, Amanda. "Color(ed) Theory Series." Studio website. Accessed December 24, 2022. https://awstudioart.com/section/373029-Color-ed-Theory-Series.html.

Williams, Raymond. *Keywords: A Vocabulary of Culture and Society*. Oxford: Oxford University Press, 1983 [1976].

Willis, Dave. "House of Gold Makes a Statement in Wilkinsburg," *Pittsburgh City Paper*, June 24, 2015, https://www.pghcitypaper.com/pittsburgh/house-of-gold-makes-a-statement-in-wilkinsburg/Content?oid=1760780.

Willsky-Ciollo, Lydia. "Apostles of Wilderness: American Indians and Thoreau's Theology of the Wild." *The New England Quarterly* 91, no. 4 (December 2018): 551–91.

Wilson, Ivy. *Specters of Democracy: Blackness and the Aesthetics of Nationalism in the Antebellum US*. Oxford: Oxford University Press, 2011.

Winnicott, Donald. "The Newborn and His Mother." In *Winnicott on the Child*, 32–42. Cambridge, MA: Perseus, 2002.

Winterbottom, Anna. "Transportation and Transplantation: Slave Knowledge and Company Plantations." In *Hybrid Knowledge in the Early East India Company World*, 163–95 London: Palgrave, 2016.

"A Word about Museums." *The Nation*, July 27, 1865.

Workers of the Writers Program of the Works Projects Administration in the State of Ohio. *Cudell House Crafts and Arts Center*. Cleveland: 1940.

Wynter, Sylvia. "Unsettling the Coloniality of Being/Power/Truth/Freedom: Towards the Human, After Man, Its Overrepresentation—An Argument," *CR: The New Centennial Review* 3, no. 3 (Fall 2003): 257–337.

Young, James E. "The Counter-Monument: Memory against Itself in Germany Today." *Critical Inquiry* 18, no. 2 (Winter 1992), 267–96.

Zootopia, directed by Byron Howard and Rich Moore. Walt Disney Pictures, 2016.

Zorach, Rebecca. "Abolition Art: Contemporary Imaginings Against the Carceral State." In *Routledge Companion to Art and Activism in the Twenty-First Century*, edited by Mey-Yen Moriuchi and Lesley Shipley, 216–29. New York: Routledge, 2022.

———. "Art & Soul: An Experimental Friendship between the Street and a Museum." *Art Journal* 70, no. 2 (Summer 2011), 66–87.

———. "Classicism, Conflict, and the White Body." In *Classicisms*, edited by Larry F. Norman and Anne Leonard, 111–25. Chicago: Smart Museum of Art, 2017.

———. "Making Space: 1961–1976." In *Art in Chicago: A History from the Fire to Now*, edited by Maggie Taft and Robert Cozzolino, 187–94. Chicago: University of Chicago Press, 2018.

———. "'Welcome to My Volcano': New Materialism, Art History, and Their Others." In *Ecologies, Agents, Terrains*, Clark Studies in the Visual Arts, edited by Christopher Heuer and Rebecca Zorach, 147–66. New Haven, CT: Yale University Press, 2018.

Zorach, William. *Art Is My Life: The Autobiography of William Zorach*. Cleveland: The World, 1967.

Index

Page numbers in italics refer to figures.